Hidden in Plain Sight: Selected Writings of Karin Higa

Edited by Julie Ault

Dancing Foxes Press, Brooklyn, in association with the
Magnum Foundation Counter Histories initiative

Selected Writings and Exhibitions by Karin Higa

Travels with Karin

Pamela M. Lee

A reader scanning the pages of this volume could not fail to be struck by the diamantine intellect, prescience, and ethical commitments of its author, the pathbreaking curator, critic, and art historian Karin Higa (1966–2013). Written between 1992 and 2011, the essays comprising *Hidden in Plain Sight* powerfully attest to a voice that we need now more than ever: they register Karin's vision for what art history, museums, and art worlds could be—indeed, must become. In charting the work of Asian American artists across the long twentieth century, Karin surfaced the breadth of individual and collective practices as shaped by ethnicity, diaspora, systemic racism, gender, and geopolitics. She forged connections across time and space in shared and parallel projects of creative endeavor and communitarian belonging, too often produced under conditions of acute depredation but no less beautiful because of them. Take, for example, her work on the 1920s photography studio of Toyo Miyatake in Los Angeles's Little Tokyo, a formative site for the representation of Japanese Americans in California.[1] Or consider Karin's writing on Ruth Asawa in the wake of Executive Order 9066, which forcibly relocated some 120,000 Japanese Americans during World War II: speaking to Asawa's sculptural fugues in looped wire, Karin narrated the artist's movements from the internment camp in Rohwer, Arkansas, to La Escuela Nacional de Pintura y Escultura La Esmeralda in Mexico City, to Black Mountain College in North Carolina—and beyond. Karin also reflected upon Theresa Hak Kyung Cha's text-based works and video of the 1980s, poetic meditations on colonial dispossession in Korea under Japanese occupation, Cold War language games in the United States, and the vicissitudes of race and gender everywhere.[2] Then there was her "incomplete" history of Godzilla, the Asian American arts network based in New York, in which she was a formative interlocutor, advancing the group's own particular approach to institutional critique during the culture wars that coincided with the rise of neoconservatism in the 1980s. Finally, and foundationally, there was Karin's abiding commitment to the art made

1 The work of Toyo Miyatake and others was the subject of Karin's unfinished PhD dissertation at the University of Southern California, Los Angeles, "Little Tokyo, Los Angeles: Japanese American Art and Visual Culture, 1919–1945."
2 In addition to these examples, all chosen for their implicit relation to this essay's interest in the thematic of travel, Karin's stunning exhibition *Living Flowers: Ikebana and Contemporary Art* and the retrospective *Bruce and Norman Yonemoto: Memory, Matter and Modern Romance* should also be pointed out here.

in U.S. concentration camps in Arizona, Arkansas, California, Colorado, Idaho, Utah, and Wyoming. For her, Hisako Hibi's intimate renderings of domesticity, maternity, and incarceration at Manzanar War Relocation Center and Henry Sugimoto's proud modernist portraits from the Jerome internment camp posed necessary questions of the method, politics, and history underwriting the entirety of her project: *What is Asian American art history?* Karin traveled far afield in seeking answers, trailing her subjects' movements and pathways as a kind of itinerant archive.

Indeed, travel was a lodestar of Karin's work, whether articulated in the prospects of diaspora, the traumas of compulsory migration, or the movements of artists seeking opportunity beyond the routinized spaces of daily life. To be sure, both the pleasures and the occasional annoyances of travel were continuous with her métier as curator and critic, for she was always on the move, always looking and learning about art. Here, then, I'll slip into first-person narrative, as consistent with Karin's own methodological outlook of eschewing the presumed authority of the distanced observer. If the opening paragraph of this essay introduced her contribution as a principled rebuke to art history's racial and geopolitical blindness, it was in part because she abhorred any pretense of a universal art history, absent any acknowledgment of positionality or self-reference. Instead, Karin's work was explicit in its outreach to communities of scholars, artists, and friends.[3] Her approach was nothing but subjective, intrapersonal, and collaborative in its intellectual engagements; it was no less rigorous because of it. Travel—as metaphor, research subject, and activity—enabled those engagements. For Karin, travel was not an escape from the world, a heady and abstract flight, hovering above material realities. It was a process installed in the contingencies of history and the actualities of concrete experience, life on the ground.

The first thing to say on the topic of Karin and traveling is that she was damn good at it—not just because she had her packing down to a science, sublime minimalist that she was. I can see her now. Among the many journeys we shared over the years, we met frequently in the Frankfurt Airport on the way to catch flights elsewhere. Beleaguered passengers scrambled to make connections, flustered and fumbling with passports and

baggage, but not Karin. She was inevitably pragmatic, present, and unencumbered: the girl traveled *light*. Speaking of her rare aptitude for travel comes at a risk, no doubt, as it would seem to invite charges of art-world privilege and platinum membership in the traveling class. The fact that Karin was the least entitled person you could ever meet should put any such accusations to rest. Instead, her sensibility was deeply humble, curious, and open to being in the world—the opposite of an imperious tourist.

I got my first glimpse of this ethos not in the air but on a road trip Karin and I took from Los Angeles to the Luiseño reservation in La Jolla, California, in December 1990. I had only known her a few months at that point and was thus excited for the journey ahead: two young Asian American women talking art, family, food, and fashion on a two-hour-plus drive south with FM radio for our soundtrack. We were meeting James Luna to discuss an exhibition we were organizing with Jonathan Caseley as curatorial fellows at the Whitney Museum Independent Study Program. Not long after setting out on Interstate 5 South, several things about Karin's approach became startlingly clear; talking to James with her about the traffic in Indigenous art and cultural heritage only cemented my admiration. At root was her insistence on how forms and histories of itinerary—alternately promoted through the sun-kissed advertisements of the tourist industry or strong-armed by war or colonial diktat—produced and reproduced social relations and in turn concomitantly gross inequities. Travel is necessarily embedded in structures of power and subjugation, both performance of and technology for such dynamics, whatever the workaday associations the rhetoric of travel may conjure. The point may seem an obvious one—particularly after the fact of the "global" turn in the history of art, not to mention the extraordinary corpus of research in Black, ethnic, and postcolonial studies. But the way Karin thematized such conceits relative to a specific set of artists, cultures, histories, and practices—all unrecognized by the official canons of art history and the art world—remains that much more meaningful in the present.

3 Karin collaborated, consulted, and exchanged ideas about museums and art history with countless scholars, critics, activists, and curators over the years, many of them artists and very dear friends. While there are too many to name here, these include Tomie Arai, Julie Ault, Melissa Chiu, Susette Min, Lydia Yee, Elaine H. Kim, Mark Dean Johnson, Kellie Jones, David Joselit, Bing Lee, Margo Machida, Yong Soon Min, Catherine Opie, Moira Roth, Kerri Sakamoto, Eugenie Tsai, Lynne Yamamoto, and Alice Yang.

Indeed, the theme of travel was at the center of one of her earliest publications, a short text written for a show we coorganized in 1990–91 at the Whitney Museum of American Art, *SITEseeing: Travel and Tourism in Contemporary Art.* Karin's essay, "The Artist as Traveler," is the work of a rising thinker. Impassioned and plainspoken, it issued a challenge to one of art history's most storied and romantic genres: the artist and the Grand Tour. Images of wide-eyed American naïfs in Roman sculpture galleries or intrepid explorers sketching in the jungle might be laughable clichés were they not so pernicious. "The artist as traveler is a stereotype," she opened, "whether in the guise of the early nineteenth-century leisure-class explorer-documenter on his expeditions or the rebellious and romantic artist finding refuge in 'primitive' and exotic lands."[4] Karin's discussion of artists including Renée Green, Kelly Ann Hashimoto, Leandro Katz, Renée Stout, and Tseng Kwong Chi spoke to competing forces of desire, critique, and ambivalence underlying the contemporary travel experience, addressing interlinked legacies of colonialism, war, tourism, and dispossession.

Karin touched upon related questions with her first major exhibition as curator at the Japanese American National Museum (JANM) in Los Angeles, beginning her tenure in 1991.[5] *The View from Within: Japanese American Art from the Internment Camps, 1942–1945* (1992) performed the difficult if necessary labor of showcasing the work of thirty-five artists who were interned in the camps following Franklin Delano Roosevelt's program of "relocation"—polite speech for the mass incarceration of U.S. citizens of Japanese ancestry. To draw a neat equivalence between travel, with its evocations of unfettered mobility, leisure, and lifestyle choice, and the forced relocation of thousands to wartime relocation centers, demands some qualification. The connection I'm establishing here means to surface the interpersonal—literally familial—dimensions of Karin's thinking and research process.

In 1969, when Karin was all of about three years old, her father, Kazuo Higa (1935–1994), joined a group of activists and former internees on what is considered the first official pilgrimage to Manzanar, near the Sierra Nevada mountains in California and perhaps the most (in)famous of the camps.[6] As a child, Kazuo was incarcerated at Heart Mountain War Relocation

Center in Wyoming; starting in 1968, he taught art and art history at Los Angeles Community College, where he "recognized the important connection for aspiring artists of color between making and seeing art."[7] The decade's coalitional politics of Third Worldism saw the Asian American movement gaining ground in ethnic-studies departments across California—but not only. The movement was in the streets: in communities of color, in solidarity with Black Power, refusing the enduring legacies of Jim Crow; protesting the military disasters in Vietnam, Laos, and Cambodia then unfolding; and confronting earlier colonial escapades of the United States in Hawaii, Korea, the Pacific Islands, the Philippines, and elsewhere.

The movement was also taking to the road. As documented by filmmaker Tadashi Nakamura, whose father, Robert A. Nakamura, was a close friend of Kazuo's (and is himself widely recognized as an éminence grise of Asian American media and cinema), the pilgrimage to Manzanar included some 150 people, who loaded into buses and carpools to make their way to the skeletal ruins of the camp, erased in the triumphalist narratives of the recent postwar past. Understandably, for many former prisoners who endured the brutalization of their civil liberties—the raw winters, mass displacement, "loyalty assessments," and barbed wire—the prospect of such a trip was too much to bear. Those who did make it, among them Kazuo and Robert, came together with student activists not only to mourn what transpired decades earlier and recognize communal survival but also to find a way forward into the future. Collective remembrance would indeed model a new history for later generations, Karin's included, because the official chronicles of American history—a history organized around heroic and singular Great Men—are not at all the same thing as the "past."

A collective pilgrimage on the road or in the air, a trip back in time, and a movement forward all at once: in many ways, this

4 Karin Higa, "The Artist as Traveler," in *SITEseeing: Travel and Tourism in Contemporary Art* (New York: Whitney Museum of American Art, 1991), 2.
5 *The View from Within: Japanese American Art from the Internment Camps, 1942–1945* was an institutional collaboration between the Japanese American National Museum, Los Angeles; Wight Art Gallery, University of California, Los Angeles; and the UCLA Asian American Studies Center.
6 "Unofficial" pilgrimages to Manzanar took place until 1969, when the ad hoc Manzanar Committee began sponsoring annual pilgrimages to the site. Karin described her family's pilgrimages to Manzanar in "California Registered Historical Landmark no. 850," in this book, 254–61.
7 On this history, see Karin's essay "Black Art in L.A.: Photographs by Robert A. Nakamura," reprinted in this book, 390–97. The essay was written on the occasion of *Now Dig This! Art and Black Los Angeles, 1960–1980* (2011–12), curated by Kellie Jones for the Hammer Museum, Los Angeles.

litany captures the dynamic spirit of Karin's endeavor. There's a photograph from her childhood I'm thinking of—a road-trip souvenir—that provides the most poignant illustration of this conceit, found here on page 255. (Karin's deep love of the medium—her scholarship on photography—renders the example especially apt.) Like so many pictures enshrined in family albums from decades past, it records a family outing and features the typical hallmarks of such visual documents. A wash of faded color, an outmoded pictorial format, and two kids in shorts are dutifully posed for the camera, in front of a monument.

But for what kind of monument and to what past—to what future—are such photographic souvenirs recollected and then recruited? Kazuo and Keiko Higa clearly saw travel with their young children less as recreational idyll than as opportunities for learning. Starting out from Los Angeles, they took to the highway on several occasions in their trusted, Ceylon-yellow VW bus, demonstrating to their children by example just how history gets made. Five hours on the road, from the heat of Death Valley to the arid climes of the eastern Sierra, the family made their way. The photo records the destination. Here Karin stands with her younger brother, Kevin, before the cemetery shrine at Manzanar, amid the dust and scrub of the camp's remains; in the background, the Sierras loom above the creosote, imparting a sense of scale and desolate grandeur. Kevin angles away from the lens as if he were about to dash off, perhaps in pursuit of a lizard, while Karin places her hand behind him in a gesture of sibling seniority, facing forward and proud. The shrine marks the barrenness of a recent history that would have been all but erased from the mainstream record were it not for the work of activists of the earlier generation that included Kazuo. "Monument to console the souls of the dead," the monument reads, "August 1943." Even as a young child, Karin intuited how the travel experience was directly related to the historian's practice. "We were all scavenging for history there," she recalled.[8]

Abundantly gifted with an eye at once generous and piercing, Karin knew better than anyone that a picture's meaning is always in transit, standing in excess of its representation, the literal contents of the image or the blunt fact of its vintage. Indeed, closing on this childhood photograph of Karin is no mere

exercise in nostalgia, even as so many of us continue to mourn her loss and honor her extraordinary contribution. Rather, like travel itself—like Karin following her parents' lead—the collective return to such images constitutes its own kind of historical activity, a reckoning with past sites in the present tense. History itself becomes a pilgrimage, and Karin's thinking as scholar and traveler—guided by implacable ethics and a ferocious love of community, family, and friends—was always in motion, always moving forward, always directed to new possibilities on the coming horizon.

This essay is dedicated to Russell Ferguson, Keiko Higa, Kevin Higa, and to the next generation, including Karin's niece, Rose Keiko Higa.

8 Higa, "California Registered
Historical Landmark no. 850," 255.

The Makings of Karin Higa

Julie Ault

Karin Higa was twenty-five when Karen L. Ishizuka and Robert A. Nakamura handpicked her to curate a historic exhibition for the newly opened Japanese American National Museum (JANM) in Little Tokyo, Los Angeles, where they worked.[1] Ishizuka and Nakamura were colleagues and friends of Karin's father, Kazuo "Kaz" Higa, and Ishizuka remembers first meeting Karin as an eleven-year-old: "I remember our first meeting well because one of the first things this pre-teen did was ask me how I felt about the ERA, the equal rights amendment. So that was my introduction to Karin: precocious beyond her years, and the youngest feminist I ever knew."[2] Regardless of Karin's inexperience, Ishizuka and Nakamura trusted that she could bring the watershed exhibition to fruition and do justice to its impactful content. *The View from Within: Japanese American Art from the Internment Camps, 1942–1945*, which would open in October 1992, indeed proved groundbreaking for the museum and its constituencies, the Japanese American community at large, and pivotal for Higa and her lifework.

In the years ahead, Karin Higa (1966–2013) would become a leading thinker on twentieth- and twenty-first-century American, Asian American, and especially Japanese American art, bringing profound consideration and vivid portrayal to every artist, object, situation, and history on which she focused. In her capacity as a museum curator and art historian, Higa was revered for her curatorial passion and collaborative spirit, down-to-earth manner, enthusiastic outlook, and critical acumen, which opened new paths of study and recuperated significant artists and oeuvres from historical neglect engendered by racial discrimination.

"The View from Within: Japanese American Art from the Internment Camps, 1942–1945" opens this book of twenty-one essays, arranged chronologically. In it, Higa identifies the imprisonment of Japanese Americans during World War II as a crucial reference point for Japanese American culture and collective narrative and

1 Karen Ishizuka is a historian and curator and current chief curator at the Japanese American National Museum. Robert Nakamura is a photographer, filmmaker, and cofounder, in 1970, of Visual Communications (VC), the first nonprofit organization in the United States devoted to the development of Asian Pacific American film, video, and media. Nakamura's 1970 portraits of Los Angeles–based Black artists, made in their studios at the invitation of Kazuo Higa, are the subject of Karin Higa's essay "Black Art in L.A.: Photographs by Robert A. Nakamura," in this book, 390–97.
2 Karen Ishizuka, memorial remarks, life celebration for Karin Higa, Hammer Museum, Los Angeles, December 8, 2013. Published in *Karin Higa* (Los Angeles: Russell Ferguson, 2015), 23.

memory; she would return to this history frequently, as the experiences and trauma of the camps haunt the work of so many of the artists that captured her attention, whether or not they or their families or friends themselves were incarcerated.

While wartime imprisonment could be seen as representing the climax of state-directed anti-Japanese bigotry, it was buttressed by a long history. It wasn't until 1965 that the Hart-Celler Immigration and Naturalization Act finally abolished the national-origin quota system restricting U.S. immigration to northern and western Europeans. For almost fifty years, immigration from Asian nations had been barred due to the 1924 Immigration Act, which had upheld the earlier Asiatic Barred Zone Act, instituted in 1917 to maintain a majority-white population. Besides these blunt exclusion acts, U.S. federal legislation and public policies discriminated against Asian immigrants and American-born residents and citizens of Asian ancestry through alien land laws, sundown regulations, sanctioned segregation, marriage restrictions, targeted taxation, and state and federal Supreme Court rulings that denied naturalization. Commonplace practices of economic bigotry, exploitation, stereotyping, and harassment further dispensed racial hatred.

Fueled by powerful labor unions, the dominant white public widely mistreated and sometimes violently abused immigrants from Asian countries and Americans of Asian descent, especially in the western states, despite the liberal, progressive, even "utopian" reputation often associated with California and the Pacific Northwest. Beginning in the late 1840s, men from China, first to join the gold rush and then to build the railroads, relocated to California and, soon after, Oregon, where they encountered explicit racism and brutality, including mass lynching and massacres. The Japanese immigrants who journeyed to Hawaii to work on sugarcane plantations and to the Pacific coast states to find employment in agriculture faced similar obstacles. Educator, writer, and poet Walidah Imarisha argues that Oregon was a fitting "case study for the larger society because the ideas that founded Oregon are the same ideas that founded the United States." It was, however, "the only state blatant enough to put racism into its constitution,"[3] establishing statehood with a racial-exclusion clause that was not entirely excised until 2001: "No Negro, Chinaman, or Mulatto shall have the right of suffrage."[4] Imarisha repudiates the claim that such discrimination is history, calling it "a living legacy, because the reality is the repercussions of this continue to exist with us."[5] The founders of the United States formulated the nation in their image as white men of property, barring all others from legal standing and voting and citizenship rights. Despite the country's mythology of nurturing multiplicity, *American* meant white—a linguistic sleight of hand comparable to the generic use of *he*, which only purports to include women.

Aerial perspective of crowd boarding buses in front of Nishi Hongwanji Buddhist Temple, Los Angeles, 1942

Santa Anita Assembly Center, Arcadia, California, April 1942

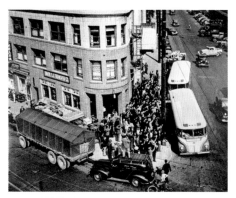

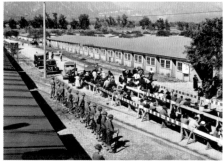

3 Walidah Imarisha, "Why Aren't There More Black People in Oregon? A Hidden History," presented by Diverse and Empowered Employees of Portland (DEEP), November 9, 2017, accessed at https://www.youtube.com/watch?v=7Lcm1LDZZXg.
4 Constitution of Oregon, Section II, Article 6, approved November 9, 1857, and established with statehood, February 14, 1859.
5 Imarisha, "Why Aren't There More Black People in Oregon?"
6 Some estimate less and some more, but Higa frequently cites this figure in her writings.
7 Karen Ishizuka reminds us, "FDR himself called [the camps] concentration camps and federal spin doctors later rechristened [them] 'relocation centers' and even 'pioneer communities.'" Ishizuka, *Serve the People: Making Asian America in the Long 1960s* (London: Verso, 2016), 23–24.

The so-called Japanese internment, which imprisoned approximately 120,000 Japanese Americans solely based on race, was a turning point, a delineation of a *before* and a resounding *after* for Japanese Americans.[6] Fearful of what was to come after Japan bombed Pearl Harbor on December 7, 1941, many Americans of Japanese descent destroyed anything that traced them back to their ancestral home, including photographs and family albums, books written in Japanese, printed material and correspondence, mementos and heirlooms. Harassment surged, racist headlines increased, and people boycotted Japanese American businesses. Under pressure from the jingoistic press, chief military advisers, and agricultural associations intent on eliminating competition from Japanese American farmers, President Franklin D. Roosevelt signed Executive Order 9066 on February 19, 1942, effectively expelling all persons of Japanese ancestry from western states to camps administrated by the War Relocation Authority (WRA). The government labeled all U.S. residents of Japanese ancestry "enemy aliens" and froze their bank accounts, depriving them of due process, even though as many as two-thirds of this population were American citizens.

Given mere days to vacate their homes and businesses, they were forced to gather items they "could carry"—bedding, clothing, and essential personal items, which the government would not supply—and to dispose of the rest of their belongings. After they had reported to "assembly centers" as ordered, military staff registered, numbered, tagged, and fingerprinted each person and assigned them to a temporary detention center, such as the Santa Anita racetrack, where families were given raw horse stalls as living quarters. No one informed them where they were going or for how long they would be detained. Although the government brought no charges against them, the WRA sent the evacuees to one of ten concentration camps, euphemistically called "relocation centers" and "wartime residences," hastily constructed for the incarceration in remote locations with extreme climate conditions, where some would stay for as long as four years.[7]

Release from the camps was bittersweet. Japanese Americans faced fresh persecution on their return home. Many moved to the Northeast and Midwest to escape the conspicuous racism of the West Coast. It wasn't until 1976 that Executive Order 9066 was repealed, under President Gerald Ford Jr., and it took another decade for Congress to issue a formal apology and twenty thousand dollars in reparations to more than eighty thousand Japanese Americans. The echoes of the atrocity unfold over time: the shock, fear, anguish, distress, disappointment, shame, anger, and weight of being betrayed by the country called home, and of being torn from home, livelihood, and community. The trust that the United States had been given but never actually earned was lost. Opinion writer Elizabeth Bruenig recently deliberated on the limits of court and governmental "justice": "Pain lasts, grief lasts, anger lasts. The life you had before loss is never returned to you."[8]

Higa's influential research on the grassroots artistic life in the camps "as seen through the eyes of imprisoned artists" adroitly moves in and out of personal and collective narratives, signaling an enduring aspect of her model art historical practice.[9] In *The View from Within* exhibition and her writing on it, Higa introduces numerous artists and protagonists, many of whom (including Ruth Asawa, Hideo Date, George Matsusaburo Hibi, Hisako Hibi, Toyo Miyatake, Chiura Obata, Miné Okubo, Henry Sugimoto, and Tokio Ueyama) she would later explore in fuller and monographic depth.

Shifting between in-depth, close examinations of artists and artworks and investigations of various contexts of dialogue and production, Higa maps communal life and collegial networks. She details the art classes and art associations that took root and blossomed in several camps under the guidance of renowned artists who had flourished in prewar western U.S. culture. The artists' associations, networks, and milieus in and outside the camps that animate Higa's work include Shaku-do-sha, a group of Japanese American painters, poets, musicians, and photographers founded in the Los Angeles neighborhood of Little Tokyo to study and further all forms of modern art; the larger cultural life of Little Tokyo; and the entanglement of Asian American and Euro American artists, particularly during the interwar period in California.

Karin Higa was born to Kazuo and Eileen Keiko (Shigaki) Higa in Los Angeles in 1966—a year after the Hart-Celler Act was passed. Her brother, Kevin, was born two years later. The Higas raised their children in Culver City, a neighborhood west of downtown Los Angeles that, as home to MGM studios, served as a center of television and film production. When a child, Kaz had been incarcerated with his Okinawa-born parents at Heart Mountain

From left: Karen Ishizuka's daughter Thai; Nancy Araki; Kevin, Kaz, Keiko, and Karin Higa; John Esaki (behind); and Robert A. Nakamura holding his son Tadashi, 1980

Karin Higa (front row, right) with Robert A. Nakamura and Karen Ishizuka (back row, right) and others, 1979

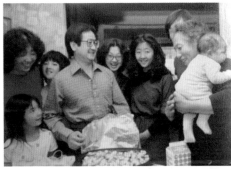

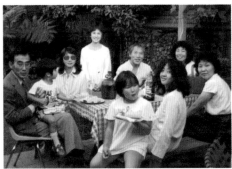

8 Elizabeth Bruenig, "Chauvin Was Convicted. Something Is Still Very Wrong," *New York Times*, April 24, 2020.
9 Pamela M. Lee, memorial remarks, life celebration for Higa. Published in *Karin Higa*, 66.
10 "Nakamura's friend and colleague Kaz Higa came up with the name Visual Communications," notes Joshua Glick. Joshua Glick, *Los Angeles Documentary and the Production of Public History, 1958–1977* (Berkeley: University of California Press, 2016), 226n76.
11 Eileen Keiko Higa was active in such organizations as Japanese American Community Services of Southern California, Culver City Sister City Committee (for Kaizuka, Japan), and Mokichi Okada Association, Los Angeles.
12 Lee, memorial remarks, 63.

War Relocation Center in Wyoming, one of the ten American concentration camps the U.S. government constructed to imprison Japanese Americans during World War II. He later studied art, design, and art history and began teaching art and art history at Los Angeles City College in 1968. A wholehearted advocate of all minority students and a dedicated teacher until he died in 1994, Kaz became chair of the Ethnic American Cultures Department and directed the school's Da Vinci Art Gallery. As a graphic designer, he worked for the studio of Charles and Ray Eames. Kaz was also active in the Asian American movement and involved with the L.A. media organization Visual Communications (VC), for which he conceived the name.[10] Eileen Keiko Higa was an avid participant in several Japanese American community associations.[11]

The social and creative communities to which Karin's parents contributed and belonged shaped the stimulating cultural and political environment that she grew up in. She would share her father's passions for art, education, history, social justice, and community vitality, as well as her mother's social spirit and commitment to cultural community service. In 1984, Higa moved to New York to study art history at Columbia College at Columbia University, where she earned her bachelor's degree. Already demonstrating her drive and ample skills, she worked, from 1988 to 1990, as an assistant and then associate director at the advocacy and grantmaking agency New York Foundation for the Arts (NYFA), before entering the Independent Study Program (ISP) at the Whitney Museum of American Art in 1990 as a Helena Rubenstein Fellow. The scholar and art historian Pamela M. Lee, who attended the ISP alongside Higa and became a lifelong friend, recalls being "instantly impressed by this ferociously intelligent woman who took no prisoners in seminar, particularly when discussions turned to questions of race and ethnicity, as they often did during those embattled days of the culture wars." She continues, "But what distinguished Karin…was that she betrayed no venom, arrogance, nor ego in staking her position in a debate. Even at her most incisive she was a generous interlocutor."[12]

While conversant in current theoretical discourses throughout her career, Higa preferred cutting through the jargon to get to the heart of matters.

With her curatorial and scholarly practice unfurling in tandem with the developing field of Asian American art history in the early 1990s, amid upheavals over such issues as racial justice, the AIDS crisis, gay liberation, women's reproductive rights, and multiculturalism,[13] Higa joined, as an early member, the New York–based Godzilla: Asian American Art Network. Founded in 1990 by Ken Chu, Bing Lee, and Margo Machida, Godzilla forged a dynamic and open-ended alliance between art-field practitioners of Asian ancestry; the group was influential in critiquing the art-field hierarchy and generating visibility for Asian Americans in the arts and discourse around Asian American art.

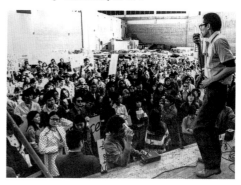

Yuji Ichioka speaking at Asian Americans for Peace march, Los Angeles, January 17, 1970

In 1991, Lee introduced Higa to Russell Ferguson, who worked at downtown Manhattan's New Museum and had coedited the recently published *Out There: Marginalization and Contemporary Cultures* (1990).[14] The two instantly hit it off. When Higa moved back to Los Angeles to begin what was to become an influential career at JANM, Ferguson accepted a position as editor at the Museum of Contemporary Art (MoCA) in Los Angeles. (The pair would marry in 1997.) Said Lee, "New York's loss was L.A.'s gain."[15]

Soon after her move, Higa wrote to Eugenie Tsai and fellow Godzilla-ites about a symposium on Asian American artists she was coorganizing: "L.A. Asian American artists have not mobilized or organized in any formal or informal way. A lot of people don't know each other or have the opportunity to connect. There seems to be a real desire for a Godzilla to descend into town and take over. Perhaps the advisory committee and symposium will have a catalytic affect. Who knows what will or could happen. There are a lot of good artists here and the mood seems hopeful."[16]

Born on the cusp of the transformative events of the late-sixties Asian American movement, Higa hailed the radical origins of Asian American political agency, noting how "many have argued and commented on the fact that it is racism (either in threat or experience) that is the unifying scheme for an Asian American identity."[17] The Asian American movement took shape amid postcolonial critique, civil rights, Black Power, women's rights, and antiwar struggles during the

13 Educator and curator Susette Min notes that "'Asian American art' arguably did not appear until the early 1990s, an outcome of identity politics and multiculturalism." Susette Min, introduction to *Unnamable: The Ends of Asian American Art* (New York: New York University Press, 2018), 16.

14 Lee, memorial remarks, 65. "Earlier it had occurred to me that Karin and Russell should be introduced. Russell had coedited that formative volume *Out There: Marginalization and Contemporary Cultures* (1990), and I knew the two would have plenty to say to one another. And so, Karin and Russell met that night. Maybe it sounds a little gauzy in the telling—and Russell will no doubt have an entirely different version of their first meeting—but in retrospect it did seem like a waters-parting kind of moment. Because, of course, they were beyond right for each other."

15 Ibid., 66.

16 Karin Higa, letter to Eugenie Tsai, in *Godzilla: Asian American Arts Network 1990–2001*, ed. Howie Chen (Brooklyn, NY: Primary Information, 2021), 187. Working on behalf of JANM, Higa collaborated with Kim Kanatani, the associate director of education at the Museum of Contemporary Art (MoCA), Los Angeles, and Julie Lazar, MoCA curator, to organize a one-day panel discussion/symposium about contemporary Asian American visual, media, and performance artists.

17 Karin Higa, "Outside Field Exam," undated, Karin Higa personal papers.

18 Led by the Third World Liberation Front (TWLF) and the Black Students Union at SFSU, the strike extended for five months. The Berkeley strike began in January 1969.

19 Yuji Ichioka, quoted in Brittany Martin, "L.A.'s Asian-American Activist Newspaper from the '70s Is Back in Print," *Los Angeles Magazine*, December 19, 2019, https://www.lamag.com/culturefiles/gidra-asian-american. The term was coined at the founding of the Asian American Political Alliance (AAPA) at Ichioka and Emma Gee's apartment.

20 Ishizuka, *Serve the People*, 62.

21 Margo Machida, "Reframing Asian America," in *One Way or Another: Asian American Art Now*, ed. Melissa Chiu, Karin M. Higa, and Susette S. Min (New York: Asia Society, in association with Yale University Press, New Haven, 2006), 16, 19.

1968–69 student strikes at San Francisco State University and the University of California, Berkeley.[18] The student groups demanded the schools create ethnic studies to counter and expand the Eurocentric educational perspective. Yuji Ichioka and Emma Gee coined the term *Asian American* to unite an "inter-ethnic-pan-Asian self-defining political group" and replace then-rampant derogatory terminology, such as *Oriental*, *yellow*, and *Asiatic*.[19] UC Berkeley and SFSU established Asian American Studies the following year, and the University of California, Los Angeles, inaugurated the Asian American Studies Center, with Ichioka as its first professor.

In her book about the movement, Ishizuka recounts, "The self-identifier 'Asian American' marked a seismic shift in consciousness. More than just a descriptor, the term subverted the Orientalist tradition of lumping all Asians together—this time as an oppositional political identity imbued with self-definition and empowerment, signaling a new way of thinking."[20] For Ishizuka, the term crystallized ethnic pride, cultural identity, and political agency. In her essay for *One Way or Another: Asian American Art Now*, the catalogue that accompanied the eponymous exhibition Higa, Melissa Chiu, and Susette Min cocurated in 2006, Margo Machida notes, "Many of the early leaders of that movement were American-born second and third generation East Asians who found commonalities in being raised in this country, and often in struggling with institutionalized discrimination, racism, and ethnic stereotyping," adding that "one may speak of collectivities without necessarily positing a totalizing homogeneity among individuals or their particular concerns."[21] Curator and editor Mark Dean Johnson, who has coorganized some of the most comprehensive exhibitions and publications on modern and contemporary Asian American art, agrees: "And, while the practice is well understood within the discipline of Asian American studies, our grouping together diverse nationalities separated by distinct language and cultural expression does not indicate that we mean to collapse the

very real differences between these communities."[22] Speaking to the term's prehistory, Higa wrote: "The artists of the pre–World War II era could not have conceived of such a designation, though they not only valued their specific ethnic heritage but also made connections with artists of varying backgrounds. Using the term *Asian American* broadly and with shaded meaning in different contexts…is not historically accurate but acknowledges that the vocabulary we use to indicate self and group identification is woefully inadequate."[23]

Karin Higa at the National Endowment for the Humanities Summer Institute, Asian/Pacific/American Institute, New York University, 2012

Curator Howie Chen notes that "Asian American identity, with its origins in 1960s radical anti-imperialism, has been shaped by its function as a pragmatic organizing tool counterbalanced by a critique of its racial underpinnings." He continues, "Godzilla organized under the label 'Asian American' as a strategy, while subjecting the racial category to rigorous critique."[24] Despite its liberating origins, *Asian American* lumps together U.S. residents and citizens of Asian ancestry, compressing specificities and histories— generations of immigrants and American-born citizens with roots in more than twenty countries in East and Southeast Asia and the Indian subcontinent in blanket compaction, linking diasporic Asian Americans and American-born persons to ancestral lands, regardless of relationship. The use of *Asian American* and its critical appraisal have been symbiotic for more than half a century. Many organizations and individuals use *Asian American* and the permutation *Asian American Pacific Islander (AAPI)* strategically. Others do so by default, for expediency.[25] Yet many people who are so designated do not identify themselves as such. "The moniker is now flattened and empty of any blazing political rhetoric" for writer and poet Cathy Park Hong. "We're this tenuous alliance of many nationalities. There are so many qualifications weighing the 'we' in Asian America. Do I mean Southeast Asian, South Asian, East Asian, *and* Pacific Islander, queer and straight, Muslim *and* non-Muslim, rich *and* poor?"[26]

Like *Asian American, Asian American art* has been a contested term since its inception forty years ago. Writing in 1993 about Asian American exhibition frameworks, curator Alice Yang asked, "Is it simply a descriptive label referring purely to the racial background of the artist? Or does the term serve a critical purpose in designating a kind of art with shared concerns, vocabularies, and histories that imply the combination of Asian and western modes?"[27] Speaking to the seminal exhibition

22 Mark Dean Johnson, "Beyond East and West," introduction to "Artists of Asian Ancestry in America," in *Asian American Art: A History, 1850–1970*, ed. Gordon H. Chang, Mark Dean Johnson, and Paul Karlstrom (Stanford, CA: Stanford University Press, 2008), xvii–xviii.

23 Karin Higa, "Some Notes on an Asian American Art History," in this book, 80.

24 Howie Chen, "Godzilla: Critical Origins" in *Godzilla*, 17, 18.

25 For a comprehensive and compelling history of Asian America from the 1850s to the present, see Erika Lee, *The Making of Asian America* (New York: Simon & Schuster, 2015).

26 Cathy Park Hong, *Minor Feelings: An Asian American Reckoning* (New York: One World, 2021), 19.

27 Alice Yang, "Why Asia?," in *Why Asia?: Contemporary Asian and Asian American Art* (New York: New York University Press, 1994), 104.

28 Karin Higa, in "Conversation 2: Asian American Community. Kyung Sun Cho, Karin Higa, Candace Lee, Ann Page, Kim Yasuda, and Notes from May Sun," in *Personal Voices/ Cultural Visions: Conversations in the Visual Arts Community, Los Angeles 1994–1996*, ed. Ann Isolde (Los Angeles: Southern California Women's Caucus for Art, 2018), 44–83.

29 Min, introduction to *Unnamable*, 17.

30 Ibid. "Leaving the art unnameable is on one level a refusal of neoliberal multiculturalism's deleterious promise of representational invisibility, and on another level breaks away from narrow modes of entry into art history that find the curating of Asian American art as a residual practice" (28).

31 bell hooks, in *bell hooks—Cultural Criticism & Transformation*, Media Education Foundation, transcript, 1997, https:// www.mediaed.org/transcripts/Bell-Hooks -Transcript.pdf, accessed April 5, 2022.

32 I am reminded of bell hooks's mantra-like use of "white supremacist capitalist patriarchy." "I began to use the phrase in my work…because I wanted to have some language that would actually remind us continually of the interlocking systems of domination that define our reality and not to just have one thing be like, you know, gender is the important issue, race is the important issue, but for me the use of that particular jargonistic phrase was a way, a sort of short-cut way, of saying all of these things actually are functioning simultaneously at all times in our lives." She continues, "To me an important breakthrough…was the call to use the term *white supremacy*, over racism because racism in and of itself did not really allow for a discourse of colonization and decolonization." Ibid.

33 The exception was *One Way or Another: Asian American Art Now* (2006), cocurated with Susette Min and Melissa Chiu for the Asia Society, New York.

Asia/America: Identities in Contemporary Asian American Art (1994), Higa commended curator Margo Machida for putting together a show that was "not about ethnicity [but] about the art.…This body of work…was about transition between cultures, about immigrants who were born and acculturated in another country and how that manifested in their work."[28] Recently, curator and educator Susette Min wrote, "'The inner contradictions of the term…[have] consistently been deferred or negated by scholars and curators of Asian American art alike."[29] She poses the thorny question, "How does one weigh a call and desire for inclusion against the very logic of neoliberal multiculturalism that will coopt this inclusion?" Min proposes to dispossess the insoluble dilemma, insofar as Asian American art and art history are concerned, and *unname*.[30] In an opposite move, feminist author bell hooks marks all groups in her writing and speech as a way of leveling the field; hooks long discerned a "tremendous reluctance" in the U.S. "to have a more complex accounting of identity."[31] Identity, race, and ethnic-based frameworks are now often foregrounded, both divisively and productively, but hooks suggests that calling out whiteness holds out potential for progress toward racial justice.[32] Should new terminology and classifications be created, or are such designations altogether expendable? To what degree does naming, defining, and delimiting "Americans" indicate a historical and generational disposition to reinforce long-enduring structural hierarchies? To what degree is revision possible? Are such hierarchical naming systems on the verge of becoming history? Younger-generation curators, authors, policy-makers, and educators are vigorously taking up these predicaments. Will they create effective possibilities and resolutions?

Though the Japanese American National Museum, which was explicitly organized around cultural identity, directed her curatorial attention for much of her career, Higa did not set out to construct racially or ethnically defined exhibitions.[33] Her perspective on art and artists was boundless and generous. "Their job is to make

work, in whatever way they please," she insisted.[34] Engaging divergent traditions, styles, and modalities, she imposed no firm concepts of representational responsibility, message, or political purpose on art. Reflecting on some of the critical reception of *The View from Within*, she reveals her high regard for artists:

> The art that was made during the internment of Japanese Americans…was dismissed by young Japanese American activists as not being resistant enough. They claimed that by making "pretty pictures," rather than overt scenes or signs of protest and resistance, these artists made the internment camps seem like really nice places….
>
> Some people felt the pictures of flowers or a mother and child did not adequately capture the horror of the camps. They couldn't see how these paintings and drawings were critiquing camp life or telling a story—depicting or legitimizing their experiences—or just offering a sense of hope, all of which are active forms of resistance.[35]

For Higa, art registers political circumstances through open-ended means. She understood the contradiction at the heart of Japanese American and Asian American art and embraced the paradox and the double edge, sometimes subduing the conflict so as not to undermine her work and purpose. She affirmed the right of artists to either claim or remain free of categorizations.

Artist Mika Tajima recalls a studio visit she had with Higa and cocurator Susette Min in preparation for the exhibition *One Way or Another*: "I was curious and skeptical about what the curators were proposing with this exhibition, as I never viewed my work as racially designated art. But this blunt subtitle belied Karin's nuanced political, rational, and passionate thoughts about the myriad issues surrounding race, representation, art, and the art world at large." Tajima continues, "[Higa] did not think of Asian American as a marginal position, but rather confronted the complex, contradictory, and unique perspective of the moniker itself. Moreover, my ethnicity or race did not overshadow her perspective or connection with my work. It wasn't my identity that necessarily interested her about my work; it was the work itself, and that was so satisfying to be respected as an artist."[36]

Art historian Marci Kwon recently detailed the difficulties confronting early curators and historians of Asian American art, including Higa, Johnson, and Machida.

> These scholars…traverse boundaries not typically crossed by art historians: between academic and curatorial; scholarship and activism; art and community; historical and contemporary.

Their work suggests the flexibility, collaboration, and above all, trust required to produce scholarship on artists whose work and histories are often located in private residences rather than institutions, in memories rather than archives, and whose affective charge, especially to the communities to which they belong, greatly exceed their monetary value.[37]

Kwon continues,

The ethical challenge of writing about Asian American artists is to respect, rather than to solve, the paradox of their existence. We must neither deny the effects of structural violence on their lives and work nor reduce their practices to these structures. We must respect the depth and boundlessness of their imaginations, the conceptual and emotional richness of their aesthetic propositions, while also recognizing the way such experiments often, but not always, arise from specific experiences of violence, confinement, dehumanization, and grief. To see their art, we must hold all of these things together.[38]

Acutely aware of the hazards, Higa forged a particular path that acknowledged the enormous value of scholarship and curating in terms of cultural and ethnic identity, while remaining vigilant and vocal about the interpretive pitfalls, stereotypes, and ghettoization categories and terminology can impose. In 1999, she organized *Bruce and Norman Yonemoto: Memory, Matter and Modern Romance*, which was accompanied by the artists' first monograph. As a contemporary-art exhibition, the show was trailblazing for JANM, founded as a history museum. It comprised two decades of the Yonemoto brothers' extensive body of single-channel videos and film and media installations, which appropriated and blended television, Hollywood, and

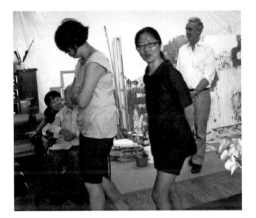

Karin Higa on a tour of Po Kim's studio, National Endowment for the Humanities Summer Institute, Asian/Pacific/American Institute, New York University, summer 2012

34 Karin Higa, in "Mapping from the Cultural Cringe: A Roundtable Discussion with Michael Dear, Ann Goldstein, Karin Higa, and Stephen Prina," in *LAX/94: The Los Angeles Exhibition*, ed. Catherine Gudis and Sherri Schottlaender (Los Angeles: LAX, Los Angeles Exhibition, 1994), 13.
35 Ibid., 15.
36 Mika Tajima, memorial remarks, life celebration for Karin Higa, Hammer Museum, Los Angeles, December 8, 2013. Published in *Karin Higa*, 45–46.
37 Marci Kwon, introduction to "Asian American Art, Pasts and Futures," *Panorama: Journal of the Association of Historians of American Art* 7, no. 1 (Spring 2021), doi.org/10.24926/24716839.11446.
38 Ibid.

documentary strategies in investigations of the relations between mass media, technology, and narrative.[39] Noting that some of their film installations "address the issue of...ancestral heritage head-on," Higa argued that it would be "a mistake to read their work as either a strict commentary on ethnic identity or solely concerned with issues of race. Of greater interest to the artists are the ways in which meaning is constituted, especially as expressed through specific formal devices."[40] On a parallel with the artists, Higa joined the historical and the contemporary in fresh articulations that restore, examine, and activate both, as well as the built-in dialectic of Asian America, without shying away from the perpetual conflict. Practice was Higa's touchstone and guide. By giving voice to the inherent complexity that marks the "genre" of Asian American art and its art historical study, her work profoundly considers what is gained and lost in such frameworks.

Advancing in 1999 to director of the curatorial and exhibitions departments at JANM, Higa set the stage for rigorous research, intellectual vitality, and dialogue among the programming departments. The educator and historian Arthur Hanson, whom she dubbed "senior historian," recounts the "animated discussions that ensued" at the weekly curatorial meetings that Higa "presided over...in the spirit of *primus inter pares* (first among equals). While she did not shy away from taking and defending strong stands on controversial and delicate issues, she invariably encouraged thoughtful, informed, and candid opinions from the rest of the staff so that policy decisions...were characteristically produced through a lively democratic process and endorsed by an operational group consensus."[41] Over a fertile five-year period, JANM mounted significant exhibitions, including *Henry Sugimoto: Painting an American Experience* (2001), *Living in Color: The Art of Hideo Date* (2002), *Sights Unseen: The Photographic Constructions of Masumi Hayashi* (2003), and *George Nakashima: Nature, Form & Spirit* (2004), and published the first substantial studies of both Date's and Sugimoto's work. JANM's longtime art director and exhibition designer Clement Hanami, whom Higa referred to as "the backbone of the museum,"[42] recalls that her "drive and diligence made every project we worked on so much richer and made us all better staff" and that her "passion for preserving and interpreting the art history of Japanese Americans was unparalleled."[43]

Higa took full advantage of her institutional scope at JANM, which involved not only exhibition making and programming but also pursuing and reviewing potential art and documentary material for the museum's collection. Curatorial colleague Sojin Kim recollects that "Karin loved the revelations that came from interactions with collection donors as well as JANM

volunteers, for whom she had great fondness and respect."[44] Such testimonials speak to Higa's transformational power for shaping effective collaborations and deepening individual experiences and museum practices.

Curator Aleesa Pitchamarn Alexander recently noted that "hosting a major exhibition of Asian American art is not the same type of investment as actively building, conserving, storing, and exhibiting it. A curatorial position within the museum also impacts an institution's future investment in the material."[45] Higa understood this; she knew that a permanent collection could have a lasting impact on the community, as an agent of maintaining and expanding collective memory and as a prospect for dissemination, interpretation, and history writing. "The acquisition of objects for the collections and the production of exhibitions provide the building blocks for knowledge creation. They hinge on specific, tangible actions and require fundamental conditions: there must be items to acquire or objects to exhibit."[46] About newly acquired material for JANM's collection from and about Manzanar, Higa wrote, "Can the land tell us something about the experience? Can it speak to us now?…Manzanar and the experience of incarceration do speak through the art, artifacts, photographs, and creative expression of those who experienced it then and those who still experience it now. This is the beauty of our permanent collection. It will outlive all of us, and in so doing, it can continue to speak."[47]

Higa was equally committed to scholarly research and grassroots fieldwork. Gregarious and curious, she believed in direct contact with artists to learn about their experiences, to gather historical data, and to find the communal in the individual. Higa's method, like that of Machida, who has pushed the limits of artist-centered art writing by fashioning methods for analyzing and articulating art and by positioning artists as primary knowledge bearers of their and others' work, was rooted in a deep regard for art and the sustained study of artwork, photographs, artifacts, and archives through close looking.[48] "I am interested in both the historical evidence of these artists, their specific personal narratives, and what their art might have to say as visual texts that must be unpacked through analysis of form."[49]

39 See Karin Higa, "Bruce and Norman Yonemoto: A Survey," in this book, 112–47.

40 Ibid., 122.

41 Arthur A. Hansen, "Memories of a Colleague and Friend: Karin Higa," *Discover Nikkei*, November 22, 2013, http://www.discovernikkei.org/en /journal/2013/11/22/karin-higa.

42 Karin Higa, acknowledgments in *Living Flowers: Ikebana and Contemporary Art*, ed. Karin Higa (Los Angeles: Japanese American National Museum, 2009), 86.

43 Clement Hanami, quoted in "Karin Higa, Curator of Asian American Art, Dies at 47," *Rafu Shimpo*, November 1, 2013, https://rafu.com/2013/11/karin -higa-curator-of-asian-american-art -dies-at-47.

44 Sojin Kim, "In Memoriam: Karin Higa (1966–2013)," *Discover Nikkei*, June 9, 2014, http://www.discovernikkei.org/en /journal/2014/6/9/karin-higa.

45 Aleesa Pitchamarn Alexander, "Asian American Art and the Obligation of Museums," conclusion to "Asian American Art, Pasts and Futures," *Panorama: Journal of the Association of Historians of American Art* 7, no. 1 (Spring 2021), doi.org/10.24926 /24716839.11465.

46 Karin Higa, "Use-Value: Art Museums and Humanistic Study in the University," in this book, 402.

47 Karin Higa, "The Permanent Collection and Re-Visioning Manzanar," in this book, 152.

48 See especially Margo Machida, *Unsettled Visions: Contemporary Asian American Artists and the Social Imaginary* (Durham, NC: Duke University Press, 2009), and Elaine H. Kim, Margo Machida, and Sharon Mizota, eds., *Fresh Talk/Daring Gazes: Conversations on Asian American Art* (Berkeley: University of California Press, 2003).

49 Karin Higa, notes for "Outside Field Exam," University of Southern California, Los Angeles, Karin Higa personal papers.

Higa and her colleagues also worked closely with artists' estates, often families who inherited the role of caring for and narrating art that has been overlooked and marginalized or, in some cases, dislocated during internment. Researching Tokio Ueyama, a cofounder of the Shaku-do-sha artists' club and a prominent painter of landscapes, countryside, and portraits, Higa noted, "By working in the Western medium of oil on canvas, the Japanese American painters associated with the Shaku-do-sha decoupled artistic style from race."[50] Ueyama widely exhibited his work between the wars and taught art while imprisoned at Granada War Relocation Center, aka Camp Amache. He and his wife, Suye, opened a gift shop, Bunkado, in Little Tokyo after returning from the camp. After he died in 1954, Ueyama's paintings and papers were cared for by his brother and sister-in-law, Masao and Kayoko Tsukada, whose daughter, Irene Tsukada Simonian, has run

Ikebana workshop for *Living Flowers: Ikebana and Contemporary Art*, Japanese American National Museum, Los Angeles, 2008, with Karin Higa, bottom row, fourth from left

Bunkado for decades. Higa encouraged Kayoko Tsukada to donate *The Evacuee* (1942), Ueyama's portrayal of his wife at Camp Amache, to the museum, thereby making it accessible in perpetuity for study, exhibition, and publication. *The Evacuee* was the tip of the iceberg in terms of the treasures Higa found in Ueyama's archive. Irene Tsukada Simonian looks after her uncle's collection with her sister, Grace Keiko Nozaki, safeguarding Ueyama's paintings, drawings, prints, and sketchbooks, including those he made at Camp Amache, as well as decades' worth of scrapbooks and diaries.[51]

While organizing the extensive survey exhibition *Henry Sugimoto: Painting an American Experience*, Higa and fellow curator Kristine Kim visited the home the artist had shared with his daughter, Madeleine Sugimoto. Higa recalled,

> What we found there, at the end of the hall of the Sugimotos' modest yet large apartment, was Henry's studio: a room filled with clear northern light, left virtually intact since his death years before. A well-used palette hung on the door of the cabinet filled with pencils, tubes of paint, sketchbooks, photographs, scrapbooks, and art. Homemade shelves extended to the ceiling, stuffed with portfolios, boxes of prints, unused supplies, and stacks of unstretched paintings, presumably removed from their stretchers to save space. In the span of a few hours, hundreds of works of art surfaced, astounding even Madeleine.

Kristine and I were overwhelmed and elated as we realized that the Japanese American National Museum's collection—what we had believed to be the bulk of Sugimoto's remaining work—was just a fraction of what existed. As we pored through portfolios constructed of recycled cardboard boxes and perused Sugimoto's library of books, we stumbled upon major discoveries, minute by minute.[52]

Higa's excitement over experiencing art and discovering artists and their histories is palpable in her writing. Readers encounter her delight in sharing precious knowledge.

In 2004, Higa advanced to senior curator, a position she would hold until 2006, when she gave up her full-time position to plunge into doctoral studies. But she did not give up her career at the museum in full. As adjunct senior curator, she would go on to organize her final exhibition for the museum in 2008, *Living Flowers: Ikebana and Contemporary Art*. Exploring what "two art forms can say about one another," the beautifully innovative exhibition would model what she considered ideal exhibition making.[53] An aesthetic enterprise and a research exhibition, *Living Flowers* was a "visual and conceptual argument" that "foster[ed] careful and deep looking" and "value[d] the possibilities that derive from seeing and experiencing objects through the deliberate act of installing them in space, rather than in communicating ideas about them through language and text."[54]

Situating ikebana on a par with and in proximity to contemporary art in a museum, Higa had advanced it beyond artful flower arranging and cultural tradition to a full-fledged art form and discipline—"a significant art practice with its own codes and conventions."[55] At the core of *Living Flowers* were collaborations that Higa orchestrated with three of L.A.'s most prominent ikebana organizations, schools of thought and practices rooted in, reflecting, and innovating centuries-old traditions: Ikenobō Ikebana Society of Los Angeles, Ohara School of Ikebana, and Sōgetsu Los Angeles Branch. She devised a platform for the schools and their masters, or sensei, and students to produce and present in the museum, commissioning 135 different arrangements during the exhibition. Furthermore, Higa invited Escher GuneWardena

50 Karin Higa, "Painting in Little Tokyo," draft of chapter one in "Little Tokyo, Los Angeles: Japanese American Art and Visual Culture, 1919–1945." PhD diss. [unfinished], University of Southern California, Los Angeles, 18.
51 Irene welcomed my visit and proposal to professionally photograph some of the material for use in this book and to ensure future access for others' research. We are grateful to Joshua White/JWPictures for the photographic record he made for this purpose.
52 Karin Higa, "Henry Sugimoto: Painting an American Experience," in this book, 197–201. Some years after Henry Sugimoto's family made their initial donations of Sugimoto's artwork to JANM, his daughter, Madeleine Sugimoto, donated hundreds more artworks and documents. JANM is currently engaged in the enormous project of digitizing the material for public access.
53 Karin Higa, quoted in Scarlet Cheng, "How Their Roots Intertwine," *Los Angeles Times*, July 6, 2008.
54 Karin Higa, "Living Flowers: Ikebana and Contemporary Art," in this book, 333. *Living Flowers* is the only exhibition Higa curated for which there exists ample installation photography. The images, taken by the noted art photographer Joshua White, provide a rare opportunity to look back at the visual field of one of Higa's curatorial endeavors.
55 Ibid.

Architecture (Frank Escher and Ravi GuneWardena with Chau Truong) to materialize the exhibition's spatial design into an "otherworldly" environment. Using translucent scrims and expanses of furrowed paper to delimit areas and guide viewers, Escher GuneWardena "extended the conceptual arguments of the exhibition while creating a beautiful transformation of the museum beyond the galleries themselves."[56] For Higa, their "spare design abstractly evoked the Japanese *tokonoma, man-maku,* and *shoji*," translating "traditional Japanese aesthetics to a contemporary prism."[57] (Higa here refers to typical display spaces for ikebana: tokonoma, an alcove-like area; manmaku, a hanging screen or curtain element; and shoji, a translucent paper spatial divider.)

By setting loose relays and relations between transience and permanence, the natural and the synthetic, and traditions and innovations, the exhibition presented ikebana, whose displays last only a few days, in both its *practice* and its *performative* dimensions. For Higa:

> The impact of the ikebana in the galleries was startling. The introduction of living material into the gallery palpably changed the dynamic of the space, prompting one to consider how the experience of museums is so conventionalized that one is scarcely aware of it until faced with something different....Aromas wafted through air, testing the nose, which tried to discern their origins.[58]

Living Flowers not only accomplished one of Higa's enduring aspirations for her work, the interlacing of the historical with the contemporary, but also enacted a quietly radical move by showcasing a multiracial group of artists (many were not Asian American) in a museum devoted to Japanese American history. It also signaled her prospective curatorial desires and potential directions for *Made in L.A. 2014*, the second of the Hammer Museum's popular biennials, which Higa and writer and curator Michael Ned Holte were commissioned to curate.[59]

In her work for JANM, Higa repeatedly began with the art, object, photograph, or material evidence to establish histories of Asian America and immigration widely unknown or largely disregarded. She incorporates these histories into monographic writings and essays on specific contexts and ideations. For example, she detailed how Hideo Date's paintings fuse *nihonga* (traditional Japanese painting techniques) with methods derived from the American Synchromism movement and cross-analyzed internee Toyo Miyatake's photographic work from Manzanar with official photos for government reports and photographs by renowned landscape photographer Ansel Adams.[60] But her critical work was

not limited to her work for JANM; she engaged in independent criticism throughout her career. Art historians, editors, and museums regularly called on her to address historical, theoretical, and curatorial subjects for essential books on Asian American art history and California's modern art history.[61] Writing about the exhibition *With New Eyes: Toward an Asian American Art History in the West* (1995), Higa surveyed the slowly emerging accounts of artists of Asian descent in the greater California culture of the 1920s and 1930s, and pointed to the "rich bounty" of artists the organizers uncovered, "forcing us to reframe the questions we ask about our own history." Typically attending to her love of art, she noted, "While the mere existence of art created by artists of Asian ancestry necessitates a reevaluation of our historical understanding of these communities, the art should be looked at, studied, and analyzed because it is art of quality."[62]

For a book and an exhibition that surveyed the impact of Asian American artists on modernism and Abstract Expressionism, Higa delineated and deciphered the pendulum swing of dominant perceptions of Japanese American identity in California, tracing the "fluidity of group identity and its expressions in the realm of culture" across sociopolitical histories of immigration, anti-Asian racism, and "yellow peril," while underscoring the positive postwar reception of Japanese and Japanese American aesthetic practices.[63] To a publication focusing on women artists in California during the second half of the twentieth century, Higa contributed "What Is an Asian American Woman Artist?," taking up an appellation contingent on context that "could be used to affirm, to delimit, to marginalize, or to valorize"; in the process, she discusses in depth five artists with divergent practices from multiple generations and ancestry: Ruth Asawa, Hisako Hibi, Theresa Hak Kyung Cha, Rea Tajiri, and Hung Liu.[64] In a volume that took on the ambitious challenge of unearthing more than a century of Asian American art, Higa dedicated her essay to the aesthetic vitality of the Little Tokyo enclave, finding that Japanese American artists "operated in a transnational milieu of porous physical and conceptual borders," "participating in the open culture of Los Angeles."[65] And, in her essay on the exhibition *Asian/American/Modern Art: Shifting Currents, 1900–1970* (2008–9), she discusses the importance of "ancestor" exhibitions in providing "pathbreaking antecedents that can be built upon, destroyed, or reassembled." Identifying the necessity, merits, and problems of organizing

56 Higa, acknowledgments in *Living Flowers*, 86.
57 Ibid.
58 Higa, "Living Flowers," in this book, 361.
59 As her health declined, Higa was ultimately unable to fulfill the role.
60 See Karin Higa, "Manzanar Inside and Out: Photo Documentation of the Japanese Wartime Incarceration," in this book, 156–95.
61 Such editors, scholars, and institutions include Mark Dean Johnson, Jeffrey Wechsler, Diane Tani, Gordon H. Chang, the Los Angeles County Museum of Art, and New York's Asia Society.
62 Higa, "Some Notes on an Asian American Art History," 79, 80.
63 Karin Higa, "From Enemy Alien to Zen Master: Japanese American Identity in California during the Postwar Period," in this book, 103.
64 Karin Higa, "What Is an Asian American Woman Artist?," in this book, 240.
65 Higa, "Painting in Little Tokyo," 5. See "Hidden in Plain Sight," in this book, 296–323.

an exhibition based on race, Higa argues that the framework was "as much a revelation of the present moment of art and culture as an unencumbered recovery of the past."[66]

Higa's doctoral research emerged organically in the midnineties from her work at JANM, which was located in the heart of Little Tokyo.[67] The museum's Historic Building and first home, the Nishi Hongwanji Buddhist Temple, built in 1925, had been converted into an assembly center in early 1942 for Japanese Americans who had been ordered to report according to Executive Order 9066.[68] After completing her doctoral coursework at UCLA, Higa planned to focus her dissertation on Toyo Miyatake, whom she considered the grassroots archivist of Little Tokyo and who, for decades, maintained a photo studio on First Street. "Toyo is fascinating because not only was he a photographer who had artistic aspirations—he had a business, and he was a community documenter."[69] However, the departure of her doctoral adviser from UCLA corresponded with her desire to concentrate solely on museum work, and Higa put her doctoral studies on hold.

When she withdrew from her full-time curatorial post at JANM in 2006, finding "the university context to be the only viable place where I could create rigorous, challenging, and cross-disciplinary work that has no *immediate* application," Higa began anew at the University of Southern California (USC). She expanded her research to encompass her entire context of interest—Little Tokyo—and examined the practitioners, associations, networks, communities, and cultural politics in, around, and beyond a neighborhood that gave rise to vibrant creative production. Combining ethnic studies and art history in her investigation held the possibility of "rearranging existing ideas and objects to create new, previously unforeseeable understandings."[70] Higa regarded her dissertation, in part, as a "salvage operation" to bring the diverse range of artists living and working in Little Tokyo during the interwar period to light, and she sought to evaluate "representations of and by Japanese Americans and Japanese American artists in the pre– and post–World War II period."[71] She also aimed to reanimate the intellectual and artistic dialogue between "East" and "West" that marked the period. "Little Tokyo, Los Angeles: Japanese American Art and Visual Culture, 1919–1945" promised to be an unprecedented contribution to Asian American art and cultural history. Previously unexplored and underdocumented terrain harbors an especially formidable burden for the historian who necessarily must delimit her scope.

The 2008 essay "Hidden in Plain Sight" provides a clear view into Higa's dissertation-in-progress.[72] Accounting for a range of associations and L.A. schools where Asian American artists

formed affinity and discourse, exhibited, studied, and taught in the pre–World War II period (from Otis Art Institute to Arts Student League to Chouinard to Art Center), Higa gives the reader "glimpses of the city" in which, despite limitations in political agency, economic opportunity, and social freedom, Asian American "cultures overlaid each other and intersected in ways that would soon become unlikely if not impossible."[73]

She recounts how Miyatake fortuitously met with Harry Shigeta in the late 1910s at the suggestion of a friend he ran into on East First Street. The established Shigeta, a photographer, magician, entrepreneur, and expert retoucher who made commercial portraits and advertising photos, as well as artful modern studies of nudes, sand dunes, and aesthetic forms, not only inspired Miyatake to open a studio just after he spontaneously decided to be a photographer but also became a wide-ranging mentor. Higa highlights how retouching studios were thriving in Little Tokyo for "proof of…success in America" but also because "photographs were means of making a tangible connection and were exchanged from both sides of the Pacific." She stresses how important photographic portraiture was in the 1920s to immigrant families, who were separated physically, and how the use of "double printing" could reunite a family in a portrait.[74]

Higa counters the common conception of Little Tokyo as an "ethnic ghetto" and illuminates how it, in a "global city," enabled Japanese American artists to foster "relationships with artists outside the ethnic enclave, [show] their work in exhibitions around the city, and perhaps most notably… [create] art that defied racial expectations."[75] She enumerates not only the Shaku-do-sha association and its link to Edward Weston (Shaku-do-sha mounted solo exhibitions of Weston in 1925, 1927, and 1931) but also Japanese American photographers and filmmakers' work in Hollywood; the close relationship between Miyatake and choreographer and dancer Michio Ito; the influential associations of Stanton Macdonald-Wright, Hideo Date, and Benji Okubo; and more. While Higa's dissertation remained unfinished at her death, "Hidden in Plain Sight" reads as its blueprint.[76]

66 Karin Higa, "The Search for Roots, or Finding a Precursor," in this book, 325.
67 In 1997, Higa earned her MA in art history from the University of California, Los Angeles (UCLA), with her thesis "*Flower Drum Song* Revisited," which cross-examines critical responses to the *Flower Drum Song* book (1957), musical (1958), and film (1961). "Examined and considered in light of recent debates on ethnicity, identity, and gender, the movie musical *Flower Drum Song* prophetically anticipates many major contemporary critical questions concerning representation by foregrounding Asian-American identity, familial relations, sexuality, and American assimilation against the backdrop of the musical genre."
68 After incorporating in 1985, JANM began renovating the temple to convert the building into a museum, which opened to the public in 1992. In 1999, the museum expanded into a new structure designed by Gyo Obata.
69 Karin Higa, in *Toyo Miyatake: Infinite Shades of Gray*, directed by Robert A. Nakamura (Los Angeles: Japanese American National Museum, 2002), film, 29 min.
70 Higa, "Use-Value," 401.
71 Dissertation outline, Higa personal papers.
72 Higa, "Hidden in Plain Sight," 296–323.
73 Karin Higa, "Living in Color: The Art of Hideo Date," in this book, 208–27. Kaz Higa attended the latter two.
74 Higa, "Hidden in Plain Sight," 301.
75 Higa, "Painting in Little Tokyo," 4.
76 Higa's primary adviser at USC, Richard Meyer, regarded her dissertation as "a beautiful reclamation project." Nancy Troy, who served as one of her advisers, wrote, "Karin conceived her dissertation as a profoundly revisionist study of Japanese American art in Los Angeles that would change the way we think not only about a concept such as japonisme, but also about the structuring categories of American art and modernism more generally." She continued, "It was perhaps the process of its conceptualization rather than the achievement of the final product that Karin herself most valued." Meyer and Troy, in "Karin Higa: A Collage of Remembrances," *Art Journal* 72, no. 3 (Fall 2013): 11.

Doctoral research represented freedom from the tangible requirements of museums and their funding and production-driven schedules. "Humanistic study in the university affords the latitude of intellectual inquiry where complex problems can benefit from cross-disciplinary questioning free from the strictures of direct application…in ways that are unpredictable and that unfold over time," Higa maintained.[77] But the dissertation format is not open-ended, and it is weighted with its own conditions and restrictions. Professor Deborah S. Bosley reminds us, "Academics, in general, don't think about the public; they don't think about the average person….Their intended audience is always their peers."[78] Higa directed her voice to familiar, inclusive publics. The obtuse vocabularies of academia were remote to many of the colleagues, interlocutors, and friends that Higa cultivated and called her community. Given her collegial spirit, community-mindedness, and dialogic method, the relatively solitary practice of dissertation work presented a particular challenge. The clarity of her writing and her judicious use of *I* and *we* pronouns were somewhat at odds with conventional academic writing, which is characterized by stringent mechanisms that constrain articulations of subjectivity.

Nevertheless, Higa gradually brought her personal history and lived experience into her writing. In the 2006 essay "California Registered Historical Landmark no. 850," she recollects family trips to Manzanar "in our archaeological search for truth….We didn't learn about Japanese internment at school—we learned about it at home, and it seemed to me, as a child, a secret that Japanese American families kept among themselves."[79] That year, she wrote "Origin Myths: A Short and Incomplete History of Godzilla," taking up the New York–based group in which she had been a "fervent participant" during her last year in New York.[80] For "Black Art in L.A.: Photographs by Robert A. Nakamura," she narrates an occasion of "cross-cultural flowering," when her father, in his capacity as director of the Da Vinci Art Gallery, "invited Alonzo Davis, of the Brockman Gallery, to gather artists who represented the 'new Black renaissance in art' for the exhibition *Black Art in L.A.*" In her examination of the photographs of thirteen Black artists in their studios that Kazuo Higa commissioned from Nakamura, Higa writes, "Creativity was not the sole domain of white artists exhibiting in La Cienega galleries or at the newly created [Los Angeles County Museum of Art] in Hancock Park, a refrain I heard repeatedly as a child from my father as we traversed the city in the family's VW bus."[81] By 2011, Higa proves secure writing in first-person mode.

Higa's writings initially appeared in exhibition catalogues and museum booklets, scholarly journals, and books, many of which are now out of print.[82] I think of the selection reprinted here as a "partial whole." Linked by Higa's commitment to Japanese and Asian American art and cultural history, the chronologically arranged sequence shows the empirical, organic flow of her dynamic thinking and developing positions, which reflect the unfolding of the paradoxical category of Asian American art in the 1990s and 2000s. The expansive field of images here stretches beyond that of the original publications, which were determined in part by limited schedules and resources. In order to do justice to the vibrant cultural worlds to which Higa dedicated herself, this book mines the breadth of art, photography, artifacts, and other visual evidence that her writings reference and conjure.

Throughout her professional history, Higa made use of multiple forms—writing, curating, research, scholarship, community and institution building, archiving, consultation, collaboration, and teaching.[83] Ultimately, she belonged to academia no more or less than she belonged to the museum; she was suited to and variously invigorated by *both and. Hidden in Plain Sight* aims to extend Higa's radiant work and resound her conscientious ways of being. With her tenure finished at JANM, where would Karin Higa have ultimately taken her dissertation and where would she then have turned her dazzling attention, deep looking, and stirring optimism?

77 Higa, "Use-Value," 407.
78 Deborah S. Bosley, quoted in Victoria Clayton, "The Needless Complexity of Academic Writing," *Atlantic*, October 26, 2015, accessed at https://www.theatlantic.com/education/archive/2015/10/complex-academic-writing/412255.
79 Karin Higa, "California Registered Historical Landmark no. 850," in this book, 254–57.
80 Karin Higa, "Origin Myths: A Short and Incomplete History of Godzilla," in this book, 263. The arts association Godzilla offered its members support, advocacy, feedback, critique, collaboration, collectivity, networking, exhibiting and publishing occasions, a newsletter, and professional advisement. Higa's participation in the group puts *into practice* her regard for the associations that emerged in Little Tokyo in the early and mid-twentieth century.
81 Higa, "Black Art in L.A.," 391, 392.
82 The complete bibliography of Higa's published and unpublished writing consulted for this selection appears in this book, 408–9.
83 Higa taught courses on cultural display, race in contemporary art, and Asian American art history at numerous educational institutions, including Mills College, Oakland, California; Asian/Pacific/American Institute, New York University; Otis College of Art and Design, Los Angeles; University of California, Irvine; and University of Southern California, Los Angeles.

The View from Within: Japanese American Art from the Internment Camps, 1942–1945

> We believe that art is one of the most
> constructive forms of education.
> Through creative endeavors
> and artistic production, a sense
> of appreciation and calmness
> is developed, and in consequence,
> sound judgment and a fine spirit
> of cooperation follow.
> —Chiura Obata[1]

These words, written by artist Chiura Obata in spring 1942, while he was organizing the Tanforan Art School, speak to the fundamental goal of creativity for Japanese Americans incarcerated during World War II. Faced with confusion and uncertainty in the wake of Executive Order 9066 and the subsequent mass evacuation from the West Coast, Japanese American artists such as Obata laid great faith in the power of the creative spirit and its ability to provide hope to individuals as well as an entire community.

The Tanforan Assembly Center in San Bruno, California, was the temporary detention camp for Japanese Americans in the San Francisco Bay Area. It was a racetrack and stable that had been only modestly modified to house more than eight thousand internees, representing the second largest of the fifteen assembly centers scattered throughout the West Coast. On May 19, 1942, a mere twenty days after their arrival at Tanforan, a group of Japanese Americans, many of them artists, finished cleaning and scraping the muddy floors and dusty walls of Mess Hall #6. Registration for the Tanforan Art School was to begin that day.[2]

By the time the art school opened its doors six days later, on May 25, 1942, the former racetrack building had been transformed into a comprehensive art school offering more than twenty-five subject areas, including finger drawing, landscape, still life, mural painting, anatomy, sculpture, art appreciation, fashion design, interior decoration, cartoon drawing, architectural drafting, and commercial layout. The school was led by Chiura Obata, who had joined the art faculty of the University of California, Berkeley, in 1932. Obata spearheaded a curriculum that offered sequential class offerings at five levels—elementary, junior high, high school, junior college, college, and adult education. There were ninety-five classes per week running from 9 a.m. to 9 p.m. daily. Students ranged in age from six to more than seventy years old.

The school was a place of both recreation and serious study. For many in Tanforan, the art school provided a way to pass the undifferentiated spans of time. For others, especially young adults and children, the school provided early exposure to art, art making, and artists. Contemporary fiber artist Kay Sekimachi recalls her early training in Tanforan and the respect and admiration she had for her instructors. The school managed to mount exhibitions of the instructors' and students' artwork, in and outside of the assembly center. From June to September 1942 there were exhibitions of Tanforan-made art at International House and the YWCA in Berkeley, Mills College, and the Pasadena Art Institute. In August, when the school held a three-month anniversary exhibition at the assembly center, more than three thousand people attended, nearly 40 percent of the total population.

Clearly an endeavor of this scope and scale required the support and cooperation of many people. Obata was able to secure the approval of the assembly-center administration to begin the school and used his many contacts in the "outside" world to gather donations of supplies and materials. In many cases,

1 Chiura Obata, "Tanforan Camp Art School," papers of Chiura Obata, courtesy of Estate of Chiura Obata (hereafter cited as Obata papers).
2 Information about the school, its curriculum, instructors, and exhibitions come from the Obata papers.

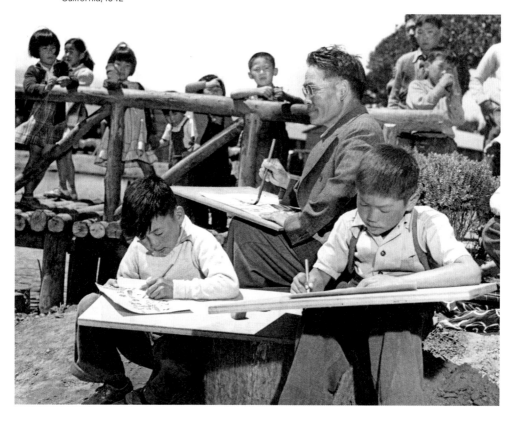

Chiura Obata teaching a children's art class at Tanforan Art School, Tanforan Assembly Center, San Bruno, California, 1942

he was assisted by his former students and colleagues, who often visited and delivered the supplies in person. But the most essential component in the formation of an art school is the teacher. Tanforan was unusual in the number of professional artists interned, since the San Francisco Bay Area was home to a significant group of Japanese American artists. There were sixteen artist-instructors in all, and although it is unclear as to the extent to which these artists knew each other before incarceration, once interned they joined forces with Obata to help with the art school.

Obata enjoyed a unique stature as both an artist and a member of the Japanese American community. Born in Sendai, Japan, in 1885, Obata immigrated to San Francisco in 1903. He began his artistic training in Japan at age seven, studying painting under the tutelage of several masters of the Shijō, Kano, and Tosa schools at a time when the influence of Western painting was strong.[3] He worked in the Japanese *nihonga* style, which represented an innovative fusion of sumi-e, traditional Japanese ink painting, with Western concepts of naturalism and an expansion of the color palette. Obata was particularly interested in the California landscape, taking inspiration from excursions made to locations such as Yosemite. Rather than documenting specific locales, his work of the postwar period captures the grand scale and monumentality of the western landscape through line and

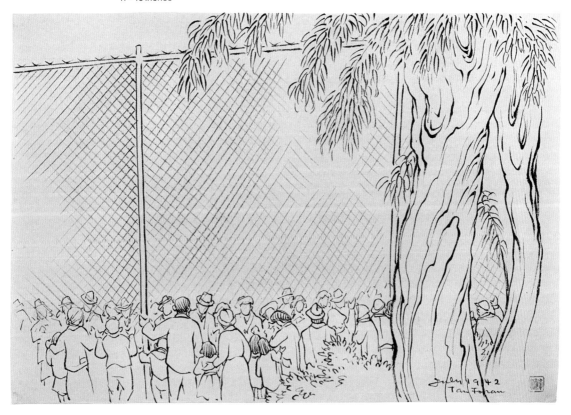

Chiura Obata, *Talking through the Wire Fence*, 1942. Sumi ink on paper, 11 × 16 inches

broad washes of ink to evoke mood. By the time of evacuation, he had participated in more than sixty exhibitions, including some twenty-five at institutions such as the Honolulu Academy of Arts (1930), the M. H. de Young Memorial Museum (1932), and the Crocker Art Gallery (1938). His extensive schedule of exhibitions as well as his teaching position at Berkeley made him a prominent figure in both the Japanese American and arts communities.

While Obata's work remained steeped in Japanese tradition, it became much more documentary in nature with evacuation. He continued to use the medium of sumi-e, but used it to illustrate and record events both seen and experienced. *Talking through the Wire Fence* (1942),

made shortly after the evacuation, depicts an early experience of visiting with students and friends through a high wire fence at Tanforan. According to his widow, Obata's students had exclaimed, "Oh, how terrible Professor Obata, you are behind a fence!" To which Obata replied, "From my perspective it looks like you are behind the fence."[4] In *Two Angels in the Rain—the First Students of the New Art School* (1942), young

3 James H. Soong, "Introduction to Obata Retrospective," in *Chiura Obata: A California Journey* (Oakland, CA: Oakland Museum, 1977), 3.
4 Haruno Obata, oral history by Kimi Hill, 1986, courtesy of Estate of Chiura Obata.

girls wait on the steps of the arts school building under a eucalyptus tree branch. A furious storm raged on the day of the opening of the art school, and Obata worried that attendance would be hindered. When he approached the building, he saw the young students waiting, drenched from the rain. "In my heart, I thanked the mothers for their bravery in sending their beloved children even in such storms. I thanked Heaven for having started this movement."[5]

These works suggest two important views put forth in Obata's art: the necessity of maintaining perspective and the never-ending cycle of change; and an unwavering faith in the power of creativity to better the life of the artist, as well as the lives of fellow internees. His choice of subject matter highlights the ways in which internees continually sought to make the best of the situation. Without offering a direct commentary on the legitimacy or illegitimacy of internment, Obata's work succeeds in evoking sympathy, compassion, and respect for the plight and perseverance of the internees. Interestingly, when Tanforan was closed and the internees moved to Topaz War Relocation Center, Obata turned to depicting the landscape in addition to his more documentary work. He captured the wide expanses of Utah and the colors of the desert sunsets in *Sunset, Water Tower, Topaz* (1943), including the water tower, as if to remind us that he was indeed interned.

The Tanforan Art School moved along with the internees, reopening as a division of the Topaz Adult Education Program. Obata continued to provide leadership to the school until he was released from Topaz and moved to St. Louis in 1943 as part of the War Relocation Authority's early relocation program. George Matsusaburo Hibi took over the leadership of the school. Like Obata, Hibi was born in Japan, in Shiga Prefecture in 1886. In artistic style, however, Hibi and Obata could not be further apart. While Obata maintained an aesthetic adherence to Japan, Hibi embraced the West, even adopting the name George. Hibi was fascinated with the art of Cézanne and the Post-Impressionists, teaching a class at Topaz called History of Western Art. The class description

read: "Lectures in history of Western art and especially on the movement of modern art."

Hibi immigrated to Seattle in 1906, staying there and in Los Angeles before settling in San Francisco. In 1919, Hibi entered the California School of Fine Arts (now the San Francisco Art Institute) and studied there for eleven years. From 1922 until the evacuation, he participated in annual exhibitions of the San Francisco Art Association, the Oakland Gallery, and the California Palace of the Legion of Honor. He married Hisako Shimizu, a fellow art student, and in the early 1930s moved to Hayward, California, where they ran a Japanese language school while continuing to paint and exhibit. Unfortunately, the location of most of his prewar paintings are unknown. Just prior to the evacuation, Hibi donated fifty of his paintings and prints to local hospitals, schools, libraries, and public halls in Hayward. As reported in the April 7, 1942, edition of the *Oakland Tribune*, Hibi declared: "There is no boundary in art. This is the only way I can show my appreciation to my many American friends here."

While his paintings resist any overt critique of the internment, they remain powerful in their subtlety and ambivalence. *Going for Inoculation* (1942) hints at the early confusion caused by incarceration and the newfound experience of living among so many in such close quarters. A long line of people, of small stature, wait amid the imposing structures of Tanforan. The act of inoculation takes on new meaning when considering the forced circumstances. Japanese Americans are undistinguished as individuals and must adhere to the requirements, rules, and routines of the new officials.

The coyote was often present in Hibi's Topaz, as a real entity and a figurative symbol. In *Camp at Night, Topaz* (1945), we see what appears to be a distant city protected by a fence from prowling coyotes. The nighttime scene is serene and calm. Yet the questions remain: Who is free in this picture? The fence is there to protect but to protect whom? The painting refers to

5 Chiura Obata, Obata papers.

Chiura Obata, *Landslide*, 1941.
Watercolor on paper, 22 × 28 inches

Chiura Obata, *Works with Natural
Woods*, 1942. Sumi ink on paper,
11 × 16 inches

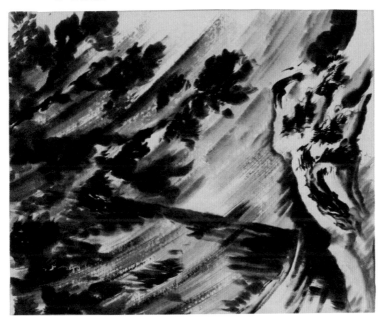

George Matsusaburo Hibi, *Camp at Night, Topaz*, 1945. Oil on canvas, 16 × 20 inches

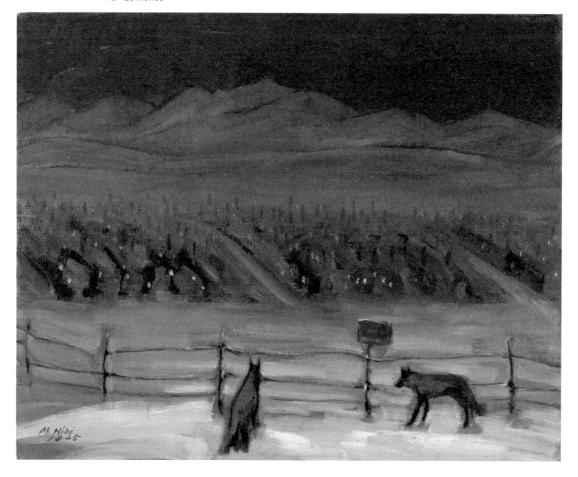

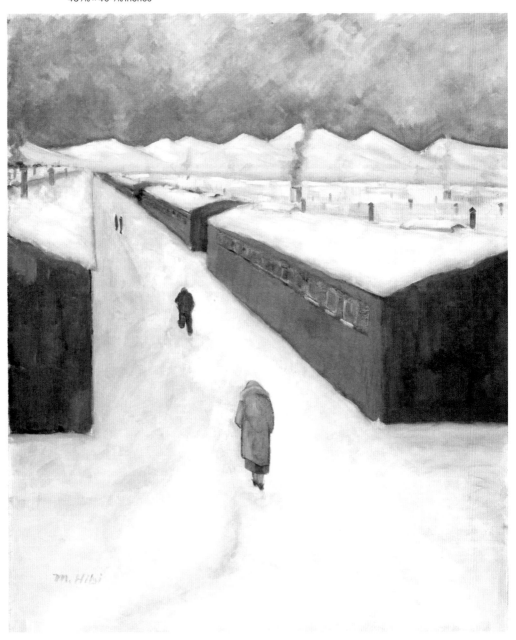

George Matsusaburo Hibi, *Winter, Topaz*, 1940–50. Oil on canvas, 48 1/16 × 40 11/16 inches

Certificate of attendance for
Tamako Okamoto, Topaz Art School,
Topaz Relocation Center, Utah, 1944

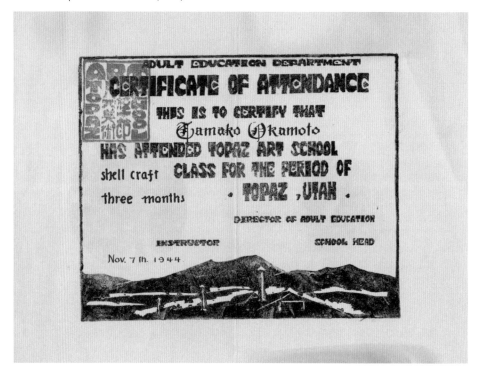

one of the common justifications for the incarceration: that the camps were there to *protect* the Japanese Americans. The coyotes are on the outside, yet they are free. The "city" lights are in fact the lights of the internment camp Topaz, an artificially constructed site that had the largest population in central Utah. Hibi was both an artist and an internee, and as the viewpoint of the painting suggests, he could be simultaneously inside and outside of camp.

Perhaps *Men Painting, Sunset, Topaz* (1945) best exemplifies the ambivalent predicament of many of the artists in camp. Four men sit in front of easels, painting the desert sunset. In the distance, the blurred outline of the barracks is barely visible. The viewer is drawn instead to

the intensity of the sunset and the casual yet serious posture of the men. These painters are focused on transforming their situation into art. The power of creativity overcomes the incarceration. Likewise, Topaz provided Hibi the uninterrupted time to paint, and as the director of the art school, he was able to unite his work life and artistic life in a way that he had not been able to before.

Hisako Hibi was also an artist. Considerably younger than her husband, she was born in Japan in 1907 and came to America as a teenager. She met and married George Hibi while a student at the California School of Fine Arts. When not taking care of their two young children, Hisako taught the children's art

42

George Matsusaburo Hibi, *Men Painting,
Sunset, Topaz*, 1945. Oil on canvas,
16 × 20 inches

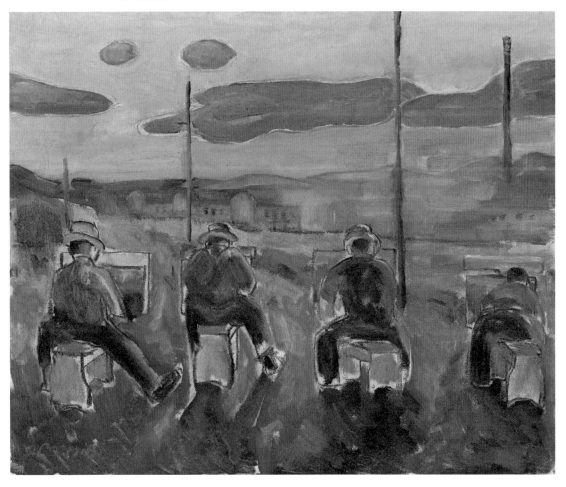

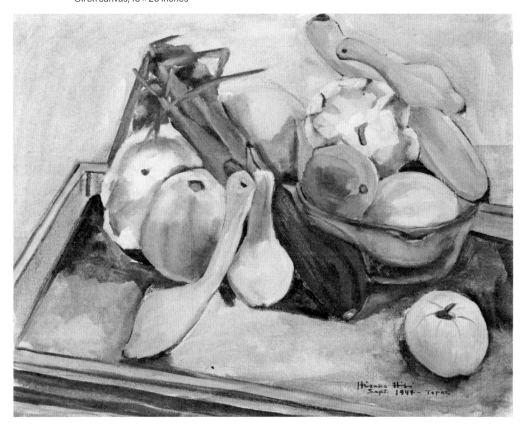

classes at Tanforan and Topaz. Perhaps because of her roles as a mother and a teacher of children, Hibi's most successful work explores domestic situations in camp. The barrack bathing and toilet facilities were notoriously poor. Communal latrines meant little privacy and long waits. Ingenuity became a necessary requirement for survival. The room in Hibi's 1943 painting *The Laundry Room* looks more like a bathroom. With only four baths for an entire block, mothers bathed their children in the laundry room. An open door at its rear reveals rows of barracks beyond, reminding us of the context of this scene. The ingenuity of the mothers in adapting to their situation mirrors Hibi's own position as an artist in camp.

Like her husband, Hibi was inspired by Western painters of the late nineteenth century, in particular Mary Cassatt. In *Homage to Mary Cassatt* (1943), the circle of influence is completed: a Japanese American mother bathes a child in a direct reference to Cassatt's *The Child's Bath* (1893). Hibi, a Japanese American artist, paints an homage to Cassatt, a Western artist who was herself influenced by Japanese woodblock prints.

The teachers at Topaz had a range of opinions and working styles, all of which influenced their young students. One of the instructors was Byron Takashi Tsuzuki. Tsuzuki immigrated directly to New York from Japan at age sixteen. He studied at the Art Students

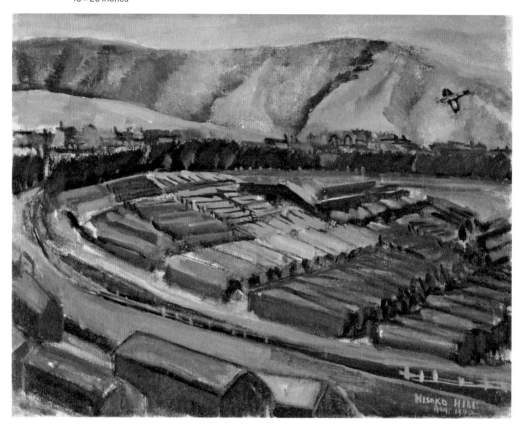

Hisako Hibi, *Tanforan Assembly Center,
San Bruno Calif.*, 1942. Oil on canvas,
16 × 20 inches

League in the 1920s, participated in annual exhibitions of the Society of Independent Artists, and eventually became a director of the Salons of America along with his friend and colleague Yasuo Kuniyoshi, before moving to the San Francisco area in the 1930s. Tsuzuki's affinities lay with the artists of the Ashcan School. At Topaz, he and George Hibi often engaged in heated discussions about their differing artistic sensibilities. Taneyuki Dan Harada received his first artistic training at Tanforan and Topaz. His teacher was George Hibi, who discouraged the students from using small brushes to prod them to work on larger planes. Although the school was located near a guard tower and the barbed-wire fence, Harada recalls that he found

it awkward to paint the legs of the tower with a large brush and therefore chose not to depict the tower at all. Attention to the lessons of art superseded the need to document his surroundings.

Another artist affiliated with the Tanforan and Topaz art schools was Miné Okubo. Okubo was born in Riverside, California, in 1912. She attended the University of California, Berkeley, where she received her bachelor's and master's degrees in art, with a course of study emphasizing fresco and mural painting, not the traditional Japanese techniques taught by Obata. In 1938, after receiving the school's prestigious Taussig Travel scholarship, which afforded her a two-year stay in Europe, Okubo returned to Northern California and participated in the

Hisako Hibi, *Study for a Self-Portrait*,
ca. 1944. Oil on canvas, 21¾ × 17½ inches

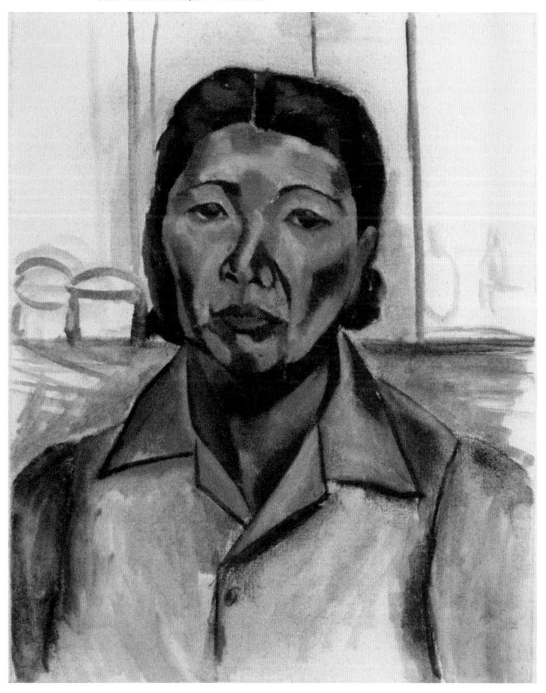

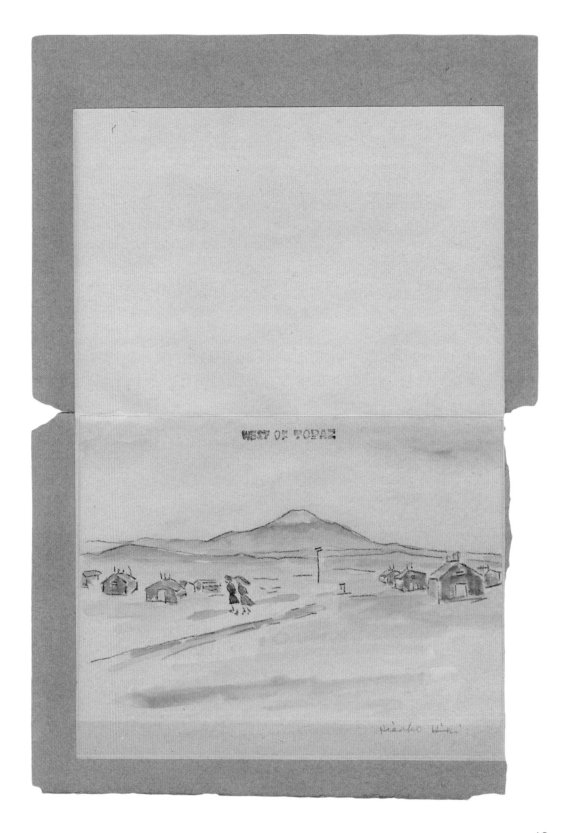

WEST OF TOPAZ

Hisako Hibi

opposite: Hisako Hibi, *West of Topaz*,
1942–45. Watercolor on paper,
paper size: 11 × 8 ½ inches

Dorothea Lange, Hisako Hibi family,
evacuees of Japanese ancestry,
await evacuation with baggage piled
on sidewalk, Hayward, California,
May 8, 1942

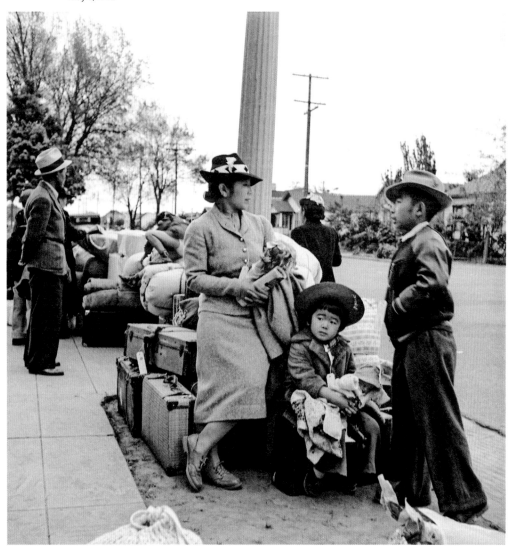

Miné Okubo, *Miné with open newspaper,
surrounded by anti-Japanese slogans,
Berkeley, California*, 1941. Ink on paper,
9¼ × 13 inches

opposite, top: Miné Okubo, *Interior view
of Miné and Benji's barrack, Tanforan
Assembly Center, San Bruno, California*,
1942. Ink on paper, 9¼ × 13 inches

opposite, bottom: Miné Okubo, *Untitled*,
n.d. Ink on paper, 9¼ × 13 inches

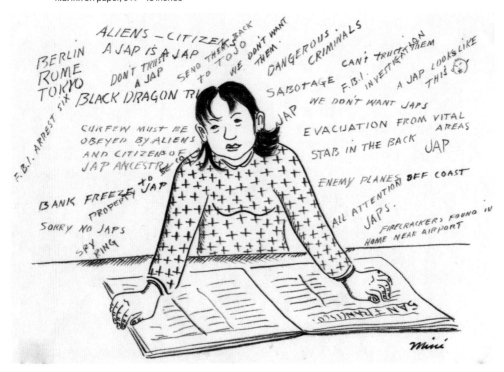

Federal Art Project, completing murals at the U.S. Army post Fort Ord, Oakland Hospitality House, and Government and Treasure Islands.

Immediately after evacuation, Okubo began a series of pen-and-ink drawings that would ultimately form the basis of her book, *Citizen 13660*, originally published by Columbia University Press in 1946. The title refers ironically to her status as a citizen, juxtaposed with the number she was assigned during evacuation. The drawings provide a detailed account of her experiences accompanied by a running text. Okubo uses humor to indict her jailers, eliciting sympathy and compassion through her depiction of everyday life in the camps.

A series of charcoal drawings, including *Mother and Children* (1943), expressionistically portray the despair and weariness of the internment experience. The directness and overt emotional content of Okubo's charcoal drawings suggest her more secure status as a citizen. Unlike George Hibi and Chiura Obata, Okubo was an American by birth and sensibility, and her citizenship granted her certain privileges. In 1944, when the editors of *Fortune* magazine saw *Trek*, a camp publication collaboratively organized by Okubo and several writers including Toshio Mori, they asked Okubo to come to New York to illustrate the April 1944 edition of the magazine, which was to focus on Japan. Ironically, Okubo,

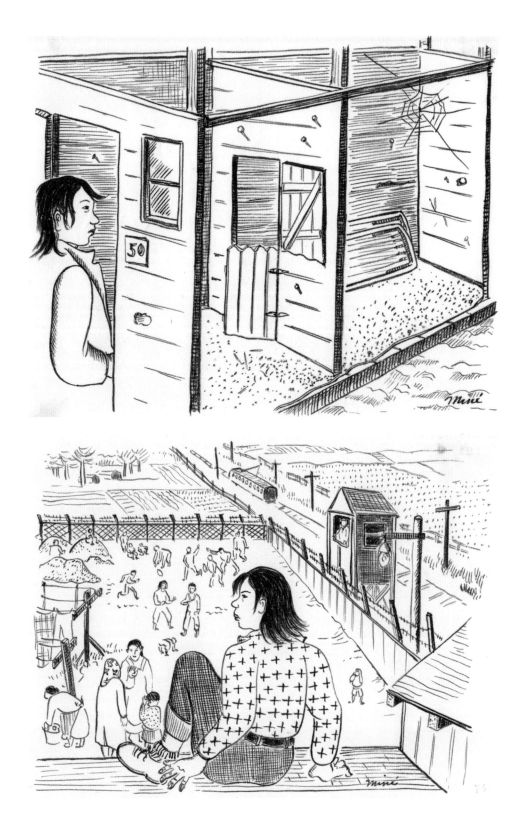

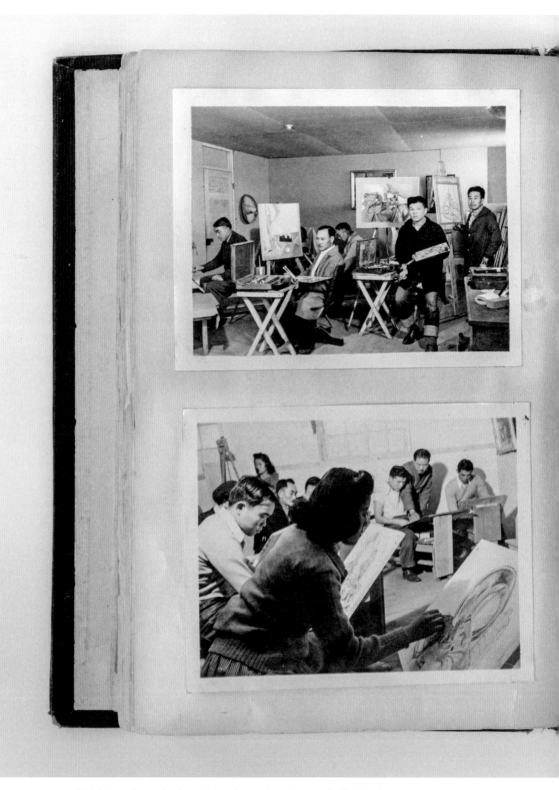

Tokio Ueyama's scrapbook containing photos of art classes under his direction at Granada War Relocation Center, also known as Camp Amache, in Colorado, including photos by Tom Parker (bottom left and top right)

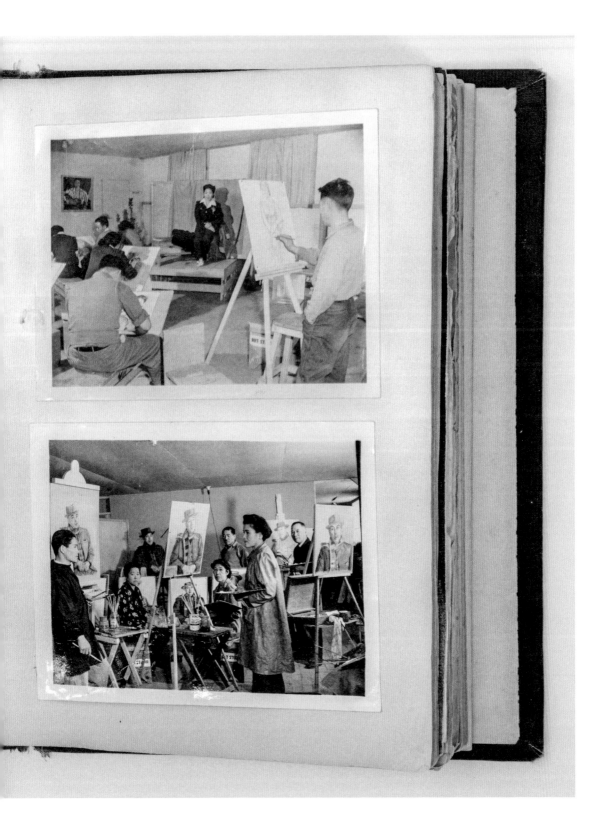

Tokio Ueyama's sketchbook containing
portraits drawn at Granada War
Relocation Center, also known as
Camp Amache, Colorado

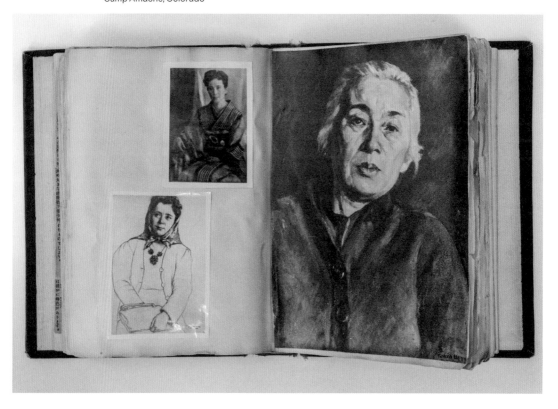

who had never visited Japan, was asked to interpret the country for *Fortune*'s American readers.

The art made in Topaz is not restricted to the work of the instructors. Yoshiko Yamanouchi and Seizo Murata were amateur artists. Both have long since passed away, and we have no idea whether they were students at the school, or how they came to make their art. Other artists, such as Charles Erabu (Suiko) Mikami and Chikaji Kawakami, were quite prolific and accomplished. Mikami's watercolors represent the barrack landscape generally unpopulated except for a few lone figures. According to his son, Kawakami was largely self-taught and worked independently of any school or group.

The differences between the art of those affiliated with the Topaz school and the art by those who were not begin to suggest the tremendous range of artistic activity within the confines of one camp, making it impossible to generalize about a single style or method of working. While Tanforan and Topaz were perhaps the most sophisticated schools in scope and scale and were unusual in the high concentration of professional artists, they were not alone in using the arts to provide a "home" to artists and a creative release for the internees. On a much smaller scale, Tokio Ueyama taught art classes to adult students in Granada War Relocation Center, also known as Camp Amache, located in central Colorado. Although little information about the school exists, a photograph taken at the time shows serious students at work in front of easels, painting from a live model, in this case fellow student Shunichi Hashioka.

Ueyama was born in Japan in 1889, immigrating to the United States in 1908 to attend art school in San Francisco. He entered the University of Southern California in 1910 and graduated four years later with a degree in fine arts. After living in Los Angeles for a few years, Ueyama entered the Pennsylvania Academy of Fine Arts in Philadelphia. In 1919, he received the academy's Cresson travel scholarship and spent the following year in France, Germany, Italy, and Spain. After returning to Little Tokyo in Los Angeles, Ueyama and friends T. B. Okamura, a poet, and Sekishun Uyena, a painter, formed Shaku-do-sha, an association of Japanese artists "dedicated to the study and furtherance of all forms of modern art."[6] Based in Little Tokyo, Shaku-do-sha acted as a support group for artists of various disciplines, including photographer Toyo Miyatake, and was responsible for organizing several exhibitions of the work of Japanese American artists each year. But the group also supported artists outside the Japanese community. In 1927, when Edward Weston returned from an extended stay in Mexico, Shaku-do-sha sponsored an exhibition of his photographs taken in Mexico in a Little Tokyo storefront. Ueyama himself had traveled to Mexico in 1924, and it is possible that Ueyama was in touch with Weston at that time.

Ueyama was technically accomplished and worked in an academic style that focused on realistic depictions of the Amache landscape. The complete absence of conscious commentary on the incarceration in his painting is noteworthy. Ueyama focused on what was formally dynamic. Yet his 1942 painting *The Evacuee* is a quiet moment of normalcy and contemplation that in many ways sums up the experience of camp. A woman, Ueyama's wife, sits crocheting in the doorway of a barrack. Inside are the little objects that signify a home. Beyond the open door are rows of barracks. The woman is focused on her crocheting, but her position hints that perhaps she is thinking of something else. Neither happy nor distraught, she simply exists at that instant, within the confines of her barrack home and the physical parameters of camp yet can overcome the circumstances by the force of normalcy.

The call to help with art education was heard beyond the camps, inspiring sculptor Isamu Noguchi to participate. At the time of evacuation, Noguchi lived in New York and was therefore outside the Western Defense Command Zone, the areas from which Japanese Americans were evacuated and moved into camps. In spring 1942, Noguchi participated in a meeting of "creative people of Japanese

6 From a July 7, 1927, article in
Tokio Ueyama's scrapbook.

Tokio Ueyama, *The Evacuee*, 1942.
Oil on canvas, 24 × 30¼ inches

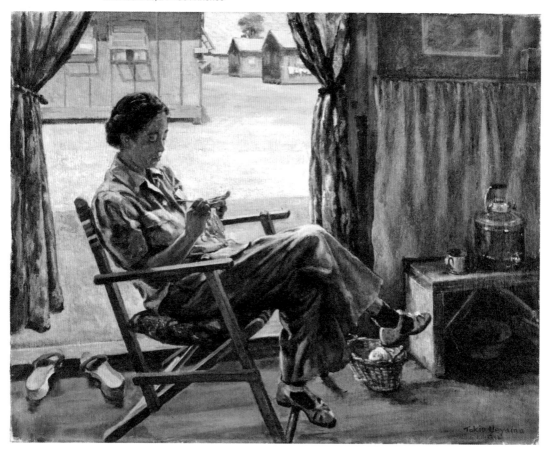

Tokio Ueyama, self-portrait in situ at
Bunkado, Little Tokyo, Los Angeles

extraction" held in the New York studio of Yasuo Kuniyoshi.[7] The purpose of the meeting was to discuss ways to help the internees. Noguchi later wrote of the meeting, "They all wished to be able to participate as visiting artists, teachers and lecturers."[8] With the encouragement of John Collier, commissioner of Indian affairs for the Department of the Interior, Noguchi voluntarily submitted to incarceration on May 8, 1942, so that he "might contribute toward a rebirth of handicraft and the arts which the nisei have so largely lost in the process of Americanization."[9]

Once interned in Poston, Noguchi found it difficult to mobilize arts instruction and craft apprentice guilds. By July 1942, only three months after his arrival, Noguchi finally gave up and began the long process of seeking release. His idealistic desire to "fight for freedom" through creative endeavors was frustrated by the bureaucracy at the camp administration and his incompatibility with the interned nisei.[10] The desert heat, the difficult living conditions, and the restrictions on his freedom left Noguchi embittered.[11] He had entered Poston as a well-known and well-respected artist, but once interned he was simply another incarcerated Japanese American. He sought permission to leave Poston to work in San Francisco but was denied it on the basis of ethnicity despite the references listed on his permit-to-leave form, which included John Collier; Francis Biddle, attorney general of the United States; and Henry Allen Moe, secretary of the John Simon Guggenheim Memorial Foundation.[12] He was released to return to New York in spring 1943. No art from this period of Noguchi's career has survived, though we know from anecdotal information that he sculpted from the hardwood available throughout Poston.

Although Noguchi could not realize his vision, there was art made at Poston. Kakunen Tsuruoka painted the Arizona desert, depicting the Southwestern desert landscape in a distinctly Japanese style. Harry Yoshizumi painted his surroundings in watercolors, Frank Kadowaki in small oil paintings. Perhaps Noguchi's experience is most useful in understanding the difficult circumstances of internment and traits

necessary for survival. The seeming ease with which the art schools were established in other camps belies the reality of the camps, where survival meant compliance and intense idealism was tempered by a realization of the limitations.

While the art schools provided many internees with the only opportunity to make art, there were also many artists who found jobs in camp that enabled them to continue working. Henry Sugimoto taught in the camp secondary schools, first as the adviser to the high-school students at Jerome War Relocation Center and later at Rohwer War Relocation Center, both in southeastern Arkansas. He was born in Japan in 1900 and joined his parents in central California after completing middle school in Wakayama, Japan. He studied art at Berkeley before transferring to California College of Arts and Crafts. By the time of the evacuation, Sugimoto had been painting for close to twenty years. He traveled to Europe in 1929, making an extended stay in Paris, where he participated in the 1931 Salon d'Automne. He exhibited at the California Palace of the Legion of Honor (1933) and the Nika-kai Annual Exhibition in Tokyo (1937) and was invited to participate in the Pittsburgh International Exhibition in 1941 when war broke out. With evacuation, more than one hundred of his prewar paintings entrusted to a San Francisco gallery were never seen again.

In the camp, Sugimoto's two biggest obstacles to making art were the lack of supplies and the fear of the authorities' reaction to his painting. He had managed to bring a few tubes of paint, a couple of brushes, and a small bottle of turpentine to the Fresno Assembly

7 Isamu Noguchi, letter to Mrs. Adams, June 15, 1942, Isamu Noguchi War Relocation Authority case file (hereafter cited as Noguchi WRA case file).
8 Ibid.
9 Isamu Noguchi, letter to Mr. Fryer, July 28, 1942, Noguchi WRA case file.
10 Isamu Noguchi, letter to John Collier, July 27, 1942, Noguchi WRA case file.
11 Ibid.
12 Form WRA-71, Application for Permit to Leave a Relocation Center for Private Employment, undated, Noguchi WRA case file.

5. 7. A. Poston Arizona May 30 1942

Dear George,

　　　　Your letter just got to me via Man Ray who heard of my
whereabouts over the radio. You see I came to Poston which is a resettle-
ment project for the people of japanese ancestry located on the Parker
Indian Resevation. The expectation is that the evacuees will develope
the land which will be returned to the Indians at the end of war.

　　　　Last month I was in Washington on much such a mission as you
suggest. Although I did not have an introduction from your brother I did
see a number of people in the donovan committee, but with no success.
Yas. Kuniyoshi does occasional pieces for them in N.Y.. I just didnt seem
to get located.

　　　　I decided that things being the way they were I might as well
dive into one of these relocation settlements to see what I could do to
help preserve self respect and belief in America. I came voluntarily, and
find myself in as strange a situation as exists, or could exist in a
democracy.

　　　　This place is the first of the areas which is marked for per-
manent improvement - this element plus the proposition that a maximum
of self government is to be fostered, inside of the military cordon,
differentiates it from the temporary reception centers which arenot much
else than internment camps. Unfortunately here as in all the other
camps there is absolute segregation from the rest of America, civil and
economic. That this will result in moral irresponsibility for the well-
fare of America is already showing evidences.

　　　　Many of us have asked that there be established tribunals
for the examination and subsequent to establishment of absolute loyalty
American citizens educated in our schools should be free to leave the
camps if they have a job to go to. A proceedure such as this was endorsed
by the Tolan Committee for certain categories of Germans and Italians
but not for Americans if they have Japanese blood. It is very distressing
as I feel we should make clear that we are fighting the enemies of demo-
cracy, and not our own citizens who unfortunately have the blood of one
of our axis enemies,Japan. I understand that neither Germans nor Italians
have been moved (excepting of course knownmsubversive elements). Nor
is it contemplated to have evacuations in any other part of the country.
The Army anounces that the removal of the Japanese is purely a California
problem.

　　　　I am to have a show at the San Francisco Museum in July.
If exhibitions such as mine or Kuniyoshis would help to change the
inhospitable attitude of those Western states which refused admision,
then I should think the government would help to promote it - alas they
are too busy winning the war - maybe they think that race hatred is good
for the war spirit. Maybe they are right - its very sad.

　　　　　　Dont stay away too long, we need you here.

　　　　　　My best to Helaine,

　　　　　　As ever,　　　　Isamu [Noguchi]

Center in California. Since he did not have canvas or paper, he used anything he could find: sheets, pillowcases, a mattress bag. And he painted secretly. In a 1982 interview, he said:

> One time an army lieutenant came to my place and said, "I want to take your picture inside your apartment." Perhaps on the outside he already heard I am artist, painting inside. So, he came in: "I want to take your apartment picture." Inside I got paintings, still I'm painting, you know. That's why he told me: "We want to take movies. You do your work. Your wife bring to you some tea." Me, my wife—like actors....

> Then they took movie. Then they took another movie in the mess hall. We went to lunch. On the corner table, so much good, chicken and all, like we never eat before here. They let them film to make record, you know. I ask lieutenant, "What are you going to do with those movies you took at my place?"

> "That's only government record. In case it's needed, maybe they show it—we treat Japanese like this: artist, some people teaching school—very free and happy." That's our government record. That's why they let me act like that.[13]

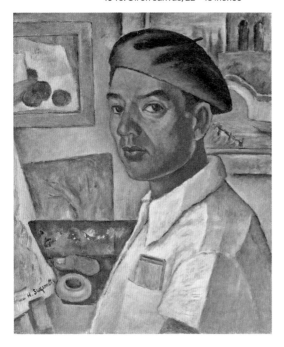

Henry Sugimoto, *Self Portrait in Camp*, 1943. Oil on canvas, 22 × 18 inches

a still life painted at Fresno Assembly Center. Nothing other than the title, *Self Portrait in Camp* (1943), suggests that the artist is interned.

Most of Sugimoto's work, however, is characterized by an emphasis on visually complicated, highly charged scenes of camp life. *Rev. Yamazaki Was Beaten in Camp Jerome* (1943) depicts a real-life event. When Reverend John Yamazaki acted as a Japanese translator for the government's loyalty questionnaires in February 1943, he was thought to be an agent of the American government and therefore responsible for the ensuing separation between the "loyal" and "disloyal." The painting is unusual in its representation of the tensions and divisions within the camps, which were brought to a head by the questionnaires. Reverend Yamazaki's resemblance to a Christ figure is clearly articulated. An electric wire post above the referenced head forms a cross, and his body, held by one of his attackers, suggests Christ on the cross.

Sugimoto's brother Ralph was drafted before the war and eventually served as part of the 442nd Regimental Combat Team, an all-nisei unit of the United States Armed Forces. Along with the 100th Battalion, which was composed of nisei from Hawaii, the 442nd became the most decorated in U.S. military history for the size and length of service. In many of his paintings, Sugimoto explores the irony of the nisei soldiers who fought while their families were interned. A portrait of his mother (1943) shows the colors and symbols of the 442nd in the background with her weary face embodying the toll of internment and a son in war. *Old Parents Thinking about Their Son on the Battlefield* (1943) depicts issei parents in front of a barrack, with an image of their son hovering between them. The son, proud in army uniform, stands in stark contrast to the dark and gloomy predicament of his parents.

After this experience, Sugimoto felt free to paint, and he was known throughout camp as an artist. Above his barrack door was a wooden sign in the shape of an artist's palette with the name Sugimoto carved in relief. His barrack became a studio. His job in the high school enabled him to request materials that he needed to make his own work, including oil paints and canvas, "That's why I started all the paintings. The government gave to me."[14] A self-portrait painted in 1943 sums up the triumph of Sugimoto's identity as a working artist. Wearing a beret and with palette in hand, he stands in front of an easel. Two paintings are visible in the background. On the right is one of Sugimoto's prewar European landscapes and, on the left,

13 Henry Sugimoto, quoted in Deborah Gesensway and Mindy Rosen, *Beyond Words: Images from America's Concentration Camps* (New York: Cornell University Press, 1987), 35–37.
14 Ibid., 37.

Sugimoto's longtime friend Sadayuki Uno was also interned at Fresno Assembly Center, Jerome, and Rohwer. Uno was born in Japan in 1901 and came to the United States to join his father, who had immigrated a few years earlier. After finishing high school in Oakland, he received a scholarship to the California College of Arts and Crafts. He stayed at the art school for a few years before heading east, first to Chicago and then on to New York, where he enrolled in photography and cinematography school. He returned to the Oakland area in the late 1920s upon hearing of the illness of his father. Uno made his living as an interior decorator, and as the economic climate of the Depression worsened, he found work as a gardener. He painted throughout this time.

At Fresno Assembly Center, Uno took up carving. With no tools or equipment to speak of, internees were forced to use butter knives and other modified carving implements. One of his first projects was five small carved pine sculptures. Each stood only four inches high and depicted major leaders of the warring nations: Mussolini, Stalin, Hitler, Churchill, and Roosevelt. The tone is at once serious and humorous, simultaneously presenting caricatures and an understanding of their power in world affairs. The sculpture of Roosevelt was given to an admiring administrator at the assembly center, leaving only four pieces. Not surprisingly, Emperor Hirohito is conspicuously absent. Any depiction of the Japanese emperor would have aroused suspicion and distrust.

For Uno, the internment represented the most prolific period of his artistic life. He painted, carved sculpture and wooden masks, and took up *shigin*, a Japanese form of spoken poetry. His art captures both the humorous aspects of camp life and serious moments of inner despair. His untitled painting of men playing cards (1944) is a behind-the-scenes look at the camp firehouse, where gambling, smoking, and jokes were the norm. In contrast, his *Portrait of Nishida* (1942), painted on a potato sack and framed in wood from a celery crate, is more somber in tone. It was rumored that Nishida was a spy and former Japanese military man. The FBI

deemed him suspicious and transferred him to another camp. With the hysteria brought on by the bombing of Pearl Harbor, many fell under government suspicion as potential threats to national security, sometimes by their mere affiliation with Japanese immigrant clubs and prefectural associations. Despite the U.S. Justice Department's concern about traitors and spies, no evidence exists to support the assertion that the Japanese Americans harbored a security risk. The dark, inward focus of Uno's portrait of Nishida does not reveal any verdict as to the sitter's innocence or guilt. He remains a noble, seemingly harmless man caught up in the consequence of world politics.

Artists Kenjiro Nomura and Kamekichi Tokita were friends and colleagues before the war. In the 1920s, they were partners in Noto, a sign-painting business located in the international district of Seattle. Nomura immigrated to America with his family at the age of ten, and when they decided to return to Japan six years later, he stayed. In 1921, he began formal art training with Dutch painter Fokko Tadama. Born in Japan in 1897, Tokita had arrived in the United States in 1919 with the intention of working in the tea business. After starting the sign shop, he became interested in oil painting and studied with his partner Nomura.

Beginning in 1928, Nomura and Tokita began exhibiting professionally. Their works were included in the annual exhibitions of the Oakland Art Gallery, the San Francisco Art Association, and the Seattle Art Museum. In 1933, Nomura had a solo exhibition at the Seattle Art Museum, and later that year his paintings were included as part of *Painting and Sculpture from Sixteen American Cities* at the Museum of Modern Art, New York. Nomura and Tokita had closed the sign-painting business after struggling with the economic downturn brought on by the Depression, but both continued to flourish as fine artists. In 1937, Tokita and Nomura were part of a loosely formed association called Group of Twelve, which also included artists Kenneth Callahan and Morris Graves. Once interned at Minidoka War Relocation Center in Arkansas, Nomura and Tokita "opened" a

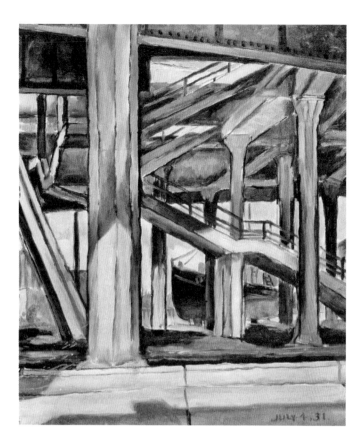

Kamekichi Tokita, *Bridge*, 1931.
Oil on canvas, 23¼ × 19¹/₁₆ inches

Kenjiro Nomura, *Red Barns*, 1933.
Oil on canvas, 28 × 36 inches

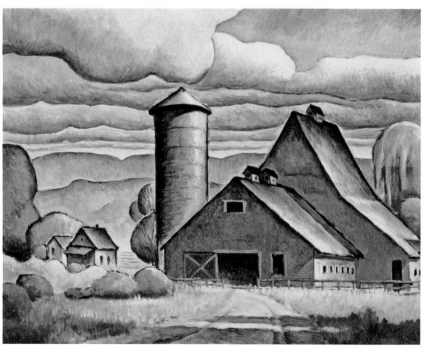

Kenjiro Nomura, *Camp Harmony*, 1942.
Watercolor on paper, 24 × 19 inches

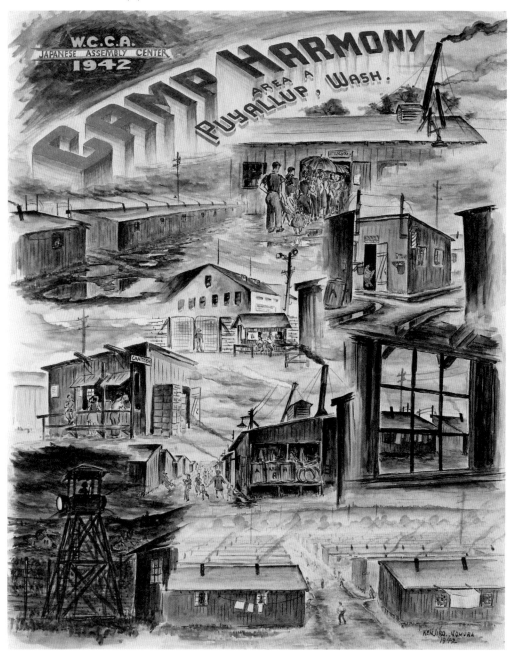

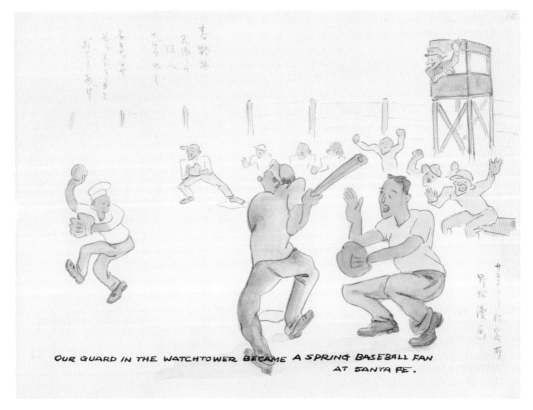

Kango Takamura, *Our Guard in the Watchtower Became a Spring Baseball Fan*, ca. 1942. Watercolor on paper, 8½ × 11 inches

OUR GUARD IN THE WATCHTOWER BECAME A SPRING BASEBALL FAN AT SANTA FE.

sign-painting shop in Warehouse 20. They continued to make art using whatever materials they could find, from beaver board to canvas. Unfortunately, Tokita's paintings were given away or lost, and only a few remain. Nomura's paintings were considered lost until his son found them in the family garage in the 1980s.

For some of the artists, the art made during incarceration represented continuation of an individual vision and did not contain conscious commentary on the circumstances of incarceration. For others, art was a means of recording events and incidents. The photographer Kango Takamura saw himself as a documenter, replacing the forbidden camera with his artistic talents. Takamura immigrated first

to Hawaii and then to the mainland. After a few years in Southern California, he decided to try his luck in New York, where he worked for Paramount Pictures and Lasky Studios. He returned to Hollywood with the hope of becoming a cameraman. As a child, Takamura wanted to be an artist, but after seeing an exhibition of "modern" art in Hawaii, he decided that photography better suited him as an art form.[15]

Immediately before the attack on Pearl Harbor, Takamura worked as a photo retoucher at RKO Studios in Hollywood. Three weeks before the bombing, his supervisor at RKO had taken an order for two movie cameras from a

15 Ibid., 128–29.

Kango Takamura, *Some Characteristics of Guayule Strains*, ca. 1940s. Watercolor on paper, 8½ × 11 inches

SOME CHARACTERISTICS OF GUAYULE STRAINS

VARIATIONS IN THE MORPHOLOGY OF POLLEN.

TOP VIEW OF A FLOWER-HEAD SHOWING RAY FLOWERS AND DISC FLOWERS. (STRAIN 593)

RAY FLOWERS WITH TWO TYPES OF COROLLA. A, STRAIN 406; B, TEXAS TYPE.

TWO DISTINCT STEM TYPES. A, TEXAS; B, SALINAS.

TWO MATURE SEEDS, AND YOUNG ACHENE WITH DARK SPOTS. SPOTS ABSENT IN STRAIN III.

RAY FLOWERS SHOWING TWO TYPES OF COROLLA SHAPES. A, 593; B, 406.

Japanese army officer. The order was later canceled, but because Takamura had dinner with the Japanese officer, he was unwittingly under suspicion. In February 1942, he was taken away by the FBI. After four days in a city jail, he and other Japanese Americans were bused to a former boy-scout camp in Tujunga Canyon. Ten days later, they were put on a train to New Mexico, where they were interned at the Justice Department/FBI Santa Fe Internment Camp. He remained in Santa Fe for nearly five months, until he was released to join his family in Manzanar War Relocation Center.

The fear of censorship was always present, though many artists did not explicitly articulate their concerns. For Takamura, the purpose of his drawings and watercolors was to document and record, and he was fully aware of the implications of this when he began to draw.

> Enemy aliens were not allowed to carry cameras with them anytime, anywhere….At first I drew in a cartoon style to avoid troubles, but no one bothered me. So I became bold and depicted the life in camp as realistically as possible….Whenever possible, I sketch the life in camp. The drawings were like photographs.[16]

The use of humor to explore politically and emotionally laden issues was not unusual. In *Our Guard in the Watchtower Became a Spring Baseball Fan* (circa 1942), a group of internees play baseball while a guard cheers from the tower above. What initially appears to be an innocuous depiction of fun and games becomes complicated when the presence of the guard and barbed-wire fences is considered. His ironic sense of humor carries over to watercolors made in Manzanar. *Progress after One Year, the Mess Hall Line* (1943) comically depicts a long line leading into a barracks' mess hall. Restless children, young and old people all wait to partake of their daily meal. The family dining room is replaced by a wood-and-tar-paper structure, and the family unit becomes one extended line. A photo inset in the upper right of the watercolor shows the mural Takamura painted inside the mess hall.

Takamura was an accomplished illustrator able to capture distinct and individual personalities and experiences, and his work was not limited to humorous drawings. At Manzanar, he documented the Manzanar guayule team, which conducted research on the propagation and development of guayule, a rubber substitute. The Manzanar team included interned scientists, chemists, and agricultural specialists working under the direction of Robert Emerson of the California Institute of Technology. Because access to rubber supplies was limited during the war, the Manzanar guayule team's research was important to the war effort. Takamura's watercolors follow the progress of the research team, from the growth of seedlings to experimentation in the sophisticated science lab.

An early watercolor painted on the evening of May 31, 1942, at Santa Fe, *At Evening Sketched This Beautiful Unusual Cloud Formation* (1942), is eerie in its prescience. Internees saw a mushroom cloud in the eastern sky. Takamura wrote, "We wondered whether these clouds might mean that we would be at peace."[17]

George Hoshida also used his drawing skills to document. Hoshida was born in Japan and immigrated to Hawaii at the age of five. He was a civic-minded man, active in the United Young Buddhists Association and judo organizations while working for the Hilo Electric Company. After the bombing of Pearl Harbor, Hoshida was arrested by the FBI because of his leadership in community organizations, in particular the Big Island Hongwanji Judo Association. Japanese Americans constituted a significant proportion of the total population of Hawaii, making mass evacuation economically and logistically impossible. However, Japanese Americans in Hawaii were not free from government suspicion and paranoia. Within days following the attack on Pearl Harbor, "suspicious" Japanese Americans were rounded up. Others were singled out and forced to relocate when

16 Kango Takamura, *Hariuddo ni Ikiru* [Living in Hollywood] (self-pub. 1986), 127. Passage translated from Japanese by Eiichiro Azuma.
17 Ibid., 129.

George Hoshida, *Playing "Go" K5-BA, 8-24-42*, 1942. Ink, paper, laminate, 9½ × 6 inches

opposite: George Hoshida, *Fujita Sawaichi, 7-28-42*, 1942. Ink, paper, laminate, 6 × 9½ inches

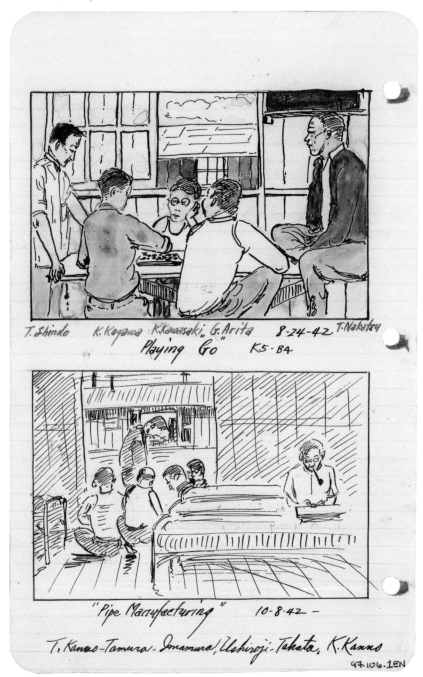

their farms, businesses, or homes were perceived to be in sensitive zones. The forced relocation was based solely on race: only those of Japanese descent were affected.

Hoshida was one of seven to nine hundred Japanese Americans in Hawaii incarcerated in Justice Department internment camps.[18] He was first sent to Volcano Military Camp, also known as Kilauea Military Camp, and was later transferred to Sand Island Detention Center. From Sand Island, he began a long journey to the mainland, where he was interned at Lordsburg Internment Camp and Santa Fe before being reunited with his family, who left Hilo to join him at Jerome. More than one thousand women and children left Hawaii to join their husbands and fathers in mainland internment camps.[19]

Hoshida had been interested in art since childhood, and he used his abilities to keep an almost daily record of his incarceration. He was fully aware of the importance of recording his experiences through his pen-and-ink drawings, and through the countless letters he sent to his wife and family. He drew on the loose-leaf paper that he had requested from

his wife upon arrival at Kilauea and carefully compiled the drawings into binders. He documented his surroundings and his daily activities. Interestingly, the tone of his sketches stands in sharp contrast to that of his written word. While his letters reveal despair, uncertainty, loneliness, and constant concern for his family, his sketches feel more positive. The drawings were a way to communicate with his pregnant wife and three daughters, including one who was severely disabled. Hoshida did not attempt to make any overt commentary on the internment, but he succeeded in providing a continuous and detailed account of images he saw and the people he knew.

The internment experience was also shared by a few Caucasians. Estelle Ishigo was a white woman married to a nisei. With incarceration, she chose to accompany her husband to the camps, first to Santa Anita Assembly Center in California and later to Heart Mountain War

18 Roland Kotani, *The Japanese in Hawaii: A Century of Struggle* (Honolulu: Hawaii Hochi, 1985), 80.
19 Ibid., 85.

Taneyuki Dan Harada, *Typical Barrack
Plan—Tule Lake*, 1998. Acrylic on canvas,
36 × 36 inches

Relocation Center in Wyoming. Ishigo's work is most powerful in its simple yet stark contrast of human life against the physical and psychic boundaries imposed by incarceration. In *Boys with Kite* (1944), two children attempt to untangle their yellow kite from the barbed wire of a fence. The innocence of childhood and, by extension, of Japanese Americans is caught behind an unremitting barrier. Even attempts at recreation and normal activity within the confines of camp are stymied. Ishigo's direct and uncompromising indictment of incarceration suggest that her status as a Caucasian granted her the confidence and freedom to create these strikingly forthright images.

Other artists created work in isolation, by choice or circumstance. Hideo Kobashigawa was one such artist. Born in Arizona in 1917, he moved to Okinawa with his family as a small child. He returned to the United States as a teenager and later worked as a gardener and took classes at Otis Art Institute in Los Angeles.

Kobashigawa did not interact with the other artists in Manzanar, yet he participated somewhat in community life. Shortly after his arrival in Manzanar, he completed a mural in the block mess hall, and in spring 1942 he began a large woodblock-print project. He hoped to give a print of a panoramic view of Manzanar to every family interned for the cost of the paper. But the 1943 "loyalty" questionnaires halted this desire. In February 1942, the government required all people older than seventeen years of age to sign what constituted an oath of loyalty. One question required internees to forsake former allegiance to the emperor of Japan and pledge allegiance to the United States. Another asked about the willingness to serve in the armed forces. The language was tricky. An affirmative answer implied forsaking former allegiance to Japan and left the issei, who were forbidden by law to become citizens, without a country.

With Kobashigawa's "no-no" response to the loyalty questionnaires, he was transferred to Tule Lake War Relocation Center in spring 1943. While he found inspiration in the natural beauty of Manzanar, Tule Lake had a completely opposite effect. The large mass of the dark mountain and the thick, mud-like application of paint in *Tule Lake* (1945) echo the depressing circumstances of Kobashigawa's transfer to camp and the possibility of forced deportation to Japan. But at Tule Lake, there were other artists who met informally to make art. Kobashigawa participated, as did Harada, who continued learning from the older artists at Tule Lake as he had with George Hibi at Topaz.

The internment remained a key event in Kobashigawa's artistic life. After his release, Kobashigawa continued to work and rework images of the camps based on memory and imagination. He compiled more than ninety drawings and watercolors from his incarceration at Manzanar and Tule Lake, along with close to forty drawings and watercolors made in 1991 based on memories of the camps. His idiosyncratic artistic style developed, from 1941 to the present, through his exploration of the impact of incarceration on his life.

But what was the impact of incarceration on the artistic lives of those interned? For many artists, the time during incarceration would provide the last opportunity to make art. Prewar racism and the social and economic difficulties that faced the issei would pale in comparison to the postwar milieu and the psychological scars left by incarceration. Like any traumatic and disruptive incident, the internment manifested effects over the course of time. For George Matsusaburo Hibi, Kenjiro Nomura, and Kamekichi Tokita, the wartime paintings were among their last, as they died shortly after being released. For others, like Sadayuki Uno and Tokio Ueyama, the postwar pressures of starting anew made the pursuit of art making impossible. Henry Sugimoto turned to the memories of specific incidents, and Hisako Hibi would change and grow as an artist until her death in 1991. Incarceration changed the lives of all those interned and, by extension, the way they made art. Through the art they made in the camps, we can begin to learn more about the artistic output of a vital and prolific generation of Japanese American artists and start the long process of reclaiming their histories.

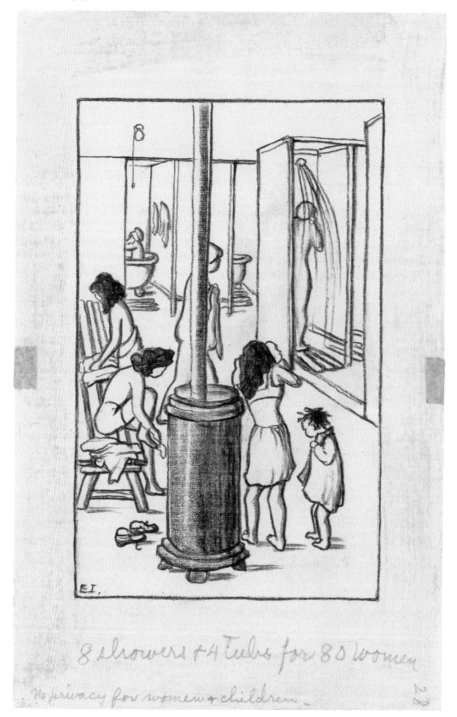

Hideo Kobashigawa, *Manzanar*,
1944. Woodblock print on rice paper,
12 × 18 inches

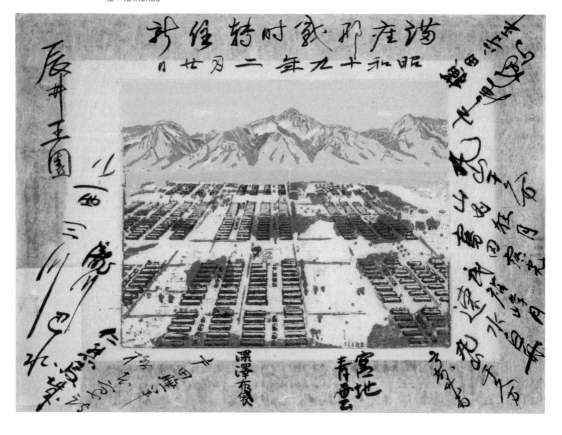

Dorothea Lange, still-life class, Tanforan
Art School, Tanforan Assembly Center,
San Bruno, California, June 16, 1942

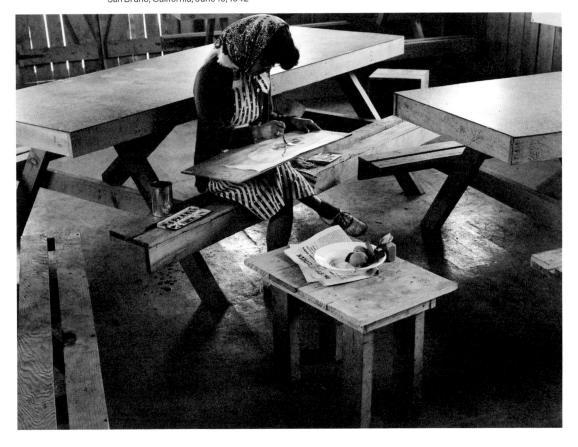

Residents of Granada War Relocation
Center, also known as Camp Amache,
Colorado, ca. 1943

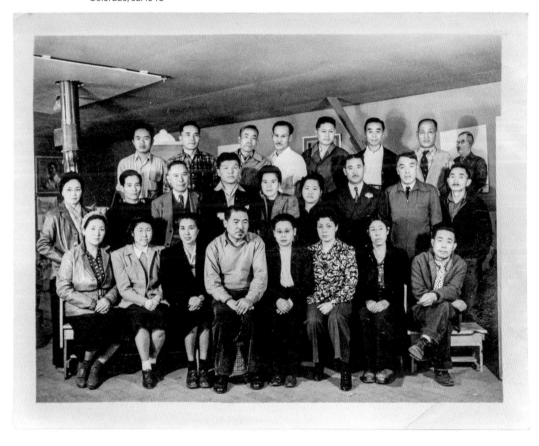

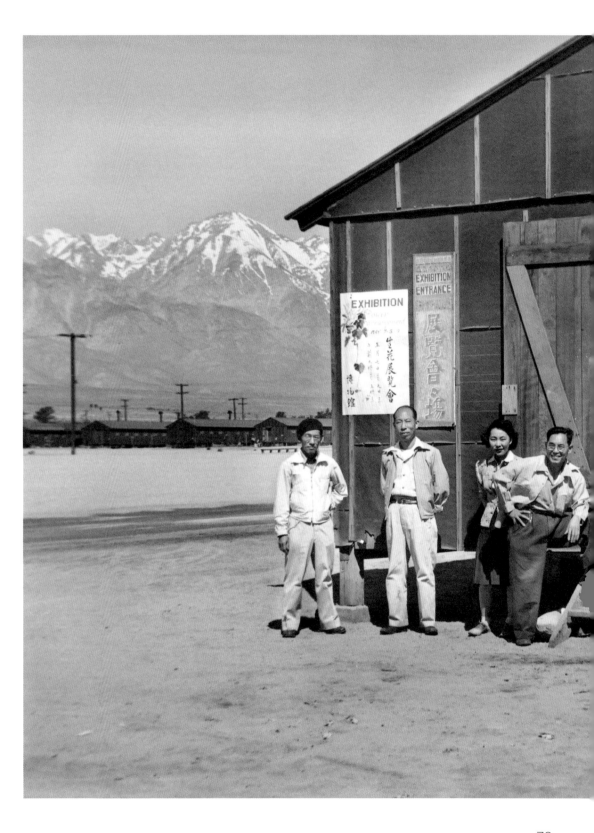

Toyo Miyatake, Manzanar War Relocation
Center, California, ca. 1943

Some
Notes
on
an
Asian
American
Art
History

It begins as a mystery: an image that is followed by a name, place, and date; a colorful abstraction of interlocking arcs of three faces with tears, a huge sumi-e landscape of a mountain stream, and a painting of an Asian woman staring up at a cliff face seemingly formed from figures. The names of the artists are Yun Gee, Chiura Obata, and Chee Chin S. Cheung Lee. The place is California, and the date of execution is sometime during the 1920s and 1930s. Who were these artists?

We know a lot more about the history of Asians in America than we did twenty-five years ago. The history has emerged slowly, through the careful reconstruction of individual life stories, collective experiences, and community struggles in the immigrant's new world. The traces of Asian American lives lived—letters, diaries, personal effects—and the evidence of active organizations, newspapers, neighborhoods, and collective social and sports activities has brought to light a complex picture of vital communities throughout the West Coast. Combined with an analysis of the political and social responses to Asian immigration—much of it fraught with evidence of racism—we now have a greater understanding of American history and the place of Asians within that history.

These opportunities for uncovering lost history are inextricably linked to the emergence of the civil rights movement and the wave of student strikes of the late 1960s that spawned the development of ethnic-studies departments. These new departments changed the way history is created by providing an intellectual home for the contestation of an American history that excludes the lives of people of color. However, one notable absence was an investigation of the visual arts. Since the students and

faculty of San Francisco State University played a pivotal role in the emergence of the ethnic-studies movement in the 1960s, it is exciting that this spirit continues.[1] The exhibition *With New Eyes: Toward an Asian American Art History in the West* (1995), at the SFSU Art Department Gallery, is bound to make a significant impact on the reevaluation of Asian American activity in the visual arts.

The most remarkable aspect of *With New Eyes* is the sheer number of artists and objects the organizers have uncovered. The mere existence of the paintings by Asian American artists represented in the exhibition, and the multiple questions they elicit, forces us to reconsider and supplement our understanding of early Asian American history. On an evidentiary level, the art suggests layers of Asian American activity that have not been explicated. Ironically, many advocates of the Asian American studies movement are implicated in such an omission. One popularly held belief among contemporary Asian Americans is that our ancestors were laborers, whether on farms or in cities, whose struggles to make new lives precluded the possibility of creative exploration in the visual arts. It was assumed that the investigation of identity, ethnicity, and individual expression in the visual arts was not developed by Asian Americans until the advent of the civil rights movement. Could it be that in our quest to validate the lives of the everyday immigrant, we ignored the possibility that our laborer ancestors could also have been artists? *With New Eyes* provides us with a rich bounty, forcing us to reframe the questions we ask about our own history.

Before proceeding further, it is important to highlight several issues for consideration as we strive to create this new art history. First, the term *Asian American* is itself of recent usage. The artists of the pre–World War II era

1 For more on Asian Americans and the ethnic-studies movement, see Karen Umemoto, "'On Strike!' San Francisco State College Strike, 1968–69: The Role of Asian American Students," *Amerasia Journal* 15, no. 1 (1989): 3–41.

could not have conceived of such a designation, though they not only valued their specific ethnic heritage but also made connections with artists of varying backgrounds. Using the term *Asian American* broadly and with shaded meaning in different contexts, as I have here, is not historically accurate but acknowledges that the vocabulary we use to indicate self and group identification is woefully inadequate. Our own contemporary cultural assumptions easily obscure historical conditions, and we must be aware of this.

Secondly, given the scope of this short essay, my remarks are limited primarily to artists of Chinese or Japanese ancestry. Though there was early immigration from Korea and the Philippines, the bulk of immigrants from Asia before 1965 were Chinese or Japanese, and these ethnicities were directly linked by the American anti-Asian movements that resulted in restrictive legislation and a conflation of the xenophobia of Chinese and Japanese "yellow peril" in the American popular imagination. In the specific case of the Philippines, the scale and duration of Western imperialism and the Philippines's political relationship to the United States would necessitate a different type of analysis. Furthermore, I do not intend to infer that art from Asian ethnicities other than Chinese and Japanese did not exist or that such art is unworthy of analysis. However, I do hope to suggest just how vast such a task of "Asian American art history" could be and to stress the importance of acknowledging the particular histories and circumstances of each ethnic group.

Probably the most important point that deserves clarification is the reason for examining Asian American art activity at all. While the mere existence of art created by artists of Asian ancestry necessitates a reevaluation of our historical understanding of these communities, the art should be looked at, studied, and analyzed because it is art of quality. What strikes me about the work in *With New Eyes* is that its small sampling of art reveals compelling artistic talent. It is difficult to make grand pronouncements about artistic excellence given such a small amount of art, but the promise of

excellence is there, waiting to be uncovered and analyzed. Admittedly, the word *quality* is a red flag. It immediately calls forth multiple debates about what quality really is, whose and what values it supports, and who isn't in the position to make such assertions. Obviously, not all work by artists of Asian ancestry is the same, and there will be debates as to who and what work is significant. But in breaking down the traditional canons of art historical scholarship, we should not ignore appropriate questions of skill, aesthetics, and rigor of practice in our analysis. To do so would be a disservice to the artists and their original intentions.

The period between the two world wars provides a particularly interesting starting point for examining Asian American artists and the visual arts. In addition to the actual objects—the paintings, sculpture, photographs, prints, and drawings—that were created by Asian Americans, the artists themselves are important given their participation in the development of a greater arts community on the West Coast, which included artists of multiple ethnic heritages, from Europe to Asia.

Amid the increase of restrictive legislation and growing institutional hostility directed at Chinese and Japanese immigrants, the social and cultural life of Japanese and Chinese Americans seemed to flourish, embodying a vitality that appears in direct contrast to institutionalized forms of racism. While American anti-Asian sentiment was consolidated in the legislative arena, Chinese and Japanese immigrants solidified their communities and planted firm roots in the American soil. Neighborhoods of Chinese or Japanese residents were firmly established; the first American-born generation emerged and with them grew a new sense of community and family life.

Historically, the anti-Chinese movement began in the mid-nineteenth century, as soon as the first immigrants arrived from China, though naturalization restrictions were already in place that prohibited Asians from becoming American citizens, rendering them "aliens ineligible for citizenship." Chinese laborers were accused of taking jobs from "real" American

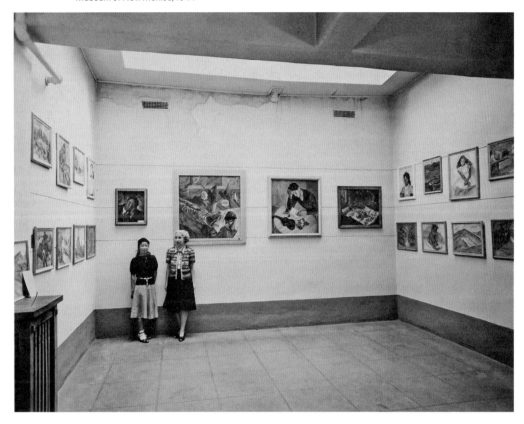

workers, and their visual markers of ethnicity distinguished them from the previous waves of European immigrants, making overt racial discrimination easy. The Chinese Exclusion Act of 1882, the first of several congressional acts that excluded immigration based solely upon ethnicity, was designed to eliminate Chinese immigration to the United States. When Japanese migrants were recruited to fill the need for labor previously met by the Chinese, they were faced with similar discrimination. In 1904, the National Membership of the American Federation of Labor called for an amendment to the Chinese Exclusion Act to include the exclusion of Japanese and Koreans. Though no such an amendment materialized, by the end of

World War I legislation specifically aimed at the Japanese would be activated by the Gentlemen's Agreement of 1907, and local alien land laws were enacted on the state level.

The comprehensive Immigration Act of 1924, which provided a decisive break for immigration from Asia, coincided with the continued development of art associations and informal groups of Asian American artists, the inclusion of Asian American artists in museum and gallery exhibitions, and the presence of Asian American students at art schools throughout the western states. The nature of Asian participation in what we might now call mainstream arts activities is telling. The arts establishment in the western states was smaller and less developed

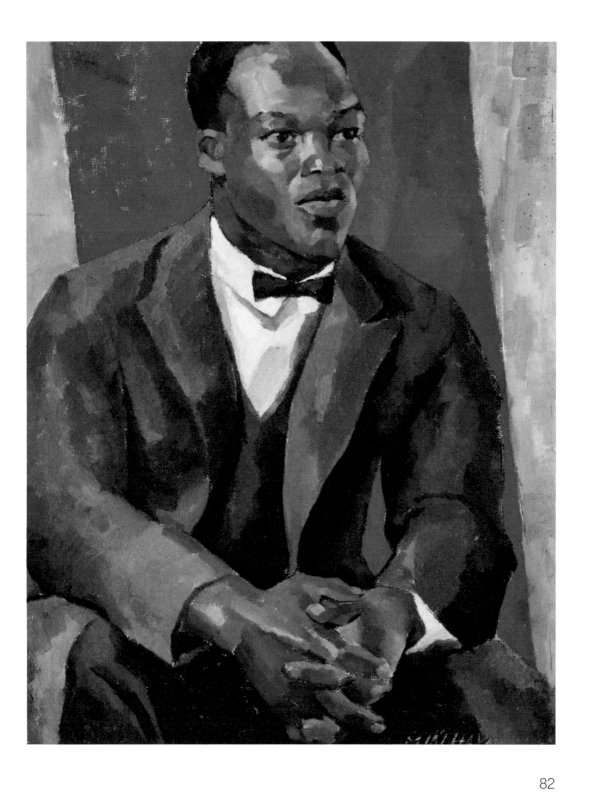

opposite: Miki Hayakawa, *Portrait of a Negro*, 1926. Oil on canvas, 26 × 20 inches

Yun Gee, *Where Is My Mother*, 1926–27. Oil on canvas, 20⅛ × 16 inches

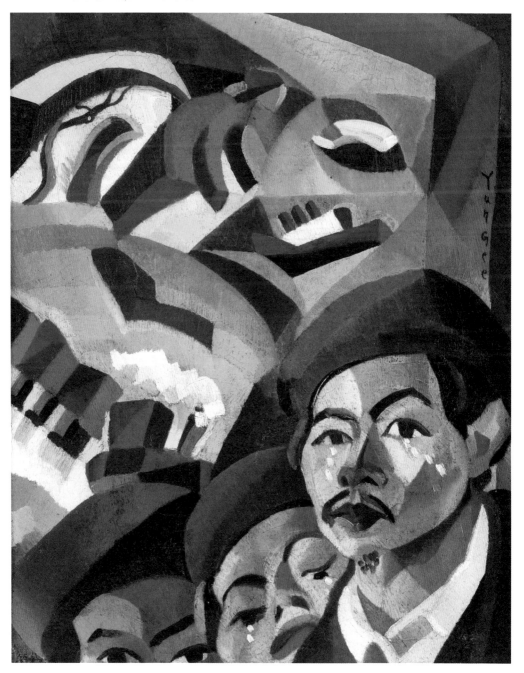

Yun Gee, *Artist Studio*, 1926.
Oil on paperboard, 12 × 9 inches

Chiura Obata, *Untitled (redwood tree spire, Alma)*, ca. 1925. Watercolor on paper, 12 × 9 inches

Some Notes on an Asian American Art History

Chee Chin S. Cheung Lee,
Mountain Fantasy, 1933.
Oil on canvas, 38 × 48 inches

than that on the East Coast or in Western Europe; the scene that did exist included many Asian American artists. In San Francisco, Los Angeles, and Seattle, Asian Americans were involved in important roles as leaders, organizers, and teachers of art. The participation of artists of Asian ancestry in such roles on the West Coast suggests an alternative picture to the one painted on the legislative front.

Whether the art produced during this period is a direct commentary on the political situation awaits further analysis. However, there is evidence that the artists were acutely aware of the importance of art as a transmitter of culture and, by extension, as a tool for mutual understanding. Japanese artists George Matsusaburo Hibi, Teikichi Hikoyama, and Chiura Obata were among the members of the East West Art Society, which was founded in San Francisco in late 1921, based on the "ardent desire for researches [*sic*] of Occidental and Oriental Arts and thus finding the way to a high Idealism where the East unites with the West."[2] The catalogue for their second exhibition, which was held at the San Francisco Museum of Art in 1922, lists the participation of twenty-seven members, including ten with Japanese names, one Chinese, and sixteen with European American names. Five artists—Hibi, Hikoyama, Yukie Kotoku, Lee, and Obata—from the 1922 East West Art Society exhibition are included in *With New Eyes*. Though Kotoku

spent time in Seattle and San Francisco, he appears primarily to have resided in Los Angeles by the 1920s. This would make it plausible that "T. Uyeyama," who appears in the 1922 catalogue, is Tokio Ueyama, an important Los Angeles–based painter.

Ueyama himself was involved in the formation of an artists' association in Los Angeles. The Shaku-do-sha was formed by Ueyama, poet T. B. Okamura, and painter Sekishun Uyena. Based in the Little Tokyo area, the association was "dedicated to the study and furtherance of all forms of modern art."[3] Shaku-do-sha organized exhibitions in the neighborhood and supported artists both within and outside the Japanese community. In the mid-1920s, Ueyama traveled to Europe and Mexico and had exhibitions as far away from Los Angeles as Philadelphia and Oregon. The possibility that he participated in the East West Art Society suggests a larger network of Japanese American artists that exceeded the geographical boundaries of a particular city.

Associations seemed to be important for Chinese artists as well. In 1926, Chinese American painter Yun Gee formed the Chinese Revolutionary Artists' Club in San Francisco with the assistance of two prominent Chinese doctors. The aim of the group was to teach modern art theory and painting.[4] As Taiwanese curator David Teh-yu Wang has pointed out, a photograph of the club circa 1926 exhibits the cross-cultural tendencies of the group. The photograph shows students working at painting easels. Gee is dressed in traditional Chinese clothes, and a reproduction of a hanging-scroll landscape by Ni Tsan is shown in the background.[5] However, Gee did not limit his sphere of activities to the Chinese arts community. In 1926, he established the Modern Art Gallery as a cooperative venture with Otis Oldfield, his former teacher from the California School of Fine Arts.

Another Chinese artists' group was the Chinese Art Association, which appears to have been founded in 1935, the year it held its first exhibition, which took place that fall at the M. H. de Young Museum in San Francisco.

Although there is much more to be discovered about the association and its membership, Lee was a member. In a *San Francisco Examiner* review of December 22, 1935, Lee receives special citation for his scenes of San Francisco. In the same review, the writer positively indicates that the members of the association, "whether born in California or the Orient, have generally submitted to familiar Western influences."[6]

The split between the idea of the West and the East, the Occidental and the Oriental, seems to provide a basic framework in the formation of the associations. Yet the artists of Asian descent used their freedom as artists to explore a broader definition of their culture, their artistic heritage, and their place within the arts scene to move past the divide between the United States and their ancestral homes. Clearly, the next step is to begin deciphering the artists' individual stories, an endeavor that starts with the paintings and expands beyond.

2 "Catalogue of Second Jury Free Exhibition of the Work of Members of the East West Art Society," draft manuscript, Archives of the San Francisco Art Institute.
3 From a July 7, 1927, article in the scrapbook of Tokio Ueyama.
4 For more information about Yun Gee, two exhibition catalogues are extremely useful: *The Art of Yun Gee*, 2nd ed. (Taiwan: Taipei Fine Arts Museum, 1993); and *Yun Gee* (Storrs: William Benton Museum of Art, University of Connecticut, 1979). Currently, archivist Mei-Lin Liu is in the process of researching and archiving the papers of Yun Gee.
5 *The Art of Yun Gee*, 21.
6 "Group Shows at de Young Museum Cover Wide Range," *San Francisco Examiner*, December 22, 1935.

The author wishes to thank Michael D. Brown, Mark Johnson, Li-lan and Lisa Seitz for their help and assistance.

Alfred and Dorothy Morang, Mary
Hunsacker, unknown friend, and
Miki Hayakawa, November 1943

George Matsusaburo Hibi, *A Corner of
Topaz*, 1945. Woodcut, 10½ × 16¼ inches

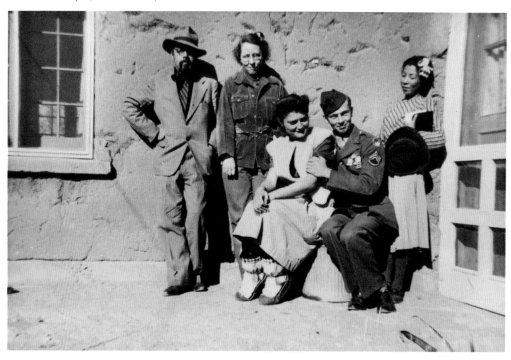

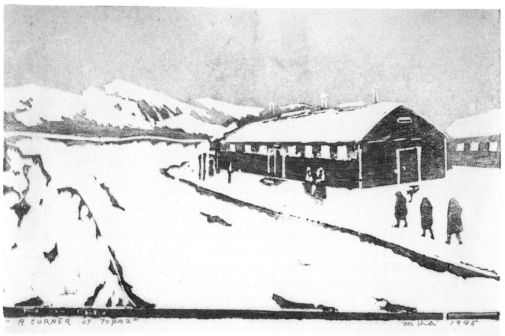

Photograph of Tokio Ueyama's
1928 portrait of a woman

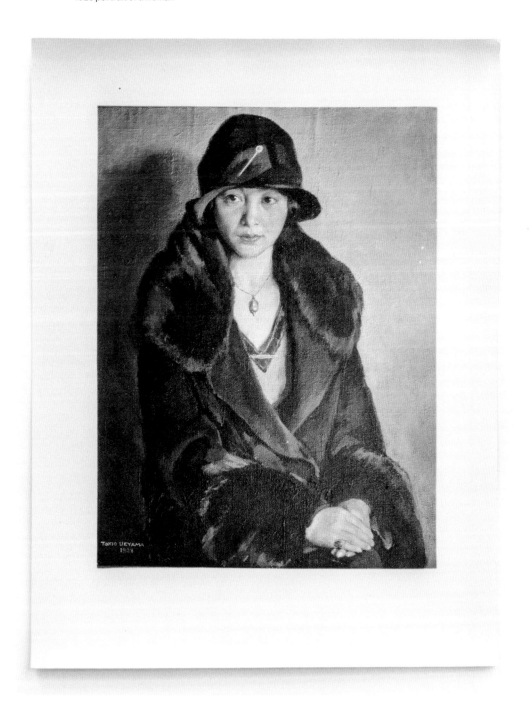

Toyo Miyatake, artists' association
portrait, ca. early 1920s

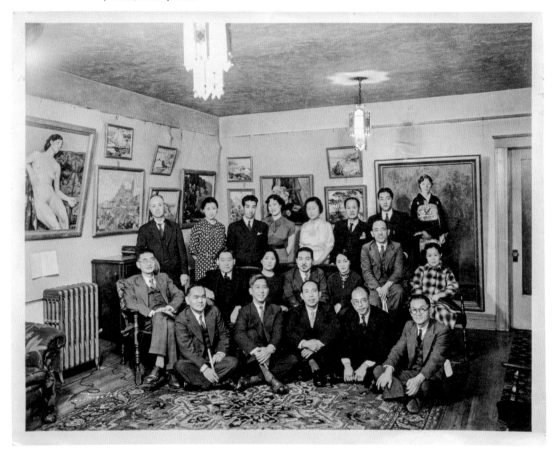

Installation view, *With New Eyes: Toward an Asian American Art History in the West*, San Francisco State University, Fine Arts Gallery, 1995. From left, works by Yun Gee, Roberto Vallangca, Chiura Obata, and May's Photo Studio

Installation view, *With New Eyes: Toward an Asian American Art History in the West*, San Francisco State University, Fine Arts Gallery, 1995. From left, works by George Tsutakawa and May's Photo Studio

Some Thoughts on National and Cultural Identity:
Art by Contemporary Japanese and Japanese American Artists

Japanese and Americans of Japanese ancestry have been linked in the American political realm and in popular imagination since the beginning of Japanese migration to the United States in the late nineteenth century. The conflation of a foreign Japanese identity with a Japanese American one has mostly resulted in both tremendous racism and cultural misunderstanding. Anti-Japanese immigration and naturalization laws and the World War II incarceration of more than 120,000 Japanese Americans are evidence of the former impulse; the continued expectation and interpretation of an essential "Japanese-ness" in the art and expression of Japanese Americans exemplifies the latter.

Contemporary artists of the last decade have challenged these cultural stereotypes by exploring, interrogating, and critiquing notions of national and cultural identity. In the United States and Japan, artists have begun to examine the contours of their ethnicity, to engage in a nuanced interpretation of national and cultural identity, both as a primary project and as the by-product of other concerns. Such investigations are taking place against the recent fiftieth anniversary of World War II's end, an especially compelling backdrop to reconsiderations of Japanese and Japanese American identity and expression.

World War II left Japan defeated and devastated. The aggressive military actions and the attempts to establish, through force, the so-called Greater East Asia Co-Prosperity Sphere were brought to a decisive halt. In an unprecedented radio broadcast, Emperor Hirohito, the divine ruler, announced surrender, and the United States began its postwar occupation, which would continue into the next decade.

Yukinori Yanagi mines this period in United States–Japanese history to investigate the residue of Japanese nationalism in the postwar period, despite the explicit goals of the occupation to demilitarize and democratize Japan. In a recent exhibition at the Peter Blum Gallery in New York, Yanagi paired *Chrysanthemum Carpet* (1994) with an untitled photographic work from 1995. In the center of the deep red carpet is the outline of the imperial seal of Japan, the chrysanthemum. He covered the central image with a single brass petal and scattered more brass chrysanthemum petals around; the phrase "he loves me, he loves me not" is embroidered in different Asian languages. Excerpts of the Japanese constitution, which was drafted under the jurisdiction of U.S. General Douglas MacArthur, are reproduced on the carpet's underside, making them impossible for viewers to see without turning the carpet over. On the far wall, Yanagi placed a photograph of MacArthur—whose official title, incidentally, was supreme commander of the Allied Powers—with Emperor Hirohito. A quotation from the Japanese writer Yukio Mishima on the emperor's renunciation of his divinity appears between the two figures. Here Yanagi deftly explores the wartime legacy of Japanese nationalism and its lingering effects, carefully constructing a critique that implicates the American occupiers as well.

During the war, on the other side of the Pacific, Americans of Japanese ancestry were branded enemy aliens, subjected to acrimonious treatment and, ultimately unjustly incarcerated. Lynne Yamamoto uses the personal history of her "picture bride" grandmother as a starting point for creating objects and installations that explore issues of labor, domesticity, sexuality, identity, and death in the life of a Japanese American immigrant woman. It was only recently that Yamamoto discovered that her grandmother, who worked as a laundress on a sugar plantation in the territory of Hawaii, committed suicide ten months after the bombing of Pearl Harbor by drowning herself in an *ofuro*, a Japanese bathtub. *Submissions. For Chiyo* (1995) consists of 1,500 muslin squares arranged in a grid, each obsessively embroidered with nine stitches of the artist's hair.

The structured purity of the grid is disrupted both by the hair, which is at once intensely personal, private, and sexual, and by

Yukinori Yanagi, *Chrysanthemum Carpet*, 1994.
Wool carpet and brass, 252 × 472½ inches

Some Thoughts on National and Cultural Identity

Lynne Yamamoto, *Submissions.*
For Chiyo, 1995. Hair, muslin, pins,
photograph, 60 × 120 × 1 inches

Lynne Yamamoto, *Submissions.
For Chiyo*, 1995 (detail). Hair, muslin,
pins, photograph, 60 × 120 × 1 inches

Some Thoughts on National and Cultural Identity

dates embossed on the wall that mark statistical events of the grandmother's existence: birth, migration, marriage, death. Yamamoto successfully conjures the presence of her grandmother, while evoking the repetitive actions of domestic labor and the physicality of the body.

While Yamamoto's work derives from the experiences of a poor immigrant woman in the first half of this century, Mariko Mori's recent photographs investigate the transformation of tradition, gender roles, and fashion in the technologically savvy and media-driven culture of contemporary Japan. Chanoyu, the Japanese tea ceremony, which has its origins in fifteenth-century Japan, is now regarded as a feminine pursuit that stresses constraint, discipline, and tradition. However, the practitioner of Mori's *Tea Ceremony III* (1995) is a cyber "office lady" inspired by high-tech fashion and japanimation, the fast-paced techno form of contemporary cartoon animation. Instead of partaking tea in the traditional tatami room with tokonoma and Japanese art, the "participants" of Mori's tea ceremony casually stroll by. The Tokyo school of fashion and other edifices representative of late twentieth-century capital loom large in the background. Mori has stated that her work "metaphorically questions women's positions in Japan and elsewhere."[1] In *Tea Ceremony III*, the explicit connection to a specifically Japanese context is essential to the work's provocative meaning.

For Takashi Murakami, popular culture, cartoons, and japanimation provide a way of locating a contemporary Japanese identity that is expressed through commodity culture. Using as his model cute, cartoon-inspired toys and comics ubiquitous in contemporary Japan, Murakami fashions his own creations. As dolls, balloons, and graphic representations, Murakami's creations mimic the "real" thing. However, slight exaggerations and modifications push the cartoons over the edge. Appealing though they may be in form, they are also remarkably grotesque, bordering on the vulgar. It is interesting to note that Murakami is trained in *nihonga*, a Meiji-era painting style that emerged in the late nineteenth century in reaction to Japan's rapid aesthetic embrace of oil painting. *Nihonga* incorporates aspects of

Western practices, such as modeling and shading, with traditional Japanese material and subject matter to create a popular though high-art form of artistic expression. Such a practice is useful in considering Murakami's contemporary manifestations of hybridity and commodity culture.

Bruce and Norman Yonemoto take on media imagery and popular cultural expression, though different in origin from that explored by Murakami. For the past twenty years, the Yonemotos have interrogated the filmic language of Hollywood and television and its constitutive effects on identity formation. The installation *Environmental* (1993) consists of a large screen made up of multiple home movie screens. Footage used in films about the war in the Pacific from the special-effects department of Warner Brothers Studio is projected onto the fragmented surface. Across the room, a video monitor plays excerpts of early television commercials. Moving images represent the visual heritage of the Yonemoto's childhood in postwar America. As Japanese Americans, they participated in but were also the targets of the media's propaganda and sometimes openly racist attitudes.

For most of the artists examined here, looking Japanese remains the key starting point for the work. The Japanese presence is manifested visually by some form of representation. Gavin Flint, however, uses language and communication as a marker of difference. Born in Guam and raised in Japan by American and Eurasian parents, Flint does not appear to be "Japanese." In a recent performance, he used the disparity between external appearance and audience expectation to underscore the way communication is either confirmed or denied by visual representation. The performance consisted of Flint giving a lecture in Japanese to an audience who knew him to speak English only. Flint knew in advance that one person in the audience could understand Japanese. Unwilling to translate his speech into English, Flint not only confounded the audience but forced one person to become the interpreter for the others.

1 Mariko Mori, quoted in Kathleen F. Magnan, "The Cyber Chic of Mariko Mori," *Art Asia Pacific* 3, no. 1 (1996): 66.

Bruce and Norman Yonemoto,
Environmental, 1993. Two-channel
video installation, fourteen home
movie screens, monitor, dimensions
variable. Installation view, *Living Apart
Together: Recent Acquisitions from
the Hammer Contemporary Collection*,
Hammer Museum, Los Angeles, 2017

Still from *Environmental*, 1993

opposite: Takashi Murakami, *Miss Ko²
(Project Ko²)*, 1997. Oil paint, acrylic,
fiberglass, and iron, 73¼ × 26¾ ×
25½ inches. © 1997 Takashi Murakami/
Kaikai Kiki Co., Ltd. All Rights Reserved

Mariko Mori, *Tea Ceremony I*, 1994. Fuji
Flex supergloss print, wood, aluminum,
pewter frame, 48 × 60 × 2 inches

From Enemy Alien to Zen Master: Japanese American Identity in California during the Postwar Period

In the period immediately following World War II, a Japanese American identity emerged that was marked by complexity and contradiction. That the war radically changed the tenor of all aspects of American life is not debated. But the time between 1941 and 1946 represented a defining moment for the Japanese American community's ideas about identity, experience, and expressions of national origin. This brief essay will trace some of the key elements in the identification and reception of Japanese Americans, Japanese American culture, and a relationship to the concept of Japan.[1] By examining some of the political and social forces operative in California in the immediate postwar period, it will be possible to suggest the fluidity of group identity and its expressions in the realm of culture. In particular, it is interesting to note the prominent role of kibei (American born but raised in Japan) and immigrant artists in the transmission of Japanese cultural and aesthetic beliefs in this period.

By 1946, most of the Japanese Americans incarcerated for the duration of the war were released.[2] The war did more than disrupt daily life for the 120,000 Japanese Americans living on the West Coast; it challenged the very foundations of their American identity. Since the incarceration was based solely on ethnicity and not behavior, legal status as citizens and acculturation in American values meant little. Fundamentally, Japanese Americans were singled out because they were thought to embody the spirit and sensibility of a Japanese person and, by extension, represent the interests of Japan. The fact that nearly two-thirds of those incarcerated were American citizens and that most had not even visited Japan did little to alter this perception. As General John L. Dewitt,

commander of the Western Defense Zone, summarized in 1943, "A Jap's a Jap....They are a dangerous element. It makes no difference whether he is an American citizen....You can't change him by giving him a piece of paper."[3]

Though recent scholarship has uncovered a greater number of "resistors" and critics of the incarceration than had been previously recognized, the general representation of Japanese Americans during this period is characterized by articulations of a hyper-American identity. This expression must be seen as a strategic one. Within hours of the bombing of Pearl Harbor, the FBI began rounding up selected Japanese Americans. In addition to leaders of Japanese American businesses and community organizations, practitioners of Japanese martial arts, Japanese language teachers, and others with identifiable connections to Japanese cultural activities were labeled as dangerous to American security. In the days and weeks following Pearl Harbor, many Japanese American families quickly moved to eliminate any physical representation connected to Japan; letters and photographs were burned, and mementos and objects were carefully and purposefully discarded. Given the FBI's actions, it is unsurprising that Japanese Americans would distance themselves from any overt ties to Japan and Japanese culture.

1 My use of the term *Japanese American* includes Americans of Japanese ancestry as well as immigrants from Japan who were prevented by law from becoming naturalized American citizens until the McCarran-Walter Act of 1952.
2 By the end of 1945, nine out of ten of the War Relocation Authority camps were closed. Tule Lake, a special "segregation center" for those deemed "disloyal" and potentially disruptive, remained open until March 1946. Crystal City, a Justice Department internment camp that also included families, remained open until the end of 1947.
3 John L. Dewitt, quoted in Clifford I. Uyeda, ed., *Americans of Japanese Ancestry and the United States Constitution, 1787–1987* (San Francisco: National Japanese American Historical Society, 1987), 25.

ARM AGAINST YELLOW PERIL.

Building Trades Ask Citizens to Unite in a Convention.

WANTS LEAGUE ORGANIZED

Call for Petitions Asking School Board to Exclude Adult Japanese.

RESOLVED, That the Building Trades Council of San Francisco invite the San Francisco Labor Council, the City Front Federation, the several employers' associations, the various improvement clubs and other civic bodies in this city to send three representatives each to a convention, for the purpose of organizing an Anti-Japanese League.

RESOLVED by the Building Trades Council of San Francisco, That the secretary be and is hereby instructed to prepare a petition and circulate same for signatures requesting the Board of Education of the city and county of San Francisco to exclude all adult Japanese pupils from our public schools.

WARNING against the peril that lurks in unrestricted Japanese immigration was sounded last evening at the meeting of the Building Trades Council of San Francisco. This is the representative central labor body of this city, composed of delegates from about sixty unions of skilled mechanics with an aggregate membership of 30,000. Secretary Tveltmoe introduced resolutions inviting the San Francisco Labor Council, the City Front Federation, the several associations of employers, the improvement clubs and all civic bodies in this city to meet in convention for the purpose of organizing an anti-Japanese league, and calling for the circulation of petitions for signatures requesting the Board of Education to exclude all adult Japanese from our public schools.

The resolutions met with general favor in the council, and many stirring speeches were made by delegates in favor of speedy and effective measures to avert the danger which threatens the whole country from such an influx.

SOUNDS A WARNING.

Tveltmoe has made a thorough study of the Japanese question and the disastrous effects an unrestricted immigration is bound to have upon the whole country, and sounded the warning notes several years ago. He urged that the question was of such vital importance to the employer as well as to the wage-earner that it should be taken up by all classes, no matter what their occupation.

During his remarks he referred to the efforts of the 'Chronicle' in that direction in terms of unstinted praise, and urged all right-minded men who had the interest of the country at heart to aid with all their power in stemming the tide of this menace which threatens to engulf the whole country. A number of other delegates spoke in a similar vein, and as the first step in that direction the resolutions quoted above were unanimously adopted.

Employers and manufacturers of California are not indifferent to the danger from Japanese immigration, and one of the first organizations of manufacturers to voice its protest is the Cabinet Manufacturers' Association, which indorsed the course of the "Chronicle" at a recent meeting and sent the following letter to the editor:

EMPLOYERS ACT.

SAN FRANCISCO, March 7, 1905— Editor "Chronicle." Sir: The Cabinet

(Continued on Page Two.)

(Continued from Page One.)

Manufacturers' Association of San Francisco, Cal., at its last meeting, held on Thursday evening, March 2, 1905, at the Builders' Exchange, 108 Jessie street, San Francisco, instructed its president and secretary to express the indorsement of this association of the policy of the "Chronicle" in its agitation of the restriction of Japanese immigration to this country, and its appreciation of your efforts to have proper laws enacted to prevent the further invasion of this class of aliens, as the members of this association believe that the rapid increase of the Japanese population in this city will result in being detrimental to the manufacturing interests of California, and injurious to the welfare of the mechanics of this city.

There are at present some so-called Japanese cabinet manufacturers in existence in this city, and the character of their work and their method of doing business do not elevate the standard of cabinet manufacturing, and it certainly affects the further interests of the cabinet makers and carpenters of San Francisco.

We trust that your agitation of the subject of the restriction of Japanese immigration will result in having Congress consider this question, and cause the passing of laws that will give the people of this State protection from the evils of excessive Japanese immigration. Yours very respectfully,
A. C. SCHINDLER, President.
L. H. ALLEN, Secretary.

L. H. Allen and A. C. Schindler, "Arm Against Yellow Peril," *San Francisco Chronicle*, March 10, 1905

For Better Americans in a Greater America: The Story of the Japanese American Citizen's League, booklet published by the Japanese American Citizens League, 1950

for BETTER AMERICANS in a GREATER AMERICA

the story of the Japanese American Citizens League

The nisei, the first American-born generation of Japanese Americans, vigorously voiced their opposition to Japanese aggression in the Pacific. The Japanese American Citizens League (JACL), a national organization founded the late 1920s by nisei, took an aggressively pro-American stance, encouraging the nisei to accept incarceration as a way of "proving" their loyalty. Japanese American loyalty was further evidenced by the formation, in 1942 of the 100th Battalion in Hawaii, an all-nisei unit, and the subsequent organization of the 442nd Regiment Combat Team, composed largely of nisei drafted from the confines of the internment camps. Although the JACL was not above criticism from within the community during this period, it remained a powerful force in defining Japanese American identity in the community itself and to the greater American public.

The Japanese American expression of an American identity was underscored by the representation and interpretation of the internment camps by War Relocation Authority (WRA) photographic documenters, as well as through private agencies such as the American Friends Service Committee (AFSC), which advocated on behalf of the rights of the Japanese Americans.[4] The WRA was the civilian authority established in 1942 to administer the incarceration. Presumably on opposing sides, the WRA and agencies like the AFSC benefited from representing the camps as civilized outposts of American loyalty. For the WRA, photographs of the well-fed, clothed, hardworking, and "happy" Japanese Americans suggested a visual representation far from popular conceptions of prison camps and individuals held under duress. Critics of the internment used the same images to demonstrate the unfair abrogation of the rights of the community clearly depicted as cooperative and loyal.

These images differed drastically from the way Japanese Americans were depicted before the war. The onset of Japanese immigration in the 1880s immediately met with hostility and anti-Asian sentiment. By the 1910s, the anti-Japanese movement had enough popular support to pass legislation that limited the rights of Japanese immigrants. In 1913, California enacted the first of several alien land laws that prevented "aliens ineligible for citizenship" from owning land. Japanese immigrants, like many other non-European immigrants, were restricted from becoming naturalized citizens. Takao Ozawa's 1922 challenge to the discriminatory laws ended in the Supreme Court's decisive rejection of Japanese attempts at naturalization. The ruling stated that the original framers of the Constitution intended "to confer the privilege of citizenship upon that class of persons whom the fathers knew as white, and to deny it to all who could not be so classified."[5] In 1924, the anti-Japanese movement culminated in the passage of the comprehensive Immigration Act, which virtually halted further immigration from Asia, with the primary emphasis on limiting Japanese immigration.[6] California-based organizations like the Asiatic Exclusion League and the Native Sons and Daughters of the Golden West characterized the Japanese immigrant as a "yellow peril" to be feared and stopped at all costs.

Despite the pervasiveness of such negative depictions, it is necessary to be cautious claiming all representations of Japanese as negative. In specific instances and locales, Japanese Americans were afforded more generous treatment, especially in the realm of culture. The articles and reviews of the issei (first-generation) artist Chiura Obata that appeared in the Northern California press in the 1920s and 1930s are one such example.[7] After a lengthy review praising the artistic accomplishments of Obata, an *Oakland Tribune* writer commented on the contributions of Obata's wife,

4 For selected images, see Maisie and Richard Conrat, *Executive Order 9066* (Sacramento: California Historical Society, 1972).
5 See *Ozawa v. United States* (1922).
6 Sucheng Chan, *Asian Americans: An Interpretive History* (Boston: Twayne Publishers, 1991), 55.
7 *Oakland Tribune*, March 11, 1928; December 11, 1930; March 5, 1931; March 24, 1935; June 12, 1938; September 11, 1938; December 12, 1937; and July 23, 1939. *San Francisco Chronicle*, November 23, 1930. *San Francisco Examiner*, January 4, 1931.

a practitioner of ikebana, and suggested the greater sophistication of Japanese aesthetics. "Mrs. Obata made two flower arrangements after the manner of the Japanese. Then, after the flowers have been arranged and the vases placed just so to fill a definite space, along came an American [who] plunked his derby down beside one of the vases. And that illustrates the difference between American and Japanese understanding and appreciation of art."[8]

The return and resettlement of Japanese Americans to normal living conditions after the war have yet to receive much scholarly attention. However, the logistical feat of organizing tens of thousands to return home should be obvious. While the WRA encouraged early resettlement into the Midwest and eastern states by single nisei as early as 1943, the collective reintegration of Japanese Americans after the war had differing effects. Primarily elderly issei and families, many without financial resources, remained in the camps until the end of 1945. After hastily leaving their belongings and communities in spring 1942, they cautiously returned under entirely different circumstances. The projected fear of a wartime Japanese invasion never materialized. The 100th/442nd returned home as decorated war heroes after battling on the European front. The linguistic skills of nisei in the Military Intelligence Service continued to be used during the occupation of Japan. Most important, the massive Japanese American "fifth column" was admitted to being a fabrication born of wartime hysteria. The return of formerly incarcerated Japanese Americans revealed a community devastated by the internment and that was hardly a serious social or economic threat. Throughout the late 1940s and 1950s, Japanese Americans put experiences of the war years behind them, concentrating on reestablishing their livelihoods and their communities.

Although Japanese Americans were reintegrated into American society, Japanese immigration remained restricted in the postwar period. The McCarran-Walter Act of 1952 set new quotas on the number of immigrants allowed into the United States, but the entirety of Asia was granted an amount of less than three thousand immigrants per year.[9] From 1952 until 1965, nearly one-third of all new Asian immigrants settled in California.[10] The overhaul of the Immigration Act in 1965 was of greater significance for Asian migrants because it eliminated the national origins component of immigration legislation.[11] The act received support from a variety of sectors. The relative economic prosperity in the United States, the push for demonstrations of American democracy in the face of Cold War international relations, and the low domestic unemployment rate guaranteed widespread acceptance. Furthermore, the largest group of immigrants from 1952 to 1965 were Japanese "war brides." They made up 80 percent of all Japanese immigration during the 1950s.[12] By 1965, the Japanese American community was the only Asian group where women outnumbered men.[13] Coupled with the weak international status of occupied Japan, the American conception of Japanese and Japanese Americans differed dramatically from the prewar and World War II periods. Japanese Americans ceased to be enemy aliens. The expression of Japanese culture was received in a cultural climate that valued different perspectives and viewpoints. It was also a time when the perceived Japanese threat to American social and cultural values was at its weakest.

One example of the positive reception of Japanese culture can be found in the widespread interest in Zen. By 1958, when *Time* magazine reported that "Zen Buddhism is becoming more chic by the minute," the popularization of Zen had reached dramatic heights in the American cultural arena.[14] The individuals most associated with Zen's popularity included Daisetz T. Suzuki, who moved to the United States and lectured at

8 *Oakland Tribune*, November 3, 1928.
9 Chan, *Asian Americans*, 146.
10 Bill Ong Hing, *Making and Remaking Asian America through Immigration Policy, 1850–1990* (Stanford, CA: Stanford University Press, 1993), 58.
11 Chan, *Asian Americans*, 145.
12 Ibid., 140.
13 Hing, *Making and Remaking*, 56.
14 "Zen: Beat and Square," *Time*, July 21, 1958, 49.

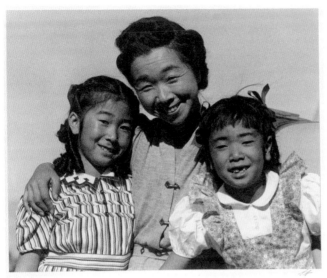

Ansel Adams, Mrs. Nakamura
and two daughters (Joyce Yuki and
Louise Tami), 1943

Haruko Obata, ca. 1930s

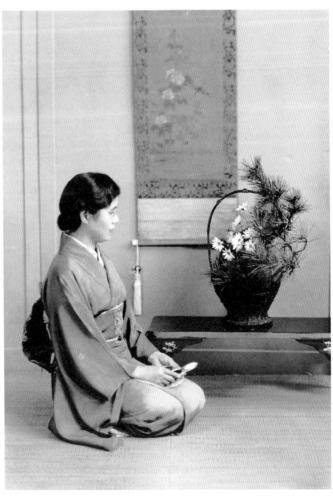

Matsumi Kanemitsu, *Yellow-Orange-Black*, 1960. Sumi ink and watercolor on Strathmore paper, 29 × 22 7/8 inches (unframed)

Columbia University in the late 1950s and the philosopher and author Alan W. Watts. Explaining the extraordinary interest in Zen, Watts writes in his preface to *The Way of Zen* (1957), "It is connected, no doubt, with the prevalent enthusiasm for Japanese culture which is one of the constructive results of the late war."[15] However, Zen's appeal was not limited to the intellectual elite. *Mademoiselle* magazine published an article titled "What Is Zen?" to help its young readers master the philosophy that entered "cocktail party conversation" and that was "exerting a curious influence on a number of writers, painters, musicians and students in this country."[16] It is interesting to note that the article was illustrated with images of Japanese art, as well as with works by Mark Tobey and Morris Graves.

Asian Traditions/Modern Expressions: Asian American Artists and Abstraction 1945–1970 (1997) demonstrates that Asian American artists were central to an investigation of abstraction in American painting. While it is necessary to consider the cultural climate that enabled the positive reception of these artists, it is also critical to examine how these artists identified themselves at different points in their lives and, more specifically, to investigate the circumstances of their immigration and acculturation. The most important of the abstract painters of Japanese ancestry in California—Matsumi Kanemitsu, James Suzuki, and Saburō Hasegawa—were either kibei or Japanese who migrated after World War II. While the kibei traditionally occupied a marginal position in the Japanese American community, the postwar acceptance of Japanese aesthetic practices made room for the assertion of a distinctly Japanese identity in the United States. The personal history of Matsumi Kanemitsu is illuminating. Though Kanemitsu was born in Ogden, Utah, in 1922, he lived in Japan for fourteen of his first eighteen years. Like many kibei, he recalled after returning to the United States, "I was ashamed of my Japanese accent and poor English.... I was kind of a scapegoat for other Japanese Americans."[17] However, in the postwar period, Kanemitsu came to be seen as an important link to Japan and Japanese aesthetics.[18]

Cover of Alan W. Watts, *The Way of Zen*, published by Pantheon, 1957

James Suzuki did not immigrate to the United States until after World War II. Although he eventually settled in California, his formative years as an artist in the United States were spent on the East Coast, in New York and Washington, DC, and his experiences as a Japanese in America would have been dramatically different from Japanese Americans who lived in the United States before and during the war. Saburō Hasegawa, though identified by some as Japanese American, only lived a short time in this country. Aside from the duration of his lecture tour,

15 Alan W. Watts, preface to *The Way of Zen* (New York: Pantheon, 1957), ix.
16 Nancy Wilson Ross, "What Is Zen?," *Mademoiselle*, January 1958, 64.
17 Nancy Uyemura, "Portrait of an Artist," *Tozai Times*, December 1988, 10.
18 See, for example, Gerald Nordland, *Kanemitsu: Selected Works, 1968–1978* (Los Angeles: Municipal Art Gallery, 1978).

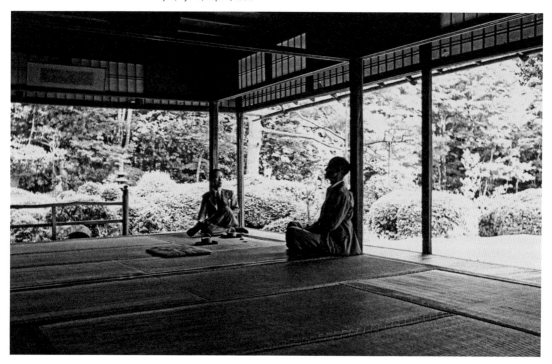

Saburō Hasegawa and Isamu Noguchi at Shisen-dō Temple, Kyoto, Japan, 1950

he spent little time as a U.S. resident. Arguably, he could be characterized as a Japanese artist who happened to reside in United States at the time of his death. Nevertheless, Hasegawa was closely connected to the popularization of Zen in America through his friendship with Watts, providing Watts with aesthetic assistance during his preparation of *The Way of Zen*.[19]

This essay does not mean to imply that the positive reception of Japanese and Japanese American abstract artists in the postwar period merely reflects an acceptance of Japanese cultural expression. Such an assertion would be a useless simplification of complex factors. However, it is interesting to examine how the Japanese American community and postwar Japanese immigrants emphasized specific aspects of their cultural heritage to create their own identity. This identity differed from both the insidious prewar "yellow peril" label applied to Japanese Americans and from the wholesale adoption of assimilated American expressions during the war years. This requires us to consider individual and group identity as fluid and strategically implemented. Here, the use of the word *strategic* should not be interpreted cynically. Rather, individual agency and identity formation is a critical way of conceptualizing the dynamic interplay between external forces of identification and individual response. It suggests the tremendous fluidity of ethnic and community identity, the significance of varying external forces upon such identities, and the importance of examining such identities within specific cultural contexts.

19 Watts, *Way of Zen*, xv–xvi.

The author would like to thank Kristine M. Kim for her research assistance and Brian Niiya for his useful comments on the text.

Saburō Hasegawa, *Nature*, 1952.
Two-panel folding screen, ink on paper,
53¾ × 52⅜ inches

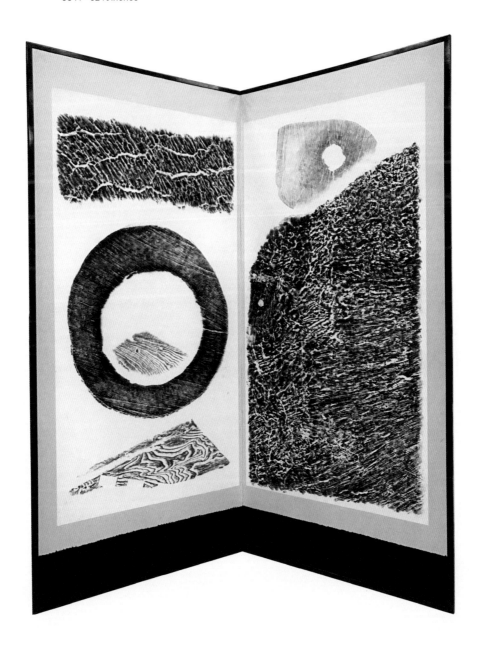

Bruce and Norman Yonemoto: A Survey

The director's slate slams shut with a decisive, though inaudible, thud. The chalkboard writing indicates "ROLL-26, SCENE-30, TAKE-1, CAMERA-36." The action begins. Young men hammering away at manual typewriters with self-conscious and deliberate activity, avoiding the camera's gaze yet seemingly aware of its presence. The black-and-white grainy film rolls on, showing us that the modest, wood-constructed room prominently displays the Stars and Stripes, which lies flatly and graphically against the back wall.

This footage could be the raw material for a movie about a 1940s-era high-school reporter who dreams of breaking into journalism with the energy and sprightliness of the young Jimmy Olsen, immortalized as Clark Kent and Lois Lane's *Daily Planet* sidekick. Or it could be a minor diversion in a love story or maybe even part of a family drama—except for one obvious fact. The clean-cut young men in the film are Japanese, and although we don't consciously ponder the facial difference, we are startled by the representation in film of Japanese American young men as normal and everyday. *Have I ever seen an old movie with a cast like this?* There is a vaguely documentary feel to the footage, but its staged nature and the clearly defined commencement of the action work against our understanding of documentary veracity and the documentarian's drive to capture unrehearsed activity on film.

Bruce and Norman Yonemoto are artists who use film and video as both the medium and subject of their art. Since 1976, the brothers have created an extensive body of film, single-channel video, video installations, and objects that explore the creation of meaning through filmic representation and analyze mass media's

hold on our perceptions of personal identity. In their complex configurations, whether manifested in single-channel or installation form, the Yonemotos show us how the fabricated stories of Hollywood and documentary "evidence" mingle with personal memories, prompting us to believe in the romance and truth of it all when a healthy dose of skepticism is more in order. The language of film and the drive toward neat narratives and tidy endings as epitomized in Hollywood cinema undergo rigorous scrutiny in the Yonemotos' art. Things are not as they may appear, they caution us. Yet at the same time, the Yonemotos recognize the seductiveness of media and the viewer's complicity in believing, desiring, and consuming all that TV and movies have to offer. Bruce and Norman Yonemoto found the raw and uncut footage described above at the National Archives in the late 1980s while researching the mass incarceration of Japanese Americans during World War II. The film was commissioned by the War Relocation Authority (WRA), the civilian agency established in 1942 to administer the ten concentration camps, which ultimately held more than 120,000 innocent civilians.[1] What at first viewing appears to be evidence of counter-stereotypes of Japanese Americans on film is actually an example of wartime propaganda produced to legitimate the abrogation of civil rights. The footage contains happy-go-lucky images of men, women, and children who garden, dance, and play, and, as we have seen, even publish their own newspaper. The barbed-wire enclosures and the loss of civil liberties appear to have no impact on the idyllic and seemingly carefree life portrayed on celluloid.

Bruce and Norman Yonemoto take as raw material the WRA film footage and reframe it in their installation *Framed* (1989). Spectators

1 See Michi Weglyn, *Years of Infamy: The Untold Story of America's Concentration Camps* (New York: William Morrow, 1976); and Clifford I. Uyeda, ed., *Americans of Japanese Ancestry and the United States Constitution, 1787–1987* (San Francisco: National Japanese American Historical Society, 1987).

Stills from Bruce and Norman Yonemoto,
Framed, 1989. Video installation,
dimensions variable

Stills from Bruce and Norman Yonemoto,
Framed, 1989. Video installation,
dimensions variable

enter a small and narrow room. In front, a mirror reflects their images against the painted backdrop of clouds floating in the clear blue sky. Suddenly, the room plunges into darkness and the mirror becomes a window through which a still image appears on a transparent scrim. Behind the scrim, a monitor silently plays the unedited WRA footage: the young men at the typewriters, a dancing girl, kids playing, and an old man gardening. On the scrim, the blue sky slowly dissolves as photographic images of the Japanese American incarceration, shown in succession like an apparition, hover in front of the moving images. The photographic stills contrast with the cheery activity of the film. At first, it appears as though they come from another source or experience, but after a minute or so the viewer understands that the still images are close-ups and details of the film footage. The still images are framed by the artists to uncover different meanings, to reveal another reality. A simple pan of the barrack landscape shows a soldier with a bayonet marching along the barbed-wire fence. A close-up of a boy's anguished face contrasts with the depiction of industrious children happily working away.

The footage on the monitor and the stills on the scrim fade to black, leaving viewers in darkness. Suddenly the lights come on and the viewers face their own reflections against a blue sky. Not unlike the controlled environment of the concentration camps, everything in *Framed* is controlled. The discrepancy between still and moving pictures, the physical proximity and distance to the multiple layers of images, and the contrast between the vigorous activity as projected and the silence with which it is received reproduce the conceptual space of personal and collective memory, suppression, and recovery. By leaving the film itself unaltered, the Yonemotos suggest that the experiences depicted, even though obviously staged for the camera, represent a legitimate "truth," just as the fond remembrances of some Japanese Americans of their camp experiences derive from a sincere sentiment. The Yonemotos demonstrate, however, that highlighting or framing the specific aspects of the seemingly

innocuous scene allows a new meaning to emerge that does not negate other meanings. Rather, it reveals more. Sometimes we cannot see what is before our very eyes.

Framed was the Yonemotos' first foray into video installation after thirteen years of collaborating on single-channel videos, but the conceptual concerns derive directly from their earlier work. Whereas the WRA footage uses the tropes of popular media to fabricate documentary "truth," the Yonemotos appropriate the formal and textual strategies of mass media for different ends: to reveal rather than obscure. From the outset, the Yonemotos have had a special interest in duplicating the editing techniques used in classical Hollywood cinema; their aim is not to make low-budget versions of Hollywood drama, TV commercials, or soap operas but rather to make the manipulative strategies of mass media apparent to viewers during the process of the manipulation itself. By overemphasizing the formulas of traditional media, the artists reveal its ideological underpinnings. This subtle and savvy strategy results in an art that teeters perilously between critique and acceptance, forcing viewers to continuously assess where their allegiances lie.

The WRA footage posed a challenge for the Yonemotos. To structure the raw and uncut footage as a single-channel video would have necessitated a capitulation to a propagandistic aim too close to that which enabled incarceration in the first place. The contemporaneous machinations of media manipulation—from the newspaper headlines about Japanese American disloyalty to Hollywood portrayals of their evil nature—succeeded despite a ludicrous logic that defied common reasoning. Wartime hysteria took over, and all reason took flight. The Yonemotos recognized that perhaps the formal strategies of thirties and forties mass media, though lacking the redemptive criticality, bore too close a resemblance to their own work. *Framed* displays the Yonemotos' interest in reading against the text and image while simultaneously agreeing with it. They recognize the multiple ways in which viewers identify with what they see, while engaging critically with it.

Bruce and Norman Yonemoto
with TV lamp

This strategy is both generous and respectful, for the artists want to validate—or at least accept—viewers' desires, but they also insist that viewers are sophisticated and critical readers. The Yonemotos highlight the submerged anguish in *Framed*, but they find evidence of it on the surface. They acknowledge the complex experience of incarceration: happy and pleasant memories coexist with tragedy and horror.

That there are multiple ways to interpret the story finds a parallel in the Yonemotos' biographies. Norman was born in 1946 in Chicago. Three years later, Bruce was born in the Northern California city of San Jose. Although it is somewhat unusual for there to be such a wide geographic difference in sibling birthplaces, among

Japanese Americans it tells a common story. Bruce and Norman's family were among those who were incarcerated during the war. Their mother, Rosie, and her family were removed from their home in Sacramento and held at the Tule Lake concentration camp in Northern California, where Rosie's uncle was tragically murdered. The family of their father, Tak, had worked in the flower business in Sunnyvale. Tak met Rosie at a dance in Sacramento; he was attending the University of California, Davis, when war broke out. He was allowed to transfer to a college in Colorado, which was outside the Western Defense Command Zone, and was subsequently drafted into the United States Army and stationed at Fort Knox, Kentucky,

for the duration of the war. When Tak heard about the murder of Rosie's uncle, he sent a wire and flowers. This rekindled their prewar courtship and culminated with Tak traveling to Tule Lake. Rosie was granted permission to leave with Tak. They were married at a train stop in Minnesota. Many nisei were allowed to leave camp early with the stipulation that they relocate to the Midwest or East Coast; the government's aim was to disperse the Japanese American population. Despite the continued evidence of loyalty to the United States, Japanese Americans were urged to avoid association with other Japanese Americans. Rosie was granted permission to relocate to Chicago, a common destination for Japanese Americans, in order to live closer to Fort Knox. After the war ended and governmental controls were removed, many Japanese American families returned to their homes on the West Coast. Tak and Rosie, with baby Norman, had resettled in Northern California by the end of 1946.

With the experience of the wartime incarceration still fresh, the Yonemoto family's reintegration into postwar life, like that of many Japanese Americans, was characterized by the suppression of difference and the wholesale assimilation of the American ideal, especially as seen on TV. More than one million TV sets could be found in American homes at the beginning of the 1950s, with the number mushrooming to fifty million by the decade's end.[2] Television firmly overtook the movie as the dominant mass medium, prompting movie mogul Samuel Goldwyn to ask, "Why should people go out and pay money to see bad films, when they can stay at home and see bad television for nothing?"[3] More than the economic viability of Hollywood was at stake, however; for television's ascendancy also changed the physical space of viewing from the public domain of the theater to the domestic space of the family. Norman recalls spending hours watching Hollywood movies on the Yonemotos' Hoffman cabinet TV set, alone, without the collective audience of the movie theater. On TV, the brothers could watch the same old movies over and over again. The family did venture to the Fox and United Artists theaters

in downtown San Jose and to San Francisco for big extravaganzas like *Ben-Hur*, but the brothers' primary consumption of film was mediated through TV, with the interruptions by endless huckster-like commercials and the lack of control characteristic of the living room.[4] On the other hand, moviemaking technologies became an increasingly common component of family life. In the postwar period, filming the family, setting up the home movie screen, and projecting the footage were everyday occurrences.[5]

The growing presence of these technologies transformed the suburban home. In popular magazines, in sociological and design studies, and as a subject for the movies, the television set as an object became a pivotal element in representations of the new suburban family.[6] Lynn Spigel has charted the advertising strategies and magazine articles that discuss TV placement, optimal viewing conditions, and challenges to traditional family relations posed by the new technology. The impact of a new medium on psychological and physical health, sexual relations, children's well-being, and women's work all entered public discourse in the 1950s.[7] For every concern, a new solution was floated. To combat the harmful effects of extended hours in front of the television, health professionals advocated the placement of lamps near the TV to relieve eyestrain. TV lamps in the

2 Douglas Gomery, "The Coming of Television and the 'Lost' Motion Picture Audience," *Journal of Film and Video* 38, no. 3 (Summer 1985), 5.
3 Sam Goldwyn (1956), quoted in *A Dictionary of Cinema Quotations from Filmmakers and Critics*, ed. Stephen M. Ringler (Jefferson, NC: McFarland, 2001), 24.
4 Norman Yonemoto, "A Mediatized Life: Some Thoughts on Our Single-Channel Work" (unpublished essay).
5 Patricia R. Zimmermann, *Reel Families: A Social History of Amateur Film* (Bloomington: Indiana University Press, 1995), 132–35. Thank you to Karen Ishizuka for suggesting this source.
6 Lynn Spigel, *Make Room for TV: Television and the Family Ideal in Postwar America* (Chicago: University of Chicago Press, 1992), 36–72.
7 Ibid.

form of ceramic ducks, owls, cats, dogs, and panthers graced the tops of many sets as both decorative objects and therapeutic aid. Bruce has accumulated more than fifty different varieties of the lamps. In *Definition of a TV Lamp* (1984–99), the Yonemotos display the amassed objects as both an elegiac monument to the environment of their youth and a reminder of TV's radical refiguring of the space of the home. Like Walter Benjamin's notion of the "outmoded"–that which is just past, which is in the process of extinction–the TV lamps contain the traces of critical energies.[8]

The fifties and early sixties meant relative peace and prosperity despite Cold War tensions, and for the Yonemotos this meant a home in the suburbs, Cub Scouts, and an all-American life. The war in the Pacific had been decisively won, leaving Japan under American occupation for seven years. Throughout the fifties and sixties, Hollywood representations (or stereotypes) of Japan and the Japanese transformed from the hostile, wily, and insidious "Jap" enemy to the goofy villager (Marlon Brando in yellowface in *Teahouse of the August Moon* [1956]), exotic beauty (Miiko Taka in *Sayonara* [1957]), or Zen master. On TV, however, the war movies from the 1940s were recycled for *The Late Show*. *Environmental* (1993) explores this visual heritage of the Yonemotos' childhood. The installation consists of two media components. On one side, fourteen home movie screens of varying sizes overlap to create a large-scale surface. Footage produced by the Warner Bros. special-effects department for use in movies about the Pacific war are projected onto the fractured surface of the combined screens. Though the clips are projected silently, with the director's slates and people's arms commandeering the model battleships and bombers clearly visible, the images immediately recall the narratives of World War II–era movies: a Japanese woman hiding in a bamboo grove relays a secret message that will undoubtedly sabotage the American soldiers, and battleships are blown to bits.

Across the room, a monitor plays a compilation of films from the Yonemotos' childhood, ads for Anacin, Band-Aids, Mr. Clean, and Winston cigarettes. With simple animation and catchy jingles, the commercials remind us of the powerful pull TV enacted upon a young and newly defined consumer group. Television provided a new vehicle for advertisements that united disparate constituencies with the drive to acquire,[9] and the brothers purchased their coonskin caps and Hula-Hoops along with millions of other kids. Hygiene and personal appeal are linked when the Pepsodent toothpaste jingle cheerily proclaims, "You'll wonder where the yellow went."

Like the footage in *Framed*, the artifice of filmic reproduction is made plainly available in *Environmental*, but in the latter case the brain supplies the missing narrative. From years of watching movies of this ilk, we know who the good guys and the bad guys are and gleefully cheer for victory over the misbegotten "Japs." This conceptual process of filtering out excess information (the director's slates) or filling in gaps in the plot finds its formal correspondence in the compilation of home movie screens. The overall surface area of the projected footage duplicates the monumental and spectacular scale coincident with the film's original propagandistic aims, but the fractured and collaged screens rupture the seamless recovery of visual information: each individual screen contains only a fragment of the overall image.

Just as personal memory remains illusory and incomplete, the ability to recall visual material is subject to the filters of individual interests and subjectivity. *Environmental* re-creates the media memories of the artists' 1950s American childhood, but it goes beyond that intention by suggesting the contradictory points of identification and disavowal. The viewer of TV and the movies can assimilate aspects that reconcile with their own subjectivities while

8 Walter Benjamin, "Surrealism: The Last Snapshot of the European Intelligentsia," in *Reflections: Essays, Aphorisms, Autobiographical Writings* (New York: Schocken Books, 1978), 181.
9 Erik Barnouw, *Tube of Plenty: The Evolution of American Television* (New York: Oxford University Press, 1975), 131–33, 163.

Bruce and Norman Yonemoto,
Environmental, 1993. Mixed-media
installation with two-channel video
projection, dimensions variable

suppressing those parts that don't. Meaning is continually reconstructed through individual memory. A kid of Japanese ancestry can find pleasure at the movies, even though the movies themselves ostensibly invalidate the identity of the Japanese American, either through absence or negative portrayals. The Yonemotos also cleverly play with sound: the silence of the projected footage is interrupted by the announcements and jingles of the commercials. As the two media components scramble and mix, the lilting phrase "You'll wonder where the yellow went" takes on a new and ominous meaning.

Framed and *Environmental* address the issue of the Yonemotos' ancestral heritage head on, but it is a mistake to read their work as either a strict commentary on ethnic identity or solely concerned with issues of race. Of greater interest to the artists are the ways in which meaning is constituted, especially as expressed through specific formal devices. While I would argue that this impulse is inextricably tied to an interest in race and its construction, the content of their work traverses a wide range of topics and "faces." This range has left the Yonemotos firmly at the fringes of the impressive and exciting Asian American movement in film and video. They have benefited from the support of organizations that display and interpret Asian American media, as evidenced by their prominent inclusion in the 1983 New York Asian American film and video festival sponsored by Asian Cinevision, as well as numerous festivals and screenings organized by the Los Angeles–based Visual Communications. However, it is primarily videos that visualize Japanese or Japanese Americans which have been included. While the reasons for this may appear obvious and legitimate to some, it raises pertinent questions. What are the parameters for making an "Asian American" work? Does the exploration of ethnicity and identity require the representation of an Asian face?[10] Clearly, the answers to such an inquiry have import beyond the scope of this analysis, but the Yonemotos' work provides a compelling case study. As we shall see, their art—in both form and content—works against the conventions of representing race and ethnicity and the conventional definitions of an avant-garde or radical practice.

The First Collaboration

Norman's training is in film. In 1969, he produced the documentary *Second Campaign* with Nikolai Ursin, his longtime companion (and the principal cinematographer of subsequent Yonemoto-brother collaborations). The film follows the volatile confrontation at Berkeley's People's Park that year and captures the transforming political and social climate of Berkeley in the 1960s. After attending Santa Clara University and UC Berkeley, Norman studied at the film school at the University of California, Los Angeles, and in 1973 he completed a fellowship at the American Film Institute. During his two years there, the institution underwent a radical change: it was initially under the leadership of Frank Daniel, former dean of the Czechoslovakian Film and Television School in Prague, who sought to create an academy dedicated to experimentation and innovation. Daniel was succeeded by the industry-aligned George Stevens Jr. Norman's training emphasized both the traditions of classical Hollywood cinema and the work of European filmmakers of the 1950s and 1960s New Wave. During this period, Norman also recognized the opportunities and production experience that pornography could afford an aspiring filmmaker. With *Brothers* (1970, also known as *Kid Brother*), and *Big Men on Campus: The Fraternity* (1973), Norman secured

10 For a history of the Asian American media movement, see Renee Tajima, "Independent Asian Pacific American Media Arts," in *Moving the Image: Independent Asian Pacific American Media Arts*, ed. Russell Leong (Los Angeles: UCLA Asian American Studies Center and Visual Communications, 1991), 10–33; for a discussion of some of the pertinent issues in assessing the history and current production of Asian American film and video, see Abraham Ferrer, "Before and After 1993: Crossing the Divide in Asian American Film," in the catalogue of the 11th Singapore International Film Festival (1998), 56–57.

Stills from Bruce and Norman Yonemoto,
Garage Sale, 1976. 16 mm film (color,
sound), 85 min.

Goldie Glitters at the premiere of
Garage Sale, Fox Venice Theater,
Los Angeles, 1976

financing for his scripts, completed production, and found distribution for his work, an occurrence that would've been unlikely in the mainstream film industry.[11]

Bruce was trained as a visual artist. He did undergraduate work at UC Berkeley, followed by an extended stay in Japan, where he studied at the Sokei Bijitso Gakkō in Tokyo. He returned to California and enrolled at Otis Art Institute, where he received a master's in fine arts in 1979. Germano Celant was a visiting lecturer at Otis during this period and his impact on Bruce was tremendous. At the time, Celant was best known as an interpreter of the Italian Arte Povera, a heterogeneous movement that examined the constituent parts of the art object, from its materials to the critical structures where it circulated. Both the object, understood through an investigation into material and process, and the context, including the gallery, criticism, and theoretical interpretations, played a role in the constitution of "art." Before he enrolled at Otis, however, Bruce had already completed his first videotape, the documentary *Homecoming*, which charted the real-life campaign, election, and crowning of drag queen Goldie Glitters as Santa Monica City College's 1975 homecoming queen.

The brothers' first collaboration was a film that combined their recent interests. *Garage Sale* (1976) is an ambitious tale about the search for love and happiness of a young

blond man named Hero and his wife Goldie (played by Glitters). The treatment simply summarizes the plot, but it also contains a blueprint for all of the brothers' subsequent single-channel work. An excerpt from the treatment reads:

> Over a broken fingernail Goldie demands a divorce from her husband Hero. Seeking a way to regain Goldie's love, Hero confronts a succession of characters, each immersed in their worlds, each ready with unorthodox prescriptions for love and/or happiness. Meanwhile Goldie strives to change her way of life, but her inability to leave behind romantic ideas and cherished dreams thwarts her attempts.[12]

Garage Sale also contains many of the formal and stylistic traits that would become hallmarks of the Yonemotos' style: Goldie's over-the-top camp performance, bad acting, and the obvious evidence of her biological existence as a man don't hinder the audience's ability to empathize with her plight as we acknowledge her delusional self-identification through the filters of Hollywood romance. The fact that we know that Goldie is really a man who thinks he's a woman helps distance us from the narrative drive of the film, but the brothers succeed in creating a connection between the audience and the characters, especially Hero. Despite the carnival of absurdities, by the movie's end we are as crushed as Hero by Goldie's tragic death (when a monster that looks suspiciously like a plastic Godzilla literally crashes the party). *Garage Sale* also contains references to Fellini and Ken Russell, a hard-core sex sequence, a send-up of art-world performance, a kitten killer, a feminist rap session, and bondage practitioners. The film is primarily set in the neighborhood of Venice Beach, and the sense of locale is strong and palpable because friends and area residents participated in its creation. A flyer advertising the final day of shooting exclaims:

> Witness the destruction of LA by Mothra. Live Music, Refreshments.

BE IN THE PICTURE!*
*You will be requested to sign a release so your performance may be included in "GARAGE SALE," the west coast art film of the seventies.[13]

The world premiere of *Garage Sale*, on a double bill with Andy Warhol's *Trash* (1970), took place at the Fox Venice, an old Art Deco movie house that was originally part of the Fox network of movie theaters that emerged in the "golden" era of Hollywood's monopoly on film production, distribution, and exhibition.[14] It was turned into a revival house in the seventies and eighties before being sold off in the era of multiplexes; it is currently home to a continuous swap meet of sorts. It is fitting, then, that the faded grandeur era of movie palaces should host the *Garage Sale* premiere. The film captured the changing landscape of Los Angeles and, by extension, Hollywood, as the programming and milieu of the Fox Venice itself reflected a Los Angeles post–*Hollywood Babylon* and post–*Easy Rider*. Gala festivities for the *Garage Sale* premiere included a "grand entrance" by Goldie and her entourage, followed by a Goldie look-alike contest, complete with an unnamed grand prize.[15] The exaggerated performance on the screen extended to the real-life performances of the audience.

11 While produced as pornography for a gay male audience, *Brothers* also contained strong political commentary on the war in Vietnam. It represents Norman's interest in making a critical intervention in a form meant for sexual titillation. *Big Men on Campus* was the first example of gay porn conceived for and executed on videotape.
12 Treatment for *Garage Sale*, ca. 1976, papers of Norman Yonemoto.
13 Flyer for *Garage Sale*, 1976, papers of Bruce and Norman Yonemoto.
14 Douglas Gomery, *Shared Pleasures: A History of Movie Presentation in the U.S.* (Madison: University of Wisconsin Press, 1992), 63–65.
15 Fox Venice Theatre calendar, December 1976.

Still from Bruce and Norman Yonemoto, *Vault*, 1984. Single-channel video (color, sound), 11:45 min.

The Early Tapes

Garage Sale demonstrated the Yonemotos' initial interest in romance, which they explored to a greater degree in what was to become their *Soap Opera Trilogy*. The trilogy took the form of the American movie melodrama as a way to examine standard perceptions of romantic love. *Based on Romance* (1979) is the first in the series. In it, two artists come to grips with their sexual relationship vis-à-vis traditional gender roles and their commitment to art. When Anastasia thinks she might be pregnant and considers terminating the pregnancy in order to continue making art, her boyfriend sheds all pretense of bohemian values to reveal his traditional take on the family and a woman's responsibility. What makes the experiment interesting is the Yonemotos' conscious quotation of Yasujirō Ozu (1903–1963), the Japanese film director whose long career received attention by the West only at the end of his life. The camera angles reference Ozu's use of a low vantage point, and the dramatic tension attempts to duplicate the family conflicts characteristic of the Japanese master. The actors are European American, but they sleep on the futon in a tatami room. Although today the use of a futon is far from unusual in the West, in the late 1970s Japanese items were much less available. The quotation of Ozu and the use of Japanese objects represented one way the Yonemotos could reference

Stills from Bruce and Norman Yonemoto,
Vault, 1984. Single-channel video
(color, sound), 11:45 min.

ethnic differences without foregrounding the search for ethnic identity.

Based on Romance lays out the Yonemotos' key interest in narrative and melodramatic form. It contrasts with contemporary developments in video art that, on the one hand, took its cues from a documentary tradition and, on the other, investigated the technological form of the video medium itself.[16] The Yonemotos' stake in what could be considered a very traditional and conventional form of filmic exposition placed them outside of the dominant modes of early video-art practice. Beverle Houston has written about a false assumption common in early discourses about video art, namely that in order to create a critical practice, one necessarily had to exploit

16 Although there is no definitive history of video art, a number of the key texts indicate the prevailing tendencies of early video practice. Deirdre Boyle surveys the various documentary practices in "A Brief History of Documentary Video," in Doug Hall and Sally Jo Fifer, *Illuminating Video: An Essential Guide to Video Art* (New York: Aperture; San Francisco: Bay Area Video Coalition, 1990), 51–69. In examining video art's early history, John Hanhardt and Maria Christina Villaseñor cite Nam June Paik and Wolf Vostell's early confrontation with the TV as object; the use of live-feed video technology; video as an extension of performance; feminist deconstruction and critique of mass media; and the skits of William Wegman, which examined television performance and personalities. See Hanhardt and Villaseñor, "Video/Media Culture of the Late Twentieth Century," *Art Journal* 54, no. 4 (Winter 1995): 20–25.

technological form. The Yonemotos, however, engage in a "realist" practice precisely because the exploration and exploitation of narrativizing form enables them to expose the coded ideology of romance. As a case in point, Houston notes that a later work, *Vault* (1984), which more overtly referred to psychoanalytic and Freudian sexual trauma through quick edits and the use of sound, seemed to find greater acceptance for the Yonemotos.[17] The Yonemotos' eschewal of the documentary mode also distinguished their work from much early Asian American film and video, which typically created powerful and three-dimensional portrayals of Asian Americans to contest formally invisible or stereotypical representations.

The melodramas of Douglas Sirk (1897–1987) are an important source for the brothers. Sirk's critical reputation hinges on his films' ability to transcend the strictures of melodramatic form through formal complexity and social commentary.[18] In *Imitation of Life*, Sirk's 1959 adaptation of the Fannie Hurst novel, questions about race, class, and "passing" are explored head-on. Lana Turner stars as the inspiring (and later successful) actress Lora Meredith, who has a young daughter (Sandra Dee). Juanita Moore plays Lora's African American maid, Annie; her young daughter, Sarah Jane (Susan Kohner), passes as white. The tearjerker highlights a number of complex social issues—Lora's proto-feminist careerism, class differences, Sarah Jane's internalized self-hatred, and racism—all within the conventional format of the Hollywood melodrama. In another significant movie, *All that Heaven Allows* (1955), Sirk tells the story of an upper-class widow (Jane Wyman) who falls for a younger gardener, Ron (Rock Hudson). She ultimately succumbs to pressure from her children and her neighbors and leaves Ron; her children, in turn, give her a new TV set. For many film theorists of the 1970s, Sirk demonstrated the possibilities of inserting a radical critique of bourgeois culture within conventional genre through displacement and discontinuities in the plot, contradictions between the form and the text, and in general a use of Brechtian distantiation.[19]

Even more important to the Yonemotos than Sirk's movies are those of producer Ross Hunter. Hunter produced nine of Sirk's pictures for Universal-International and worked closely with Rock Hudson throughout his career, producing him in *Pillow Talk* (1959) with costar Doris Day, as well as other films. Hunter was also responsible for the Tammy series, including *Tammy Tell Me True* (1961), which starred Sandra Dee, as well as the film adaptation of the musical *Flower Drum Song* (1961).[20] For the Yonemotos, Hunter's productions represent the height of a "camp" sensibility—a model to which they aspired.[21] In his movies, a stylized exaggeration can be read in two ways, as performance and as real; as a gay man, perhaps Hunter knew how to function with double meaning.

In her 1964 essay "Notes on 'Camp,'" Susan Sontag writes, "Indeed the essence of Camp is its love of the unnatural: of artifice and exaggeration. And Camp is esoteric—something of a private code, a badge of identity even."[22] Or, as Philip Core has suggested, "Camp is a form of historicism viewed histrionically."[23] Although

17 Beverle Houston, "Television and Video Text: A Crisis of Desire," in *Resolution: A Critique of Video Art*, ed. Patti Podesta (Los Angeles: Los Angeles Contemporary Exhibitions, 1984), 117–18.
18 See, for example, the special issue of *Screen* devoted to Sirk (*Screen* 12, no. 2 [Summer 1971]); and Laura Mulvey, "Notes on Sirk and Melodrama" and "Fassbinder and Sirk," in *Visual and Other Pleasures* (Bloomington: University of Indiana Press, 1989), 39–48.
19 Paul Willemen, "Towards an Analysis of the Sirkian System," *Screen* 13, no. 4 (Winter 1972–73): 128–34.
20 For a reevaluation of *Flower Drum Song* and its significance within discourses of Asian American representation and identity, see Karin Higa, "*Flower Drum Song* Revisited" (master's thesis, University of California, Los Angeles, 1997).
21 Bruce Yonemoto, conversation with the author, May 14, 1998.
22 Susan Sontag, "Notes on 'Camp,'" in *Against Interpretation* (New York: Dell Publishing, 1966), 275.
23 Philip Core, quoted in Barbara Klinger, *Melodrama and Meaning: History, Culture, and the Films of Douglas Sirk* (Bloomington: Indiana University Press, 1994), 132.

Stills from Bruce and Norman Yonemoto,
Green Card: An American Romance,
1982. Single-channel video (color, sound),
79:15 min.

top, left and right: Stills from Bruce
and Norman Yonemoto, *Green Card:
An American Romance*, 1982. Single-
channel video (color, sound), 79:15 min.

bottom: Wedding of Bruce Yonemoto
and Sumie Nobuhara at the premiere
of *Green Card: An American
Romance,* 1982

the camp response to Sirk's films was disavowed by the first wave of Sirk's interpreters in the 1970s, a camp interpretation of melodrama remains a central component of the Yonemotos' work and evinces their nuanced relationship to the critical discourses in film studies.[24]

The quest for happiness, especially through a search for sexual identity, continues in the second of the Yonemotos' Soap Opera series, *An Impotent Metaphor* (1979). In it, a young artist (played by Norman) combines his quest to explore the boundaries of artistic practice with questions about mass-media programming, the possibility and limits of computers, his sexual identity, his metaphoric and real impotence, and his subtle though pronounced interest in a male friend. Although no mention is made of race or ethnicity, the fact that an Asian American man is figured on the screen discussing his art and sexuality frankly and suggesting his sexual interest in men is remarkable for the time. That the lead character is called Norman and is played by Norman, who is also the tape's director, further confuses the viewer's understanding of fact versus fiction. This mirroring of real life is characteristic of all of the Yonemotos' early tapes. The purposeful interplay between the real and the fabricated is another device the Yonemotos use for manipulating the audience's expectation and desire to know the "real" story.

Green Card: An American Romance (1982) marks the third in the Soap Opera Trilogy and represents the most ambitious of the Yonemotos' early tapes. It also represents the first time the Yonemotos received a grant from the National Endowment for the Arts and interest from other exhibition mechanisms such as KCET, the Los Angeles PBS affiliate.[25] *Green Card* follows the story of Sumie, a Japanese artist who comes to the United States to pursue her creative dreams. In order to stay in the country, she realizes that a green-card marriage may be her only option. She is conflicted about the implications of such a business arrangement but slowly finds herself succumbing to the ideal of marriage and romance, and she falls in love with Jay, a California surfer. As her emotional attachments grow, her original dreams of freedom become mired in a fantasy of romantic love. The story is further complicated by Jay's overt and stereotypical dismissals of Sumie's plight. Sumie's Japanese identity makes it impossible for Jay to see her for who she is, just as her capitulation to a Hollywood version of romance makes her unable to fulfill her original goals of artistic and social freedom. Does Sumie really love Jay, or is it an expression of the consumerist desire created by the media? The Yonemotos liberally quote from a number of Hollywood movies, especially those that mine the depths of melodramatic action. A climactic kiss between Sumie and Jay mimics Bette Davis and Paul Henreid's kiss in *Now, Voyager* (1942), including the dialogue and the dramatic Max Steiner score. In another sequence, an old Sumie utters from her wheelchair, "Now that our romance is dead, our love can begin"; the young Jay is resurrected in a shot-by-shot sequence quoted from *The Ghost and Mrs. Muir* (1947). Against the strains of the Bernard Herrmann score and like a young Gene Tierney, Sumie is transformed once again into a beautiful young woman as she and Jay walk into the light.

As with *Garage Sale*, the premiere of *Green Card* was much more than a screening. The character Sumie was played by Sumie Nobuhara, a Japanese artist living in Los Angeles, and the green-card marriage also found its correspondence in real life. Notices for the premiere at Los Angeles Contemporary Exhibitions (LACE), the nonprofit alternative space, featured an invitation to a real wedding: after the lights went out, Bruce and Sumie walked down the aisle to the strains of Carl Stone's wedding march and were promptly and officially married.[26]

24 For an insightful analysis of camp and melodrama in the work of Sirk, see ibid., 132– 56.

25 Among those who expressed early support was program director at KCET, Steve Tatsukawa, a pioneering founder of Visual Communications and supporter of emerging Asian American media.

26 Like the productions of classical Hollywood cinema, three of the Yonemotos' videotapes were scored, in their case, by Carl Stone: *Green Card: An American Romance*, *Kappa* (1986), and *Made in Hollywood* (1990).

Production stills from Bruce and Norman
Yonemoto, *Made in Hollywood*, 1990.
Single-channel video (color, sound),
56:12 min.

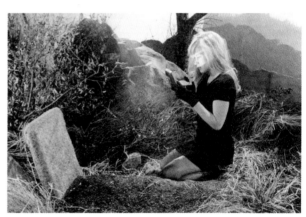

The line between performance and life was blurred once again. Was Bruce, as the writer/producer/orchestrator of the fictional soap opera, fabricating another event before the audience? What is a performance and what is real? The divide between real versus fake, fact versus fiction, expresses a similar impulse to that of *Framed*. For the Yonemotos, it isn't a question of determining what is real or fabricated. It is a matter of uncovering the structures, controls, desires, and performances that work to form and create "truth."

In discussing the oppressive and compulsory structures that categorize sexuality and sexual identities, Judith Butler suggests that perhaps gender itself is a kind of performance.[27] Drawing from Esther Newton's *Mother Camp: Female Impersonators in America*, Butler argues that "drag constitutes the mundane way in which genders are appropriated, theatricalized, worn and done.... If this is true, it seems, there is no original or primary gender that drag imitates, *but gender is a kind of imitation for which there is no original*."[28] Extending this argument, we can see parallels with the Yonemotos' work. The brothers seem to suggest that identities and behaviors are themselves performances of performances with no original or authentic source. The models for ethnic or sexual identities are recycled in the complex discourse of culture—who knows what's real? In the heady mix of *Garage Sale*, Goldie's drag was obvious and upfront at the same time that it disappeared through the storyline. In the Soap Opera Trilogy, the "drag" becomes slightly submerged. It hovers at the surface, and bad acting, montage techniques, and sound contribute to the sense that at any moment the story will turn from melodramatic excess into hysteria.

Hollywood

Made in Hollywood (1990) takes Hollywood as its subject. Ron Vawter and Mary Woronov play Matt and Mary, a New York art-world couple who, after the tragic death of their child, move to Hollywood to make it big. They come under the wing of the mythic Irving Silver—an old Hollywood movie mogul modeled

after the real-life mogul Samuel Arkoff and played by Michael Lerner—and his gay son Tim (Tim Miller).[29] Once in L.A., Matt can't stomach the hackneyed scripts and cynical manipulations that he finds poolside. In turn, Tim wants Mary to dump Matt so that their movie can get made. Matt becomes fixated on aspiring actress Tammy (Patricia Arquette), an innocent with a Southern accent who sincerely spouts aphorisms passed down to her by her granny in Gopher Junction. Performance artist Rachel Rosenthal plays Mrs. Silver, and the aging father of Irving (Dean Jones), who represents the first-generation movie mogul, spends most of the tape dying as he watches the classics of Hollywood—including D. W. Griffith's *The Birth of a Nation* (1915) and *Intolerance* (1916)—on TV.

The video is shot as both drama and documentary, for the actors—whose characters often have the same name—break out of the diegesis of the story to talk about their characters in the movie itself. The narrative action is further disrupted by Stater Brothers (a California grocery store chain) commercials in which a throaty voice sings, "In the heartland of Cal-i-fornia, we're State-er Brothers." After finding her actor boyfriend in bed with Tim, Tammy leaves Hollywood to return to the "heartland"—the country. Matt takes a taxi to search for her in Gopher Junction; in a direct reference to *Tammy Tell Me True*, Matt finds Tammy at the foot of her granny's grave in front of an orange-purple sky, which the Yonemotos commissioned based on the sky in Frederic Edwin Church's painting *Twilight of the Wilderness* (1860). Tammy opens the blue porcelain box that her granny instructed her to open only when she really

27 Judith Butler, "Imitation and Gender Insubordination," in *Inside/Out: Lesbian Theories, Gay Theories*, ed. Diana Fuss (New York: Routledge, 1991), 13–31.
28 Ibid., 16.
29 It is interesting to note that Michael Lerner received an Academy Award nomination for Best Supporting Actor in 1991 for his portrayal in the Coen Brothers' *Barton Fink* of a movie mogul, a character remarkably similar to the one he played in *Made in Hollywood*.

needed it. As she lifts the lid, we see a small mirror reflecting back her eyes—she appears transformed. She stands up and walks toward the camera. The film turns from color to black-and-white as the camera pulls back to reveal the location as a soundstage.

Matt, who is waiting for her, implores her to come back to Hollywood with him. She explains that she can't, for she's finally found the answer.

> I don't want to be in movies. There's only one place where I can find the world I'm looking for, and it was right in front of me the whole time. It's a place where there are real families and real love, a place where there ain't no doubt or want. Where nobody's hungry and nobody hurts or is hurt…The commercials on TV! That's where I want to be, that's where I want to be a star.

After Matt's nervous response, a newly resolved Tammy turns around and reenters the set as the film returns to the color of real life. As the soaring score swells, Mr. and Mrs. Silver, Tim and the boyfriend, Mary, and Tammy's Granny stand erect against the painted sky, in essence saluting Tammy's recognition of the commercial. Matt remains in black-and-white, separate from the rest of the cast. As the doors to the soundstage open, he turns around and exits.

The cast of *Made in Hollywood* evinces the Yonemotos' interest in working with the subcultural stars of the arts and performance worlds.[30] Just as Warhol anointed as stars those from second-tier Hollywood and such marginal figures as transvestites and local New York personalities, the Yonemotos use the name and face recognition of various art and performance figures to produce layered meaning and an alternative system of glamour.[31] In 1984, for example, the brothers created *Spalding Gray's Map of L.A.* Commissioned for the opening of Los Angeles's Museum of Contemporary Art, it follows monologuist Gray as he travels the freeways of L.A. ruminating on his and our country's simultaneously dependent and liberating relationship with

the car. Two years later, the brothers completed two ambitious videotapes, each in collaboration with an L.A.-based artist. *Kappa* (1986) features Mike Kelley as the malevolent and mythological Shinto god of fresh water. Kelley prances nearly naked while the myth of Oedipus, enacted by Woronov and Eddie Ruscha, is played out against the backdrop of L.A. *Blinky* (1998), in collaboration with Jeffrey Vallance, tells of the story of Vallance's "friendly hen," whom he purchased in the meat section of a supermarket in 1976 and then buried in the L.A. pet cemetery.[32] Just as Evelyn Waugh's novel *The Loved One* (1948) was a send-up of Hollywood in the 1930s, *Blinky* recasts an eye toward the documentary form by seriously investigating Blinky's cause of death with the help of a UCLA pathologist.

In much of the Yonemotos' work, the city of Los Angeles becomes a player in the action. Perhaps this derives from Bruce and Norman's strong ties to the art and independent-film scenes in L.A. and the community of artists who are their peers and students. Both have taught regularly at institutions such as Otis, Art Center College of Design, UCLA, and Occidental College. Bruce was instrumental in the early video programming at LACE. Among the projects in which he was involved were *TV Generations* (1986), which he cocurated with John Baldessari, and an exhibition and symposium accompanied by the publication *Resolution:*

30　In addition to the cast already cited, Mike Smith, David Schweizer, and Mike Kelley appear in the video.

31　Mary Woronov provides a direct link to Warhol. See Woronov, *Swimming Underground: My Years in the Warhol Factory* (Boston: Journey Editions, 1995). For a discussion of Warhol, the Factory, and his stars, see Russell Ferguson, "Beautiful Moments," in Kerry Brougher, *Art and Film since 1945: Hall of Mirrors* (Los Angeles: Museum of Contemporary Art, 1996), 138–87, especially 173.

32　See Jeffrey Vallance's artist's book *Blinky: The Friendly Hen* (Los Angeles: Graphix Art Press, 1979; Santa Monica, CA: Smart Art Press, 1996); and Jeffrey Vallance, *The World of Jeffrey Vallance: Collected Writings 1978-1994* (Los Angeles: Art Issues Press, 1994).

Still from Bruce and Norman Yonemoto, in collaboration with Mike Kelley, *Kappa*, 1986. Single-channel video (color, sound), 26 min.

Still from Bruce and Norman Yonemoto, in collaboration with Jeffrey Vallance, *Blinky*, 1988. Single-channel video (color, sound), 15 min.

Bruce and Norman Yonemoto, in collaboration with Timothy Martin, *Land of Projection*, 1992. Video installation with fiberglass sculpture and audio, dimensions variable

A Critique of Video Art (edited by artist Patti Podesta in 1984), presented while Bruce was chair of LACE's video committee. New York, the perceived center of the art world, seems to exert little influence on the Yonemotos' practice.

Exotica

The Yonemotos' collaborative work with other artists also extends to installations. A 1993 project for the Santa Monica Museum of Art was collaboratively initiated by the Yonemotos and John Baldessari; *Three Locations/Three Points of View* takes rear-projection footage used as background material for film and foregrounds it. In 1992, the brothers collaborated with the writer Timothy Martin to create *Land of Projection*. The installation combines the Yonemotos' ongoing interest in TV and the television "supertext" with an eye toward what constitutes the "exotic." A single four-meter-tall fiberglass shell reproduces a statue made by the Rapa Nui people of Easter Island. In consultation with archaeologist Jo Anne Van Tilburg, the size and scale of the statue were based on a statistical amalgamation of 838 *moai*, which Tilburg documented during more than ten years of fieldwork, though the features were modeled to reproduce the appearance of a specific figure. Fabricated under the guidance of artist Gary Lloyd, the statue stands in a dark room where a video projector beams images taken from a television supertext onto the statue's back. Viewed from the front, the statue becomes a transparent, though modeled, screen for the commercials, talk shows, soap operas, sports events, and cable TV shows that form the "text" of contemporary Western media culture. At listening stations around the gallery, the spectator can hear various "explanations" of Easter Island culture from sources ranging from eighteenth-century texts up to current material. The cultural projections onto the Rapa Nui people are alarming: as Martin suggests, the preoccupation with the "mysteries" and origins of Easter Island statues is "as much a mirror to the West as it is a window to the Easter Island phenomenon."[33]

The idea of Western misinterpretation of non-Western cultures is further explored in *Paraná* (1994) and the trio of works that make up *Exotica* (1994). In 1994, Bruce received a Lila Wallace Reader's Digest Fellowship to live and work in Brazil, and while there he acquired the souvenir coffee set used in *Paraná*. The coffee set commemorates the inauguration of Brasília with painted reproductions of the capital city's buildings decorating each serving piece. As a planned city designed in the modernist style, Brasília has been both acclaimed as an exercise in utopian design and for the architectural innovation of Oscar Niemeyer and derided as a symbol of political dysfunction as embodied by the artificiality of a planned city. In the vaults of the Cinemateca Brasileira, Bruce found home-movie footage, shot by a man named Udihara, which documented the Japanese Brazilian community in Paraná. Unlike movies created for public consumption, home movies give a glimpse into community and familial life, revealing aspects of experience that are not part of official documentation but instead form a personal visual diary. The Yonemotos project Udihara's footage of a 1935 Japanese Brazilian sumo tournament onto the medallion of the coffee server, literally fusing the utopian vision and hope promised by Brasília's design with the figuring of one of its minority communities. The fact that this coffee set itself was fabricated in Paraná makes the combination all the more powerful.

Cultural appropriation and the transformation of nature, tinged with a sense of nostalgia and loss, are the subjects of *Exotica*. In *Exotica: Outdoor-Indoor*, a common indoor plant sits underneath an upside-down table made of jacaranda wood. The Yonemotos present the two forms as domesticated, though both originally hailed from the rain forest surrounding Rio de Janeiro. *Exotica: Le Cabinet Chinois* consists of a glass-fronted cabinet, also made of jacaranda wood, which holds a photograph of Bruce and Norman as children alongside a TV monitor that shows an image of the rain forest. The still and

33 Timothy Martin, brochure for *Land of Projection*, exhibited at the Japanese American Community and Cultural Center, Los Angeles, January 12–February 9, 1992.

moving images are items for a cabinet of curiosities: both represent past moments that are irrevocably lost to time and change. The final component of the series, *Exotica: Hashi de Mato Grosso*, uses disposable chopsticks purportedly made from rain-forest wood as a screen onto which ethnographic film footage produced by the Brazilian explorer Marshal Cândido Rondon (1865–1958) is projected. The ritual dance of a tribe native to Mato Grosso intersects with the contemporary tendency toward disposable goods.

Materiality and the Modern

The powerful sense of loss is expressed in a subsequent piece, *A Matter of Memory* (1995). An oversize glass of water stands innocently on an acrylic table. Peering into the glass, one sees an image of a sugar cube sitting at the bottom. A photograph of the two artists as children and 1950s TV commercials hover on the surface of the cube as it slowly dissolves in the water. Directly referencing—though with a twist—the canonical 1896 text *Matter and Memory* by French philosopher Henri Bergson (1859–1941), the Yonemotos ruminate on both the duration of decay and the fragility of memory. The artists suggest that dissolution is inevitable, and through the media environment we lose the last vestiges of individual personal and political identity. An elegiac tone pervades the piece, one that conveys a profound sense of phenomenological loss. The physical materiality of the artists' bodies disintegrates into the hazy, cloudy water in the glass.

Materials, the actual physical components of film and its projection, are explored in the *Achrome* series (1993). In 1957, in a commentary on the centrality of painting as an art form, Piero Manzoni (1933–1963), an Italian artist associated with Arte Povera, first created what he termed *Achromes* or paintings without color, which consisted of a mixture of white kaolin and glue applied to the surface of the canvas. A few years later, he dispensed with paint entirely by stitching together pieces of canvas, creating, in essence, a "painting" characterized by the complete absence of paint itself. In their *Achromes*, the Yonemotos examine the constituent parts of movies. By sewing together fragments of

beaded home movie screens, they simultaneously call attention to the material of film projection and create film without image. They also subjected celluloid to the same process by cementing together fragments of celluloid that, when projected, create a mirror image of their sewn *Achromes*. In related works, the brothers continue their interest in the materiality of film by literalizing the Hollywood metaphors of dreams and decline. In *Golden* (1993), the surface of a home movie screen is gilded—dreams and desires find a place on the surface of the screen. *Disintegration* (1993) consists of a glass container filled with nitrate film, which looks innocuous but is actually a highly combustible material that becomes increasingly flammable when stored above 110 degrees Fahrenheit. Hollywood imagery should be literally and figuratively handled with care, the Yonemotos tell us. In *La Vie Secrète* (1997), the autonomy of the screen—and by extension the seamless mass of filmic imagery—is punctured by a large hole. What lies on the other side of the screen? The Yonemotos challenge viewers to stick their heads through the screen: what the viewer finds is an image of the back of his/her head. In a playful reference to René Magritte's series of paintings of the same name, the Yonemotos comment on the futility of a mirror's (in Magritte's case) or film's ability to reflect a "true" reality. At the same time, they cast a skeptical glance at notions of the real.

Manzoni sought to eliminate "all the useless gesture, everything in us that is personal and literary in the pejorative sense of the word: nebulous childhood memories, sentimentalism, impressions, deliberate constructions, practical, symbolic or descriptive preoccupations, false anxieties, unrealized unconscious facts, abstractions, references, repetitions in the hedonistic sense."[34] The Yonemotos continuously move between two poles: one reminiscent

34 Angela Vettese, "Piero Manzoni and the Peculiar Origins of Italian Conceptual Art," in *Piero Manzoni: Line Drawings* (Los Angeles: Museum of Contemporary Art, 1985), 40.

below and right: Bruce and Norman Yonemoto, *A Matter of Memory*, 1995. Video installation, dimensions variable

bottom right: Bruce and Norman Yonemoto, *Achrome I*, 1993. Beaded-glass projection screen on TV tray, 35 × 20 × 16 inches

Bruce and Norman Yonemoto, *La Vie
Secrète*, 1997. Altered screen, closed-
circuit camera, and LED screen,
66 × 44 × 22 inches

Stills from Bruce and Norman Yonemoto, *Japan in Paris in L.A.*, 1997. 16 mm film (color, sound), 30 min.

of Manzoni's drive toward the elimination of the sentimental, repetitive, and hedonistic, the other as evidenced by a wholesale, though sly, adoption of these nebulous forms. *Japan in Paris in L.A.* (1997) assimilates these two modes, as it simultaneously addresses the formal experimentation of Structuralist film and manifests a continued exploration of a camp aesthetic. It is the Yonemotos' most recent narrative piece and their first work in film after *Garage Sale*, their earliest collaboration. The film is loosely based on the life of the early twentieth-century Japanese painter Saeki Yūzō (1898–1928) and reinterprets the encounter—of near-mythological status in Japan—between earnest Saeki and the French painter Maurice de Vlaminck (1876–1958). Like other works by the Yonemotos, the film is simultaneously a documentary, a docudrama, and a melodramatic soap opera. Against the score by composer Mayo Thompson, the narrative moves through 1920s Paris and Los Angeles: a soundstage serves as the interior of a Parisian café, atelier, and bedroom; Richard and Dion Neutra's Van der Leeuw house represents modernist L.A.; and home-movie footage of Paris in the 1920s is intercut throughout the film—all examples of the modern experience.

Vlaminck spouts over-the-top modernist platitudes about art, while Saeki, played by well-known Japanese model and commercial star Yusuke Tōdo, strives to reconcile his Japanese heritage with a desire to be "modern." Susan Tyrrell, who appeared as Johnny Depp's white-trash mother in John Waters's *Cry-Baby* (1990), plays the muse, who alternates between sexual encounters with both Vlaminck and Saeki. The film pokes fun at modernism's macho posturing of painting, life, and creativity at the same time as it sympathizes with Saeki's wondrous enchantment with his "other." Saeki exclaims, "Have all the photographic reproductions I've come to call memories finally come alive?" Saeki's fateful encounter with Europe also stands in for the East-West divide and the exotic and the familiar as they are mediated through the photographic image. For the Yonemotos, the Saeki-Vlaminick encounter

demonstrates both the desire for the literary trappings of modernist origins and the futility of such constructions. All the while, the situation of contemporary Asian American artists resonates like static, background noise.

Mutation and Renewal

Silicon Valley (1999), a new installation commissioned for the Historic Building of the Japanese American National Museum, returns to the brothers' childhood milieu and relates it to the origins of the museum's structure. Unlike the traditional Buddhist temples in Japan, the former Nishi Hongwanji Temple, originally built in 1925, was used by the Japanese American community in Little Tokyo as both a sanctuary space and as a stage for performances and movie screenings. The Yonemotos reference this dual history as a place of worship and a place to show films in *Silicon Valley*. The installation combines footage of the verdant valleys that surrounded the Yonemotos' childhood home—before the area's explosive transformation into Silicon Valley—with clips from the 1952 MGM production *Above and Beyond*, the infamous Daisy Girl commercial created for Lyndon B. Johnson's 1964 presidential campaign, and actual footage of the atomic bomb blast over Hiroshima. For the artists, the atom bomb became a symbol of the obliteration of the past and technological progress. The media version of history as seen in *Above and Beyond*'s fictional assessment of the bomb's drop and the "innovations" in advertising strategies as evidenced by the "Daisy Girl" reveal a fabricated past and ominous future.

Asexual Clone Mutation (for our father) (1995) presents an alternate idea of mutation and decline. The Yonemotos' paternal grandfather was among the first to grow the Simm variety of carnations in what is now known as Silicon Valley. Simm carnations were a new hybrid derived from Mediterranean and garden-pink varieties developed at the turn of the century. After the incarceration, the Yonemotos' father, Tak, continued working with flowers, discovering and cultivating new varieties. In propagating carnations, plant pathologists search for the

Bruce and Norman Yonemoto,
Silicon Valley, 1999. Movie screen
and two-channel video projection,
dimensions variable

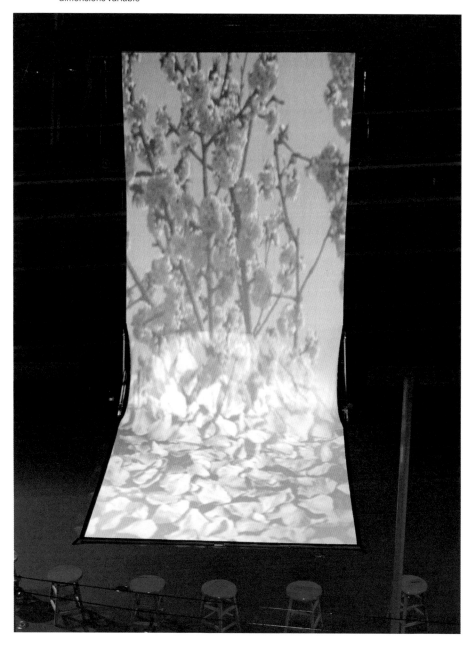

mutation that can be developed into a favorable characteristic, anything from leaf size, shape, and curliness of petals to the strength of the stem. Color marks the most dramatic of desired changes. The plant propagator isolates carnations with appealing genetic mutations, and, through cloning, a new form eventually develops. In *Asexual Clone Mutation*, a single gold petal is inserted among the petals of a bright red carnation. Is it a desirable mutation that will become the golden flower through technological innovation and genetic engineering? Or is it an unattainable fantasy akin to alchemy?

These tensions, between the fantasy and falsehood of the image, between the fact of the matter and the fabrication of its origins, and between romance and reality run throughout the Yonemotos' work. And in every case, the artists challenge the viewer's expectations while giving them what they want. Like the mutation that suggests the possibility of the golden flower, the Yonemotos employ the conventions of media representation and, through interventions of form and text, create something new, invested with criticality but endowed with pleasure.

opposite: Bruce and Norman Yonemoto, *Asexual Clone Mutation (for our father)*, 1995. Carnation, gold petal, glass, steel, rubber, and water, dimensions variable

Bruce and Norman Yonemoto, *Golden*, 1993. Gold leaf on projection screen, 64 × 43 × 12 inches

Goldie Glitters at the premiere of *Garage Sale*, Fox Venice Theater, Los Angeles, 1976

Bruce and Norman Yonemoto, ca. 1953

Bruce and Norman Yonemoto,
Definition of a TV Lamp, 1984–99.
Thirty-two ceramic lamps, dimensions
variable. Installation view, *Neotoma*,
Otis Gallery, Otis College of Art and
Design, Los Angeles, 1995

Still from Bruce and Norman Yonemoto,
A History of Clouds, 1991. Single-channel
video (color, sound), 34 min.

The Permanent Collection and Re-Visioning Manzanar

You can't judge a book by its cover, but you most certainly can judge a museum by its collection.

The permanent collection of the Japanese American National Museum is the core, both literally and figuratively, of our operations. It is the central component of our mission to preserve and interpret the experiences of Japanese Americans, and it provides us with the most basic building blocks. Sometimes we use the collection in exhibitions. Sometimes it serves as a "proof," providing evidence of a particular incident, community, or life. In other instances, the collection is used as a research tool, allowing scholars, students, or interested individuals to investigate untold aspects of Japanese American history and culture. Simply put, the artifacts, photographs, artwork, archives, life histories, and films that make up the museum's collection individually and collectively tell stories, unlocking complex histories about people, places, communities, and time periods.

Housed in the physical center of the pavilion, a new 84,000 square-foot structure designed by Gyo Obata, our permanent collection now numbers 32,000 objects. It has steadily grown since the museum began acquiring in 1988. Most everything has entered the collection through the generosity of individuals and organizations who recognize the tremendous value of preservation, interpretation, and exhibition. The word *permanent* is the operative word, for when the museum accessions, or officially incorporates, an item into the collection, it agrees to house, care for, and preserve it in perpetuity—forever. As one can imagine, collecting is a very serious activity.

At any given time, only a small fraction of our collection is on view; this is the standard situation with any museum that has a strong collection. Not only is JANM's collection recognized for its stellar individual objects but it is also evaluated in terms of its depth. It is important for the museum's collection to demonstrate a wide range of holdings. There are objects that are unique or quite rare; yet sometimes we acquire more than one example of a particular category of object. The museum's curators strive to determine what areas and what items we want to acquire in-depth. Quality and condition are also important: not only do we want to collect in great detail, but we also want to acquire objects that exhibit the highest quality and best condition possible.

The Manzanar Models

The exhibition *Re-Visioning Manzanar: Selections from the Permanent Collection* (1999–2000), on view in the Legacy Center Gallery of the museum's Historic Building, gives us the opportunity to highlight some of the significant objects that have entered the collection over the years. The inspiration for this modest exhibition came from the scale models of Manzanar donated by Robert Hasuike. Affectionately dubbed "the Manzanar models," they are a perennial hit among the public, staff, and volunteers. Perhaps the most favorite item is a panoramic diorama of the whole of Manzanar. This model isn't an artifact from the camp experience itself because it was made after-the-fact; even so, it is meticulously rendered, and its value as an educational tool is unparalleled. But there is something else going on. In this object, we see a retrospective revisiting and reinterpretation by former inmates. In one fell swoop, the model seems to encapsulate the enormity of the World War II incarceration of Japanese Americans by showing how vast and encompassing a single camp was. In its simplicity, the model is forceful in its message: Manzanar is only one of ten War Relocation Authority concentration camps that unjustly incarcerated people of Japanese ancestry.

When collections manager Grace Murakami recognized that the models needed conservation work, they were temporarily removed from view. Once the requisite conservation treatment was completed, the models were

Manzanar model display in the ongoing
exhibition *Common Ground: The Heart
of Community*, Japanese American
National Museum, Los Angeles

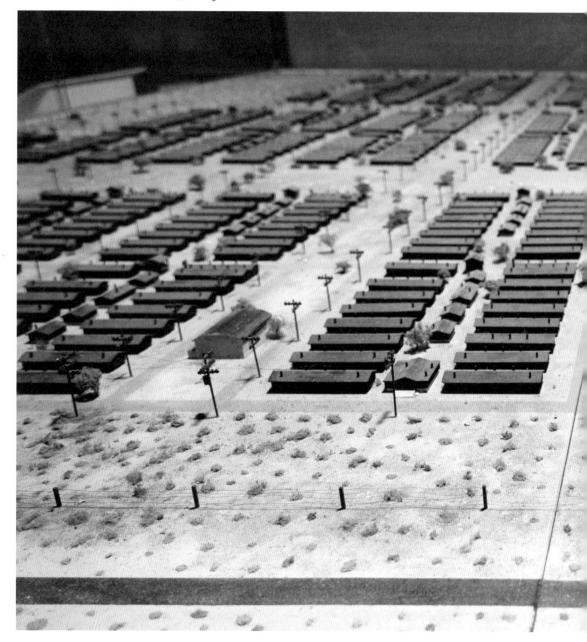

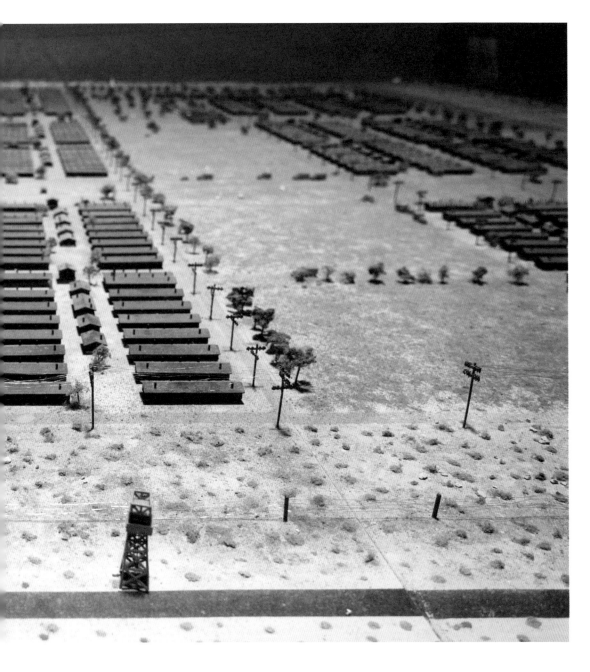

reauthorized for exhibition. The models raised several intriguing questions for Kristine Kim, the museum's associate curator, and me. We saw an opportunity to create a new context for displaying the panoramic model, one that would highlight other creative interpretations of Manzanar from the permanent collection, both renderings from the actual wartime experience and those that looked back. We looked for art and artifacts that subtly revealed the physical and psychological terrain of Manzanar through creative interpretation. From this, the exhibit *Re-Visioning Manzanar* was born.

The panoramic model of Manzanar now sits in the same gallery as other treasures from the museum's permanent collection, some of which have never before been on view. In 1993, the museum received a donation of an exquisite collection of photographs by Ansel Adams. These vintage prints were the result of Adams's visit to Manzanar at the behest of the camp director Ralph Merritt, and they were subsequently published in Adams's 1944 book *Born Free and Equal: The Story of Loyal Japanese-Americans*. Copies of the Manzanar high-school yearbooks *Our World* and *Valediction*, placed near Adams's photography, show another way in which photography was used in the service of camp life. Largely taken by noted photographer Toyo Miyatake (1895–1979), the photographs in the yearbooks construct a compelling narrative of a community that persevered despite the incarceration. At the same time, the photographic layouts seem to critique the unfair political situation with subtlety and grace.

Two works by contemporary artists in the exhibition turn conventional photography on its head. David Alan Yamamoto transforms a panoramic photograph of Manzanar into a freestanding folding screen. Yamamoto was not incarcerated because he is far too young, but the wartime experiences continue to impact subsequent generations. Masumi Hayashi, who was born in the Gila River War Relocation Center in Arizona, merges photography with the technique of collage. Small photographs—almost fragments—are combined to create one large-scale picture. Hayashi's work contrasts with the simple, though elegantly rendered, watercolor of wildflowers by Hideo Kobashigawa, which shows a side of Manzanar that diverges from that of the watercolors of camp life painted by Kango Takamura. Both artists created these works during the World War II incarceration, but each demonstrates how individuals make different choices in subject matter. The exhibition also includes work by filmmaker Robert A. Nakamura, who was a child in Manzanar. In his 1972 film *Manzanar*, he returns to the place of his childhood to ask of himself—and, by extension, the world—what it means to be a child imprisoned. Can the land tell us something about the experience? Can it speak to us now?

The answer, of course, is that Manzanar cannot literally speak. In a way, however, Manzanar and the experience of incarceration do speak through the art, artifacts, photographs, and creative expression of those who experienced it then and those who still experience it now. This is the beauty of our permanent collection. It will outlive all of us, and in so doing, it can continue to speak.

Ansel Adams, Toyo Miyatake Family,
Manzanar War Relocation Center, 1943

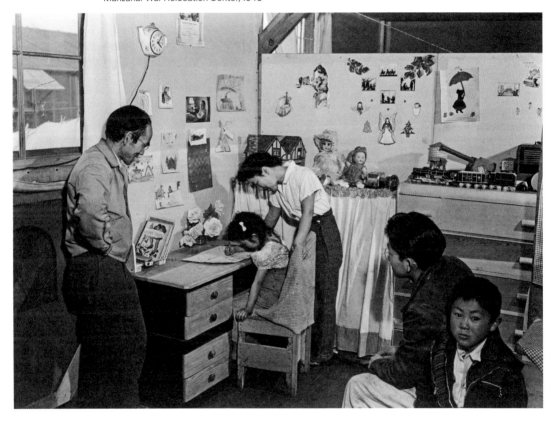

The Permanent Collection and Re-Visioning Manzanar

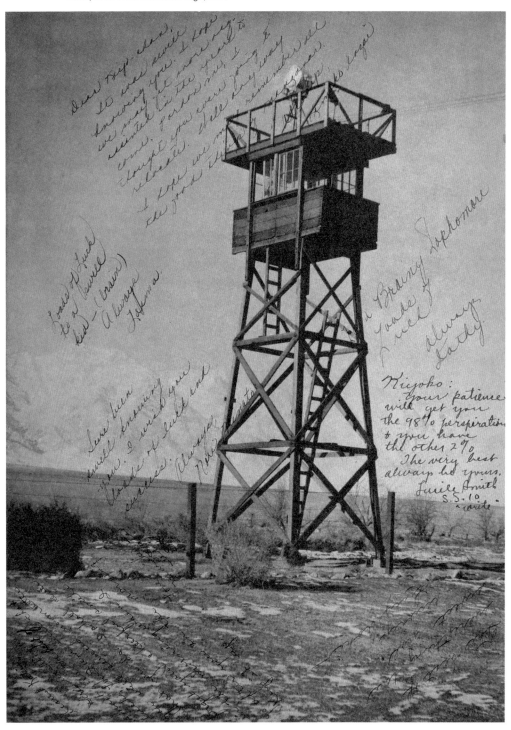

Kango Takamura, *Painting of men
observing cloud formations*, ca. 1942.
Watercolor on paper, 11 × 8 ½ inches

cowritten with
Tim B. Wride

Manzanar
Inside
and
Out:
Photo
Documentation
of the
Japanese
Wartime
Incarceration

When U.S. General John L. DeWitt, head of the Western Defense Command, bluntly uttered the now-infamous remark "A Jap's a Jap.... It makes no difference whether he is an American citizen," he summed up a prevailing attitude regarding race in the months immediately following the Japanese attack on Pearl Harbor. Sentiment, loyalty, identification—any kind of behavior that followed—was presumed to derive not from individual agency or community expression but, a priori, from racial type. American citizenship was meaningless in the face of the Japanese race. After all, according to DeWitt, "You can't change him by giving him a piece of paper."[1] On February 19, 1942, not two and a half months after the entry of the United States into World War II, President Franklin Delano Roosevelt issued Executive Order 9066. This order began the largest removal and confinement of citizens in the history of the United States, affecting all persons of Japanese descent living in the western states.

The events leading directly up to the incarceration of Japanese Americans began months before the official entry of the United States into the world war. As Americans across the country listened with shock and horror to the news of the attack on Pearl Harbor of December 7, 1941, the State Department had already begun preparing for war with Japan. Tensions between the two nations had escalated, and as early as September 1941, war had seemed imminent and the question of Japanese American loyalty required analysis.[2] Envoy Curtis Munson was charged with investigating and assessing the loyalty of the Japanese American community in Hawaii and the mainland. Japanese immigrants were long considered unassimilable, both culturally and politically; even so, Munson's report concluded that the Japanese American community posed little threat to U.S. security. A small number of individuals in the different military districts could be classified as dangerous, but the nisei (first American-born generation) showed "a pathetic eagerness to be Americans"—which, in fact, they were.[3] By the morning of December 8, the FBI had rounded up nearly eight hundred people in Hawaii and the mainland; by the end of the year, the count would increase to twelve hundred—far exceeding the number initially reported by Munson. No new intelligence emerged that would suggest an increase in the potential for Japanese American espionage, and Munson himself reiterated the conclusions of his report to the president in the days following Pearl Harbor. However, the public outcry over Japanese military action against a territory of the United States created a climate of fear and hysteria that led the State Department to disregard its own findings.[4] All "alien enemies" in the Western Defense Command Zone were ordered to surrender cameras, radio transmitters, and shortwave receivers, and in the early weeks of 1942, the FBI actively publicized in the popular media the seizure of "contraband."[5] Executive Order 9066 made no explicit reference to mass incarceration. Rather, it authorized the establishment of military areas where "any or all

1 John L. Dewitt, quoted in Clifford I. Uyeda, ed., *Americans of Japanese Ancestry and the United States Constitution, 1787–1987* (San Francisco: National Japanese American Historical Society, 1987), 25.
2 Michi Weglyn, *Years of Infamy: The Untold Story of America's Concentration Camps* (New York: William Morrow, 1976), 34.
3 Ibid., 41.
4 Ibid., 33–53.
5 Peter Irons, *Justice at War: The Story of Japanese American Internment Cases* (New York: Oxford University Press, 1983), 30. The term *alien enemies* referred to Japanese immigrants, who were forbidden by law to become naturalized citizens, as well as to German and Italian immigrants.

persons may be excluded," and it stated that the control of these areas was at the discretion of military authorities.[6]

While the headlines of popular newspapers tracked the "Jap" victories in the Pacific and Eastern Asia, the fear of Japanese American espionage continued to be openly expressed, especially through the "yellow-baiting" publications of the Hearst media empire. Among Japanese Americans, the question of the community's future was hotly debated in the public arena of the vernacular presses and privately within the family unit. All the while, possession of items that could suggest any tie to Japan—letters written in Japanese, Japanese clothes, and, most significantly for visual historians, photographs that depicted anything "Japanese"—were hastily thrown into the fire.

The first of the incarceration orders was issued in February 1942; it affected the communities of Terminal Island in California's Long Beach Harbor and Bainbridge Island in Washington State's Puget Sound. Both communities were given forty-eight hours to pack up and leave. By September 1942, all Japanese Americans living on the West Coast were incarcerated, first in fifteen temporary detention centers primarily located on the grounds of racetracks and fairgrounds in California, Oregon, and Washington. By the end of 1942, all had been transferred to one of the ten concentration camps administered by a newly formed civilian agency, the War Relocation Authority (WRA). Ultimately, more than 120,000 people served time in temporary centers and WRA camps.[7]

The images of the evacuation and internment process, much like the process itself, were tightly controlled and surprisingly narrow in their scope and in the way they were disseminated. While newspapers and magazines were provided relatively free access in their coverage of the evacuation procedures, by the time the assembly centers and then the concentration camps were in full operation, the images were restricted by the military and the WRA. As a result, beyond the images that were included in newspapers, pamphlets, and editorials, the published photographic record of the largest civilian

relocation in U.S. history is substantially contained in three disparate bodies of work: a "pictorial summary" that accompanied the final report of the Western Defense Command; Ansel Adams's exhibition and subsequent book *Born Free and Equal: The Story of Loyal Japanese-Americans*; and two high-school annuals, *Our World* and *Valediction*, produced in the camp at Manzanar.[8] This photographic record of the period, both official and personal, presents a complicated story, excessive in its accumulation of detail and yet wholly incomplete. Obviously, each body of work gives us a filtered glimpse

6 Ibid.

7 A note on terminology: we use the term *concentration camp* to refer to the ten War Relocation Authority camps euphemistically called "relocation centers." *Concentration camp* is the preferred term of historians and was popularly used during the period by government officials, including President Roosevelt and General Dwight D. Eisenhower. *Internment camp* refers to the Justice Department–administered camps created for the detention of "alien enemies." See Raymond Y. Okumura, "The American Concentration Camps: A Cover-Up through Euphemistic Terminology," *Journal of Ethnic Studies* 10, no. 3 (Fall 1982): 95–108.

8 *Final Report: Japanese Evacuation from the West Coast, 1942* (Washington, DC: U.S. Printing Office, 1943). Ansel Adams, *Born Free and Equal: The Story of Loyal Japanese-Americans* (New York: U.S. Camera, 1944). *Our World* was initiated by Manzanar High School journalism teacher Janet Goldberg and carried out by student editor in chief Reggie Shikami in 1944. A facsimile edition, edited by Diane Honda, was published with funds provided by the Civil Liberties Public Education Fund in 1998. *Valediction* was initiated and published by the Associated Student Body of Manzanar High School in 1945. It should not be forgotten that visual records in other media were produced in all the camps. It must also be noted that additional photographic records were made, such as clandestine photographs taken by camp guards and staff, as well as images taken by other photographers working on in-house camp publications. These images, however, were distributed narrowly—if it all—and are not included within the scope of this inquiry.

Pages from *Final Report: Japanese Evacuation from the West Coast, 1942,* published by the U.S. Government Printing Office, Washington, DC, 1943

FIGURE 3: Members of an advance party of evacuees loading bedding and other equipment in warehouse at Pomona (California) Assembly Center. Centers were readied for evacuee reception in advance.

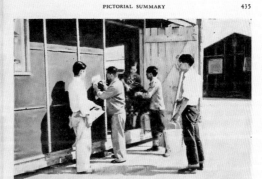

FIGURE 5: Delivering issues of bedding and household utensils to apartment of a newly arrived evacuee family.

FIGURE 4: Scene in the first kitchen to be opened at the Santa Anita (California) Assembly Center. Modern kitchen and cooking equipment were supplied the mess halls at all centers.

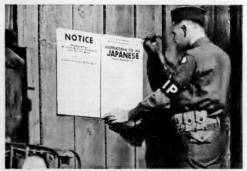

FIGURE 6: Military Police posting Civilian Exclusion Order No. 1, requiring evacuation of Japanese living on Bainbridge Island, in Puget Sound, Washington. Civilian Exclusion Orders, numbered 1 to 108, were issued by the Commanding General ordering exclusion of persons of Japanese ancestry from 108 specific areas in the states of California, Oregon, Washington, and Arizona.

Pages from *Final Report: Japanese Evacuation from the West Coast, 1942*, published by the U.S. Government Printing Office, Washington, DC, 1943

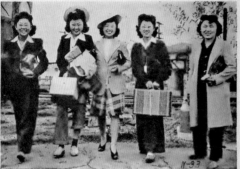

FIGURE 15: Group of young Japanese girls arriving at a Long Beach, California railroad station to board a special electric train for the Santa Anita Assembly Center, April 4, 1942.

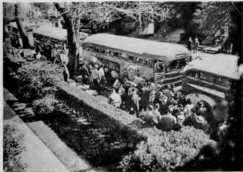

FIGURE 17: Evacuees loading baggage and boarding special busses at a Berkeley Control Station April 30, 1942. Evacuees from the San Francisco (California) Bay Area were transported from the Control Stations to Tanforan Assembly Center.

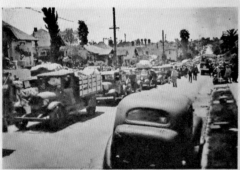

FIGURE 16: Caravan of trucks loaded with baggage and private cars ready to leave a Control Station in Los Angeles, April 28, 1942 for Manzanar Reception Center. Departure from the various areas was at first by private automobile, with trucks for baggage. Later only by train or bus. Large moving vans were available to handle household or other goods the evacuees desired to have stored under supervision of the Federal Reserve Bank.

FIGURE 18: Group of evacuees assembled at a Los Angeles railroad station waiting to board train for Santa Anita Assembly Center. Other evacuees were transported from their residence areas to Assembly Centers by train.

of the experience: one from the military/government perspective, one from a private citizen given access by virtue of his standing as an artist, and one provided by the internees themselves. Also understandably, each in its own way deals in visual terms with the immediacy of the world war; the tumultuous upheaval precipitated by the social climate of California; and the economic, political, social, and personal crises the process itself created. But while each selection of images has its own reason for being, its own manner of presentation, and its own agenda, there is consistency in some of the modes in which the images function.

In June 1943, a document bearing the official title *Final Report: Japanese Evacuation from the West Coast, 1942* was delivered to the office of Secretary of War Henry L. Stimson. Long awaited and once aborted, the report furnished a chronology and justification of the actions undertaken pursuant to Executive Order 9066.[9] The report covers the period of activity from the signing of the order until the WRA assumed authority over the relocation centers.

While the report was signed and submitted by General DeWitt, it was in great part compiled by Colonel Karl R. Bendetsen.[10] Bendetsen had previously strategized how the evacuation and incarceration of the Japanese American population could be accomplished without the hindrance of problematic issues of a strictly racist interpretation or of constitutional law. Bendetsen's plan rested on the issuance of Executive Order 9066—also authored by him—which would mandate the establishment of geographic areas from which any and all people could be excluded based on "military necessity."[11]

The Western Defense Command was commissioned to formulate and implement the domestic strategies of the war effort in the western states. Its principal charge was to oversee the evacuation and incarceration of all citizens of Japanese ancestry from the coastal zones. It devised strategies of conduct and organization that, from its perspective, were critical to the national defense. Yet within those strategies were systemic flaws regarding constitutional rights and ethics, and at the time of the report's publication, they were facing Supreme Court challenges. The final report was produced, therefore, both as a justification of the expenditure of resources and as an answer to judicial challenges.[12] The final report reasserted the justifications of the exclusion order: the interpretation of signals from shore to enemy submarines, arms and contraband found by the FBI in raids on the homes and businesses of ethnic Japanese, dangers to the ethnic Japanese from vigilante groups, concentration of ethnic Japanese around or near militarily sensitive areas, proliferation of Japanese ethnic organizations that might shelter pro-Japanese attitudes and activities, and the socially unsettling presence of kibei (nisei who were born in the United States but educated in Japan). The report then provided an overview of the Western Defense

9 Members of both the War Department and the Department of Justice were to have been accorded an approval of the report before publication. The original version of the final report met with opposition from Assistant Secretary of War John J. McCloy. Changes were made to obscure blatant racial references and stereotypes that had been inserted into the record by General DeWitt. After the offending passages had been amended, all original copies of the document were destroyed, and the revised version was resubmitted as the official version. See Richard Drinnan, *Keeper of the Concentration Camps: Dylan S. Meyer and American Racism* (Berkeley: University of California Press, 1987), 256–57. Representatives from the Department of Justice had concerns not only about the report's potential as a political liability but also about the wording of the report, which could have undermined their Supreme Court defense of the constitutionality of the evacuation-incarceration process.

10 Bendetsen was a civilian when the evacuation and internment strategy was formulated. By the time the final report was issued, he held the position of chief of the Aliens Division of the War Department, in charge of civilian affairs of the Western Defense Command.

11 Weglyn, *Years of Infamy*, 69–70.

12 For a complete analysis of judicial challenges to the evacuation and internment, see Irons, *Justice at War*.

Command's deployment of resources to the assembly-center operation.

Appended to the text of the final report was the seventy-seven-page pictorial summary, consisting of photographs, each with an accompanying caption. Of the 149 images included in the report, ninety-two were gleaned from photography archives established by the U.S. Signal Corps, six from the Army Corps of Engineers, thirty-one from the Wartime Civil Control Administration, and two from the WRA. Eighteen additional images were supplied by West Coast newspapers and picture service agencies. While the images were for the most part taken by unidentified military personnel or by stringers, some were taken by well-known photographers, including Dorothea Lange, who was employed on the strength of her work with the New Deal agencies of the 1930s. The pictorial summary provides a photographic chronology of the Western Defense Command's operation. The summary documented the construction of the assembly centers, the process of notification and evacuation, the preparation and general administration of infrastructure systems, the work and recreation opportunities available to the inmates of the centers, and the construction and preparation of the subsequent relocation centers.[13] The framers of this visual monologue included images that most convincingly demonstrated the organizational efficiency and humanity of the evacuation effort on the part of the War Department. The illustrations in the pictorial summary function much like those in an annual business report or in a traditional family album. The authors of the final report relied on the presumptive truth of the images, as well as on the familiarity of the family-album format to bolster the congratulatory and defensive tone of their summary.

The images of the pictorial summary were included in the final report to support the text. Because the internment of Japanese Americans was both a political and a military crisis, images were selected for inclusion in the summary that would portray the command's efficiency, as well as help mold favorable public and legislative opinion, in addition to providing evidence of the army's successful management of the situation. The pictures lent an emotional and psychological immediacy to the facts as they were recounted in the report, and they illustrated not merely a series of events but the authority through which those events transpired. The assembly facilities are consistently photographed with an expansive symmetry and a rigid organization that recalls a modernist visual vocabulary. Photographs of communal kitchens, laundry rooms, and housing areas feature repeated elements that stretch row upon row with a single vanishing point. These images are accompanied by captions that incorporate adjectives such as *modern*, *essential*, and *well-equipped*. The coupling and mutual reinforcement of image and text not only speak to the organization and care with which each facility was constructed but also imply the vast number of elements in other facilities like those pictured. The strategy seeks to celebrate and conflate the quality and the scale of the army's operation.

Organized in a manner reminiscent of a family album, the photographs in the pictorial summary lead the reader through the narrative of the evacuation and interment process as if they too were participating in some form of collective memory. The images repeatedly engage the viewer on a level that negates the tragic reality and consequences of the operation. The viewer is consistently met with smiling faces: smiling military personnel enforce evacuation; smiling Japanese Americans are transported, baggage in hand, from their homes; smiling government-agency workers assist in the disposal of assets; smiling groups of internees prepare domestic spaces, work, and play in the centers. The images testify to an overall sense of cooperation and camaraderie that pervaded the evacuation and internment process. They bespeak an efficient optimism and tacit

13 In the case of the Manzanar facility, what initially began as an assembly center under the supervision of the Western Defense Command was subsequently continued as a relocation center under the administration of the WRA.

Pages from *Final Report: Japanese
Evacuation from the West Coast, 1942,*
published by the U.S. Government
Printing Office, Washington, DC, 1943

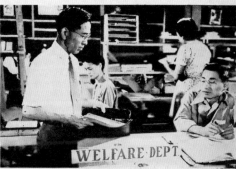

FIGURE 26: Administrative staffs under the Caucasian Center Manager were established at all
Centers to supervise all Center operations and activities. Evacuee personnel were enlisted and
paid to assist in administration as well as all other Center work. Scene in an Assembly Center
Welfare Office.

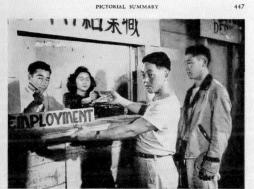

FIGURE 28: Employment office at the Portland (Oregon) Assembly Center. Employment
offices, through which evacuees desiring to work were given suitable assignments, were established
in all the Centers.

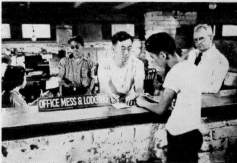

FIGURE 27: Mess and lodging office at Pomona (California) Assembly Center. Another phase
of administration was the mess and lodging staff composed of evacuees under the direction of a
Caucasian manager. This unit handled the assignment of Japanese employees to mess and
lodging employment.

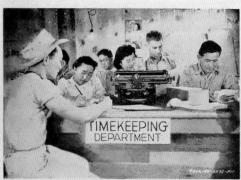

FIGURE 29: Scene in the timekeeping office at Stockton (California) Assembly Center.

agreement with the process and the situation by military and government personnel, as well as by the evacuees, who seem to be embarking on a planned holiday excursion rather than being suddenly and forcibly removed from their homes and businesses. The photographs deny any sense of personal or social hardship and serve to forestall criticism of mistreatment or unfairness. Above all, the images become witness to a cooperative undertaking in which those who have been incarcerated are both justifiable victims and willing participants.

Yet despite this presumptive participation, the Japanese Americans are visually accorded neither the ability nor the need to participate in the management of this situation. Captions and images consistently attest to the control and stewardship of the evacuees by the army. A singularly overt example of military authority is seen in a full-page image of an unsmiling soldier looking directly at the viewer from a watchtower, his back to the camp. The caption explains that the military presence provided "external security" and that the towers were "erected at strategic points and a watch kept for fires and other dangers."[14] The image, in conjunction with the coded caption, affirms one of the initial justifications for the evacuation and internment—fear for the evacuees' safety. Additionally, it visually demonstrates an almost paternalistic military control of the centers. This demonstration of control is woven into the entire pictorial summary. Each spread of images features at least one reference to this control—whether in the appearance of a European American in an obvious position of oversight or in the inclusion of ubiquitous phrases, such as "Caucasian supervision" or "is provided for the evacuees," in the captions. The exceptions to these parental reinforcements occur only in spreads that depict hobbies, sports, and other leisure activities, where not a single image or mention of "Caucasian" or "supervision" is found. In other words, the exceptions are situations that are viewed as more childlike and therefore nonthreatening to the military. The control the military asserted over the camps and the use of photographs taken of

Toyo Miyatake, portrait of Ralph Merritt, Manzanar, 1943

the camps shifted as the WRA assumed stewardship of the relocation centers—as they were now called. Cameras and other photographic equipment were still considered contraband, but exceptions were being granted, most notably those conferred by administrator Ralph P. Merritt in the Manzanar camp, located in California's Owens Valley.

By the time the evacuation process had begun, Ansel Adams was one of the most prominent art photographers in California, in company with Weston, Dorothea Lange, and Imogen Cunningham. As a founding member of group f/64, he was perhaps the most vocal and high-profile proponent of an aesthetic that defined the course of art photography for two generations of American photographers. By 1942, his accomplishments and reputation as an educator, lecturer, writer, theorist, and activist placed him at the fore of a newly emerging American photographic elite. It is of interest, then, to observe Adams as he attempted to reconcile his art with his desire to contribute to the Allied war effort in the aftermath of the Japanese attack on Pearl Harbor.

Adams was ineligible for active duty when the United States entered World War II, although he did volunteer his services in ways that were linked to his knowledge of the Sierra Nevada and of photography. Because Yosemite Valley was being utilized at the time as a training destination for troop and equipment deployments, Adams often found himself both tour guide and documentarian for the participating personnel. He was intermittently called upon to conduct training sessions in both field photography and darkroom techniques, and he also printed classified intelligence images of Japanese troop and equipment locations for army intelligence. However, Adams was frustrated in his attempts to make a substantive contribution, while close friends Edward Weston and his wife, Charis, volunteered their time with the Civil Air Patrol in Carmel and pioneer photography curator Beaumont Newhall embarked on a tour of duty in Africa and Europe. Certain that his efforts should include his photographs, Adams was at a loss to find a project that would have meaningful impact as well as showcase his talent and artistry.

His opportunity arrived in the form of old friend and former Sierra Club cohort Ralph Merritt, who had recently taken over the administration of the Manzanar War Relocation Center. Adams recounted that Merritt "proposed a photographic project where I would interpret the camp and its people, their daily life, and their relationship to the community and their environment. He said, 'I cannot pay you a cent, but I can put you up and feed you.' I immediately accepted the challenge and first visited Manzanar in the late fall of 1943."[15] The images that Adams produced during his trips to Manzanar in 1943 and 1944 were exhibited at the Museum of Modern Art, New York, in November 1944,[16] after having been previously displayed in the camp itself in January.[17] That same year, U.S. Camera published a book of photographs drawn from the exhibition, *Born Free and Equal: The Story of Loyal Japanese-Americans*. Adams intended his images for "the average American." He asserted:

Throughout this book I want the reader to feel he has been with me in Manzanar, has met some of the people, and has known the mood of the Center and its environment—thereby drawing his own conclusions—rather than impose upon him any doctrine or advocate any sociological action. I have intentionally avoided the sponsorship of governmental or civil organizations…because I wish to make this work a strictly personal concept and expression.[18]

However neutral Adams may have believed his images to be, and whatever measures he took to protect their neutrality, he was nevertheless an outsider presenting his viewpoint of the camp. Adams undertook the project with a personal agenda in mind, and his view was formed under the constraint of certain cultural and political assumptions. These assumptions affected the way he conceived his images, as well as how they were received by his intended audience. Foremost among them was an innate trust in the official story, as relayed by government and military leaders.

Adams had overtly expressed his opinion that business was not to be trusted when he stated that:

There is a great opposition out here [in California] to all Japanese, citizen or not, loyal or otherwise, chiefly coming from reactionary groups

14 *Final Report*, 444.
15 Ansel Adams, *Ansel Adams: An Autobiography* (Boston: Little, Brown, 1985), 258.
16 The exhibition *Manzanar: Photographs by Ansel Adams of a Loyal Japanese-American Relocation Center* was not without its share of controversy and was ultimately held in a basement gallery of the museum. See Jonathan Spalding, *Ansel Adams and the American Landscape: A Biography* (Berkeley: University of California Press, 1995), 208–9.
17 The exhibition of Adams's images at Manzanar was held in the camp's Visual Education Museum, a converted barrack.
18 Adams, *Born Free and Equal*, 9.

Ansel Adams, frontispiece and pages
from *Born Free and Equal: The Story of
Loyal Japanese-Americans*, published
by U.S. Camera, New York, 1944

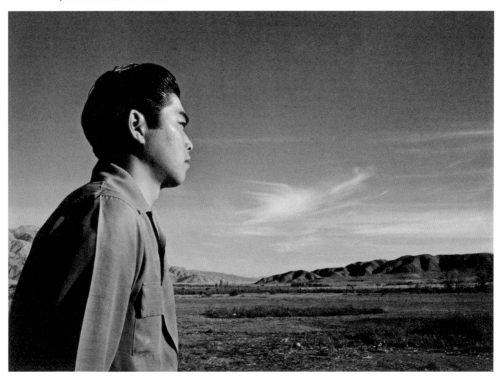

MOST OF THE LAND IS ARID. . . .

18

19

with racial phobias and commercial interests. Of course the fact remains that an American citizen with assured loyalty has all the rights that you and I have, but the big business boys have the unfortunate gift of vaporizing the Constitution when their selfish interests are concerned.[19]

Adams's distrust, however, did not extend to government policy. He, along with the majority of the general public, easily accepted the concepts of military necessity in the possibility of an objective determination of "alien loyalty"—concepts that served as the primary justifications for the evacuation internment. Adams grandly proclaimed that "the distinction between the loyal and disloyal elements must be made crystal clear, and the emphasis on the constitutional rights of loyal minorities placed thereon to support one of the things for which this war is all about. The War Relocation Authority is doing a magnificent job, and is firm and ruthless in their definitions of true loyalty."[20] In this light, the actions mandated by Executive Order 9066 are indeed unfortunate but nonetheless justifiable. Taken one step further, it could be rationalized that while the wholesale relocation of a group of primarily American citizens was a difficult and unfair solution during a time of war, it was also an understandable price to pay. Thereby, in a classic catch-22, unwillingness by Japanese Americans to accept the abrogation of their rights as citizens would call into question their very right to citizenship. In a 1943 letter to curator Nancy Newhall written during his project at Manzanar, Adams tacitly acknowledges this assumption when he describes his work as an attempt to "clarify the distinction of the loyal citizens of Japanese ancestry, and the disloyal Japanese citizens and aliens (I might say Japanese-loyal aliens) that are stationed mostly in internment camps."[21]

Using a narrative format that might also be classified as cinematic, *Born Free and Equal* incorporates a sequence of sixty-six images with accompanying captions and explanatory text. The material is presented in much the same way that a photographic essay might have been in a picture magazine of the period, such as *Life*. The structure of words and pictures is designed to lead the viewer in an expository manner toward a prescribed response and conclusion. To accomplish this, Adams arranged his images into three major sections, which are supported by smaller but strategic subsections that function as introductions, punctuation, and transitions to the whole. Roughly outlined, the larger sections consist of a series of landscapes, followed by a section of genre images, and finally a suite of military portraits. It was important to Adams that his essay convey what he felt was the correct tone. As he remembered the process later, "I was profoundly affected by Manzanar. As my work progressed, I began to grasp the problems of the relocation and of the remarkable adjustment these people had made. It was obvious to me that the project could not be one of heavy reportage with repeated description of the obviously oppressive situation. With admirable strength of spirit, the Nisei rose above despondency.... This was the mood and character I determined to apply to the project."[22]

The initial landscape section establishes location and functions as a leitmotif that surfaces intermittently throughout the entire sequence of images. This motif is also central to Adams's interpretive agenda: "I believe that the acrid splendor of the desert, ringed with towering mountains, has strengthened the spirit of the people of Manzanar."[23] Adams inserted this verbal affirmation of his belief in the spiritual power of the land in support of images consistent with those for which he had gained celebrity and artistic distinction. At the outset, he employs dramatic and majestic interpretations of the natural landscape of Owens Valley to indicate his position as an artist in the dialogue.

19 Ansel Adams, in *Ansel Adams: Letters and Images, 1916–1984*, ed. Mary Street Alinder and Andrea Gray Stillman (Boston: Little, Brown, 1988), 144.
20 Ibid., 144–45.
21 Ibid., 144.
22 Adams, *Ansel Adams: An Autobiography*, 260.
23 Adams, *Born Free and Equal*, 9.

Ansel Adams, view south from
Manzanar to Alabama Hills, Manzanar
War Relocation Center, 1943

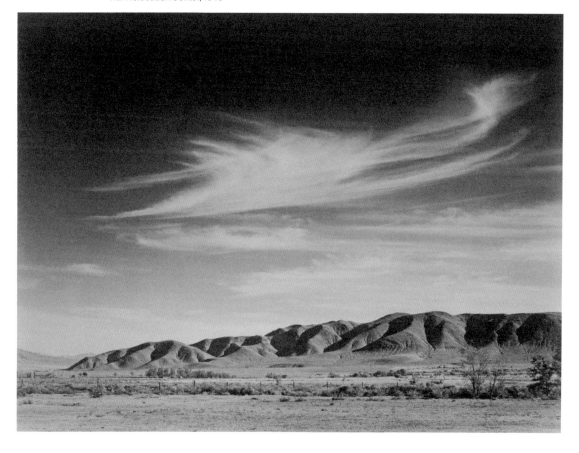

Ansel Adams, potato fields, Manzanar
War Relocation Center, 1942

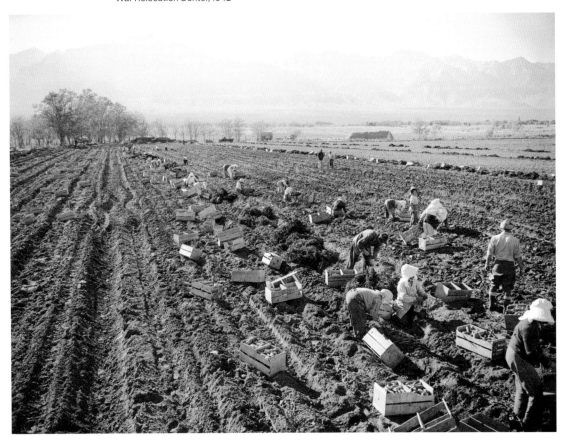

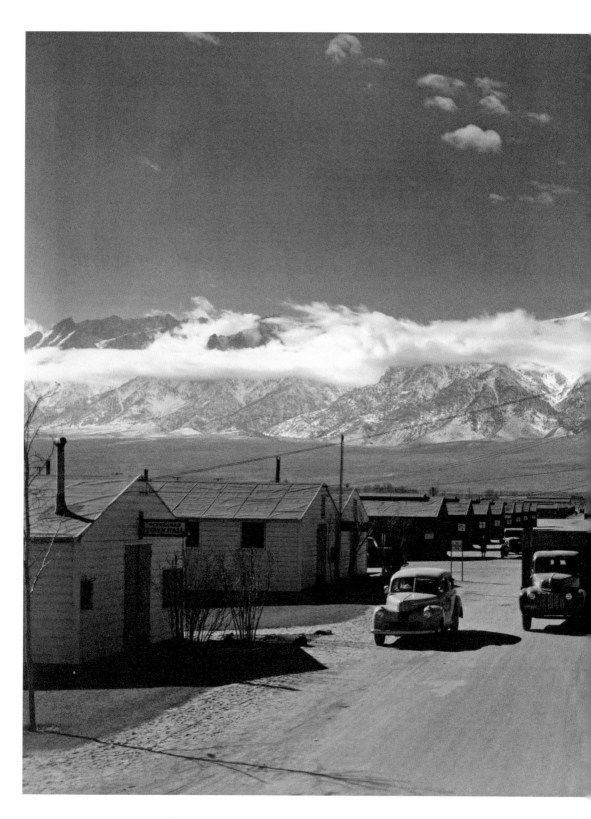

Ansel Adams, Manzanar street scene, spring,
Manzanar War Relocation Center, 1942

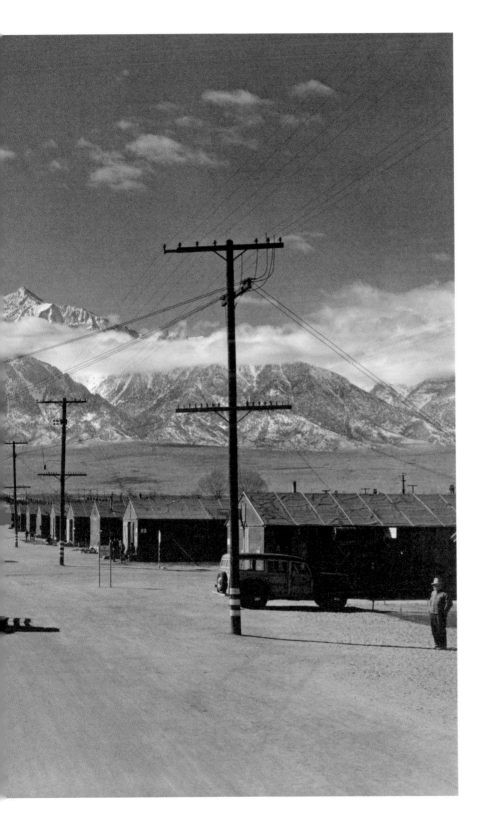

Thus, he immediately establishes that *Born Free and Equal* is above all an expressive and artistic undertaking consistent with his work as a whole. From this perspective, the work escapes Adams's own damning classification of being mere documentary or reportage and therefore "barren of human or imaginative qualities."[24]

Adams's agenda—despite his previous protestations of neutrality—is sentimentally evinced in the frontispiece and title page, which depicted a young Japanese American man pensively staring across a wide landscape in which cultivated fields give way to the foothills and mountains of the eastern Sierra. Apart from the oblique reference supplied by the cultivated cornfield, there is no evidence of the camp in the image. Never in the entire essay does the barbed wire that surrounded the camp or the surveillance watchtowers that ring the compound appear.[25] The mountains that stretch across the horizon seemed to be the only barrier between the prisoners and their former lives. The image affirms the intimate relationship between the incarcerated Japanese Americans and the land, emphasizing the reflective longing of the lone figure who looks across the land back to his life before incarceration. The image provides a stoic psychological context for the pictures that follow.

The landscape section gives way to a long sweep of genre images that portray everyday activities and social situations with which Adams's audience would easily identify. Photographs of family life, work, education, recreation, worship, and community spirit are engineered to stress the commonality of those in the camps with those outside of them. Adams's agenda is furthered as he includes images such as that of a smiling young Japanese American girl, under which the caption "An American School Girl" appears. He signals his intent to reintegrate visually the people held at Manzanar with the general American population.

The genre section is punctuated throughout with single portraits, and it is interrupted twice by small three-picture sequences. The first is an extended look at members of a single family; the next is a character sketch of one young nurse shown in a formal portrait, a scene at work, and

one at play. Viewers are thereby encouraged to relate to these people as personal acquaintances and to develop a sense of familiarity. A more substantial interruption to the genre section is an almost typological sequence of ten male portraits. Adams seems to be inviting both scrutiny and comparison in this suite of portraits. By highlighting each person's individual features, style, and character, Adams challenged his viewers to question their adherence to racial stereotyping.

The last, and smallest, of the sections is a series of six portraits of Japanese Americans in the military; these serve to integrate the Manzanar experience into the broader national experience of the war effort. If the earlier section sought to prove that not all Japanese Americans looked alike, here—using the surest symbol of patriotic loyalty at the time, the uniform of the U.S. Armed Forces—he refutes the link between people of Japanese heritage and the enemy. In a coup de grâce, Adams ends his photo-essay with an uncaptioned portrait of a Japanese American man. Tightly cropped and directly facing the viewer, the image is confrontational in its severity. If one accepts Adams's statement of intent and his essay strategy, then this final image is a shaming appeal to the conscience of the artist's fellow citizens. Adams is challenging the dominant European American population to acknowledge its racial stereotyping and to provide for the reintegration of Japanese Americans into the social fabric.

24 Ibid., 112. Adams would emphasize this distinction throughout his career. He and Dorothea Lange worked together on a project for *Fortune* magazine in which they photographed "the flux of humanity in the great shipyards of Richmond, California." Speaking later of the project and of Lange, Adams noted, "At Richmond I was exposed to a cross-section of sheer brutal life that exceeded anything in my experience. Dorothea Lange and I worked on the interpretive problems for *Fortune*. Dorothea is a superb person and a great photographer *in her particular field*" (emphasis added). Adams, in *Ansel Adams: Letters and Images*, 154.
25 Indeed, the use of images that included these elements was forbidden by WRA policy.

Ansel Adams, school children, Manzanar
War Relocation Center, California, 1943

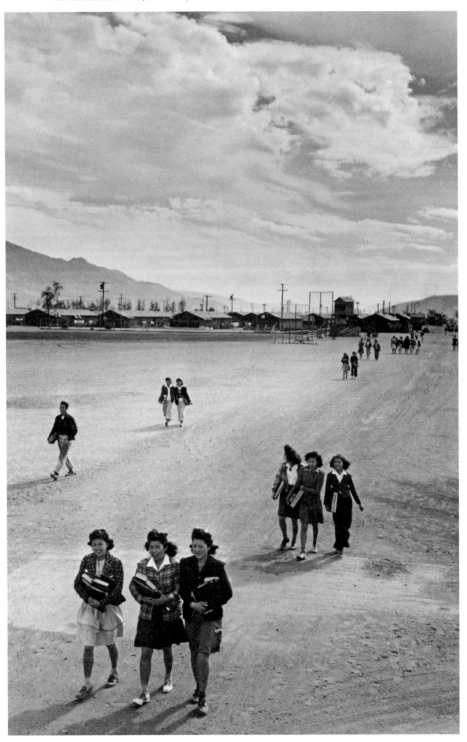

Ansel Adams, Mr. & Mrs. Dennis Shimizu,
Manzanar War Relocation Center,
California, 1943

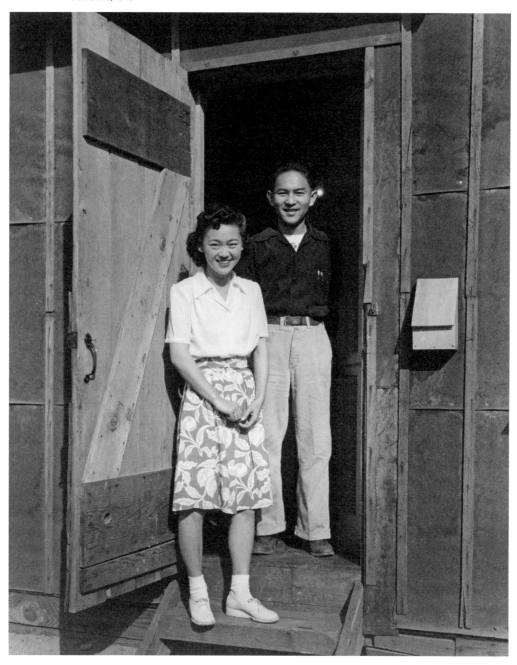

Ansel Adams, Roy Takeno, editor (far left), with Yuichi Hirata and Nabou Samamura reading a newspaper in front of an office, Manzanar War Relocation Center, California, 1943

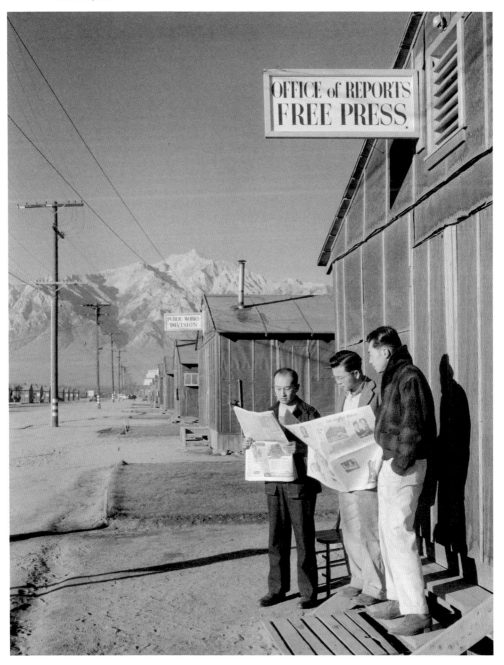

Ansel Adams, Miss Kay Fukuda, U.S.
naval cadet nurse, corps head, 1943

Ansel Adams, Toyo Miyatake
(photographer), 1943

Toyo Miyatake, from Manzanar
collection, 1943

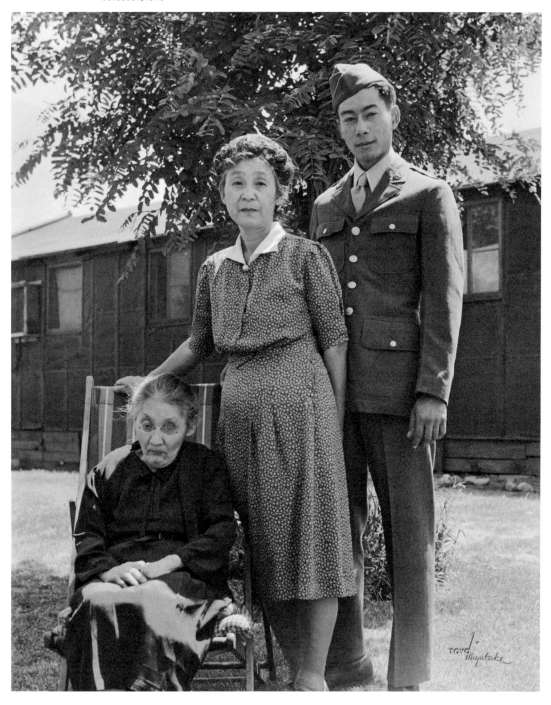

Adams was both praised and criticized for his work at Manzanar. Dorothea Lange presented the most critical appraisal of his project, calling the ultimate result "shameful" in its timidity but acknowledging that "it was far for *him* [Adams] to go."[26] Yet the incarcerated Japanese Americans at Manzanar were for the most part very pleased with the work Adams did in the camps, even purchasing prints from the exhibition there.[27] The exhibition at the Museum of Modern Art in New York was well attended and even prolonged beyond the original closing date to accommodate public demand. Adams's photographs were the most notable extended body of images available to the public to portray the "realities" of life in the concentration camps until the work of Japanese American photographer and Manzanar inmate Toyo Miyatake came to light.[28]

Miyatake played an important role during Adams's visit to Manzanar, allowing Adams to use his darkroom and introducing him to both the physical site of the camp and the people. Photographs of Miyatake and his family were even featured in the exhibition and publication *Born Free and Equal*. Miyatake was the de facto photographer of Manzanar. He had snuck a lens and film holder into the camp and found a carpenter friend who secretly used a threaded pipe and scrap wood to construct a wooden camera. In the initial months of incarceration, Miyatake clandestinely photographed with film smuggled from Los Angeles. The camps were laid out on grids designed to maximize order and surveillance and to minimize privacy. Each of the thirty-six "blocks" of Manzanar had communal latrines, a mess hall, and fourteen barracks, which, in turn, were divided into compartments housing as many as five families. Hence, it is not surprising that Miyatake's secret activities were easily discovered by the Manzanar administration. But rather than punish Miyatake, Manzanar director Ralph Merritt allowed him to set up an officially sanctioned photography studio as part of the comprehensive inmate-run Manzanar Cooperative. The ironing building of Block 30 became the home of the studio. To follow the letter of the law, which prohibited the ownership and use of photographic equipment by Japanese Americans, Merritt required that a European American activate the camera's shutter. The official photographer was actually a series of people graciously lent by Merritt's office who complied with instructions from Miyatake. After a few weeks, Merritt abandoned this requirement, and Miyatake was essentially free to photograph as he wished.

Born in Japan in 1895, Miyatake immigrated with his family to the United States in 1909. At twenty-one, he began his formal study of photography with Harry Shigeta, and in 1923 he opened his own photographic studio in the Little Tokyo section of Los Angeles. Throughout the 1920s and 1930s, Miyatake took portraits and photographed weddings and funerals, thus documenting Japanese American life. At the same time, he and other Japanese photographers—many of whom were key members of the Japanese Camera Pictorialist Club (Miyatake was not an official member)—produced some of the more significant photographs in California.[29] Miyatake participated

26 Karin Becker Ohrn, *Dorothea Lange and the Documentary Tradition* (Baton Rouge: Louisiana State University Press, 1980), 148.
27 "Pictures Available," *Manzanar Free Press*, April 29, 1944, 2.
28 See Graham Howe, Patrick Nagatani, and Scott Rankin, eds., *Two Views of Manzanar: An Exhibition of Photographs by Ansel Adams and Toyo Miyatake* (Los Angeles: UCLA Wight Art Gallery, 1978). It should also be noted that the husband-and-wife photographic team of Hansel Mieth and Otto Hagel also produced a little-seen but highly praised body of work under the auspices of *Life* magazine at the Heart Mountain War Relocation Center, soon after Adams finished his work at Manzanar.
29 See Dennis Reed, *Japanese Photographers in America, 1920–1945* (Los Angeles: Japanese American Cultural and Community Center, 1985); and Dennis Reed, "Southern California Pictorialism: Its Modern Aspects," in Michael G. Wilson and Dennis Reed, *Pictorialism in California: Photographs, 1900–1945* (Los Angeles: J. Paul Getty Museum and Huntington Library, 1944).

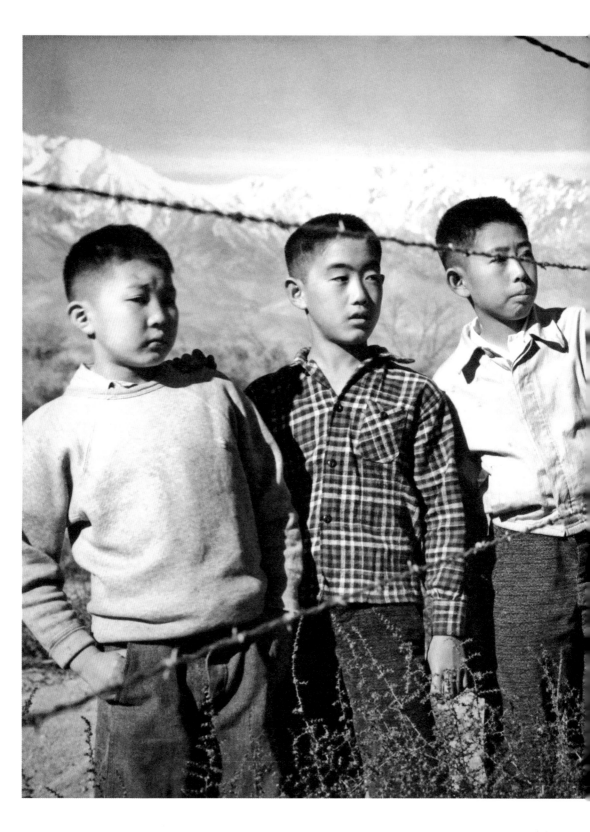

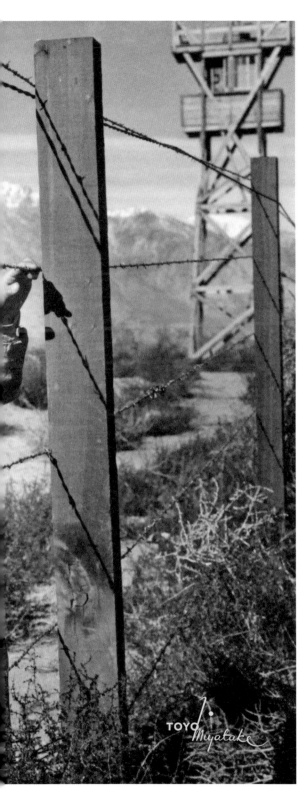

Toyo Miyatake, from Manzanar
collection, 1943

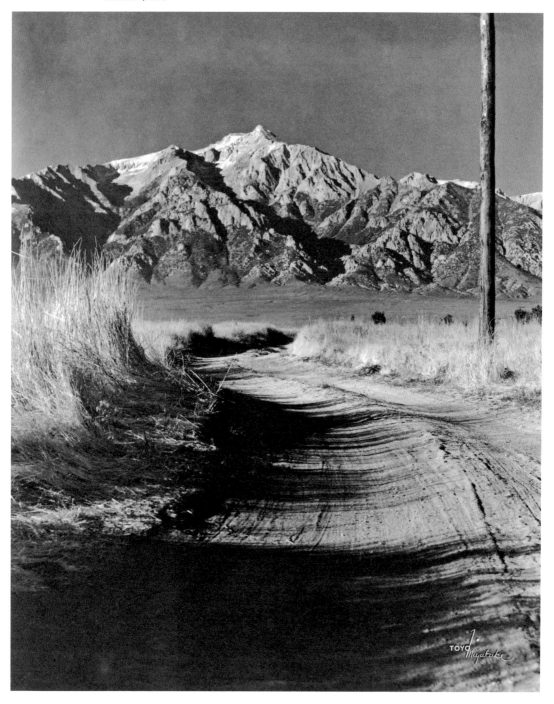

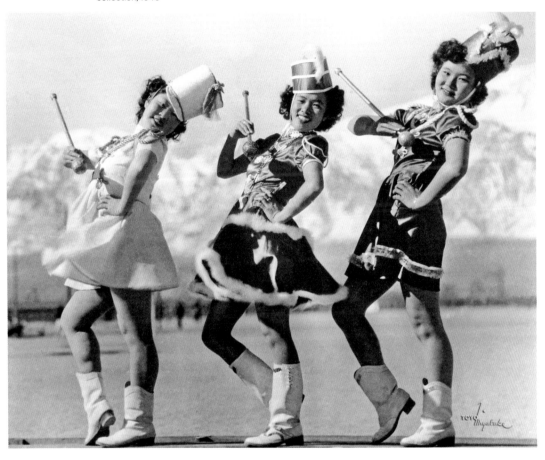

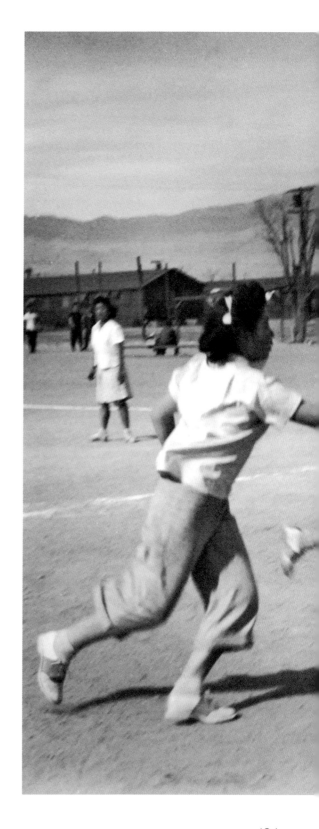

Toyo Miyatake, from Manzanar
collection, 1943

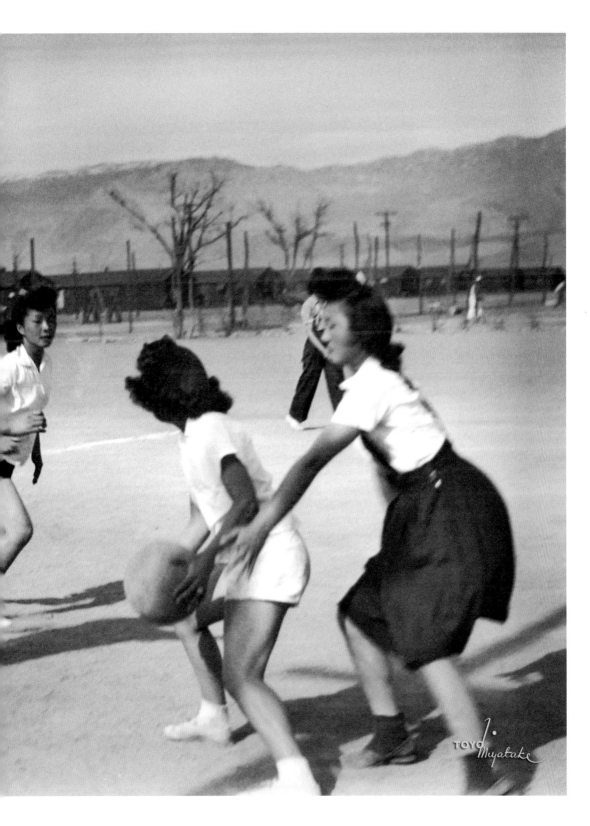

in international and national photography salons, photographed the 1923 Olympics as a correspondent for the *Asahi Shimbun*, and produced a remarkable series of photographs of the choreographer Michio Ito.[30] Miyatake's association with the Shaku-do-sha, an interdisciplinary group of painters, poets, and photographers based in Little Tokyo "dedicated to the study and furtherance of all forms of modern art," provided a vehicle for discussion, exhibition, and support for artists in Little Tokyo.[31] These activities included exhibitions of Edward Weston's work during the 1920s. Miyatake's profound and frequent connections with individuals and pursuits apart from the ethnic enclave of Little Tokyo gave him a special position as both insider and outsider in his photographic practice.

In Manzanar, Miyatake's services were immediately sought out. The studio essentially began where it left off before the war. The high demand necessitated a system of rationing, whereby coupons were distributed to block managers, who then disbursed these to families based on various events: weddings or the departure of a son for service in the U.S. Armed Forces ranked high in priority. In addition to photographing family rites, Miyatake roamed the camp and its environs in his trademark black beret, making photographic notes on the physical, natural, and built surroundings. The incongruity of a fully functioning photography studio within the confines of a concentration camp attests to the strange dichotomies that characterize the incarceration. On the one hand, the government took great pains to exclude and detain Japanese Americans, stripping them of their most basic civil liberties. On the other hand, the infrastructures within the camps simulated those of a free city.

When the high school initiated ambitious plans for creating a "real" yearbook, Miyatake and the studio were the crucial elements. The resulting publication embodied the first opportunity to see the comprehensive photographic record of Manzanar created by Miyatake. More than one thousand copies of the yearbook were presold to the students and other inmates months before its publication; this group constituted more than 15 percent of the Manzanar population. Manzanar High School was a responsibility of the camp administration and, as such, was an official arm of the WRA. The yearbook of 1944, *Our World*, had all the hallmarks of a midcentury high-school annual, with only oblique references to the world war and the circumstances that produced this "city" in the desert. The voice of its teenage editors clearly emerges, as evidenced by the first sentence of the foreword, which begins by stressing that "the students and faculty have been trying to approximate in all activities the life we knew 'back home.'" And indeed, in what follows, the student editors of *Our World* strove to create in pictures and words a world seemingly unmarked by the ravages of war and the abrogation of rights represented by the incarceration. The students also explicitly aimed for *Our World* to be a "history book of Manzanar, with the school emphasized as the center of the community."

The yearbook represented a tremendous organizational and financial feat. Measuring twelve inches high and nine inches wide, its heavy stock cardboard cover and seventy-five pages convey an aura of stability and longevity at odds with the facts of Manzanar and the high school's recent vintage. While funds were allocated for annuals as part of the school's budget, the student editors used their entrepreneurial skills (such as preselling the book) to leverage the initially modest amount of money. Despite the strong sense of student control, involvement, and funding, the fact remains that the yearbook bore a direct relationship to the official administration of Manzanar. The first fifty pages are devoted to the life of the high school: the classes, activities, clubs, boys' and girls' sports. By and large, the layout and photographs follow the

30 See Helen Caldwell, *Michio Ito* (Berkeley: University of California Press, 1977), 72.
31 From a July 7, 1927, article in artist Tokio Ueyama's scrapbook. See also Karin Higa, "The View from Within: Japanese American Art from the Internment Camps, 1942–1945," in this book, 34–77.

Cover (with inscription) of *Our World,*
1943–1944: Manzanar High, 1944

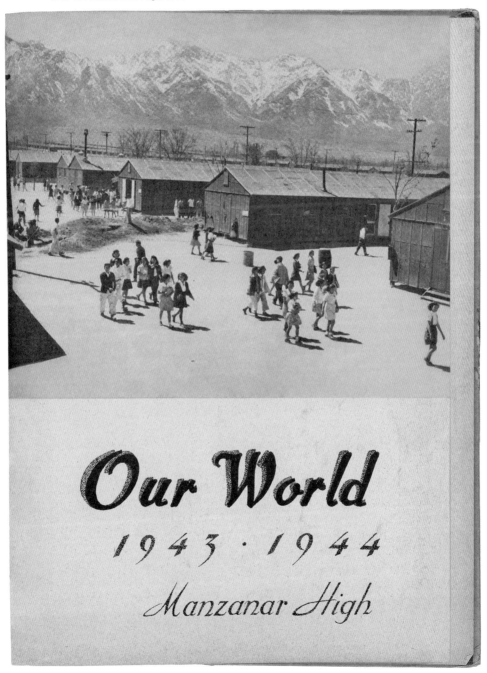

Our World
1943 · 1944
Manzanar High

Pages (with inscriptions and autographs)
from *Our World, 1943-1944: Manzanar High*, 1944

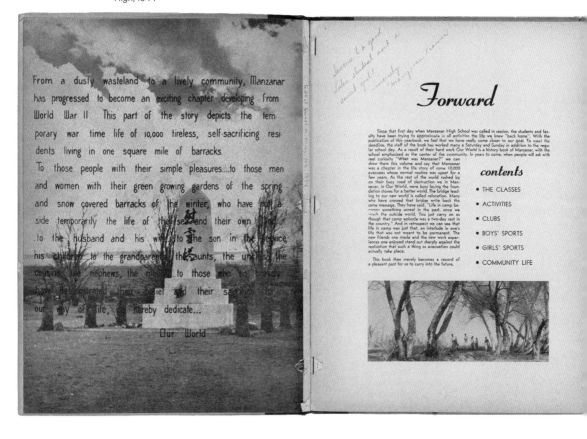

From a dusty wasteland to a lively community, Manzanar has progressed to become an exciting chapter developing from World War II. This part of the story depicts the temporary war time life of 10,000 tireless, self-sacrificing residents living in one square mile of barracks.

To those people with their simple pleasures....to those men and women with their green growing gardens of the spring and snow covered barracks of the winter, who have put aside temporarily the life of they used and their own and to the husband and his wife to the son in the service, his children to the grandparents the aunts, the uncles the cousins the nephews, the niece to those who so bravely have sacrificed their labor and their sacrifice for our way of life, hereby dedicate...

Our World

Forward

Since that first day when Manzanar High School was called in session, the students and faculty have been trying to approximate in all activities the life we knew "back home". With the publication of this yearbook, we feel that we have really come closer to our goal. To meet the deadline, the staff of the book has worked many a Saturday and Sunday in addition to the regular school day. As a result of their hard work Our World is a history book of Manzanar, with the school emphasized as the center of the community. In years to come, when people will ask with real curiosity "What was Manzanar?" we can show them this volume and say that Manzanar was a chapter in the life story of some 10,000 evacuees whose normal routine was upset for a few years. As the rest of the world rushed by on their busy road of destruction we in Manzanar, in Our World, were busy laying the foundation stones for a better world. The bridge leading to our new world is called relocation. Many who have crossed that bridge write back the same message, They have said, "Life in camp becomes something unreal in the past, once we reach the outside world. You just carry on as though that camp episode was a two-day rest in the country." And in retrospect we can see that life in camp was just that, an interlude in one's life that was not meant to be permanent. The new friends one made and the new work experiences one enjoyed stand out sharply against the realization that such a thing as evacuation could actually take place.

This book then merely becomes a record of a pleasant past for us to carry into the future.

contents

- THE CLASSES
- ACTIVITIES
- CLUBS
- BOYS' SPORTS
- GIRLS' SPORTS
- COMMUNITY LIFE

conventional language of a high-school annual: the camp and school administrators are shown at their desks, pages of collaged photographs give the effect of snapshots taken throughout the year, and small head shots of smiling faces depict well-groomed youngsters in regulated rows. (One anomaly: under each student's photograph, after the name, a second line lists his or her "home" high school.) In the activities section, the Baton Club is shown in full costume, the future farmers hold rabbits in their arms, a young journalist reads *Life* magazine, and students perform in a drama production.

The second section of the annual turns its focus on life beyond the high school. It begins with the section "Democracy," which bears the caption "Democracy at work" under photographs of a town-hall meeting of block managers (with an American flag prominently displayed on the wall), a group of nisei soldiers, and the Manzanar police. The following pages cover "industry," "agriculture," "religion," and other aspects of life in Manzanar. It is difficult to reconcile the severe and harrowing experiences of incarceration with this seemingly contradictory picture of utter normality. Inmates experienced anxiety about their future coupled with daily reminders of their losses of freedom, livelihoods, and possessions, as well as (though unquantifiable) their dignity and sense of individual agency. Yet life proceeded in a hyperreal enactment of business as usual. In addition to the experience of births, deaths, weddings, and funerals, there were inmate-run farms, a cooperative store, a research laboratory, the *Manzanar Free Press* newspaper, a garment factory, an orphanage, a hospital, an internal system of government, Buddhist and Catholic and other Christian churches, ball games, and an inmate-created garden. Representations of all these aspects of daily life were part of *Our World.*

Miyatake and his studio took the vast majority of the photographs in *Our World*, though a few images were supplied by Adams. The incorporation of both Adams's and Miyatake's photographs provide one way to track how the form of the yearbook presents a specific context that changes the meaning of the individual image. High-school yearbooks are about conventional stories: the exuberance of youth transformed through education and friendship into adulthood. *Our World* contains the self-conscious "memories" of the experience, already considered in the past tense, as the book simultaneously exists in the present. This conscious fashioning of the experience of youth takes on greater weight in the context of the concentration camps. The incarceration was predicated on visual identification of the enemy. Japanese Americans, especially nisei, internalized the surveillance of the outside world so that the performance of "Americanness" takes place at all times. Young nisei were clearly aware that their ancestry marked them as different, a difference that was cast pejoratively. The success of Miyatake's contributions to *Our World* hinges on his canny ability to service his "clients"— the students; at the same time, his photographs provide a richness of detail that heightens the irony that their "all-American" experience is taking place in confinement. In *Our World*, Miyatake avoids both direct critique and sentimental juxtapositions of signs of freedom with signs of containment. Instead, the photographs register as naive documentation, seemingly without artful construction or a documentary edge that reveals hidden truths. In using the conventional language of yearbook illustration, Miyatake succeeds in highlighting what might be missed, although in plain sight, producing implicit meanings in addition to creating conventional yearbook illustrations. The surplus of information in the photographs duplicates the excessive attempts to be "normal" and, in the process, underscores the absurdity of the incarceration itself.

The ability of Miyatake's photographs to serve as more than artifactual documentation is made explicit by comparisons with other photographs of Japanese Americans in the camps. Restrictions against Japanese Americans owning or operating cameras continued, but by the middle years of incarceration, snapshots, as well as formal photography of camp activities, were increasingly common. It is unclear how many of

Pages (with inscriptions and autographs)
from *Our World, 1943–1944: Manzanar High*, 1944

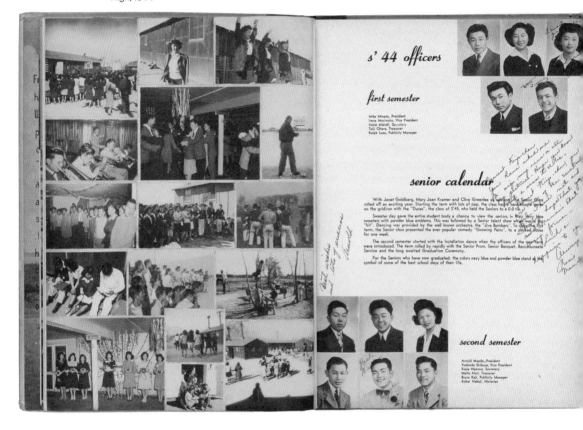

s' 44 officers

first semester

Mike Minato, President
Irene Morimoto, Vice President
Rosie Maruki, Secretary
Teiji Ohara, Treasurer
Ralph Lazo, Publicity Manager

senior calendar

With Janet Goldberg, Mary Jean Kramer and Clive Greenlee as advisors, the Senior Class rolled off an exciting year. Starting the term with lots of pep, the class had a hard-fought game on the gridiron with the "Duces", the class of S'45, who held the Seniors to a 0-0 tie.

Sweater day gave the entire student body a chance to view the seniors in their navy blue sweaters with powder blue emblems. This was followed by a Senior talent show which was a big "hit". Dancing was provided by the well known orchestra, the "Jive Bombers". To close the first term, the Senior class presented the ever popular comedy "Growing Pains", to a packed house for one week.

The second semester started with the Installation dance when the officers of the new term were introduced. The term rolled by rapidly with the Senior Prom, Senior Banquet, Baccalaureate Service and the long awaited Graduation Ceremony.

For the Seniors who have now graduated, the colors navy blue and powder blue stand as the symbol of some of the best school days of their life.

second semester

Arnold Maeda, President
Yoshiaka Shibuya, Vice President
Rosie Hanawa, Secretary
Meito Hori, Treasurer
Bruce Kaji, Publicity Manager
Kohei Nakaji, Historian

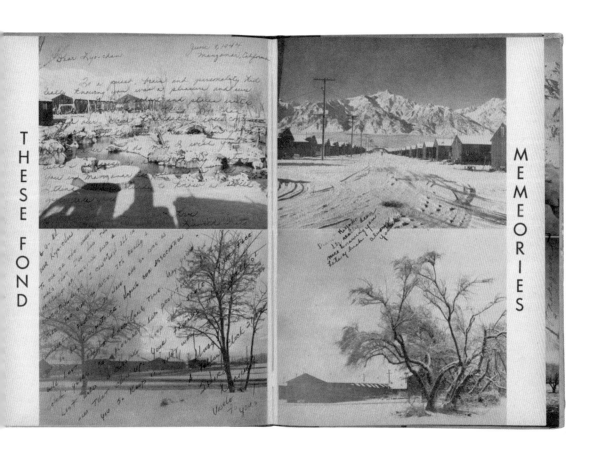

THESE FOND

MEMEORIES

these photographs were produced by Japanese Americans and how many were the work of European American staff or camp administrations. While these photographs succeed in capturing moments of individual and collective experience, they do not possess the formal rigor of Miyatake's work. Miyatake employs the standardized language of the snapshot and group picture, but through his emphasis on the telling details, the photographs contain an added layer of information, one that subtly critiques the experience.

The photo-essay that opens *Valediction*, the yearbook of the Manzanar High School class of 1945, demonstrates this skill and perhaps most explicitly reveals the ways in which Miyatake's photographs operate. Unlike the large-scale *Our World*, *Valediction* modestly documents the final graduating class of Manzanar. Its construction-paper cover and staple-bound pages lack the weight and ambition of *Our World*. Much has changed in the intervening year. The United States was clearly heading toward victory, and hostility against Japan was lessening. The all-Japanese American 442nd Regimental Combat Team's success and valor in Europe served as incontrovertible proof of Japanese American loyalty, resulting in a less fervent, less desperate emphasis on the hyper-Americanism that had characterized the earlier year. With the exclusion orders authorizing incarceration officially lifted, the Manzanar population continually declined, as more inmates relocated to the Midwest and East Coast. War would soon be over. Manzanar would cease to exist.

An elegiac tone tinged with a more nuanced criticality pervades *Valediction*. The first page features a Miyatake photograph of an empty road, curving and receding into dark shadows. The majestic peak of Mount Williamson towers over the solemn road. The following spread features this text:

> In these years of strain and sorrow one may easily become discouraged and think of the future only as an empty dream. If we are to meet the world with these difficulties and trials, we must not let ourselves be

> "Made weak by time and fate."
> Rather like the mariners in "Ulysses" we must
> "Be strong in will to strive, to seek, to find and not to yield."
> So... to the Future with its joys and sorrows... not to goals that are found only in the minds of youths but to the achievement of these goals this book is dedicated.

On the page facing this text, a photograph depicts in the foreground the wheel of a tractor whose spokes form an iron enclosure; in the background are the barracks and snow-capped mountains. A barbed-wire fence, rough-hewn electrical poles, and the wires strung between them create a diagonal thrust that contrasts with the massive, rectangular forms of the barracks and with the circular iron wheel. This interlocking web of barriers is captioned with the text "from 'Our World.'"

Turning the page, the viewer is confronted with the arm of a young person (the model was Miyatake's son Archie) holding a wire clipper—at the moment before cutting—to the taut barbed wire of a fence. A watchtower looms in the background. The caption reads, "through these portals." On the facing page, the caption continues, "to new horizons," with a photograph of a young couple stepping forward with a suitcase in hand. This attractive, well-dressed couple is shot from a low camera angle to suggest a fresh-faced monumentality. Miyatake is careful to situate the tableau in the physical context of Manzanar—the Manzanar sentry station is clearly visible.

In these pages, photographs like ones found in *Our World* take on new meaning through their clearly articulated and simple layout. The text alludes to the literal product of *Our World* and plays on its multiple meanings, while explicitly raising the difficulties forthcoming for the inmates now that they must return to the hostile environment that had previously excluded them. Archie Miyatake recalls that his father created these photographs before it was decided to use them for the yearbook. It is clear

Toyo Miyatake, image from the opening
sequence of *Valediction*, Manzanar
High School yearbook, 1945

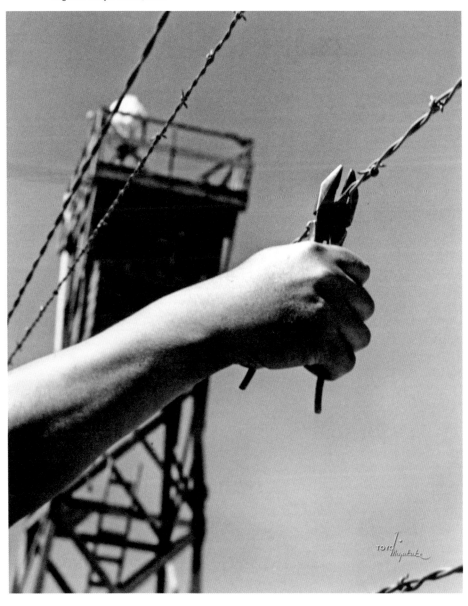

that the photographs carefully craft a narrative of future ambiguity, enclosure, and isolation, followed by direct action and a hopeful future. All the while, the motifs and elements depicted in the photographs are the stock images that made up Manzanar. Miyatake uses these components, but through subtle manipulations of composition, camera angle, lighting, and sequencing, he creates another narrative that produces additional meaning.

The Manzanar High School yearbooks, Ansel Adams's *Born Free and Equal*, and the final report issued by the Western Defense Command employ pictorial and format strategies specific to each. In each case, the formats contribute to the manner in which the images and the ideological intent of the publishers are received. These programmatic approaches capitalized on the fact that images in a sequence carry with them familiar and accepted responses that have been built up through their widespread use. Family albums tell a distinct kind of chronological, genealogical, interpersonal, and relational history; scrapbooks and yearbooks convey a temporal and experiential narrative; annual reports and sociological studies rely on the photograph as a pictorial carrier of presumptive truth in order to support data. The choice of a presentation format is established as much by the organizer of the images as by the intended viewer. Each format produces particular responses that can be relied upon to produce a desired effect.

And yet, as disparate as their appearances and interests and intents may have been, all three of these pictorial records share a common element: an attempt to reconcile race and citizenship to visual representations in photographic form, seemingly in response to General DeWitt's callous remarks. The pictorial summary in the Western Defense Command's final report depended on the idea that a photograph conveys truth and on the familiarity of a chronological narrative format common to family albums to straightforwardly assert the images as incontrovertible evidence that would justify the evacuation. Underlying this strategy is the assumption that race took precedence over citizenship in a determination of loyalty. In contrast, Adams emphasized the importance of citizenship over race, as he exploited the proselytizing nature of the narrative photographic essay format. By virtue of its consistent point of view, pictorial authority, and inductive movement from the specific to the universal, the essay inexorably elicits from his audience a preordained response. His essay addresses a crisis in social conscience that allowed the nullification of the rights of Japanese American citizens. Miyatake's photographic contributions posit the drive to retain an American identity in the face of assaults on personal liberty, property, and political identity in the camps. Miyatake captures the relentless optimism and belief in American ideals among the incarcerated. At the same time, his photographs hint at the self-conscious fashioning of young Japanese American identity.

Toyo Miyatake, image from the
opening sequence of *Valediction*,
Manzanar High School yearbook, 1945

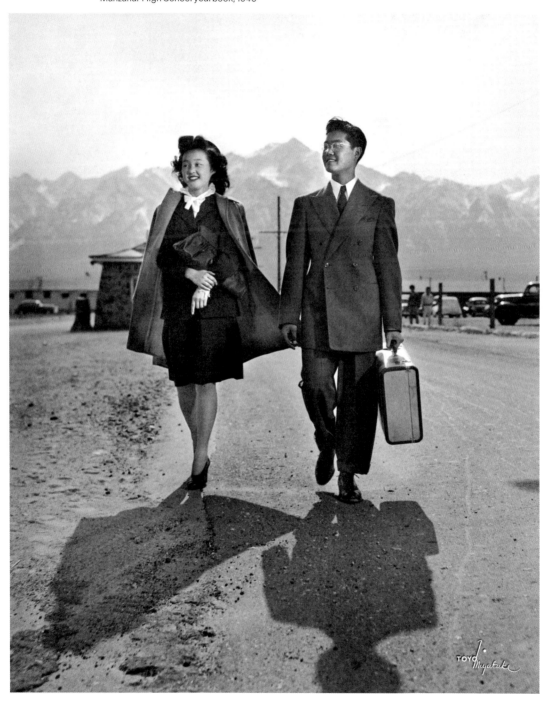

Henry Sugimoto: Painting an American Experience

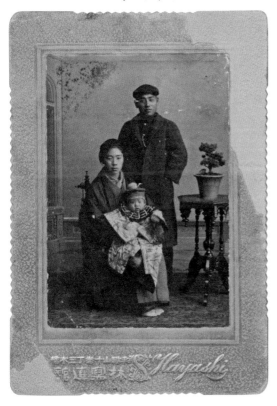

Henry Sugimoto and his parents,
Wakayama, Japan, 1900

It is a long way from the town of Wakayama in central Japan to West 146th Street in New York City's Harlem neighborhood, but Henry Sugimoto traversed this wide divide in more than just the physical sense. He was born in 1900 as the grandson of a displaced samurai and died in 1990 as an American painter. The paintings, sketches, prints, and drawings he made in the intervening years bear witness to a world of art and a world of politics in flux. The exhibition *Henry Sugimoto: Painting an American Experience* (2001), and the eponymous accompanying book, track Henry Sugimoto's art and life. They at once tell the story of an individual

painter's development and an examination of an immigrant's experience. The book looks at Sugimoto's art and life during his early years in California, Paris, and Mexico; at the transformative impact of the World War II incarceration of Japanese Americans; and at Sugimoto's increasingly self-conscious attempts to express personal and community history in visual terms during the 1960s and 1970s. The book and exhibition examine how it was that Sugimoto came to paint a distinctly American experience, one that embodied a heady belief in the power of art to exist outside of individual experience and to serve as a vehicle for critique, commentary, and the documentation of stories that would otherwise remain untold.

In 1990, the Japanese American National Museum received a substantial bequest of 142 paintings from all periods of Sugimoto's career. This body of work, remarkable in both scope and subject, revealed an artist who began his career to critical acclaim as an accomplished painter of still lifes and the landscapes of California and France, but whose identity as a painter and a citizen of the world was contested by the actions that the U.S. government took against Japanese Americans when it entered World War II. Viewing the bequests to the museum as well as another large holding of art in Wakayama, it became clear to the Japanese American National Museum that Sugimoto was a figure of historical significance, and we (cocurator Kristine Kim and I) began the long and careful process of research, conservation, analysis, and exhibition of selected paintings with the long-term aim of producing a major survey exhibition.

Sugimoto's legacy had been lovingly tended by his daughter, Madeleine Sugimoto, who is both a subject of and witness to her father's long career. Madeleine generously shared information and insights and welcomed Kristine and me into the home she had shared with her father. What we found there, at the end of the hall of the Sugimotos' modest yet large apartment, was Henry's studio: a room filled with clear northern light, left virtually intact since his death years before. A well-used palette

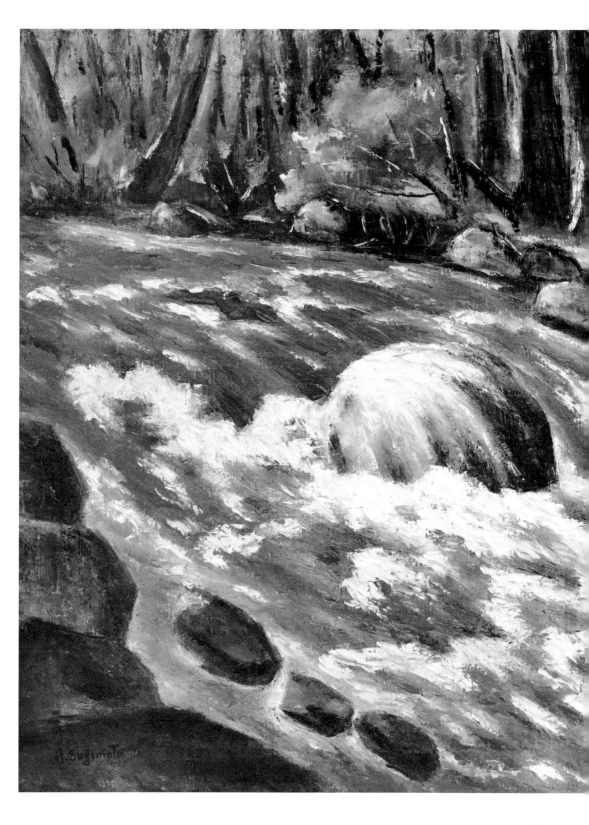

H. Sugimoto

Henry Sugimoto, *Yosemite Stream*, 1939.
Oil on canvas, 24 × 30 inches

Henry Sugimoto, *One Dollar for Nice Icebox, When the [he] Came Out (One Dollar for Nice Icebox, When War Broke Out) Evacuation*, 1942. Oil on canvas, 20½ × 25¾ inches

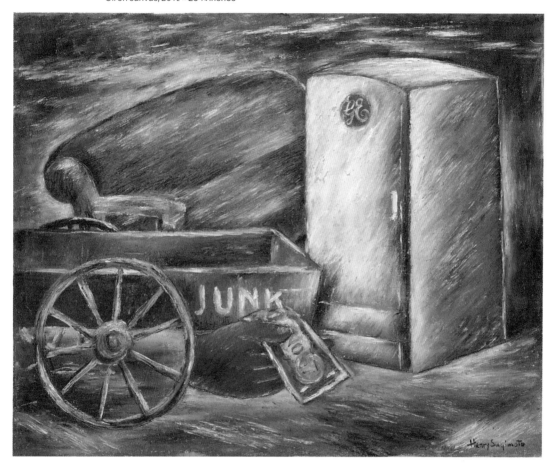

hung on the door of a cabinet filled with pencils, tubes of paint, sketchbooks, photographs, scrapbooks, and art. Homemade shelves extended to the ceiling, stuffed with portfolios, boxes of prints, unused supplies, and stacks of unstretched paintings, presumably removed from their stretchers to save space. In the span of a few hours, hundreds of works of art surfaced, astounding even Madeleine. Kristine and I were overwhelmed and elated as we realized that the Japanese American National Museum's collection—what we had believed to be the bulk of Sugimoto's remaining work—was just a fraction of what existed. As we pored through portfolios constructed of recycled cardboard boxes and perused Sugimoto's library of books, we stumbled upon major discoveries, minute by minute. One box held correspondence dating from the 1930s, including letters from museum directors throughout California and Christmas cards from friends in France. Sketchbooks from the 1930s sat neatly beside sketchbooks from the 1980s.

No sooner had we finished surveying the room than more things came out of corners and boxes. We had opened the floodgates to Sugimoto's life. Then we came upon the most startling find of all—a folder with the words "My Life Story" written on its cover. Inside were dozens of pages densely covered in Japanese. While we comprehended the magnitude of this find, it was only later, after Emily Anderson had carefully translated the material, that we fully appreciated what was there. Sugimoto's words filled out the broad contours of his biography in rich detail and a palpable sense of the man writing them. His voice, sense of humor, values, and perspectives rushed out from the pages of the story. Written when Sugimoto was seventy-eight, his life story contains facts, names, dates, and anecdotes that betray a remarkable clarity of mind. Using the resources of the Japanese American National Museum, in particular the historical expertise of curator Eiichiro Azuma, as well as the other ephemera, photographs, and papers we found in Sugimoto's studio, we have been able to construct a rich and layered sense of the artist, his life, his communities, and his art.

What became clear as our research progressed was the tremendous divide between the period before and after World War II. The crisis brought on by the mass incarceration of Japanese Americans had an immediate impact on Sugimoto's art. The beautiful and quiet studies of land, location, and light gave way, in subject matter and style, to a vigorous and fractured exploration of civil rights violated and the toll these violations took on his family and community. In the early days of incarceration, Sugimoto painted clandestinely, creating powerfully simple works like One Dollar for Nice Icebox, When the [he] Came Out (One Dollar for Nice Icebox, When War Broke Out) Evacuation (1942) that substantially differed from his prewar work. In this painting, a disembodied hand clasping a dollar clearly emerges from the wheel of a cart, while symbols of American domesticity—a new General Electric icebox and a teal sofa—are about to be hauled away. The painting is at once a metaphoric exploration of the forced removal of Japanese Americans and a documentation of an unfortunately common occurrence whereby many people exploited the tragic circumstances of Japanese Americans, buying their belongings for next to nothing in the days leading up to their hurried removal. Sugimoto creates a dramatic narrative here of disrupted homes and lost possibilities, using a newfound formal language to convey and comment upon his own experiences.

Sugimoto was determined to document the experiences of the war years and did so in complex ways that defy easy categorization. He visualized the tumultuous feelings and dire circumstances of the incarceration in his paintings, as well as the persevering drive to survive. It is this act of using his art to simultaneously critique and affirm, to document and interpret, to create and to disarm, that distinguishes his practice as a painter. In essence, Sugimoto began to identify as an American and an American artist at the very moment when his civil liberties and freedom of expression became compromised; the rhetoric of American ideals became real for Sugimoto only when those same ideals seemed lost. This

Sugimoto family on their barrack's porch at the Jerome War Relocation Center, Arkansas

Sugimoto joined his parents, who had immigrated before him and settled in the central California farming community of Hanford. His interest in the arts and subsequent matriculation at the California School of Arts and Crafts in Oakland would seem to have made him an anomaly in the Japanese immigrant communities of the 1920s. This was, after all, a decade of increasing legislative hostility toward Japanese immigrants, spurred by a highly organized anti-Japanese movement that rallied to stop immigration and limit rights of existing immigrants. Despite this unfavorable political context, Sugimoto found an open environment for the study and exhibition of his art in California, and a community of artists that included other immigrants from Europe and Asia. In the decades before World War II, Sugimoto's paintings appeared in many settings, from a 1933 one-person exhibition at the California Palace of the Legion of Honor in San Francisco to a group exhibition of "Oriental" artists in Los Angeles in 1934. Sugimoto exhibited in mainstream art venues, and he was part of an extensive network of exhibitions that included Japanese American painters. The catalogues, reviews, and correspondence of this period show a community of artists and audiences ranging from the San Francisco cultural elite to Japanese American communities throughout California. These various strands of Sugimoto's life suggest that a Japanese American artist could circulate freely in several milieus. During Sugimoto's travels to Paris and Mexico, he met Japanese artists along the way, demonstrating the extensive international presence of Japanese immigrants in the Americas and Europe. These factors force us to reassess our understanding and perception of early Japanese American experiences; the knowledge that Japanese immigrants and their experiences were far more diverse than is popularly recognized deepens awareness of the tremendous loss that Sugimoto and others suffered during and after the war and incarceration.

now crystallized identification as an American, albeit an immigrant American, is made visible as his art—subject matter and style—moved in new and provocative directions. It is this transformation that is at the core of *Henry Sugimoto: Painting an American Experience.*

Yet this project has import beyond an analysis of Sugimoto's life and art, for the mere facts of his life provide fresh insight into early Japanese American immigrant communities and expand the standard conceptions of that period. While many Japanese Americans came to the United States to work as laborers, others, like Sugimoto, had different aspirations.

The relationship between ethnicity and art is another topic of discussion raised by Sugimoto's story. Is there a Japanese American

aesthetic that can be read from the style or contents of his art? Sugimoto was fascinated by Western oil painting. During the prewar period, he painted the iconic California landscapes of Yosemite and the Carmel coast, as well as the French countryside and Mexican vistas during his 1939 visit. He was interested in the vocabulary of painters who came before him, many of them European or European American, and in the provocative possibilities opened up by the Mexican muralists José Clemente Orozco and Diego Rivera. As a Japanese immigrant to the United States, Sugimoto was forbidden by law to become a naturalized citizen or to own land; yet his second-class political status appeared to have little impact in the realm of prewar art and culture. What is significant about Sugimoto's reception during the period before the war is that his ethnicity was just one factor among many; it appears neither to have hindered nor accelerated the acceptance of his art. While the political rhetoric surrounding Japanese immigrants centered on the expectation that they could not become assimilated Americans, it was possible for a Japanese American artist to work outside these restrictive expectations and succeed.

In the years after World War II, Sugimoto rebuilt his family life and artistic life in New York's Upper Manhattan. In paintings of this period, he returned again and again to the incarceration but expanded his visual vocabulary to create complex narratives that balance critique with a highly charged expression of emotions. A story unfolds in each painting; cumulatively, the works create a visual history where none existed. This idea of painting history became a primary focus for Sugimoto from the 1960s until his death. He created canvases that capture the early history of the Japanese American immigrant experience, from the phenomenon of the "picture bride" to Japanese American labor and the drive to be accepted and valued in the United States. Visual interpretations of this history were nonexistent in the realm of art, an absence made all the more striking by Sugimoto's powerful canvases.

Yet a 1943 self-portrait shows Sugimoto as he ultimately desired to be remembered: not as a political activist or documentarian but as an artist. He stands at his easel erect, palette in hand and surrounded by his paintings, a still life and French landscape among them. Wearing his signature beret, he looks boldly at the viewer with an arresting gaze, while the easel holds a painting marked with the signature "H. Sugimoto." In 1931, while in France, he painted a similar self-portrait. In this earlier work, he also dons a beret and stands before a canvas, though it is blank. His posture is tentative, a stance further reinforced by the softness of his eyes, which appear to be searching rather than focused. The contrast between the two self-portraits highlights Sugimoto's maturation and his sharpened identity as an artist: although the latter canvas was created during Sugimoto's incarceration in the concentration camp in Jerome, Arkansas, it would not be the end of his painting but rather its beginning. Sugimoto defiantly looked out into the world and captured, in his work, experiences never before revealed on canvas.

Henry Sugimoto, *Mother in Jerome Camp*, 1943. Oil on canvas, 22 × 18 inches

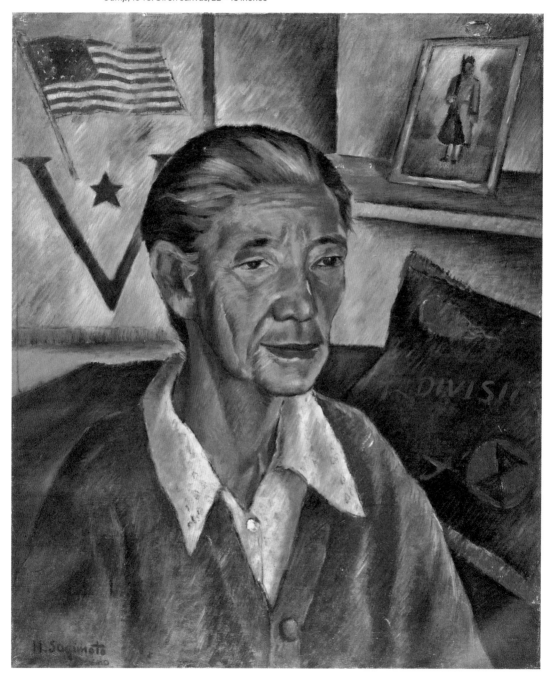

Henry Sugimoto, *Susie in Camp Jerome*,
1942. Oil on canvas, 17¾ × 14¾ inches

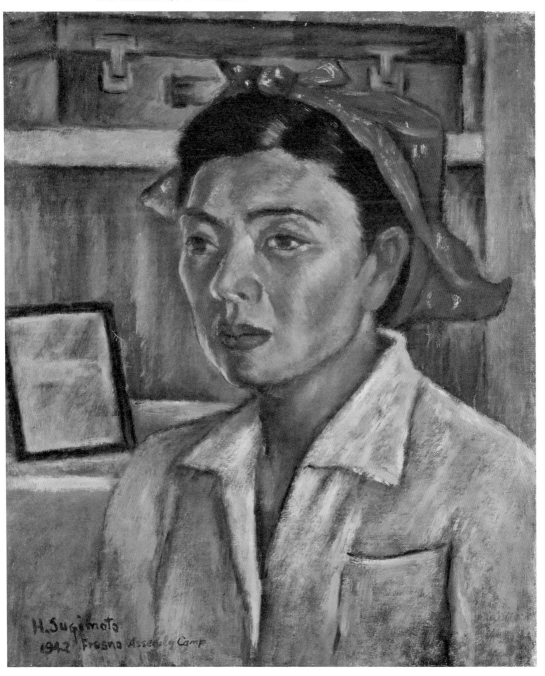

Henry Sugimoto, *Self portrait*, 1931.
Oil on canvas, 21¾ × 18 inches

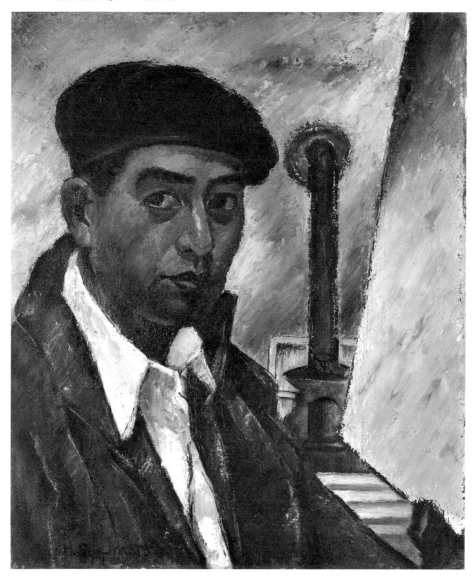

Henry Sugimoto, *Going to America*, 1980.
Oil on canvas, 32 × 25¼ inches

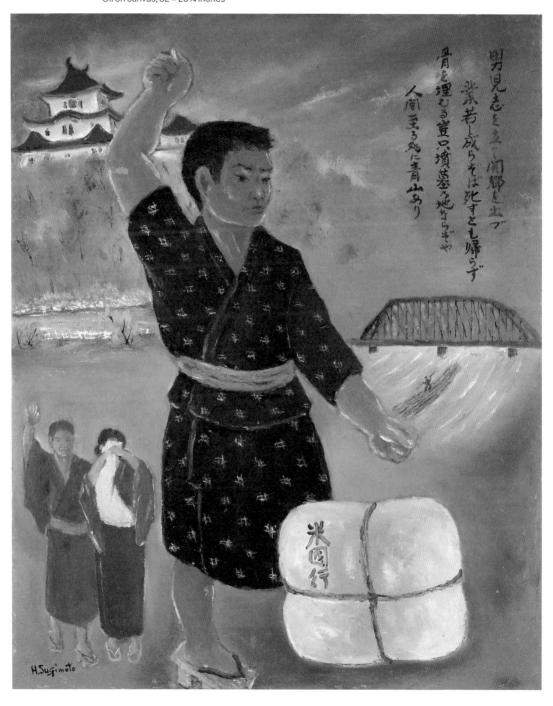

Living
in
Color:
The
Art
of
Hideo
Date

Hideo Date as a young man, ca. 1920s

Stanton Macdonald-Wright, he had worked on a Federal Art Project mural on Terminal Island in the 1930s, his work had been in significant exhibitions, and he and his good friend and fellow artist Benji Okubo were frequently characterized as dashing and charismatic figures whose paintings were intriguing and whose good looks and irreverent style created a stir.

Date was also a Japanese American issei, or immigrant. This raised even more questions. Who is this Japanese American artist, and what could he and his art tell us about the vital and engaging cultural life of Japanese Americans before World War II? So it was with shock and a bit of fear that I held onto the phone receiver. Had he just hung up on me?

Fast-forward seven years. Hideo Date, at age ninety-one, has decided that he is ready to talk to me about his art. One hot summer day, he walks spritely through the entrance of the Japanese American National Museum in Los Angeles with Wilbur Sato, the son of his old friend Justus Sato. With faded snapshots that document his paintings, he sits at the origami-making table in the museum's Legacy Center and, animated in a way that belies his advanced age, begins to tell me his story.

The next year, he allowed me to see the art firsthand at his apartment in Queens. My initial questions multiplied as I tried to make sense of his paintings and the circumstances of their creation, for Hideo Date's biography is at once a conventional story of a Japanese American immigrant and a complex narrative of art at the intersection of the United States and Japan; his experiences and his art prompt us to consider the rich and labyrinthine cultural life of prewar Los Angeles, where Asia, New York, Europe, and "Hollywood" encouraged, overlapped, and melded in a way that is only scantily understood. For Japanese Americans, this way of being would be irrevocably halted by wartime incarceration.

The basic facts about Hideo Date mirror the patterns of many Japanese. Date was born in Osaka, Japan, in 1907, the third son of Imasuke and Yusa Date. Shortly after Hideo was born, his father embarked for the United States, leaving Hideo, his mother, and his older

He hung up the phone, but not before he had politely, yet firmly, asked me not to call again. It was almost ten years ago. I was a young curator who had finally found Hideo Date (Hē-day-o Dah-tay) living in New York, in Queens. I had heard bits and pieces about Date and his art from a variety of sources, art historians and community folk alike. His was a name that had circulated on people's lips as an unknown and underrecognized find: an idiosyncratic personality who had lived in the heady days of pre–World War II Los Angeles, he had been associated with the American modernist

brothers behind while he attempted to establish a foothold in the United States. Over the next sixteen years, Imasuke gradually called his family to Fresno, California. In 1919, Hideo's mother and brothers joined him, and Hideo arrived in September 1923. While Date's father struggled to operate a hardware store, Hideo—like many young Japanese immigrants—alternately studied English and helped the family by working in the prolific orchards of central California. After bankruptcy forced the closure of the hardware store, the Dates moved to Los Angeles, where they settled in the Little Tokyo area.

Japanese immigrants to California during the early decades of the twentieth century faced many obstacles. State and federal legislation aimed to reduce the civil rights of Japanese Americans and halt further migration from Japan. During his first days in the United States, Date recalls that he saw the thing that made the biggest impression on him while he was on the train to Fresno: "I saw a big sign, 'Japs. Keep Moving.' I could read it, but I could not understand the meaning."[1]

Racism—overt and subtle—was a constant factor, but Japanese Americans found ways to subvert its effects, especially within their own growing communities and within the larger realm of education and culture. By the time the Dates arrived in Little Tokyo, the ethnic ghetto born of discrimination and racially restricted housing covenants had become a vital community of families, shops, businesses, churches, temples, schools, movie theaters, and restaurants. The community's infrastructure was complex enough to sustain fraternal and business associations, as well as a daily Japanese-language newspaper, the *Rafu Shimpo*, which added a weekly English supplement in the mid-1920s. Date found that, unlike his largely segregated existence in Fresno, life in Los Angeles offered him the opportunity to move freely through different milieus. Little Tokyo's boundaries, however real in terms of economic advancement and political rights, provided some degree of porosity on an everyday level. Japanese Americans left the enclave for work, study, and in some instances for leisure.

European Americans entered Little Tokyo to shop or conduct business. In the realm of the arts, Date would soon find that Little Tokyo supported a range of activities within the community, and that Japanese Americans had access to artistic resources outside of the ethnic enclaves as well. For European Americans who leaned toward the unconventional, especially artists, Little Tokyo functioned in two primary ways: on the one hand, its marginal status was a source of intrigue; on the other, visiting Little Tokyo was a way to catch direct glimpses of the arts and culture of Japan that inspired European and American modernists.

In 1925, Date enrolled at Polytechnic High School, where an inspired art teacher encouraged a dormant interest in drawing. In 1928 he secured a scholarship to attend Otis Art Institute, which had been established ten years before by Harrison Gray Otis, publisher of the *Los Angeles Times*, as an adjunct to the Los Angeles Museum of History, Science and Art. There Date formed friendships with other aspiring artists from a range of backgrounds, including other Asian Americans, such as Benji Okubo[2] and Tyrus Wong. An open and diverse circle of artist-friends would become a key characteristic of Date's life before World War II.

1 Hideo Date, unpublished life story written in response to an oral history interview conducted by Nancy Moure in the summer of 1998. Unless otherwise noted, all subsequent quotations are from this source.
2 Okubo was a nisei (second-generation Japanese American) born and raised in Riverside, California. While by all appearances his family, which ran a confectionery, seemed typical of Japanese immigrants, in fact Okubo's mother was a calligrapher of note who had artistic training in Japan before coming to the United States to demonstrate her skills at the St. Louis Exposition of 1904. Okubo's maternal uncle was the Japanese *yōga* painter Kentaro Kato, whose paintings of Japan and France had received some measure of acclaim. His younger sister Miné Okubo later authored *Citizen 13660* (New York: Columbia University Press, 1946) and became one of the most significant Japanese American artists of her generation.

Benji Okubo, *Untitled, Heart Mountain, WY*, 1942–45.
Oil on canvas, 20 × 24 inches

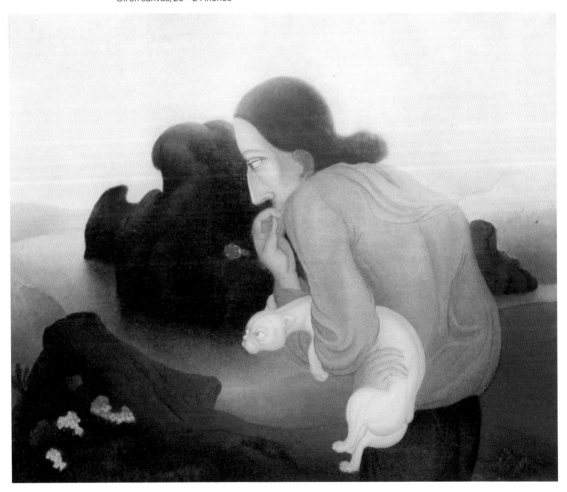

Hideo Date, *Cathleen*, ca. 1930s.
Oil on canvas, 10 × 8 inches

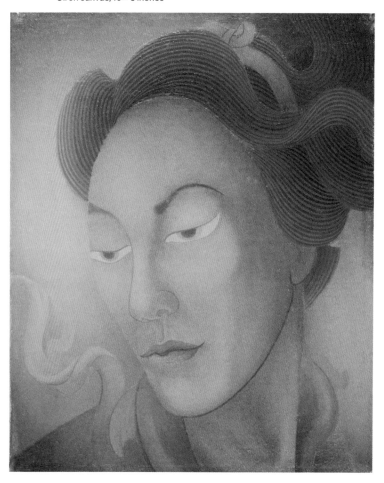

Although Date had anything but a privileged life and, as a Japanese immigrant, was subject to a number of discriminatory laws and attitudes, his experience at Otis and in the arts community of Los Angeles provided opportunities for advancement and acceptance. He and Okubo were soon among Otis's most promising students. In 1928 Okubo edited *El Dorado, Land of Gold: A Series of Pictorial Interpretations of the History of California with Accompanying Rhythmic Story by Students of the Otis Art Institute*, to which Date contributed a drawing.[3] Later that year, Date won a major cash prize for work in an Otis exhibition. "I went to the director to receive the check.... He told me, 'It's

kind of a tragedy to see you paint in an Oriental manner.' So I said, 'I don't know anything about Oriental art and if you don't like the way I paint you can go to hell.' I quit the school and decided to go back to Japan to study Oriental art."

Throughout his life, Date had sought training and worked in a manner that reflected a Western sensibility, fiercely retaining this conceptualization of himself as *not* an Oriental artist. Now he wanted to go to Japan to see and study its art firsthand, perhaps hoping to avoid categorization by arming himself with knowledge, perhaps looking to make the best of both cultures. He took a job at a fruit stand to earn money. In 1929, Date set sail for Japan.

Nihonga and Synchromism

The question of bicultural identity was frequently debated among young Japanese Americans and their issei parents. As tension between the United States and Japan increased, issei leaders believed their children could serve as a bridge between the two countries. Young nisei were sent to Japan on study tours, or *kengakudan*, to learn about Japan so they would be able to educate Americans about the emergent Pacific nation. Just as important, the experience of being part of the majority in Japan was an antidote to the hostility they encountered in the United States. For Date, the dichotomy was played out in his art. Two painting styles and two charismatic thinkers would have a tremendous impact: *nihonga*, as transmitted through the teachings of Kawabata Gyokushō, and the Synchromism of Stanton Macdonald-Wright. Date heartily acknowledges the latter influence and downplays the former.

When, in 1853, the American forces commanded by Commodore Matthew Perry appeared uninvited in Tokyo Bay to demand that Japan open up for trade with foreign nations, a modernizing revolution known as the Meiji Restoration began: a system of modern law was put in place; industrial designs were acquired from America and Europe; changes in the nation's political, economic, and social systems propelled Japan into the modern world after centuries of seclusion. As international trade commenced, the art of Japan underwent a substantial transformation. Debates about the course of traditional Japanese art resulted in the emergence of *nihonga*, a new approach to painting conceived as a direct response to Japanese artists' absorption of Western-style oil painting (called *yōga*) and heavily promoted by Ernest F. Fenollosa, an American Orientalist and educator, and Japanese author Okakura Tenshin (also known as Okakura Kakuzō).[4] Fenollosa argued that the powerful and expressive use of line in Japanese art should be augmented by Western realism—especially through the incorporation of perspective, brighter colors, and chiaroscuro—and a greater diversity of subject matter. Although the art classified under the term *nihonga* is heterogeneous, it is unified by the use of traditional materials, especially mineral pigment suspended in animal glue on silk, a medium that is similar to Western watercolor but more opaque. When Date arrived in Japan, *nihonga* and *yōga* existed side by side as viable methods of creating new Japanese art.

Armed with a letter of introduction from an artist he knew in Los Angeles, Date eventually found Kawabata Gakkō (Kawabata Painting School) and began his study of *nihonga*. While Date later minimized the impact of his training in Japan, it is worthwhile to look to the traditions, practices, and philosophy of the Kawabata Gakkō and its founder, Kawabata Gyokushō, for an understanding of Date's technique and subject matter. Gyokushō, a prominent *nihonga* painter and an influential teacher, believed that sketching from life is essential but that observation of nature alone would not result in strong painting. He argued that the basis of painting was "taking things and adding things to what actually exists in nature"—capturing essences.[5]

Gyokushō established his own school in 1909 in a period when private art schools

3 I am indebted to Marian Yoshiki-Kovinick for identifying this publication.
4 Fenollosa was influential in both Japan and the United States. His extensive writing on Japanese and Chinese art introduced Western audiences to Japanese traditions; at the same time, he interpreted Japanese traditions to Meiji-era Japan. He served as both curator of the Imperial Museum of Japan and curator of Oriental art at the Museum of Fine Arts, Boston.
5 Ellen P. Conant, *Nihonga, Transcending the Past: Japanese-Style Painting, 1868–1968* (St. Louis: St. Louis Art Museum, 1995), 78. All information about Gyokushō, who himelf had studied both Japanese and Western traditions, comes from this source. He studied under Nakajima Raishō, as well as with Charles Wirgman, a British illustrator for the *Yokohama Illustrated News* and one of the earliest teachers of oil painting in Japan. Gyokushō's appointment to the Tokyo School of Fine Arts in 1889 put him in the same company with Okakura Tenshin and Hashimoto Gahō (303–4).

were thriving in Japan.[6] Like many of his *nihonga* contemporaries, Gyokushō looked to the classical arts of Japan, China, and India for inspiration, linking them in a circular pattern to contemporary European art, which suggests he possessed a nuanced understanding that influence is often impossible to pin down to a specific starting point. For one year, Date immersed himself in this new interpretation of traditional Japanese painting technique. His training in the technical aspects of *nihonga* gained him stunning technical skills, and access to the *nihonga*'s range and type of subject matter would continue to influence him in subsequent decades.

After a year in Japan, Date returned to Los Angeles. His technical skills had improved enormously in Japan, but Date recalls that he longed for greater intellectual stimulation and dialogue about art. He found it under the tutelage of Stanton Macdonald-Wright.

In 1927, Date's high-school art teacher had introduced him to the work of Macdonald-Wright and Morgan Russell through their exhibition *Synchromism* at the Los Angeles Museum of History, Science and Art and had recommended that Date study life drawing with Macdonald-Wright at Los Angeles's Art Students League, which he had done in 1928. By the mid-1920s, the brash and charismatic Macdonald-Wright was already a recognized artist in the nascent field of American art and arguably California's most important painter. During a European sojourn in the 1910s, Macdonald-Wright and Russell had developed their theory of Synchromism, which employed color theory as a way to create form and space and to explore time and duration. Arguing that planes of juxtaposed colors produce spatial depth that optically suggest movement, the Synchromist painters proposed a method of abstraction linking color theory to music. The premise that color provides the basis for both form and content placed Synchromism at the forefront of abstract art (it has been called a forerunner of Abstract Expressionism); although relatively short-lived, it was influential. Date recalls being completely "overwhelmed by the art."[7]

Macdonald-Wright had exhibited his work in Europe and New York and was associated with some of the most significant figures in European and American art. In Paris, he had connections with Henri Matisse, August Rodin, and Gertrude and Leo Stein. In New York, Macdonald-Wright exhibited at Alfred Stieglitz's gallery 291, associated with Thomas Hart Benton (whom he had met in Paris), and collaborated with his brother, the art critic Willard Huntington Wright, on the book *Modern Painting: Its Tendency and Meaning* (1915).[8]

Upon returning to Los Angeles in 1920, Macdonald-Wright quickly became an instigator. He organized a number of influential exhibitions, including the *Exhibition of Paintings by American Modernists* at the Los Angeles Museum of History, Science and Art, in collaboration with his brother Willard and Alfred Stieglitz. The exhibition introduced art by Arthur Dove, Marsden Hartley, John Marin, Charles Sheeler, Charles Demuth, and Joseph Stella, among others, to Los Angeles viewers. Macdonald-Wright also continued to educate himself about the arts of Asia, to which he had been introduced by French art historian Henri Focillon during his Parisian sojourn.[9]

During this period, Macdonald-Wright began teaching at the newly established Chouinard Art Institute and at his alma mater,

6 Conant notes that the most innovative painters of the early Taishō attended private *juku*. Ibid., 12.
7 Hideo Date, in conversation with the author, July 2, 1998.
8 Macdonald-Wright variously used the surnames Wright, Macdonald Wright, and Macdonald-Wright. The last is the standard characterization. His brother used Wright. Huntington was a middle name. See Will South, *Color, Myth, and Music: Stanton Macdonald-Wright and Synchromism* (Raleigh: North Carolina Museum of Art, 2001).
9 Ibid., 58. Furthermore, in the 1920s Los Angeles supported a wide range of innovative practitioners and thinkers who directly looked to Japan and its arts for inspiration. Architects Frank Lloyd Wright and Rudolph Schindler, photographer Edward Weston, and choreographers Ruth St. Denis and Lester Horton were among them.

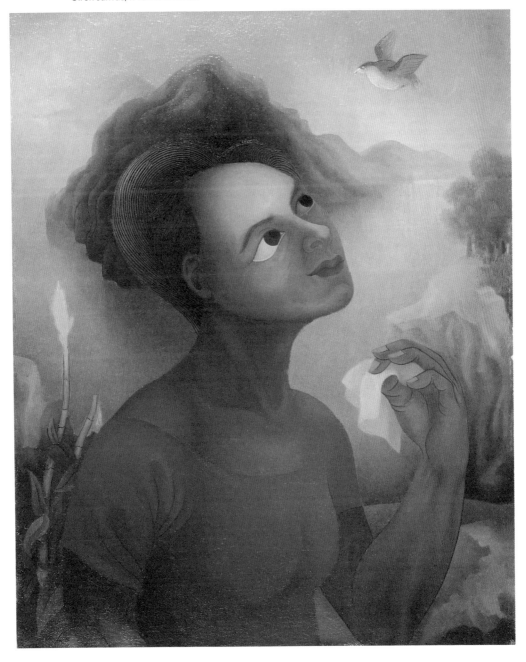

Hideo Date, *Nostalgia*, ca. 1930s.
Oil on canvas, 17½ × 15½ inches

the Los Angeles Art Students League, where he became director in 1923. Founded in 1906, the league was initially modeled on its New York namesake, where there was no prescribed course of study and artists played a primary role in running the school. When Date enrolled at the Art Students League, he entered a milieu of artistic openness, experimentation, and camaraderie. Through Macdonald-Wright, he had access to the vanguard of American art currents; his orientation in Japanese art was now supplemented by a rich and exciting exposure to art and thinkers from New York and Europe. He also found in Macdonald-Wright a respect for and appreciation of Asian art. Date's ethnic heritage, a liability in the arena of political and economic rights, was valorized in the context of art.

Macdonald-Wright's approach to teaching was twofold. He emphasized drawing from life models and encouraged freewheeling philosophical inquiries into a range of subjects, among them color, Western art history, and the nature of avant-garde music. At times, Macdonald-Wright might conduct a formal analysis of a particular Cézanne or Renoir painting; at other times, he lectured extensively on Synchromist theories of color harmony—but, as Date recalls, he did so without invoking it in name. At this time in his artistic development, Macdonald-Wright had abandoned the strict abstraction of Synchromism and was now combining Synchromist color with European-derived draftsmanship and Asian-inspired subjects. Date thus had a receptive audience for the products of his Japanese training.

After his training in Japan, Date eagerly consumed Macdonald-Wright's instruction, which included a Saturday painting class and life drawing classes two evenings a week, where Macdonald-Wright "was teaching what Michelangelo tried." Date's sketches from this period reflect Macdonald-Wright's interest in teaching students to look for the "essential rhythms of the body," avoiding surface detail.[10] They also mirror the teacher's work. Androgynous, muscular women suggest a bodily mass and weight that contradict the simplicity of the drawing. The painting class focused

on still life. As Date recalls, Macdonald-Wright employed the usual props—bottles and vases, draperies, and so on—with a different emphasis. "You would pick them up, arrange, and compose according to color harmony." While his classes were not radically different from other art curricula, Macdonald-Wright created an atmosphere that his students would never forget: prone to argumentative outbursts accentuated by a hyperbolic ego, he had a larger-than-life persona that, combined with his erudition and connections to European and New York modernism, created an environment characterized by intellectual rigor and intoxicating drama.

Emergence of a Mature Artist

Date's art from 1929 through the 1930s existed at the confluence of two major streams of thought. His paintings demonstrated a clear debt in technique in subject, to his study of the *nihonga*. In watercolors such as *Bather* (circa 1930s) and *Where Lotus Abide* (circa 1935) he employs an unusual technique that is much closer in effect to *nihonga*'s use of mineral pigment suspended in animal glue than to the prevailing methods of American watercolor. In these works, watercolor is layered to create large areas of opaque and saturated color formed by a sinuous line reminiscent of traditional Japanese art. The results are stunning. The connection to Japanese art is made even more explicit through Date's compositional strategies, where the perspectival relationship between foreground and background is reminiscent of eighteenth-century ukiyo-e woodblock prints. For content, Date borrows from the subject matter that is common to *nihonga*: fantastical Japanese and other Asian deities, writhing dragons, atmospheric landscapes, and Hindu- and Buddhist-inspired figures. Date was also fascinated by Persian miniatures, a tradition of art that interested both Macdonald-Wright and *nihonga* artists. The way in which Date fashions androgynous bodies is a direct link to Macdonald-Wright's muscular figures.

In this period, Macdonald-Wright begins to explore similar subjects. Although direct influence may be impossible to pinpoint,

it is highly likely that Macdonald-Wright learned just as much from his Japanese student as he taught him. Macdonald-Wright's theories of color had a profound impact on Date, leading to unusual choices that are especially apparent in his paintings of women, such as *Cathleen* (circa 1930s). About these images, Date steadfastly maintains that they are not simply portraits, but paintings: "All of my watercolors or oils of women, they are not portraits. I choose color harmony, composition, structure in my own way." Capturing essential form and mood was paramount; likeness was of limited importance. His paintings of this period also look to the Italian Renaissance. *Mary Campbell* (circa 1930s) bears a resemblance to Leonardo da Vinci's *Lady with an Ermine* (1489–91).[11]

It was in the 1930s that Date began to make a name for himself as an artist. He showed alongside other Japanese American artists, such as Tokio Ueyama and Henry Sugimoto, in the annual exhibitions of Japanese Artists of Los Angeles as well as in shows sponsored by the *Rafu Shimpo*. At the same time, he participated in mainstream exhibitions that included European American as well as Asian American artists, such as *Exhibition by Young Painters* sponsored by the College Art Association (1932), the 1933 iteration of the annual exhibition of California watercolors organized by the Foundation of Western Art, and *Exhibition of Paintings*, "*Independents*" in Palos Verdes in 1933. Later, he exhibited in the context of the Federal Art Project at the Los Angeles Museum.

The position of the artist in society is often ill-defined, but Date's identity as a Japanese American added another layer of complexity. He lived two concurrent lives: artist and Japanese American low-wage worker. The contradiction plagued him. His brothers, Frank and Albert, had both graduated from college: Frank studied architecture and Albert studied sociology and philosophy. Despite their credentials, American racism made it impossible for them to find work in their chosen fields, so they opened a flower shop in Little Tokyo. Date helped out at the shop by day and took classes at the Art Students League in the evening. Such an arrangement was a suitable solution to their collective limited opportunities until Date decided one day that if he were to be an artist, he needed to quit working as a shopkeeper. The brothers gave him an ultimatum: work or leave. Date packed up and moved into the Art Students League, then located on Spring Street between Second and Third Streets, just a few blocks away from Little Tokyo. Date later recalled, "It was the best thing.... I became independent, free, bohemian."

During this period, Date formed long-lasting friendships with league artists Jimmy Redmond, Don Totten, Albert King, Herman Cherry, and James Bolin that would provide substantial support, especially during World War II. At the same time, Date maintained close ties with the Japanese American community. His choice of the bohemian life did not inhibit his Japanese American friends—including lifelong friend Justus Sato, whom he had met picking fruit in Fresno—from continuing to provide important moral and financial support. Thus, when Date made a trip to Japan in 1936, the friends who signed a good-bye memento included Macdonald-Wright, Redmond, Totten, King, Cherry, and Arthur Millier, the art critic for the *Los Angeles Times*, as well as Justus and Rosemary Sato and artist Charles Morimoto.

Date's prewar life in Los Angeles provides glimpses of the city in which cultures overlaid each other and intersected in ways that would soon become unlikely if not impossible. The growing film industry of Hollywood sometimes served as a bridge between communities. At some point after Date left his brothers and moved into the league, he answered an inquiry from an architect who wanted a Japanese painter to create a mural for a Beverly Hills dining room. "He asked me to paint a tea ceremony," Date recalls. The Oriental-inspired room "was decorated with silver-leaf walls. The curtain was golden yellow, the chair was Chinese red, and the carpet was blue. So I had to use those

10 Ibid., 77.
11 I am indebted to Erin O'Toole for this insight.

Hideo Date on barracks steps at
Heart Mountain War Relocation Center,
Wyoming, ca. 1943

four colors to paint the mural." The owner of the house was none other than Mary Pickford. The Elsie de Wolfe–designed decor at Pickfair, the grandiose house so named by Pickford and Douglas Fairbanks, was described by one visitor as "Waldorf Astoria French Empire," except for a room in which guests, served cocktails by servants dressed in Kabuki-style costumes, could enjoy knickknacks the actors had collected during their travels through the Far East.[12]

Another haunt where Hollywood crossed paths with bohemia and the Orient was interpreted through Asian Americans was the Dragon's Den restaurant in Chinatown, owned and run by Eddy and Stella See. Date recalls, "We used to go there often to have poor man's dinner: *E-juck* for twenty-five cents."[13] The basement restaurant, which featured prominent murals of the Chinese Immortals, Buddha, and a writhing dragon created by Benji Okubo with the help of Tyrus Wong and others,

played host to a cross section of Los Angeles. Hollywood stars like Sydney Greenstreet, Anna May Wong, and Peter Lorre, directors, producers, designers, and even Walt Disney were among its denizens, as were artists—Date, Okubo, Wong, and Macdonald-Wright among them. At the same time, the Dragon's Den became a haven for homosexual men and women.[14]

Date made a living where and when he could, taking odd jobs and staying at the Art Students League and various friends' homes. In 1935, Macdonald-Wright took over the Works Progress Administration's Federal Art Project for Los Angeles. In 1937, he assumed leadership for all of Southern California, which was the largest of the New Deal arts projects and which provided a source of employment for some of Los Angeles's most important artists, including many from the league. Date was among those lucky enough to receive commissions: not only was he given the opportunity to paint a mural

for a school on Terminal Island, he was paid for his labor. Terminal Island, located in San Pedro Bay, was home to a large population of Japanese fishermen and their families, who worked in the canneries. At its peak, three thousand Japanese Americans lived on the southeastern part of the island. Date lived with Sato and his family, who had moved to the area. The fact that the school's student body was almost entirely made up of Japanese Americans informed Date's choice of subject: "I chose the Japanese legend of the goddess of light: she was hidden from her mischievous brother in a cave and everything was dark. People started to play music; women danced. She became curious and started to open the cave." One can imagine the fantastical narrative unfolding across the large surface, but sadly the mural is no longer extant. After the United States entered World War II, Terminal Island was considered a prime strategic locale, and the Japanese Americans there were unfairly and unjustly under suspicion. Among the hyperbolic and unsubstantiated accusations was that Japanese American fishermen used their boats to contact the Japanese military.[15] In February 1942, all Japanese Americans on Terminal Island were given forty-eight hours to leave. They were never able to return there. The school and Date's mural, not yet completed, disappeared.

World War

Japan's bombing of Pearl Harbor crystallized American anti-Japanese sentiment. Two-thirds of the Japanese Americans living on the West Coast were American citizens, but this meant little in the face of the wartime hysteria that conflated Japanese ancestry with the Japanese enemy. Between December 1941 and spring 1942, Japanese Americans were gradually rounded up. At first, the FBI targeted community leaders, many of whom were taken away within days of Pearl Harbor. This was followed by mass exclusion orders, which required all Japanese Americans to report for incarceration. Vital communities were reduced to ghost towns in a matter of weeks. By the war's end, more than 120,000 Japanese Americans had been incarcerated.

Date—along with more than 19,000 other Japanese Americans from throughout California—was sent to the Santa Anita racetrack, which had become one of fifteen temporary detention centers thrown together hastily around the West Coast. Filthy horse stalls were quickly converted to housing; many of the inmates vividly recalled the lingering stench of the animals.

On the surface, it appears that incarceration did little to stifle Date's interest in making art. He seems to have given little consideration to the political and social upheaval that surrounded him. Perhaps because he had lived so marginally before the war, moving back and forth between the league and the homes of friends, incarceration presented only one major difficulty: storing his body of art. Bringing only what they could carry, many Japanese American families left behind homes, real estate, and substantial personal possessions. But because of his friendship with European Americans from the league, Date had more options. James Bolin offered to store Date's work with family members, where it remained safe until the war's end.

In Santa Anita, Date started teaching art immediately, offering painting and life drawing classes at night. He was in demand: "I had to pose, myself, and go around to teach," he recalls. Then, in October 1942, the detention center at Santa Anita was closed and inmates were transferred to permanent concentration camps administered by the War Relocation Authority (WRA). Date was sent to Heart Mountain War

12 David Wallace, *Lost Hollywood* (Los Angeles: LA Weekly Books, 2001), 68.
13 Hideo Date, letter to the author, received June 21, 2000.
14 Lisa See, *On Gold Mountain: The One-Hundred-Year Odyssey of a Chinese-American Family* (New York: St. Martin's Press, 1995), 193–98, 225.
15 Jeanne Wakatsuki Houston and James D. Houston's book *Farewell to Manzanar: A True Story of Japanese American Experience during and after the World War II Internment* (New York: Bantam Books, 1973) poignantly dramatizes the plight of Japanese American fishermen.

Relocation Center in Wyoming. He was assigned to cramped bachelors' quarters, where he etched out a small corner among his six roommates. Okubo had also been sent to Heart Mountain, and he and Date quickly mobilized and applied to the administration to start an art school. Realizing that supporting social and educational activities was a prime way to occupy idle hands, and eager to provide activity for the more than ten thousand inmates of Heart Mountain, the WRA assented to their request. "We called it Art Students League, and we got a barracks in Block 28." Date and Okubo held classes in drawing, painting, stagecraft, and silk-screen technique, supplementing their instruction with teachers identified from the camp population. The philosophy of the school mirrored that of the Art Students League as Date and Okubo had experienced it. Okubo was also hired to teach art in the camp's high school, where he "had to give them grades," but, Date fiercely stresses, "no grades in the Art Students League." However, all did not go smoothly for the league. Date and Okubo were pressured by others who "wanted a bigger space so they could use it for gambling," Date recalls. "One man came to see me. I knew what he was going to say and want....He was a member of the Tokyo Club in Los Angeles. They are what you call mafia." When Date told Okubo about the incident, "he was afraid, and he had to carry a two-by-four."

"Benji and I started to teach day and night," Date remembers. They also organized exhibitions of student work, the first taking place less than two months after their arrival. They printed posters and smaller announcement cards announcing the exhibition of the Art Students League. The cover of the *Heart Mountain Sentinel*, the camp newspaper, carried news of the opening.[16] As art historian Will South has argued, Date's and Okubo's exhibitions mark the last flourishing of the Art Students League of Los Angeles, since the league itself had closed in 1941.[17] It is both ironic and moving that the league, a bastion of artistic and societal freedom, should have its final exhibitions in the confines of an American concentration camp.

The creation of art in the camps was by no means unusual. In Heart Mountain alone, there were many other artists, such as Jack Yamasaki, who had studied art in San Francisco and at the Art Students League in New York; Jishiro Miyauchi, who painted as an avocation; and Estelle Ishigo, a European American woman who chose incarceration over being separated from her nisei husband, Arthur. Date knew Ishigo, but notes that "she painted by herself." Because Heart Mountain became one of the largest population centers in Wyoming, it is not surprising that there were many artists who were not aware of one another's work.

Lacking money and finding it difficult to get canvas, paint, and other supplies, Date turned his focus to drawing. Unlike the work of other artists—Yamasaki, Ishigo, and Miyauchi—who carefully mapped physical and social activities in camp, Date's work bears little relationship to his transformed circumstances.

Yet his art from the incarceration period registers an enigmatic change from that which came before: his subjects had always been fantastic, but the camp drawings hover somewhere between fantasy and realism. The extant work from the war years reveals an obsession with cats. Date's cats, however, do not appear as innocuous symbols of domestic containment. They are anthropomorphic, exhibiting strangely human qualities while seemingly remaining free from social decorum. The cats are reminiscent of the work of Date's friend Jimmy Redmond, an artist from the league who exhibited a series of cat drawings in the early 1930s, and call to mind the cat that appears in Date's earlier work *In Search of His Dream* (1936). Yet it is curious that Date would, during this period of incarceration, bring his attention to these animals. Although he resisted explaining this work, perhaps the combination of domestic captivity and wild-animal impulse seemed familiar to him while incarcerated. Whatever the reason and however obscure their meaning, these mannered drawings demonstrate exquisite technical finesse.

Date's circle of diverse and fascinating friends was absent, but, besides the activities of the camp's Art Students League and his

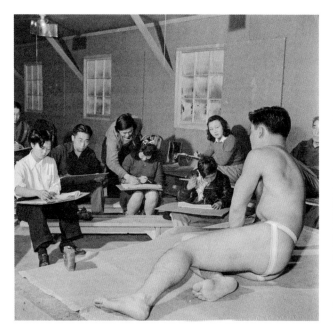

Benji Okubo instructing a life-drawing class at Heart Mountain War Relocation Center, Wyoming, 1943

Announcement card for Art Students League exhibition in Heart Mountain War Relocation Center, 1942

friendship with Okubo, Date was able to connect with a few others interested in art and music. Fellow inmate Roy Matsumura was a connoisseur of classical music. He had been given permission to have his records and phonograph retrieved from storage in the locked and empty temple of the Hompa Hongwanji Buddhist Temple in Los Angeles's Little Tokyo.[18] In camp, Matsumura held "listening" concerts, where he would play his records in lieu of live performance. Date and Matsumura became good friends through their shared passion for the music of Beethoven and its intersections with visual art.[19] One of Date's most significant works from the camp period is a drawing of Beethoven made for Matsumura. In typical Date style, the carefully rendered likeness of Beethoven hovers in front of a magical dragon weaving behind clouds where two small figures with bows and arrows are poised.

Date's skills as a muralist were also in demand. Shigeru Tanaka, a block manager, commissioned Date to paint a mural on a wall of the mess hall in honor of a New Year's celebration. The ostensible subject of the mural was Date's own experiences, "first—age of confusion.

The next was the search for the truth, then next—destination. Those three subjects in one." Incorporating mostly figures, the nearly twenty-seven-foot mural was painted with house paint on Celotex panels. "I had to ask students to help me finish it by January 1," Date says. "I worked all day and all night on December 31. I was still sleeping on the model stand when all of the directors came to see it finished in the morning."

16 *Heart Mountain Sentinel* 1, no. 8 (December 12, 1942). The article notes, "Work of Hideo Date, Bob Kuwahara, Shingo Nishiura and Benji Okubo and their pupils is on display. Yoneji Morita, wood-carving teacher, and Mrs. Kimiko Ito, crochet instructor, are also exhibiting the work of their students."
17 Will South, conversation with the author, September 28, 1998.
18 The temple is currently the Historic Building of the Japanese American National Museum, located at the corner of First Street and Central Avenue. During World War II, Reverend Julius A. Goldwater, a Jewish American who had converted to Buddhism, cared for the temple and the belongings housed there.
19 Roy Matsumura, conversation with Emily Anderson, June 14, 2001.

Hideo Date, *In Search of His Dream*,
1936. Watercolor and gouache on paper,
19 × 15½ inches

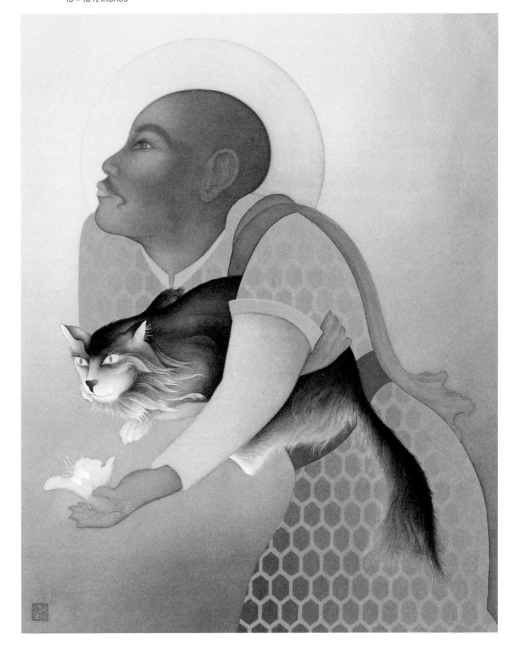

One can only imagine how Date used the vocabulary of his prewar years in Los Angeles on this impermanent mural in such a vastly different setting.

The exclusion orders that restricted Japanese Americans from living in the Western Defense Command zone were lifted in January 1945. However, as early as 1943, it had become clear that Japanese Americans posed no threat to American security, and young Japanese Americans had been encouraged to leave the confines of the camps to seek jobs in the Midwest and on the East Coast. The WRA hoped to ameliorate labor shortages brought on by war by sending Japanese Americans eastward. At the same time, the movement of Japanese Americans could serve to disperse prewar communities; actively discouraging Japanese Americans from congregating in their new locales, the WRA sought to prevent the creation of new Little Tokyos. In spring 1945, when the nation was still in the midst of world war, Date left Heart Mountain to take a job working on a mural in Buffalo, New York, but immediately decided to move on to New York City, where he hoped to restart his career as an artist.

To Start Again

At the end of the war, Date was nearly forty, unmarried, and uprooted. In New York, he found housing through the American Friends Service Committee and sought steady work. He left a job making art reproductions because he believed his employer was treating workers unfairly and took a more lucrative position as a butler for a prominent construction executive. During the war, Date had been able to keep his artistic skills honed by teaching and making art, but his life was impoverished, cut off from a broader, integrated society, and he had no opportunity to exhibit or interact with the community of artists from the league that had sustained and encouraged him in the prewar years. Now, as soon as he had earned enough money in New York, he returned to Los Angeles with the aim of retrieving the art that had been stored during the war and reconnecting with old friends. Albert King, an artist from the league, had a teaching job at Art Center. Upon his recommendation, the gallery there held a solo exhibition of Date's work—the last showing of his art in Los Angeles until 2000—with the ultimate purpose of helping Date get his work to New York. Because of the exhibition, Art Center could pay for transportation, a cost that would have been prohibitive for Date to bear.

Back in New York, Date resumed painting and slowly began to build a community of friends. A few Japanese had moved to New York, and a few passed through on their way elsewhere. Date's brother Albert had also moved to New York from Heart Mountain, and he was now running a restaurant in Harlem. Through Albert's wife, Date met Yuriko Tamaki, and in 1947 they married. Nisei artist Shinkichi Tajiri had served in the segregated armed forces during World War II, and using the benefits of the G. I. Bill, he passed through New York on his way to Paris to continue studying art.[20] Date longed to join him, "but I had no passport. I was still an enemy alien."[21]

Afraid to leave the country, Date instead made several visits to New Orleans, figuring that it was closer to France, in spirit at least, than New York. On the bus trip south, Date came face-to-face with another form of American racism. "Right after we crossed Washington, DC, the bus stopped. I was smoking in the back seat. The driver told me, 'Please come up front, because the back is saved for black people.'" Date ultimately found New Orleans unappealing. "Everything I saw was 'black and white' and 'black and white.' I got tired of it and went back to New York."

20 Although Tajiri had fought during World War II, his military service did nothing to prevent postwar racism against Japanese Americans, prompting him to leave the United States for Europe. See Rea Tajiri's 1991 video, *History and Memory*.
21 Japanese immigrants were considered "aliens ineligible for citizenship." As such, they were forbidden by law to become naturalized citizens until 1953.

Living on Carmine Street in Greenwich Village in the late 1940s, Date continued to make exquisitely rendered drawings of atmospheric landscapes where tree trunks writhe, endowed with a measure of sensuous line more suggestive of the human body than of flora. Reminiscent of his prewar work, they refer directly to Japanese painting and simultaneously resemble Macdonald-Wright's drawings of the 1930s. Most of Date's friends were artists he knew from Los Angeles. Both Philip Guston and Herman Cherry had moved to New York, and Cherry in particular became an important influence on the course of Date's painting. Cherry was associated with the New York School, a loosely defined group of artists working in the Abstract Expressionist vein. Date's work from

this period owes a tremendous debt to Cherry, as well as to general postwar trends in abstraction. Abandoning watercolor in favor of oils, Date created impressive paintings that reflect the prevailing tendencies and art of that period.

In 1952, Date and Yuriko moved to a housing development built on former swampland of Flushing Bay that had been constructed primarily for returning servicemen. From the late 1950s until the mid-1980s, Date cultivated his interest in abstraction and embarked upon a personal study of color theory informed by Macdonald-Wright's Synchromism and by contemporary art movements, especially Abstract Expressionism. There are links between Abstract Expressionism and Japanese art and philosophy, and as Jeffrey Wechsler has written,

many Japanese American and other Asian American artists helped make these connections and interpreted them in their work.[22]

The canvases that resulted from Date's study and synthesis of these elements show tremendous technical facility, examining color in ways that demonstrate his particular talent. Like Macdonald-Wright's early abstract work, Date's paintings use color juxtapositions to produce tension, vibrancy, movement, and a sense of duration. His paintings show his continued ability to create strong canvases, but the opportunities for discussion, debate, and exhibition remained limited for him in the postwar period.

One opportunity that did emerge was the possibility of international travel. The McCarran-Walter Act of 1952 eliminated race as a barrier to naturalization, and in 1955 Date became a naturalized citizen. In 1956, he departed for a European visit. "I took the Italian boat named *Andrea Doria*, a beautiful boat, but it sank the same year." After an extended tour of Italy, he proceeded to Paris, where he found a place to stay in Montparnasse and a place to buy art supplies. He sought the American consulate's assistance in locating Shinkichi Tajiri, to no avail. Then he met a Black British man who was a friend of Tajiri's, and through him, Date ultimately reconnected with his Japanese American compatriot. In Europe, Tajiri was establishing himself as a significant and recognized artist, and he associated with an international array of artists, including continental Europeans, Britons, American expatriates, and Japanese, that mirrored the diversity of Date's prewar community in Los Angeles. It seems that in postwar Paris Date again found his spiritual home. Over the next several decades, he traveled between New York and Paris countless times, living modestly in New York with the support of his wife and taking up jewelry making to fund his travels. "If I were not married, I would've stayed there all my life," he has written. "Such a beautiful city. No prejudice, so free. I can enjoy life."

To Exhibit Again

Throughout the last five decades, Date has maintained that life of an artist, pursuing his craft with the utmost seriousness and skill. Working quietly in Flushing, he has only sporadically exhibited, greeting eager inquiries—like my own ten years ago—with indifference.

In considering Date's art, it becomes clear that World War II marks a decisive shift in his practice is an artist. With the coming of war, the vitality of the multicultural milieu disappeared, shattering a community of artists and the possibilities for synergistic exchange across cultural influences and ideas that Date's art embodies. The war reified a Japanese American political identity, and this has continued, inevitably, to affect cultural identities as well. For Japanese American artists like Date, Henry Sugimoto, Miné Okubo, Chiura Obata, and others, the incarceration affected their capacity to make and show art, their trajectories as artists were cut short, sidetracked, or derailed. We need to recognize the impact of incarceration and its aftermath, but even more we need to admire the determination, and perhaps envy the passion, with which these artists have carried on. We are fortunate to be able, during the lifetime of an artist like Hideo Date, now ninety-four years old, to look through the window to the past that he has created, to ponder his intriguing life and influences while we contemplate the still-vibrant beauty and complexity of his art.

22 See Jeffrey Wechsler, ed., *Asian Traditions/Modern Expressions: Asian American Artists and Abstraction, 1945–1970* (New York: Abrams, 1997).

Hideo Date, *Untitled*, 1947.
Pencil on paper, 31¾ × 26 inches

Hideo Date, *Untitled*, ca. 1975.
Oil on canvas, 36 × 28 inches

What
Is an
Asian
American
Woman
Artist?

It must be odd
to be a minority
he was saying.
I looked around
and didn't see any.
So I said
Yeah
it must be.
—Mitsuye Yamada, "Looking Out," 1992

With characteristic brevity and force, Mitsuye Yamada's poem "Looking Out" captures the complexity of identity and its dependence upon relative positioning and visible markers.[1] What appears simple and self-evident, subtly shifts and modulates depending upon one's position. In Yamada's poem, "he" sees her as what he is not: a minority, an Asian American woman. She, on the other hand, experiences the world through a different prism, as neither minor nor "odd." The poem prods us to consider the names that we call ourselves and whether it matters who does the calling. The fact that the poem characterizes the exchange as gendered—not surprising given Yamada's self-identification as a feminist woman of color—adds another element to the mix, underscoring the degree to which even casual contacts are fraught with complex assumptions and histories. It is within this matrix that an assessment of the term *Asian American woman artist* must begin. For what are the elements that characterize an Asian American, and how might a brief glimpse into the art and lives of some women illuminate our understanding of the term, its history, and its limits?

Asian American as a term emerged with its namesake movement in the late 1960s and 1970s and represented a new pan-Asian sensibility that jettisoned the then-common appellation *Oriental*, both because of its association with European colonialism and its close connection to the stereotypical exoticism promulgated in the popular media. Inspired by the civil rights, Black Power, anti–Vietnam war, and women's movements, the Asian American movement consisted of a heterogeneous assortment of political, social, and cultural activities united by an overarching antiracist stance but with varying degrees of leftist radicality, ranging from a generalized commitment to liberal social action to the Revolutionary Red Guard party, which, as its minister of information Alex Hing proclaimed, "[was] part of the Cultural Revolution that's going down in the United States."[2] The movement overwhelmingly consisted of young Chinese Americans and Japanese Americans, acculturated in an American context that, although racist in its treatment of Asian Americans, provided a shared set of experiences and a relationship to Asia that was indirect and mediated, largely through parents or grandparents, by the successive American military interventions in Japan, the South Pacific, Korea, and Southeast Asia, or, as some critics wryly noted, "from the radio, off the silver screen, from television, out of comic books, from the pushers of white American culture."[3]

The insufficiencies of the term *Asian American* have been acknowledged and challenged since its beginning, as Yen Le Espiritu has documented.[4] Elaine Kim, writing in the introduction of her now-canonical study of Asian American literature, summarized the problems

1 Mitsuye Yamada, "Looking Out," in *Camp Notes and Other Poems* (Latham, NY: Kitchen Table: Women of Color Press, 1992), 39. See also Yamada's *Camp Notes and Other Writings* (Piscataway, NJ: Rutgers University Press, 1998).
2 Alex Hing, Minister of Information of the Red Guard Army, interview by Neil Gotanda, *Aion* 1, no. 1 (Spring 1970): 32.
3 Frank Chin, Jeffrey Paul Chan, Lawson Fusao Inada, and Shawn Wong, eds., *Aiiieeeee! An Anthology of Asian American Writers* (Washington, DC: Howard University Press, 1974), vii.
4 See Yen Le Espiritu, *Asian American Panethnicity: Bridging Institutions and Identities* (Philadelphia: Temple University Press, 1992).

in using *Asian American*, explaining that while "distinctions among the various national groups sometimes do blur after a generation or two, when it is easier for us to see that we are bound together by the experiences we share as members of an American racial minority…we are accepting an externally imposed label that is meant to define us by distinguishing us from other Americans primarily on the basis of race."[5] Hence, *Asian American* as an overarching political identity provided opportunities for mobilizing across communities, but did so with the recognition of its external origins. Today, demographic changes raise other issues. No longer does the term *Asian American* cover primarily Chinese Americans and Japanese Americans born and raised in the United States. The overhaul of discriminatory immigration laws in 1965 resulted in a massive shift in the profile of immigrants. Now Asian Americans may be identified with no fewer than twenty different ethnic subgroups and are more likely to be immigrants than American-born.[6] Asians, as a percentage of all immigrants to the United States, have steadily increased: 6 percent in the 1950s, 13 percent in the 1960s, 36 percent in the 1970s, and 42 percent in the 1980s.[7] They are (in order of largest to smallest group) Chinese, Filipino, Japanese, Indian, Korean, Vietnamese, Laotian, Thai, Cambodian, Hmong, Pakistani, and Indonesian. Most have a direct connection to Asia, with lingering sentiments, whether it be for the political and cultural context of their country of origin or for the experience of historical antagonism such as that of Japanese colonialism, that inform and shape their diverse identities in the United States. For some a pan-Asian identity is inadequate in the face of the post-1965 immigration patterns, which created even greater diversity of Asian Americans in terms of their country of origin, experience, class, and identity.

The brutal murder in 1982 of Vincent Chin, a Chinese American engineer, dramatically demonstrated how the debates surrounding the political construction of a pan-Asian identity appear to have little relevance compared to entrenched racism against Asian Americans. Two European American men beat Chin to death with a baseball bat after arguing with him at a strip club in suburban Detroit. Economic decline in the United States, especially as experienced in the American automobile sector, and the growing prosperity of Japan produced a climate of hostility toward "things" Japanese. Vincent Chin's assailants were laid-off autoworkers who reportedly fired racial epithets, including "Jap," at Chin before they retrieved a baseball bat, hunted the fleeing Chin down, and beat him unconscious. Days later, Chin died. The perpetrators were allowed to plead guilty to manslaughter, were sentenced to three years' probation, and fined less than four thousand dollars each. After a federal case charging violation of civil rights was heard in a U.S. district court, one of the European American men was sentenced to twenty-five years in prison. But the sense of justice was dashed when, on appeal in 1987, he was acquitted. Vincent Chin's murder and the ensuing struggles for legal justice were a rallying cry for many in the Asian American community and a brutal reminder of the struggles faced by Americans with an Asian face. The Chin case demonstrated how conceptual distinctions of ancestry, as well as political struggles and political games, can evaporate into thin air when confronted by racial slurs and a baseball bat.[8]

In the 1960s and 1970s, a key strategy of the Asian American movement was to counteract the often negative and willfully inadequate representation of the Asian American experience in the mainstream media and to do so by documenting and interpreting the stories of individual and community struggles through oral histories, photography, films, publications, exhibitions, and the creation of art. The activity had a profound impact, still palpable more than thirty-five years later. From the legendary journal *Gidra* to single issues produced by student collectives and alternative publications that made accessible the history of Asian American communities ignored by commercial publishers, the flurry of activity provided an arena for the voice and expression of an Asian American identity previously unheard. But the movement was not without its lacunae and omissions, most notably concerning women and the visual arts.

Sexism was not uncommon, producing a milieu where challenges to male dominance were interpreted as treasonous to the cause.[9] At the same time, European American feminist organizations displayed a profound ignorance of the critical impact of race and class and its significance to women of color.[10] Thus Asian American women were doubly excluded: by the male dominance of the Asian American movement and by the insensitive myopia of emergent feminism.

In the realm of the visual arts, the aesthetic advocated was one that emphasized a representational approach to documenting aspects of the Asian American experience and placed greater weight on accessible content that could be easily linked to political goals. Remarkable works of art were produced using this framework, such as the photography and films of individuals associated with the collective Visual Communications or the murals coordinated by Tomie Arai. A heady idealism and populist stance valorized work that challenged "high-art" practices that had previously ignored (or so it seemed at the time) the art of Asian Americans. Murals situated in accessible public spaces and prints created in multiple editions replaced easel painting. Photography, in its infinite reproducibility, served to downplay the work of art as an autonomous and unique entity. Just as some have argued that what was revolutionary in the feminist art movement was its impact on content,[11] so a key legacy of the art of the Asian American movement was its unprecedented visualization of Asian Americans beyond the stereotypical representations that had freely circulated in both popular and high-art forms. But unlike the activity in the nascent field of Asian American literature, little attention was paid to Asian American visual artists of previous generations. Writers such as Carlos Bulosan, Louis Chu, John Okada, Toshio Mori, and Hisaye Yamamoto were recognized for their pioneering work and were published alongside younger writers,[12] yet Asian American visual artists remained relatively hidden or ignored.

The reason for this absence is impossible to identify definitively. Whether it was the popular assumption that no Asian American artists had previously existed or the fact that

5 Elaine Kim, *Asian American Literature: An Introduction to the Writings and Their Social Context* (Philadelphia: Temple University Press, 1982), xii.
6 Stanley Karnow and Nancy Yoshihara, *Asian Americans in Transition* (New York: Asia Society, 1992). The statistics derive from the U.S. Bureau of the Census, 1990.
7 Ibid., 17.
8 Renee Tajima-Peña and Christine Choy's groundbreaking film *Who Killed Vincent Chin* substantially impacted the understanding of the Chin case.
9 See Espiritu, *Asian American Panethnicity*, 47–49; Espiritu notes a number of instances where Asian American women, although active in the movement, were marginalized in both the debates of the movement and its leadership. It is interesting to note, however, that women leaders and a feminist agenda at times coexisted in this general milieu of sexism. This was made possible by the decentralized and constantly changing nature of the movement and the individuals involved. I am thinking here of the catalytic leadership of poet and activist Janice Mirikitani. See, for instance, Mirikitani's "Until the People Win…" and the accompanying photo-essay, which depicts North Vietnamese women in a variety of settings and situations: as healthcare providers and students, laboring in factories and construction sites, toting guns, and engaged in combat. *Aion* 1, no. 2 (Fall 1971): 30–51.
10 See Susie Ling, "The Mountain Movers: Asian American Women's Movement in Los Angeles" (master's thesis, University of California, Los Angeles, 1984). Yolanda M. Lopez and Moira Roth explore the intersections of women of color and feminist art practice in "Social Protest: Racism and Sexism," in *The Power of Feminist Art*, ed. Norma Broude and Mary D. Garrard (New York: Abrams, 1994), 140–57.
11 Lucy Lippard, cited in Norma Broude and Mary D. Garrard, "Feminism and Art in the Twentieth Century," in *The Power of Feminist Art*, 10.
12 The introductory essays and the anthology section in *Aiiieeeee!* are separated by a page that states, "Asian American Writers: We Are Not New Here." That the writings of the earlier authors are integrated with those who came of age during the Asian American movement further emphasizes the direct relevance of the earlier work to that of younger writers.

Ruth Asawa with students and mosaic
artist Alfonso Pardiñas, Alvarado
Elementary School, San Francisco, 1970

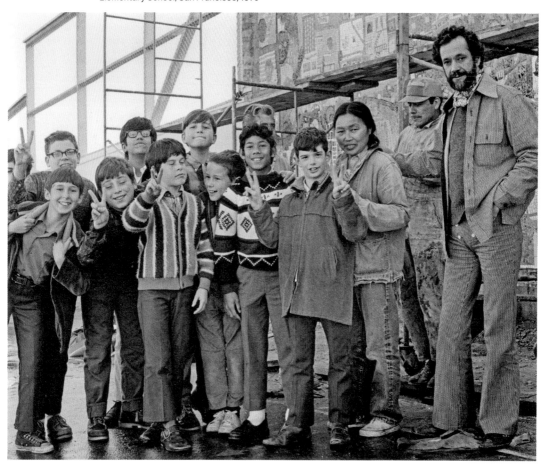

extant works were more difficult to access, the specific history of art in an American context—its connection to elite and exclusionary cultural practices and its cultural identity as a commodity—undeniably impacted an Asian American view of its own art history. The Asian American movement's emphasis on combating the cultural imperialism of the dominant society created blinders that made it impossible to see that although early Asian American immigrants worked as farmers, laborers, and in small businesses to build a better life for themselves and their families, they were also painters and sculptors.[13] The fact that the work of these earlier artists was often more concerned with formal issues than content provided further obfuscation. Perhaps a painting by Miki Hayakawa depicting the Japanese gardens at Golden Gate Park looked too much like the art collected by the San Francisco elite to be recognized as an ancestor, yet her vigorous activity and connection in the pre–World War II era with male and female painters of both Asian American and European American heritage presents an intriguing story worthy of serious consideration.

Of course, within the last decade a very different situation emerged in which the recognition and interpretation of Asian American artists vastly improved, as recent exhibitions and studies attest. But the frameworks established during the 1960s and 1970s still shape the terms of the analysis. The relative weighting of race, ethnicity, and gender with respect to artistic practice seems to continue in descending order, with the primacy of race taking utmost precedence. To gently question it is not to deny the profound and formative role race and racism play in American acculturation or the undeniable fact that the movements of the 1960s opened up previously exclusive discourses and arenas. Indeed, the most provocative and successful strategies of the 1960s have been those that challenged the structural hegemonies that serve to perpetuate existing hierarchies, rather than only combat their effects. But rather, it argues for the need to consider what is gained and lost in such frameworks. To use the appellation "Asian American woman artist" to describe, for instance, this essay's grouping of important artists—Ruth Asawa (1926–2013), Hisako Hibi (1912–1991), Theresa Hak Kyung Cha (1951–1982), Rea Tajiri (b. 1958), and Hung Liu (1948–2021)—only explains part of their significance. Even a brief review of their art and biographies suggests the limits of this designation.

The existence of Asian American women artists working in the mid-twentieth century is astonishing given the political and social restrictions against them. Despite these constraints, in 1943 Ruth Asawa managed to secure permission to attend college in Milwaukee, leaving the Rohwer concentration camp in Desha County, Arkansas, where she and her family were incarcerated. She had been born and raised in Southern California, had never visited Japan, and, like two-thirds of those incarcerated, was an American citizen. While the violation of civil rights and due process of the 120,000 Japanese Americans living in the western states who were incarcerated during World War II has been recognized and redressed in recent years by the courts and legislature, in 1940s America, distinguishing the Japanese nation from Japanese Americans seemed futile. Nevertheless, in 1946 Asawa managed to transfer to Black Mountain College, where she studied with Josef Albers and Buckminster Fuller, among others, in a provocative milieu of artistic experimentation that emphasized that the process and conceptualization of art making was as meaningful as the final art object. That Black Mountain College would become the most significant center for arts education during this period further complicates our understanding of midcentury limitations on women and Japanese Americans, given Asawa's access to and acceptance there. Asawa went on to break new boundaries outside the realm of art as well, with her work in childhood education that resulted in the Alvarado School in San Francisco, still thriving today.

13 Maxine Hong Kingston calls this a "terrible stereotype." Maxine Hong Kingston, "One Hundred Beautiful Things," in *With New Eyes: Toward an Asian American Art History in the West* (San Francisco: San Francisco State University, 1995), 7.

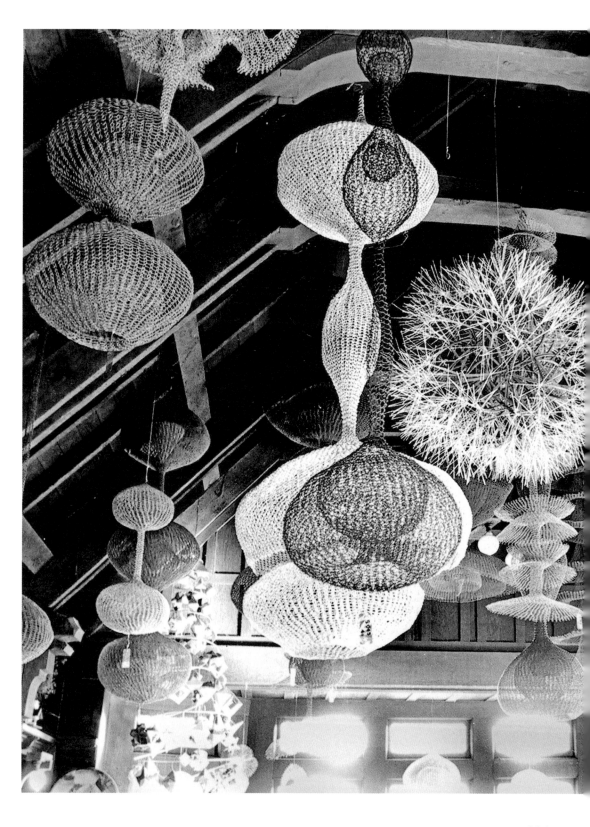

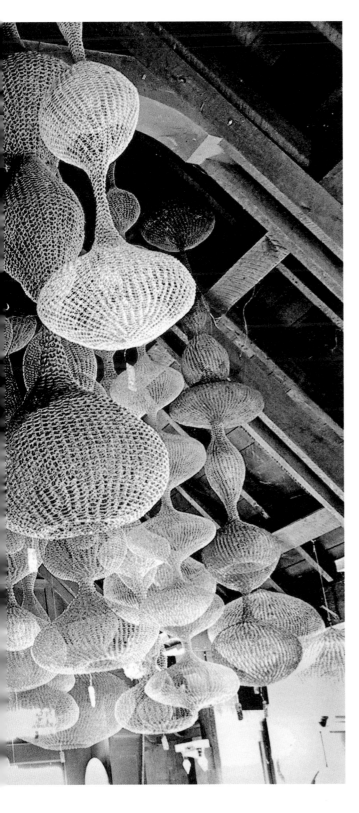

Living room of Ruth Asawa and
Albert Lanier's home, ca. 1995

What Is an Asian American Woman Artist?

For Asawa, the integrated approach to art making espoused by Albers provided the template for all subsequent practices. Work in the home, the public schools, and in specific sites replaced the need for a discrete studio art practice. In her early work of the 1950s and 1960s, Asawa was concerned with investigations of sculptural space, particularly through the manipulation of wire. The works evoked the process of crocheting and weaving—of women's work—at the same time as they evinced an interest in the abstract fashioning of organic form, suggestive of the body but clearly not representative of it.[14] This art challenged disciplinary boundaries—among some of the critical responses to the work were questions as to whether it was indeed sculpture, rather than craft or design[15]—at the same time it explored a number of binary relationships through its indeterminacy: movement versus stasis, interior versus exterior, form versus space, art versus craft. On the surface, Asawa's wire sculpture seemed to bear little connection to her experiences as a Japanese American woman, especially in light of later projects where she would take on this subject directly and representationally, such as her bronze public-art sculpture commemorating the Japanese American incarceration, installed in downtown San Jose, California, in 1995. However, in their challenge to the then-current understanding of sculptural practice, her early work is conceptually analogous to the persona that defied conventional profiles. Asawa was a woman artist working at a time when men were predominant, a self-identified homemaker, a professional artist, and a representative of the United States in an international art scene just ten years after Japanese Americans were incarcerated because they were seen as un-American.[16] Could it be argued that Asawa's abstract work, which defies easy categorization, provides a more complex relationship to her status and experience, one that, ironically, is less present later, in her more direct work?

In examining the abstract paintings of Hisako Hibi, it is difficult to decode the trajectory of her long and at times tragic life.

A generation older than Asawa and a Japanese immigrant to the United States, Hibi too had been incarcerated during World War II. Thirty-five years old at the time of incarceration, she was the mother of two young children and the wife of an accomplished painter twenty years her senior.[17] Her studies at the California School of Fine Arts (now the San Francisco Art Institute) in the 1930s had endowed her with some measure of training. In the camps, she not only created an extensive body of paintings but also taught in the art schools established there by fellow Japanese American artists Chiura Obata and George Matsusaburo Hibi, her husband.[18] It wasn't until decades later—after the untimely death of her husband in 1947, followed by her

14 While Asawa's work has been directly linked to her studies with Josef Albers, her relationship to Anni Albers, Josef's wife and an artist who made weavings, bears further scrutiny, especially vis-à-vis recent feminist recuperations and recastings of traditional women's work. For an examination of contemporary artists whose practices engage in domestic labors (Anni Albers's work is not included), see Lydia Yee, *Division of Labor: "Women's Work" in Contemporary Art* (Bronx, NY: Bronx Museum of Art, 1995).

15 Gerald Nordland, *Ruth Asawa: A Retrospective View* (San Francisco: San Francisco Museum of Art, 1973), n.p. Nordland reviews the criticism of Asawa's wire sculptures and notes that in 1953 and 1954 she exhibited with "craftsmen."

16 Asawa participated in the Bienal de São Paulo in late 1955. Her Japanese surname would have had specific resonance for the residents of São Paulo, which currently has the largest population of individuals of Japanese ancestry outside of Japan.

17 I am indebted to Kristine Kim and her exhibition brochure *A Process of Reflection: Paintings by Hisako Hibi*, published on the occasion of an exhibition of Hibi's paintings at the Japanese American National Museum, July 1999–January 2000, and to Ibuki Hibi Lee.

18 For a detailed examination of Obata's art and activities of the Tanforan and Topaz art schools, see Kimi Kodani Hill, ed., *Topaz Moon: Chiura Obata's Art of the Internment* (Berkeley, CA: Heyday Books, 2000).

Hisako Hibi, *Flower Garden*, 1964.
Oil on canvas, 24 × 20 inches

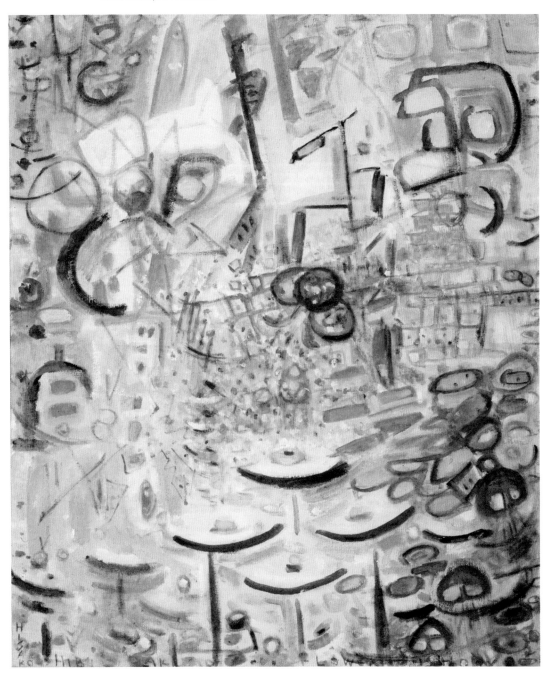

Theresa Hak Kyung Cha, *Aveugle Voix*,
1975. Performance, San Francisco

years as a single mother supporting her family by working as a seamstress in New York City and in California—that her work reached a level of formal and conceptual cohesion, demonstrating the emergence of a specific vision. Interestingly, Hibi appears to have been fully conscious of her status as a woman artist and looked for models. A 1943 painting, *Homage to Mary Cassatt*, created in the Topaz War Relocation Center in Delta, Utah, reworks Cassatt's 1893 painting *The Child's Bath*. In Hibi's canvas, the woman and the child are Japanese and their bath takes place in the concentration camp barracks. A reproduction of Cassatt's original painting from the collection of the Art Institute of Chicago is lovingly affixed to the back of the canvas.[19]

When Hibi was in her sixties and seventies, she began to merge abstraction and narrative content in a single canvas, incorporating both a calligraphic line and calligraphy itself with fragments and phrases of Japanese seemingly coming into and out of focus. The dynamic tension produced by this strategy is heightened by her interest in thinning the oil paint to create an effect similar to watercolor washes. Because they are on canvas, because the paint is not watercolor, because they vacillate between representation and abstraction, and because the finished works are left unvarnished, the paintings appear to breathe; they appear to be alive. But rather than conveying the feeling of being quickly executed, Hibi's paintings appear as though formed over time, with a durational quality that contrasts with the transparency and thinness of the paint. The incorporation of Japanese writing directly relates to Hibi's ethnic heritage, but Hibi's artistic interests were far wider, as she avidly and continuously made looking at art a central part of her life. She was interested in late nineteenth-century European art,[20] and toward the end of her life she became fascinated by German contemporary painting, such as that of Sigmar Polke, whose retrospective she saw at the San Francisco Museum of Modern Art.

While Hibi's art reached its pinnacle when she was in her sixties and seventies, Theresa Hak Kyung Cha produced mature and fully realized work in her twenties, which is all the more tragic given her death at thirty-one. Cha was born in Korea to parents who had lived through the Japanese colonial occupation of Korea (1910–45) and Manchuria (1932–45), and immigrated with her family to the United States at twelve, making her part of what would be called the 1.5 Generation, denoting the in-between status of young immigrants who claim a birthright to Korea but whose acculturation as Americans places them between generations and identities.[21] A number of movements converged in the tumultuous milieu of San Francisco and Berkeley of the late 1960s and early 1970s. Although Cha was a student at San Francisco State when the Third World Liberation Front, a coalition of multiethnic students, staged a strike to force the university administration to establish a program in ethnic studies, among other demands, her affinities appeared more connected to the radical changes affecting contemporary theory, Conceptual art practice, and performance. Her studies at the University of California, Berkeley, where she received a BA in comparative literature (1973) and both a BA and an MA in art (1975 and 1977), traversed a wide range of interests, including Korean poetry, European modernism, French film theory, and the feminism of Marguerite Duras and Monique Wittig, revealing a particular interest in the systems and place of language, semiology, and the fragmentation and rupturing of existing narrative structures.

Cha found a voice in multiple forms. She created videos and video installations, artist's books, mixed-media installations, performances, and performance documentation; edited an anthology of the film theory,

19 See Karin Higa, "The View from Within," in this book, 34–77.
20 Ibid., 25.
21 Biographical information comes from Moira Roth, "Theresa Hak Kyung Cha, 1951–1982: A Narrative Chronology," in *Writing Self, Writing Nation: Essays on Theresa Hak Kyung Cha*, ed. Elaine H. Kim and Norman Alarkin (Berkeley, CA: Third Woman Press, 1994), 151–60. It is important to note that the term *1.5 Generation* does not come into use until after Cha's death.

Apparatus/Cinematographic Apparatus (1980); and created *Dictée* (1982), a hybrid combination of autobiography, poetry, artist's book, and biography, whose form is a paperback. While the formal articulations of her art vary, it is characterized by a shared sentiment of evocative frailty and conceptual rigor. The 1977 performance *Reveillé dans la Brume* (*Awakened in the Mist*), as described by Judith Barry, overlaid sound, slide projection, text, fire, light, movement, and Cha herself in an attempt to subvert traditional spectatorship by juxtaposing multiple narrative strands to make "an interstice through which we slip."[22] While French theory as well as language (Cha first studied French at the Convent of the Sacred Heart High School in San Francisco) appear with great frequency in her art, Cha also liberally incorporated specifically Korean elements, whether snapshots of a Korean woman and child or letters and phrases in Korean in the three-channel video installation *Passages Paysages* (1978) or the narratives of her mother and the Korean revolutionary Yu Guan Soon in *Dictée*. Although an old family photograph, letters, and spoken Korean may link the artist to a specific Korean identity, the fragmentary form of her work suggests both the necessity and inadequacy of that link, as it challenges any conventionalized and simple relationship between story and meaning.

Over the last decade, the number of Asian American women artists who are producing and exhibiting complex and engaging works of art has continued to increase. Many of them have taken questions of history, cultural identity, representation, and personal and collective memory as the subject of their art, and yet no one personal profile, formal approach, or discourse has proved dominant. Even when artists share a similar interest in visualizing Asian American women in their art, other factors come into play. Two women whose artistic content may have affinities in this regard are Rea Tajiri and Hung Liu. But there is a question as to whether Tajiri, who grew up as a third-generation Japanese American in Chicago and Los Angeles and trained as an artist at the California Institute of the Arts in the late 1970s

and early 1980s, and Hung Liu, who was born in Changchun, China, studied art in Beijing and later San Diego, experienced the Cultural Revolution's "re-education" (i.e., forced labor) at age eighteen, and immigrated to the United States in 1984, can be appropriately discussed in the same context. They each engage in a conversation with historical models: Tajiri appropriates and reworks the conventional forms of documentary films and road movies, while Liu pictorially conflates received images of Oriental commodities and Chinese prostitutes for Western consumption with traditional Chinese and Western painterly forms. Clearly, the form, the tenor, and the approach of their respective practices differ radically. Through her film and video projects, Tajiri has experimented with narrative and documentary forms to question fabrications of history. Liu reprocesses traditional manifestations of China, both self-generated and externally generated, to explore the complex manufacturing of cultural identity. But if Tajiri's experiences as a third-generation Japanese American and Liu's experiences as a Chinese immigrant who was subjected to the harshness of the Cultural Revolution locate their production within specific historical circumstances, they only peripherally help the viewer unlock the meaning of their art.

What is the wisdom in grouping the diverse and divergent practices of these artists?

The parts that make up an individual's identity—biography, circumstance, appearance, beliefs, and practice—always exceed the sum, making categorical distinctions simultaneously more charged and less than adequate. So to return to the question of what is an Asian American woman artist, we find that the term itself is so specific and yet so broadly encompassing as to render itself ambiguous and opaque, thereby relying on a situational context for meaning. Since contexts are ever changing, then a characterization like "Asian American woman artist" could be used to affirm, to delimit, to marginalize, or to valorize—all subject to slight (or major) differences in context. There is wisdom in identifying Ruth Asawa, Hisako Hibi, Theresa Hak Kyung Cha, Rea Tajiri, and Hung Liu as Asian

Hung Liu, *Western Pass*, 1990.
Oil on canvas, silver leaf on wood,
ceramic, 60 × 60 × 10 inches

American women artists, just as there is the need to explore the specific ways in which their own practices are shaped and formed through other frameworks. The "I" of Mitsuye Yamada's poem, which opens this essay, understood this. Proud of her position as an Asian American woman in other contexts—even if a minority in a world hostile to her—she knew that in this case, "he" used it to delimit her, to mark her world and her existence using his terms. The "I" in turn chooses another reality. Cha described one of her performances, citing Roland Barthes, as "a plurality of entrances, the opening of networks, and infinity of languages,"[23] a fitting way to characterize an approach to thinking and writing about artists, whether women or Asian American.

22 Judith Barry, "Women, Representation, and Performance Art: Northern California," in *Performance Anthology: Sourcebook of California Performance Art*, ed. Carl E. Loeffler and Darlene Tong (San Francisco: Last Gasp Press and Contemporary Arts Press, 1989), 439–68. The essay was originally published in 1980.
23 Theresa Hak Kyung Cha, quoted in Abigail Solomon-Godeau, "Theresa Hak Kyung Cha at the Matrix Gallery, University Art Museum," *Art in America* 73, no. 4 (April 1985): 190–91.

Still from Rea Tajiri, *Strawberry Fields/ Ghost Pictures*, 1997. Film (color, sound), 90 min. From left: Luke (James Sie) and Irene (Suzy Nakamura)

Sights Unseen: The Photographic Constructions of Masumi Hayashi

Masumi Hayashi's panoramic photocollages explore the incongruity between appearance and reality in the American experience. She does this by creating photographs of contested sites: abandoned prisons, postindustrial landscapes, Environmental Protection Agency (EPA) Superfund sites, and the remains of American concentration camps. Yet the resulting panoramic photocollages exhibit a tremendous beauty, laced with both precise detail and abstraction. Without overt or critical commentary, they explore not only the surface but also the reality behind such places, whether they be panoramic landscapes or haunting interiors.

This is especially the case with Hayashi's series on EPA Superfund sites, which reminds us that another reality lurks literally beneath the surface. When she first encountered these locations, Hayashi was surprised by what she found: "The site looks everyday: bucolic, pristine and pretty. The irony is that you cannot see the pollution." *EPA Superfund Site 666* (1990) depicts a picturesque autumn landscape of blue skies and ethereal clouds reflected in a pool of water; only the title suggests something sinister. The surface beauty of the image contrasts with the basic record. From 1950 to 1969, LTV Steel Company of Elyria, Ohio, used this quarry as a disposal site for acids among other things. The result was a hazardous waste dump requiring substantial federal funds to clean and isolate. The eerie number of the site registers another stunning fact: Elyria was 666th on the list of more than a thousand toxic waste sites identified by the EPA.

Hayashi continued her exploration of stories hidden in the landscape by turning her attention to an intensely personal subject. In 1990, she began a decade-long project of photographing the physical sites of the mass incarceration of Japanese Americans during World War II. From 1942 to 1946, more than 120,000 Japanese Americans were subject to detention and housed in concentration camps in ten primary locales. Many of the sites became instant population centers, often dwarfing nearby free communities in sheer number of people. Yet today, little remains to suggest that the largest removal and incarceration of civilians in twentieth-century American history occurred there.

Hayashi inaugurated the series at Gila River, Arizona, the place of her birth. Armed with her birth certificate and a copy of the infamous civilian exclusion order of 1942 that required "all persons of Japanese ancestry" to report for incarceration, Hayashi traveled to the Gila River Pima-Maricopa Indian Reservation to photograph the site.[1] The resulting photocollage shows the desolate remains of concrete foundations set against a large expanse of sky. This scene recalls aspects of Hayashi's postindustrial landscapes, except here the contrast between the remnants of the camp and the barren landscape seems especially stark. As if to anticipate the questions about who lived there and for what purpose, Hayashi includes the copy of the civilian exclusion order in the photograph. This is a rare insertion by the artist into the landscape, as Hayashi generally photographs the sites as she finds them, though the shadow of her tripod often appears as a specter of the artist's presence.

1 Gila River and Poston were two War Relocation Authority concentration camps located on Indian reservation land in Arizona. While the camp at Poston was initially administrated by the Office of Indian Affairs, Gila River was not. Furthermore, the federal government sited the camp there without obtaining the consent of the Pima-Maricopa Tribal Council. For more information, see Arthur Hansen, "Gila River Relocation Center," in *Transforming Barbed Wire: The Incarceration of Japanese Americans in Arizona during World War II*, ed. Rick Noguchi (Phoenix: Arizona Humanities Council, 1997), 7–9.

Masumi Hayashi, *Republic Steel Quarry Site 666, Elyria, Ohio*, 1990. Panoramic photocollage, 19 × 37 inches

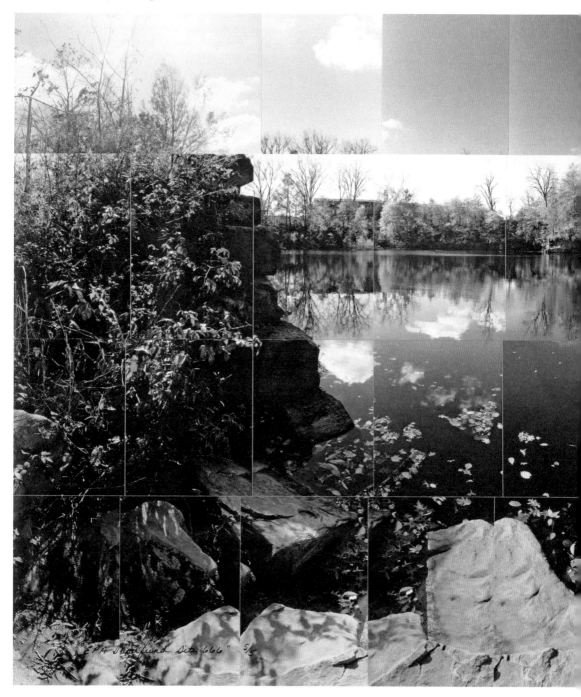

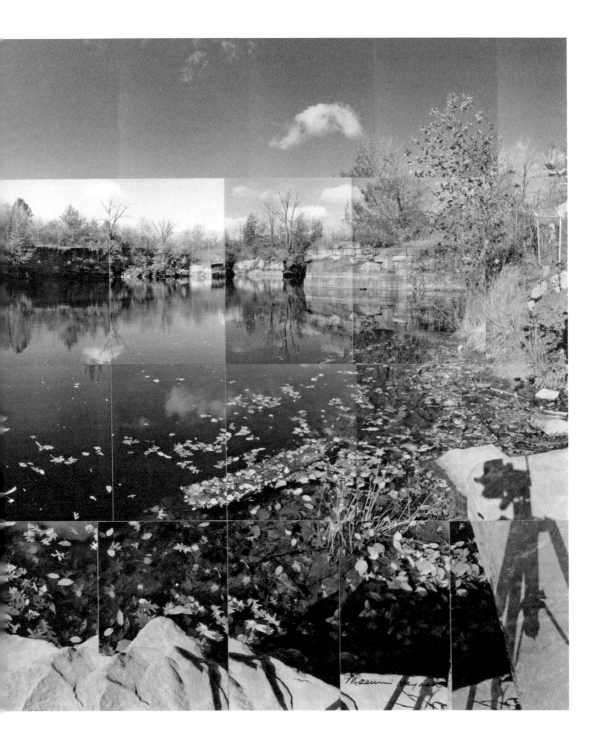

Masumi Hayashi, *Fumi Hayashida*, 1998.
Photocollage, 32 × 36 inches

Fumiko Hayashida holding her
daughter Natalie on Bainbridge Island,
Washington, March 30, 1942

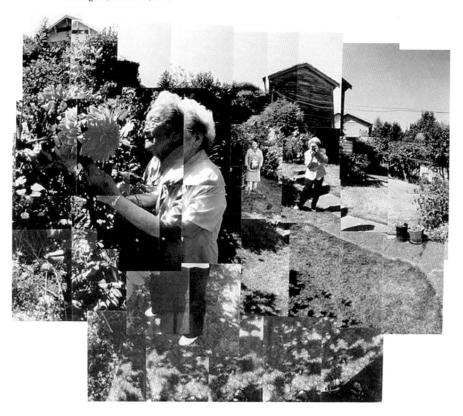

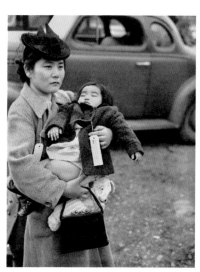

A key characteristic of Hayashi's work is the fact that her photocollages refrain from overt commentary. She creates works of tremendous beauty and simplicity, even though the landscapes she selects are primarily sites of conflict and contestation. Her work neither preaches nor condemns. Rather, it entices the viewer to learn and question through attraction to the physical, often haunting, beauty of the site—whether it be the inherent beauty of the landscape or that which results from the transformations of her art making.

To create her panoramic photocollages, Hayashi's process is both systematic and open to change. She begins at the horizon line, shooting approximately two dozen photographs in a horizontal circular rotation until she ends up where she began. She then angles upward, then downward, continuing until she has fully captured the landscape around her. After she returns to the studio, she collaborates with a printer to produce the component photographs and begins the final phase of assembling the collages. Rather than submit to a rigid framework, Hayashi plays with the discrete images to determine what might make—first and foremost—a convincing work of art. The resulting photocollages range from a 100-degree to 540-degree rotation and include as many as 140 individual photographs or as few as five.

Hayashi's use of multiple images underscores the insufficiency of a single photograph to capture complex experiences and realities. Viewers must simultaneously process the individual component parts as they try to make sense of the vertiginous perspectives produced by the circular rotation. This is especially the case in Hayashi's photographs of interior spaces, where the camera distorts what the eye and brain naturally process. In *Tule Lake Relocation Camp, Stockade* (1992), the photograph makes a dizzying one-and-a-half rotation. The stockade was constructed as a prison within the prison of Tule Lake. Several hundred Japanese Americans were held there without hearing or trial for up to nine months after a peaceful demonstration by inmates was treated as a security threat. Although the photograph is enhanced by such historical information, it does not require it; it manages to convey the aura and tumult of the site through its formal rigor and artistic expression.

For the exhibition *Sights Unseen: The Photographic Constructions of Masumi Hayashi* (2003), Hayashi presents—for the first time—a series of five portraits of Japanese North Americans who collectively represent both exceptional and ordinary actions by people subject to the vagaries of world war: Fumiko Hayashida (whose photograph by the War Relocation Authority became an emblem of the indignity of the mass exclusion), community activist Yuri Kochiyama, author Joy Kogawa, artist Miné Okubo, and World War II veteran Eji Suyama. Here the photocollages function in a different way. Instead of using the rotational perspective of landscapes, the format of the portraits is much looser. The multiple perspectives underscore the impossibility of representing a person and their life through the act of conventional portraiture.

Hayashi notes that "by working on the [camp] series, I was able to satisfy some need, some frustration about dealing" with the legacy of incarceration that affected her family in such difficult and tragic ways. It is interesting, then, that her most recent work has shifted to a different kind of highly charged locale: that of sacred sites, which often relate to ancestor worship. Traveling to Japan, India, and Nepal, Hayashi has produced a new body of work that captures spiritual depth and atmospheric detail. Here the landscape is reverentially depicted, yet the photocollages retain Hayashi's hallmark approach, which results in an art of simplicity, beauty, and resonant places.

Masumi Hayashi, *Tule Lake Relocation
Camp, Stockade, Tule Lake, California*,
1992. Panoramic photocollage,
27 × 79 inches

Masumi Hayashi, *Gila River Relocation Camp, Foundations, Gila River, Arizona*, 1990. Panoramic photocollage, 22 × 56 inches

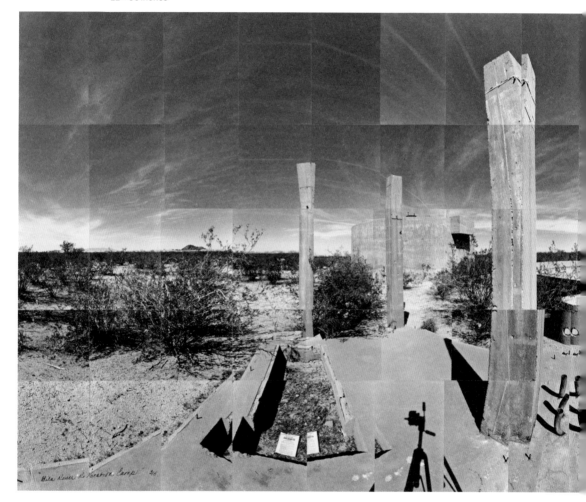

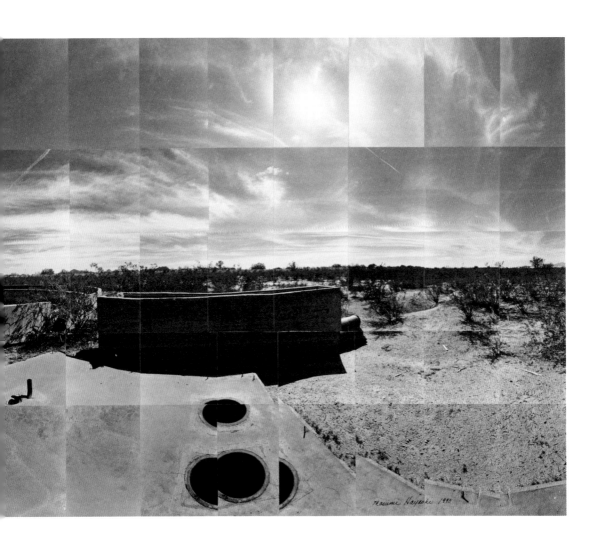

California
Registered
Historical
Landmark
no. 850

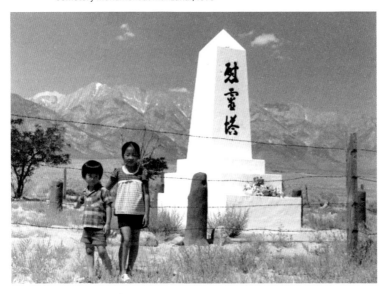

When I was a kid, in the early 1970s, my family would pile into our Ceylon-yellow VW bus and make the drive to Manzanar. The five-hour trip took us through the San Fernando Valley, past the strange grids of Palmdale and Lancaster— streets running perpendicular to the highway, along which no houses had yet been built—and into the vast expanse of Death Valley. There wasn't much to see at Manzanar. Just a stone and concrete sentry post off Highway 395, and, beginning in 1973, a small bronze historical plaque that read "California Registered Historical Landmark no. 850."

Sometimes we would go as part of the official Manzanar pilgrimage organized by the Manzanar Committee, an ad hoc group of former internees whose primary aim was to fight for recognition of the incarceration of Japanese Americans that had taken place right there in Owens Valley. This was a radical goal in an era when public discussion about internment was still taboo. At those early pilgrimages, people would convene at Manzanar, some arriving by bus, others in their own cars. It was a decidedly community affair, a hybrid picnic, memorial

service, and cleanup project, the last of which was in the interest of keeping the cemetery neat and tidy.[1] In clearing trash and debris, beer bottles and tumbleweeds, the spirit of volunteerism and unmanaged, organic collaboration arose. While adults in work gloves tired themselves out working in the desert heat, the few kids who had been brought, including my brother Kevin and me, would go hunting for lizards and horny toads or wandering around the desolate plain looking for signs of human habitation, until it was time for lunch.

We were all scavenging for history there, and we did it with our heads down, focusing on the land. There were no barracks, only piecemeal remains of concrete foundations, an occasional shard of thick, white, institutional pottery or bits of rusted metal. These fragments were evidence in our archaeological search for truth. We knew that something had happened

1 Official records note that of the 135 Japanese Americans who died at Manzanar, twenty-eight were buried in the Manzanar cemetery. After the war, all but six were exhumed and moved.

Andrew Freeman, *# 3.20.01–Northeast view from Whitney Portal Road of the Manzanar site, Alabama Hills and Hogback Road from an elevation of 7273'36˚35.759'N, 118˚12.780'W*, 2005. Dye coupler print, image size: 18 7/16 × 23 inches

at Manzanar, and despite the absence of barracks, the traces on the ground give credence to a history that was not part of official narratives of American history. We didn't learn about Japanese internment at school—we learned about it at home, and it seemed to me, as a child, a secret that Japanese American families kept among themselves. The trips we all took to Manzanar, a vast expanse of nothing, were proof of its elusiveness, as if the government had tried to sweep it all away.

Ten thousand Japanese Americans were incarcerated at Manzanar. It was one of ten War Relocation Authority camps, though not the largest or most populous.[2] The internees that spent the duration of World War II there came primarily from Los Angeles, with a smattering from San Joaquin County, in California's Central Valley, and Bainbridge Island, Washington. The official Manzanar contractor was the Los Angeles–based Griffith and Co., which initiated work on the site within a few weeks of Franklin D. Roosevelt's infamous February 19, 1942, Executive Order 9066, the presidential decree that authorized the forced removal and mass incarceration of Japanese Americans.

In a short time, Manzanar became a mini city in the desert. Comprising five hundred residential barracks arranged to the grid of thirty-six blocks, it was the most populated community between Los Angeles and Reno, with the requisite institutions of a shared public sphere. More as the result of internees' initiative than through government mandate, a camp infrastructure developed. Barracks were utilized for such functions as newspaper office, church, temple, photography studio, sign shop, and cooperative store. Small gardens flourished around the residential barracks, and internees created two large "public" gardens: Merritt Park, which had more than one hundred species of plants, several ponds, and a Japanese teahouse, and Cherry Park, a grove of cherry and wisteria trees donated by a nursery.

Despite Manzanar's perceived prosperity, it is important to remember what was lost in the incarceration: homes, businesses, relatives, friends, and freedom. How do we reconcile the vitality of a community with the loss of freedom and autonomy that engendered it? The desolate locale that Manzanar became after the war's end provides a kind of answer. In assessing an upheaval so massive and complex as the removal of all persons of Japanese ancestry living on the West Coast, the tendency is to focus on the material conditions, the inventory of individuals, families, their personal belongings. Arguments have been made about the tremendous "success" of internees to create lives in the confines of the camp, evidenced by the schools, churches, and factories. Such arguments emphasize either that Japanese Americans triumphed in the face of adversity or that the experience of incarceration was "not so bad." But at the war's end, Manzanar was gone—every last bit of it. At the margins of its absence, it becomes possible to parse the abstractions, such as how a government incarcerated its own people, how race could have been equated with loyalty—or with treason, and what the internment and its violation of civil liberties imply about the limits of American justice.

Manzanar's absence and the issues and questions that were at its margins serve as a starting point for Andrew Freeman's *(Manzanar) Architecture Double*. What happened to the five hundred residential barracks? Freeman's photographic survey provides a complex response to this seemingly simple question. Serial, deadpan photographs of former Manzanar barracks bear little surface resemblance to their original function. Like the Japanese American internees who transformed the military-style camp environs into a mini city rising from the desert brush,

2 This honor would go to the three linked camps of Poston, Arizona, which were built on land appropriated from the Colorado River Indian Reservation. For an analysis of the formation of Poston, and the relationship between the Office of Indian Affairs and the War Relocation Authority, see Ruth Okimoto, *Sharing a Desert Home: Life on the Colorado River Indian Reservation, Poston, Arizona, 1942–1945* (Berkeley, CA: Heyday Books, 2001).

Andrew Freeman, # 5.4925.7.01–Lone
Pine Indian Reservation Tribal Office,
Lone Pine, California (version 1 of 3)
36˚35.710'N, 118˚03.523'W, 2005. Dye
coupler print, image size: 11 × 22 inches

Andrew Freeman, # 5.4924.9.01–Lone
Pine Budget Inn (formerly The Willow
Motel), Lone Pine, California
36˚36.403'N, 118˚03.884'W, 2005. Dye
coupler print, image size: 11 × 22 inches

Andrew Freeman, *# 1.5.04–Rhino's Bar and Grille, Main Street at Sinclair, Bridgeport, California 38°15.365'N, 119°13.651'W*, 2005. Dye coupler print, image size: 11 × 22 inches

Andrew Freeman, *# 3.4.04–Don Becker's garage and guesthouse, Independence, California 36°48.229'N, 118°11.620'W*, 2005. Dye coupler print, image size: 11 × 22 inches

the new owners of these barracks and their doubles coax new functions, and new meanings, from the residue of the wartime experience. There is the barrack that now houses the Lone Pine rifle club. A residence in Pangborn serves as a spacious single-family home, while the barracks that are now the Lone Pine Budget Inn exude a more forlorn aura. The disjunction that Freeman's photographs emphasize between these structures' former use and their rehabilitation, their relocation from Manzanar to sites of "regular" human habitation, lead us to wonder how it is that traces of history can be represented by physical structures, and whether the barracks serve or obscure various truths. Although these buildings can each trace a relation to Manzanar, the buildings don't, and can't, explain the Manzanar experience.

(Manzanar) Architecture Double relates to the tradition of late nineteenth- and early twentieth-century photographic surveys intended to catalogue vast tracts of land in the American West. In this spirit, as a formal photographic and quintessentially Western investigation, Freeman's component photographs subtly and collectively comment on the contested history of the region and its legacy of visual representations. The barrack that serves as an office on the Lone Pine Indian Reservation hints at the confluence of settlers there, though the current tribe's relationship to the Indigenous Paiute Indians who seasonally inhabited the land before their capture and dispersal by the U.S. military remains unclear. Freeman's panoramic triptych of the broad expanse of Owens Valley, its dry lake bed and serpentine aqueduct carrying water to Los Angeles, invokes the failed narrative of the first Manzanar, a farming community of fruit orchards founded in 1910 and abandoned when the City of Los Angeles purchased its water rights in the late 1920s. In Freeman's image of a barracks converted to an airplane hangar in Bishop, foreground darkness emphasizes the exquisite late-afternoon light of the mountains behind, an evocation of Ansel Adams's surveys of the Eastern Sierras and his project *Born Free and Equal: The Story of Loyal Japanese-Americans* (1944), which documented Manzanar and its internees. In its incidental splendor, Freeman's image deflates the exuberant mastery of the grand photographer while paying homage to the still-majestic mountain range.

The convoluted Manzanar narrative took another twist when its land was formally transferred from the City of Los Angeles to the National Park Service in 1997. The plan was to complete the transformation of Manzanar into a National Historic Site, a status that was officially granted in 1992. Many in the Japanese American community had fought fervently for such recognition. On April 24, 2004, the park officially opened. Thousands attended to the roar of *taiko* drumming. Japanese American World War II veterans and members of the Lone Pine Veterans of Foreign Wars (whose headquarters are none other than part of the former Manzanar auditorium/gymnasium) carried flags. A comprehensive historical interpretation was unveiled in the partly restored, partly re-created Manzanar auditorium. For all the pomp and circumstance—the success of finally having the U.S. government's official acknowledgment of Manzanar as tragic and tragically ignored history—it wasn't without a certain ironic resonance that a National Park Service ranger cheerfully intoned, as people arrived at the event, "Welcome to Manzanar!," a greeting that seemed to imply the place itself was new, and newly receiving, visitors. Some of us, of course, had already been.

Andrew Freeman, *#3.22.01–Southeast view from Whitney Portal Road of the Alabama Hills and Owens Lake (dry) from an elevation of 7273'36˚35.759'N, 118˚12.780'W,* 2005. Dye coupler print, image size: 18 7/16 × 23 inches

California Registered Historical Landmark no. 850

Origin Myths: A Short and Incomplete History of Godzilla

What was Godzilla? From 1990 until the middle of that decade, the shifting configuration of individuals committed to a broad notion of "Asian American artists" gathered under that name in New York. From a dozen people, it grew exponentially, even spawning offspring elsewhere. The underlying intent was simple, but it had a catalytic effect: artists, writers, and curators with shared interests could band together, harness their intellectual and social networks, challenge each other, and take action to support art by Asian Americans.

My own association with Godzilla was short and intense, but because I was there at the beginning—not at its birth but early enough—I'm granted some measure of credibility as an OG. For a year or so, I was one of Godzilla's loyal partisans—not one of its leaders or visionaries but a fervent participant. After I moved to Los Angeles to work with the newly formed Japanese American National Museum, I witnessed how Godzilla grew and flourished while its activities took on a near-mythic status among Asian Americans in the visual arts. Godzilla was proof that Asian American artists could be a force with an irreverent tone that counteracted an art-world version of the model minority myth of Zen-inspired artists and venerable traditions. By the mid-1990s, the changing social context necessitated different ways of conceptualizing the display and interpretation of art by Asian Americans. The proliferation of "identity-based" work developed into a conventionalized language, triggering a backlash, which unfortunately lumped divergent and distinct practices under a simplistic rubric. The early thinkers pursued other projects. There wasn't necessarily an official end to Godzilla. It just slowly petered out.

Looking back after more than fifteen years, I see how Godzilla—at least in its early incarnations—was even more radical in its concept of an Asian American arts practice than I understood at the time. The flimsy and scientifically unsupported notion of race may make any race-based alliance suspect, but Godzilla's lack of structure, openness to diverse formal and conceptual artistic practices, and nonjudgmental stance to varying approaches to Asian American identity accommodated critique while strategically accepting notions of race as a pragmatic organizing principle. It was three artists—Ken Chu, Bing Lee, and Margo Machida—who met in July 1990 with the idea of forming some kind of alliance to address the state of contemporary Asian American visual artists.[1] They understood that power in the field of culture aligned along axes of privilege, where making art was only one part of the equation. Access to dialogue, venues for display, and engaged critical response were essential components of an arts ecology. The absence of any one part halted the cycle.

The politics of art, rather than the making of art, was therefore a central concern of the original organizers. The minutes taken from the first meeting at Margo's studio are revealing. In addition to their astute analysis of cultural race politics, the fact that that there were minutes at all suggests a seriousness of intent from the outset. Many of the things they discussed at the first meeting are still relevant today. They talked about the need for a library or archive that systematically collects material on Asian American artists, the wish for informed critics, the definition of "Asian" versus "Asian American," an interest in ways of working outside of "majority" culture, and the need for institutional support—an Asian American art museum—not only to validate Asian American artists but also to allow them to work outside of a de facto quota system operative among mainstream art institutions. Asian American artists had grown tired of being invited to participate in activities in May—Asian/Pacific American Heritage Month.

1 Godzilla meeting summary, July 25, 1990, author's personal archives.

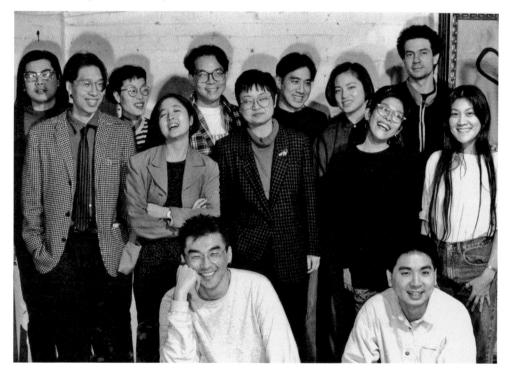

Group portrait of the members of Godzilla: Asian American Arts Network, taken in 1991 for the cover of *Godzilla Newsletter* 1, no. 1 (Spring 1991). Standing, from left: Byron Kim, Bing Lee, Eugenie Tsai, Karin Higa, Arlan Huang, Margo Machida, Charles Yuen, Janet Lin, Helen Oji, Colin Lee, Tomie Arai. Seated, from left: Ken Chu, Garson Yu

The interest in forming a museum no doubt derived from *The Decade Show: Frameworks of Identity in the 1980s*, a messy and unprecedented three-part exhibition in 1990 coorganized by the Museum of Contemporary Hispanic Art, the New Museum of Contemporary Art, and the Studio Museum in Harlem that explicitly foregrounded explorations of race and identity in contemporary art, though at those early Godzilla meetings there were debates about the feasibility and ultimate desirability of duplicating conventional institutional structures. Two books were influential. Lucy Lippard's *Mixed Blessings: New Art in a Multicultural America* (1990), a panoramic exploration of artists throughout the country, was staggering in the sheer breadth and diversity of the artists it documented. Lippard's role as an influential critic, whose ability to see and assess major moments in art as they were forming, validated an interest in artists of color; at the same time, criticism of the book showed how dismissive mainstream culture could be. In an approach quite distinct from Lippard's, the anthology *Out There: Marginalization and Contemporary Culture* (1990), edited by Russell Ferguson, Martha Gever, Trinh T. Minh-ha, and Cornel West, with images selected by Felix Gonzalez-Torres, assessed cultural marginalization by examining underlying institutional and theoretical frameworks of difference through the various lenses of race, gender, sexual preference, and class. Yet a prevailing attitude is perhaps best summarized

by a 1991 remark by Helen Frankenthaler. In reference to the National Endowment for the Art's funding recipients, according to the *New York Times*, Frankenthaler "questioned whether the demand for cultural diversity and social consciousness in grant giving was subverting the criteria for artistic excellence"[2]—the implication being that cultural diversity and artistic excellence were mutually exclusive.

By the third meeting in September 1990, when I joined, the group had grown to include Tomie Arai, Mo Bahc, Arlan Huang, Byron Kim, Stefani Mar, and Yong Soon Min. Shortly thereafter, we decided on several things, including the name Godzilla. Was it too "camp"? Would its Japanese origins inadvertently signal a predominance of one ethnicity rather than the pan–Asian American coalition we intended? Would we get in trouble for using a presumably copyrighted name? In the end, the monster's origins seemed the perfect metaphor.[3] After all, Godzilla wasn't even the monster's real name, but rather an anglicization of *Gojira*. His reemergence from the depths of the Pacific was tied to postwar American atomic intervention in the region. His celluloid existence was filled with Asian masses whose English words didn't match their lip movements, and the primary vehicle for his dissemination was the mass medium of American TV. Nothing about Godzilla was authentically Asian. He was the ultimate hybrid monster.

A spirit of adventure, self-reliance, and collectivity characterized Godzilla's incarnation. Membership was conferred on anyone who showed up. In the early months, the meetings were small, consisting of a dozen or so of us who met in the studios, apartments, or workplaces of whoever volunteered. While the organizational structure—such as it was—was flat, the unofficial leaders were Ken and Margo. It was pretty much agreed that Ken was the tallest Chinese American man anyone had ever met. His height, effusive intelligence, and goofy enthusiasm became an inspiring force. Margo brought an organizational rigor and seriousness to the group that helped maintain its focus. Both had the vision, the organizational savvy, and dogged optimism to channel divergent perspectives into a cohesive group. We didn't have uniform opinions about art and what forms it should take, but we did share an openness to engaged dialogue about art by Asian Americans.

Some of the more formative experiences for me were the small gatherings where Godzillaites and invited out-of-towners would make informal slide presentations about their work, followed by discussion. It took little in the way of resources to organize but enacted the theory that we could learn by looking, thinking, and talking about Asian American artists. Allan deSouza, who then lived in London and had founded Panchayat, the group for South Asian and other artists of color in Britain, was one of the early visitors and provided an international perspective over a potluck dinner at Helen Oji's loft. This was later followed by visits from David Medalla and Mel Chin, though by this time the number of people that constituted Godzilla took us from private homes to borrowed public spaces in New York City like the Clocktower Gallery, Artists Space, and the Chinatown History Museum (now called the Museum of Chinese in America). Panel discussions broadened the conversation. Pamela Lee, Eugenie Tsai, and Alice Yang talked about curatorial practice in a session moderated by Tomie Arai, who along with Kerri Sakamoto, later organized a discussion on notions of "quality" and "Asian American aesthetic."[4]

One of the first public actions of Godzilla was to publish a newsletter "to establish a dynamic forum that will foster information exchange, mutual support, documentation, and networking among the expanding numbers of Asian American visual artists all across the United States."[5] The first edition was published

2 Helen Frankenthaler, quoted in Byron Kim, "NEA Chief Reserves Denial of Grant to Mel Chin," *Godzilla* 1, no. 1 (Spring 1991): 2.
3 Other names considered included East West Works and Project for Asian Pacific American Art. Godzilla meeting summary, September 14, 1990, author's personal archives.
4 "Notions of the 'Q' Factor," *Godzilla* 2, no. 1 (Summer 1992): 2.
5 "Open Letter to Our Readers," *Godzilla* 1, no. 1 (Spring 1991): 1.

Godzilla 1, no. 2 (Winter 1991)

GODZILLA

▲▲▲▲

ASIAN AMERICAN ARTISTS AND THE WHITNEY BIENNIAL:

A Question of Inclusivity

By Margo Machida

winter 1991
vol. 1 number 2

On Friday, September 20, twelve members of GODZILLA met at The Whitney Museum of American Art with David Ross, its recently appointed director. By meeting face to face with us, Mr. Ross responded to our letter of May 13 [see text accompanying the article], in which GODZILLA had asserted its members' dissatisfaction with the fact that no Asian American painters, sculptors or photographers had been included in the 1991 Whitney Biennial (with the exception of Martin Wong's contribution to the Group Material installation). In addition to urging that Asian Americans participate in all aspects of the museum's operations and programming, our primary objective was to explore ways to establish mechanisms for ongoing dialogue that would better acquaint curators and museum staff with the broad range of work produced by Asian American visual artists.

WHAT HAPPENED: Two limited initiatives were accepted by Mr. Ross: 1) GODZILLA has submitted slides of twelve Asian American artists, which he will pass on to his curators to consider for studio visits; and 2) Mr. Ross will propose a follow-up meeting with Whitney curatorial staff which, however, is contingent upon their agreement. These suggestions were taken from a number of possibilities presented by GODZILLA that included both long-term goals (Asian American inclusion in exhibitions, the permanent collection and as staff, consultants and members of the Board) and such specific short term projects as: 1) curatorial visits to Asian American artists' studios facilitated by GODZILLA and 2) the establishment of an annual multiracial curatorial roundtable, sponsored by The Whitney, at which scholars and curators could share information on work and issues emanating from diverse communities.

address all
correspondence
to:

GODZILLA:

Asian American
Art Network
P.O. Box 879 Canal
Street Station
New York, NY
10013-0864
ph. 718.855.8385

copyright 1991
GODZILLA:
Asian American
Art Network

Notably, Mr. Ross responded that while he was not opposed to educational initiatives such as a roundtable for curators and staff, they were "palliatives" when compared to the sub-

Whitney letter reprinted on page 2.

stantive changes that will result from his addition of people of color to the museum's staff and Board. However, it is GODZILLA's belief that bringing about change must be an ongoing process that proceeds on many levels. Curators obviously cannot make informed choices without being exposed to the work and ideas of Asian American artists—although, of course, this presumes that there is a willingness to learn about us in the first place!

WHAT'S AT STAKE: If The Whitney Museum is, as David Ross recently stated in *Sculpture* Magazine, "America's preeminent museum of American art," then the lack of inclusion of Asian Americans in the Biennial—which represents only those artists and issues that the "mainstream" considers "worthy"—is indeed significant if our work is to begin receiving the attention it justly deserves. Clearly these actions, in spite of a growing national concern with multiculturalism and the ascendance of Asian nations as world class economic powers and cultural influences (spurring public interest in things Asian and Asian American), are not unique to the Whitney. In this, it is indicative of a broad pattern of indifference and inattention toward Asian American artists—and issues specific to being Asian in America—that, with few recent exceptions, continues to pervade most museums as well as the academic art establishment.

Beyond a handful of artists who have gained deserved international recognition, such as Isamu Noguchi, Yasuo Kuniyoshi and Nam June Paik (who has repeatedly been featured in the Biennials), the contributions of the vast majority of Asian Americans remain undocumented and underrecognized. Although many actively exhibit in both commercial and nonprofit settings, the artworld (especially at the "blue chip" level) remains notoriously parochial in who it is willing to accept in its networks of mutual verification and valorization—or, as David Ross succinctly observed in our meeting, "People tend to order what's on the menu."

However, while "mainstream" visibility is important in making the presence of Asian American artists more widely recognized, venues like the Whitney are certainly not the sole arbitrators of value. Further, I am not suggesting that only by showing at such institutions can one be validated as an artist! Rather, highly visible forums like the Biennial, by purporting to be national in scope, can be regarded as a form of visual "town hall meeting" in which our work has as much right to be seen as that of other segments of American culture.

WHAT'S NEXT: Whatever the immediate outcome, GODZILLA's dealings with the Whitney raise important questions and challenge our artists, curators and writers to develop initiatives capable of asserting our presence, and the importance of our issues, in the larger artworld. While the necessary work of documenting, exhibiting and publishing materials about Asian American artists is proceeding (primarily through independent curatorial projects, university-based scholarship and community arts organizations), we must also actively insist that the contributions of Asian Americans are an important element in the contemporary American art dialogue.

GODZILLA welcomes your responses to this situation; selected letters will be published in the next edition of this newsletter.

Godzilla 2, no. 2 (Winter 1992)

in March 1991, with a design by artist Charles Yuen and Garson Yu. We each pitched in forty dollars to cover printing and mailing costs. Although a modest four pages, including listings of exhibitions, regional news, and short pieces on critical issues in the art world, the newsletter explicitly telegraphed a diverse approach to what constituted Asian American arts. While the Asian American community arts movements of the 1960s and 1970s were recognized as significant antecedents, what distinguished Godzilla's approach was its ecumenical approach to Asian American identity.[6]

In our current age of instant communication and broad dissemination of information through electronic formats, it may be difficult to fathom how the initial printed newsletter could make such a radical impact, but it did. It was tangible evidence of the existence of Asian American artists and linked seemingly unconnected activities under a single rubric. The power of the printed word became even more apparent after Robert Atkins wrote a mere eight lines about it in his Scene & Heard column in the *Village Voice*, which generated considerable buzz and gave Godzilla currency as something official.[7] (As a sign of how much times have changed, it also included Ken's home phone number for those seeking more information.)

Atkins's column asked the question, "What if there are no Asian American artists in the Whitney Biennial?" Although the 1991 exhibition had yet to open, the artist list showed no Asian American painters, sculptors, or photographers, though Martin Wong was included in the installation by artist collective Group Material. After the exhibition opened, a working group consisting of Byron Kim, Margo Machida, Yong Soon Min, Paul Pfeiffer, and Eugenie Tsai drafted a letter to the new Whitney Museum of American Art director, David Ross. It excoriated the Whitney for its conspicuous absence of Asian American visual artists: "We feel the Biennial fails to live up to its intention, as stated in the official brochure, of providing 'a framework for better understanding the diverse creative vitality that characterizes the art of this period.'"[8] In the fall, Ross invited a small group of us to meet with

him. While at a basic level we talked of inclusivity and representation, our larger argument was more nuanced. Curators and museum professionals make value judgments based on spheres of knowledge. What if those spheres are limited because of race? Ross sympathetically and succinctly observed in the meeting that "people tend to order what's on the menu." We proposed to expand the choices. We presented specific educational initiatives, which included submitting slides of Asian American artists, organizing studio visits, and coordinating roundtable discussions. For many of us, the Whitney action was symbolic and strategic. It was not about a specific number of Asian American artists on an exhibition checklist; it was about unmasking institutional and theoretical frameworks that limited what people could see.

There is nothing like controversy to generate interest. The June 1991 issue of *Art in America* covered our Whitney challenge in a small notice, "Guerrilla Girls Move Over?" The Godzilla meetings became large and heady affairs, attendance at which had a certain cachet. The newsletters, which came out irregularly from 1991 to 1993, grew in page count and the ambition of content, due in part to the increased involvement of Eugenie Tsai and Kerri Sakamoto. The early 1992 issue weighed in at twelve pages and featured extended reviews, expanded listings and regional news, and idiosyncratic musings like Abe Yoshida's "Marcel Duchamp on Asian American Art," a half-page compilation of Duchamp's writing that *could* be about Asian American art.[9]

6 The section on the regional news included reports of Vishakha Desai's recent appointment as director of Asia Society, the Asian Pacific Islander participation at the AIDS Coalition to Unleash Power (ACT UP) benefit auction, and Mayumi Tsutakawa's position with the King County Arts Commission in Seattle.
7 Robert Atkins, Scene & Heard, *Village Voice*, April 2, 1991, 82.
8 The full letter and a summary of the events were published in *Godzilla* 1, no. 2 (Winter 1991): 1–2.
9 Abe Yoshida, "Marcel Duchamp on Asian American Art," *Godzilla* 2, no. 1 (Summer 1992): 6.

In the same issue, Paul Pfeiffer's perspectives on "Out in the 90s: Contemporary Perspectives on Gay and Lesbian Art," a symposium at the Whitney Museum that included Ken Chu as one of the panelists, perceptively explored the intersections of sexuality, race, gender, class, and age, complicating a simple notion of Asian American identity.[10]

In 1993, at the invitation of curator Connie Butler, Godzilla organized a major exhibition at Artists Space titled *The Curio Shop*, coordinated by Godzilla-ite Skowmon Hastanan. The choice of the curio shop as an organizing framework for an exhibition of Asian American artists organized by Asian American artists contained several reversals. The curio shop in an Asian American context brings to mind Chinatowns, where non-Chinese can buy kitschy representations of supposedly authentic Chinese culture. But who's playing whom? The consumer with the buying power or the seller who plays with stereotypes to move goods? Godzilla, as the organizer of the exhibition, seems to call attention to and implicate itself in the various and complex transactions between object and consumer, cultural producer and cultural performer.

The 1993 Whitney Biennial, now referred to as the "political" biennial, explored the issue of race head-on, beginning with Daniel J. Martinez's admission tags with single words that added up to the infamous statement, "I can't imagine ever wanting to be white."

Carol Sun, *Asian-American Heritage Cards*, 1993. From *The New World Order III: The Curio Shop*, Artists Space, New York, 1993

The next year, in an unprecedented move, Asia Society held its first exhibition of contemporary Asian and Asian American art. Organized by Margo Machida, it focused on artists who were immigrants and their negotiation of identity as expressed in the narrative of their art. Two major institutions—one of American art, the other of Asian art—were foregrounding Asian American artists. Museums hired or expanded the responsibilities of Asian American curators: Eugenie Tsai at the Whitney, Alice Yang at the New Museum, and Lydia Yee at the Bronx Museum of the Arts. The Japanese American National Museum, a cultural history museum founded and run by Japanese Americans, presented another paradigm of art and community.

Before this period, it was commonplace for museums to have no Asian Americans on staff or no Asian American artists in their exhibition programs. For credible institutions today, this is inconceivable—a lasting impact of Godzilla.

Clearly, the context that propelled Godzilla had changed by the mid-1990s. At the same time, Godzilla seemed to change too, morphing from its earlier incarnations into a set of increasingly fixed positions. From both within the group and outside, Godzilla and "Asian American art" came to signify a specific type of artistic practice rather than a set of artistic

10 Paul Pfeiffer, "Out in the 90s,"
Godzilla 2, no. 1 (Summer 1992): 4.

Assembling *Godzilla Portfolio* for
Urban Encounters, New Museum of
Contemporary Art, New York, 1998,
(below) with Stefani Mar, Teddy
Yoshikami, and others; (right) with
Bing Lee and Skowmon Hastanan

Assembling *Godzilla Portfolio* for
Urban Encounters, New Museum
of Contemporary Art, New York,
1998, (above) with Tomie Arai,
Todd Ayoung, and others; (right)
with Franky Kong and Ken Chu

Zilly Award party, 1992. From left:
Karin Higa, Pamela Lee

Karin Higa receiving Zilly Award, 1992

Zilly Award party, 1992. From left:
Karin Higa, Pamela Lee

Karin Higa receiving Zilly Award, 1992

interrogations. "Identity-based" art took on a codified language and mode of exposition that Asian American artists were increasingly expected to manifest, a pressure that clashed with the multifarious approach to Asian American identity and art that had been central to Godzilla's origins.

In a 1992 Godzilla newsletter, Byron Kim addressed the burden of representation for an Asian American artist. As an abstract painter obsessed with the paintings of Ad Reinhardt and Brice Marden, Byron wrote, "I'd like to make some large paintings exactly like Brice Marden's Grove Group, and I mean exactly like his. These paintings would respond directly to those who ask me, 'Why are you making abstract paintings?' The 'you' meaning Asian-American-artist, artist-of-color, artist-with-something-to-say. Of course, my intention would be to make this line of questioning the inevitable content of the painting."[11] In a double critique, Byron challenged the implied assumptions in the query, "Why abstract paintings?" at the same time he hints at the expansive possibilities for complex content in the language of abstraction.

For me, the exhibition *One Way or Another: Asian American Art Now* (2006) begins where early Godzilla left off. It takes a heterogeneous approach to artistic practice that defies the notion that there is such a thing as "Asian American art," at least one that betrays a shared and cohesive set of formal or conceptual characteristics. Instead, there are Asian American artists from many different places who make different kinds of art. Yet the scientifically suspect notion of race remains a factor in the American experience. In a 2003 conversation with Eve Oishi, Patty Chang underscores the specificity that her race gives to her work when she appears; regardless of the other content in the video, Chang states, "I'm always doing an Asian woman."[12] What "Asian woman" or "Asian American" signifies today is what *One Way or Another* proposes to question.

11 Byron Kim, "An Attempt at Dogma," *Godzilla* 2, no. 1 (Summer 1992): 8.
12 Patty Chang, quoted in in Russell Ferguson, *Patty Chang: Shangri-La* (Los Angeles: Hammer Museum, 2004), 17.

Inside and Outside at the Same Time: Ruth Asawa

Exploring the exterior surface of Ruth Asawa's looped-wire sculptures can be a tricky feat. As the eye grasps and follows the volumetric form, the exterior becomes the interior. Just when the mind adjusts to this switch, the interior transforms into the exterior again, the sculpture's undulating form suggesting a continuous movement from one state to another without interruption. As Asawa once described it, "What I was excited by was I could make a shape inside and outside at the same time."[1] This duality comes not from a transformation of the material, as the basic character of the metal wire remains the same throughout the sculpture. Nor does it derive from a dramatic manipulation of the looping process, since a simple chain stitch of evenly formed interlocking loops is employed. Rather, Asawa creates a dynamic sculpture by bringing a different approach to a conventional form of needlework and the prosaic material of wire. Like a paper Möbius strip, which is one of its inspirations,[2] an Asawa wire sculpture has no front or back or inside or outside. "You could create something…that just continuously reverses itself," Asawa has said of this work.[3]

Understanding the significance of Asawa's Japanese American identity to her art presents a similar feat. Almost all accounts of her art life remark on the fact of Asawa's Japanese heritage. From her earliest exhibitions to her most recent public-art commissions, her ethnicity is evoked as if it could unlock both the meaning of her work and the origins of her experiences. Yet being a Japanese American has meant different things at different junctures to the conditions of Asawa's art making and the contexts of her art's reception. While it may be impossible to assess what Japanese ancestry meant to Asawa—her specific subjectivity—there is no question that her race and ethnicity mattered to others and presented unique circumstances that impacted opportunities for her as an artist, just as it affected the way her art was received and interpreted. This essay proposes to briefly explore Asawa's early life and art as a way to understand how her formative experiences as a Japanese American shaped her sensibility as an artist.

Asawa has repeatedly located her transformation as an artist to Black Mountain College and her principal teacher, Josef Albers. Of course, this is not surprising. Both Black Mountain College and Albers occupy a pivotal place in the annals of American art, and their impact has been explored in numerous exhibitions and publications.[4] But without minimizing the catalytic effect of the Black Mountain experience on Asawa, a number of factors present on her parents' farm and during the family's World War II incarceration cultivated in her the requisite conditions to fully integrate the philosophy and teaching of Albers and others at the college, namely: a familiarity with self-contained communal environments, requiring collaboration and toil; an appreciation for ingenuity through thrift; and exposure to progressive education that included sustained relationships with working artists. Asawa's Japanese American ethnicity framed these experiences; while it may have condemned Asawa and her family to limited spheres of existence, it also opened up other avenues of opportunity, ones that ultimately enabled Asawa to pursue her specific kind of art and art activism.

1 Ruth Asawa, interview by Aiko Lanier Cuneo, October 20, 2003, unpaginated, Ruth Asawa papers, Department of Special Collections and University Archives, Stanford University, Stanford, California.
2 Ruth Asawa, interview by Mary Emma Harris, December 18, 1971, Asawa papers.
3 Ibid.
4 For a detailed bibliography of Black Mountain College and its faculty and students, see Mary Emma Harris, *The Arts at Black Mountain College* (Cambridge, MA: MIT Press, 1987), 277–307.

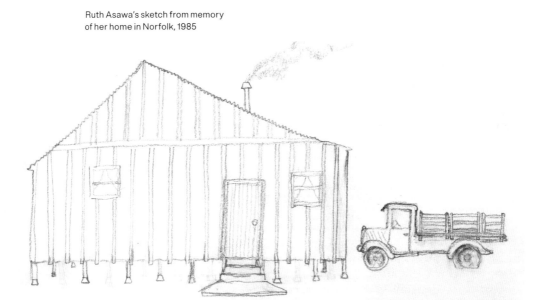

Ruth Asawa's sketch from memory of her home in Norfolk, 1985

Life on the Farm

In a 2003 interview with her eldest daughter, Aiko Cuneo, Asawa describes the meager surroundings of her childhood home: "We didn't have [art] on the walls. We had only one book, which was an encyclopedia, and we had a Bible."[5] What Ruth did have was an extended family of Asawas. Her father, Umakichi; his older brother Zenzaburo; and an uncle had established truck farms in Norwalk, California, after adventures working on the sugar plantations of Hawaii, in coal mines in Mexico, at a general store in El Paso, and on farms in Utah and in Huntington Beach and San Diego, California.[6] The Asawas' relatives in Fukushima Prefecture, Japan, arranged marriages for the brothers, which were consummated through the exchange of pictures. In a practice quite common in the period, two sisters of the Yasuda family, Shio and Haru, married Zenzaburo and Umakichi, respectively.

The families were doubly connected by blood and further tied to each other when Zenzaburo died, leaving Umakichi to assist in the care of his brother's family of six.

On the farm—on leased land, as Japanese were barred from owning property—communal labor was central. The seven Asawa children were expected to contribute to the rigorous work schedule. Upon returning from school in the afternoons, they worked until dinner, after which they worked some more. Each child had specific duties but understood how it related to the whole. One of Ruth Asawa's jobs was repairing the thin wooden boxes used for tomatoes, radishes, cabbage, cucumbers, melons, celery, lettuce, beans, and other crops.[7] Though mundane, the task required manual dexterity, the use of a hammer and hatchet, and the ability to gauge the width and depth of pieces of wood. To cultivate Kentucky Wonders, Blue Lakes, and lima beans, Asawa's father used

recycled laths to form the beanpoles, to which Ruth coiled string in a way that mirrored weaving techniques.[8]

Modesty and thrift, filtered through ingenuity and creativity, were evident throughout the farm. Built by Umakichi, the family home was a simple board-and-batten house with an interior of paper walls and a paper ceiling topped by a tin roof. "My father used to save every nail," Asawa recalls, "and straighten them out."[9] Even the family's bathwater was reused. Since Asawa did not like housework, she was assigned to tend the fire for heating the traditional Japanese *ofuro*, or bath, which required chopping wood and making sure the water was hot until the last of the family members took a bath—sometimes as late as 10 p.m.[10] When it was time to germinate seeds, the used bathwater was the perfect medium to facilitate sprouting.[11] On the farm, maximizing the limited resources was essential to the family's survival. Every element was scrutinized so that it could be utilized for multiple ends.

Japan loomed large among the Asawa clan. Like many immigrants from Japan, the Asawas intended to return to Fukushima. They regularly sent money to Japan and amassed property and houses in the town of Kōriyama for their future return. To prepare their American-born children, many Japanese immigrants set up Japanese schools in the United States, promoted Japanese activities such as the martial arts, and sent their children to Japan to be educated.[12] In Norwalk, the elder Asawa men were involved in the organization of the Japanese school, where the Asawa children were duly required to spend their Saturdays. Beginning with traditional group exercises and hearty shouts of *banzai* to the emperor, the school duplicated as much as possible Japanese practices. Discipline was valued, as was submission to rote forms of learning. Calligraphy, taught as the equivalent of penmanship, began not with free expression but as a codified set of repetitive lessons. Corporal punishment for inattentive students was the norm.

Although Asawa did not enjoy Japanese school, she—along with her older siblings—readily took to the study of kendo. Literally translated as "the Way of Sword," kendo is a form of Japanese fencing that emphasizes development of inner character married to skill and physical strength. Long associated with the samurai ethos, kendo was believed to embody the "spirit of Yamato"—the essential characteristic of the Japanese people. Although participation requires a relatively large outlay of money for the special masks, gloves, guards, *hakama*, and bamboo swords, beginning in the late 1920s Japanese immigrant parents saw kendo as a means to transmit essential Japanese values and promoted the sport throughout California.[13] Umakichi was a local leader in the kendo community, which encouraged practice by both girls and boys. For Umakichi and other issei men, kendo provided a tangible framework to convey Japanese philosophy to their children. As one community leader wrote in the San Francisco

5 Ruth Asawa, interview by Aiko Lanier Cuneo, December 19, 2003, unpaginated, Asawa papers.
6 Frank Gunji Asawa, Genealogy of Zenbei and Kura Asawa, 1990.
7 See Ruth Asawa Oral History, interview by Harriet Nathan, 1980, 15–21, Arts and the Community Interview Series, Regional Oral History Office, Bancroft Library, University of California, Berkeley.
8 Asawa, interview by Cuneo, December 19, 2003.
9 Asawa Oral History, 20.
10 Ruth Asawa, transcript of handwritten memoir, 3, Asawa papers.
11 Asawa Oral History, 17.
12 At age ten, it was Asawa's turn to go to Japan to live with her maternal grandparents and strengthen her Japanese-language skills, but her father's cousin, who was to escort her there, suddenly died, and the trip was canceled. Several years later, Ruth's younger sister, Kimiko, was chosen to go in her place, accompanied by their eldest sister, Lois. Lois returned in October 1941 on the last ship to depart Japan for the United States before the attack on Pearl Harbor.
13 Eiichiro Azuma, "Social History of Kendo and Sumo in Japanese America," in *More than a Game: Sport in the Japanese American Community*, ed. Brian Niiya (Los Angeles: Japanese American National Museum, 2002), 78–91.

Ruth Asawa (front row center)
in Ms. Fain's fifth-grade class,
Norwalk Elementary School, Norwalk,
California, 1935

newspaper *Nichibei Shimbun*, kendo allowed the nisei to "get their mind and body purified, and make the virtues of propriety, benevolence, humanity and filial purity fully understood."[14] A subtext was preparation for a return to Japan. But many Japanese Americans like Ruth and her siblings negotiated the dual life of allegiance to Japan and total assimilation into an American ideal with ease, transitioning from one state to another seamlessly. For Asawa, loyalty as a general concept was the issue. "We were loyal, so it didn't matter who it was to."[15]

Progressive Education

While daily life was characterized by the never-ending labor of a small farm, shifts in public education provided children with access to innovative models of pedagogy. Progressive educational reform took hold in California in the 1920s and 1930s, as adherents increasingly saw the schools as centers for reform and socialization as well as a force for democratization.[16]

Universal education also meant that the local public schools sustained a remarkably diverse student population despite the financial strain of the Great Depression. While Japanese and Mexican Americans faced institutional barriers to jobs, property, and social access, the public schools were a more egalitarian arena. This is not to suggest that schools were free from prejudices or the effects of racism. However, as non-segregated places of social interaction, they provided an opportunity for children to experience and interact in a broader context.

One effect of educational reform was the decentralization of decision-making from the political apparatus of the state to local superintendents and administrators.[17] In Norwalk, art and music were a regular part of the curriculum taught by artists rather than art teachers.[18] From Catherine Gregory, the students studied music. From Frederika Moore, they learned modern dance.[19] Gwendolyn Cowan taught painting.[20] Over the years, Asawa has publicly

repeated the names of these artist-teachers to underscore their influence and impact on her as working artists. Their passion and commitment to their own creative work rather than solely to their duties as teachers made a lasting impression. The music teacher Miss Gregory sang arias with such power that the blood vessels in her forehead looked as though they would burst. Asawa and the other children found this both amusing and inspirational and tried to achieve such an effect in their own singing—to no avail.[21] These regular artist-teachers were supplemented by visiting performers who graced the stage at assemblies in the school's new auditorium, rebuilt after the old edifice "crumbled" during the 1933 earthquake (another example of the public investment in the educational infrastructure).[22]

Although the yellow-peril fear of Asian immigrants translated into restrictive laws limiting the rights of Japanese Americans, in school Asawa recalls another stereotype, an iteration of the "model minority" myth. "They associated 'artistic' with the Japanese," Asawa recounted in a 2003 interview. "So we were expected to be good students and interested in the arts."[23] The dual edge of a cultural stereotype—the artistically inclined Oriental—pervaded Asawa's life early on. Just as she negotiated the question of loyalty, Asawa seems to have accepted that her Japanese ethnicity may have subjected her family's farming to exploitation by unscrupulous shippers, while in the realm of art it may have had a positive impact.[24] As later discussions of her work demonstrate, the association with artistic traditions of Japan provided a point of entry for interpreting the nature of her work.[25]

World War

On December 8, 1941, the principal of Excelsior Union High School spoke before an assembly of the student body and urged calm in the face of war. A short time later, in an act that was repeated in Japanese American neighborhoods throughout the West Coast, Umakichi "dug a big hole to bury the kendo gear, and burned the *hakama*, beautiful Japanese books on flower arrangement and tea ceremony, Japanese dolls, and Japanese badminton paddles,"[26]

as Ruth's older sister Lois cried out, "Oh, please don't, don't burn the books." After all, she had brought these volumes back from Japan only months before.[27] In early February, two FBI agents arrived at the Asawa farm to arrest Umakichi. While he ate lunch and a slice of lemon meringue pie, baked that morning by his daughter Chiyo, the agents took advantage of the time to ransack the modest house, looking for suspicious material. Ruth ironed her father's shirt while her mother packed a suitcase. Umakichi changed into his only suit and was taken away, presumably because of his

14 *Nichibei Shimbun*, July 31, 1936, cited in ibid., 83.
15 Asawa, interview by Cuneo, December 19, 2003.
16 For a summary of progressive education and its impact on the nisei, see David K. Yoo, "The ABCs of a Nisei Education," in *Growing Up Nisei. Race, Generation, and Culture among Japanese Americans of California, 1924–1949* (Urbana: University of Illinois Press, 2000), 17–37.
17 Judith Raftery, *Land of Fair Promise: Politics and Reform in Los Angeles Schools, 1885–1941* (Stanford, CA: Stanford University Press, 1992).
18 Asawa Oral History, 8–10.
19 Moore was apparently the first modern dance teacher in the state. Ibid., 24.
20 Ibid., 8, 24.
21 Ibid., 9.
22 Ibid., 7, 19.
23 Asawa, interview by Cuneo, December 19, 2003.
24 Asawa Oral History, 15.
25 As just one example, in a short piece on Isamu Noguchi and Ruth Asawa, *Time* magazine noted, "Because European art is in the doldrums, Americans are turning increasingly to the art of the East....Last week Manhattan gallerygoers crowded two shows that uniquely bridged East and West." The unnamed author goes on to write that Noguchi's and Asawa's "Japanese ancestors devoted vast efforts to making a single brush stroke look easy," a quality of "ease and oneness" that both Noguchi and Asawa achieved. "Eastern Yeast," *Time*, January 10, 1955, 54.
26 Ruth Asawa, unpublished and undated draft of speech, Asawa papers.
27 Asawa Oral History, 25.

leadership in the local Japanese American community and his practice of kendo.[28]

With Umakichi's cousin Gunji also picked up by the FBI, the extended Asawa clan was left without elder men at the helm. Umakichi was transferred among a number of holding cells and Justice Department prisons. An official hearing in May 1942 ordered him interned, first in Santa Fe Internment Camp, where he was admitted in early July, and later to the enemy alien detention camp in Lordsburg, New Mexico.[29] In recollections of the period, Asawa betrays little anxiety or fear about the circumstances of the war, despite the fact that the family was split. She and her family knew little of Umakichi's whereabouts or the conditions of his imprisonment, and the youngest member of the family, sister Kimiko, remained trapped in Japan for the duration of the war.

In April 1942, the remaining Asawas packed their one-suitcase allotment, abandoned their pets, four workhorses, chickens, and farm equipment—and for Ruth, her prized collection of Campbell's Soup can labels.[30] The family drove their own car twenty-four miles to Santa Anita racetrack, which had been transformed into a temporary detention center that ultimately housed more than nineteen thousand Japanese Americans before they were transferred to permanent camps.[31] The world of Santa Anita, though one of confinement, brought the dynamic world of Japanese America into one restricted location. The contrasts were startling. On the one hand, Asawa and her family were assigned to live in horse stalls only recently emptied of their former occupants. Horsehair remained between the cracks of the boards, and the heat of an early summer accentuated the lingering stench.[32] But because the incarceration affected all Japanese Americans living on the West Coast, regardless of education or class, Santa Anita—as the largest of the assembly centers, with Japanese Americans from Los Angeles, San Diego, San Francisco, and Santa Clara counties—effectively became a dense city of rich human resources. Almost immediately, the Japanese American inmates established a complex infrastructure in Santa Anita. A utopian spirit of self-reliance and proactive organization pervaded the camp. There were informal schools, published newsletters, baseball games, and talent shows, among other activities. As Asawa told one interviewer, "We really had a good time, actually. I enjoyed it."[33]

Although Umakichi never discussed his experiences with his children, the conditions in the Justice Department camps were vastly different from those of Santa Anita and underscore how the internment affected sectors of the population differently. A fellow inmate at Lordsburg, Reverend Yoshiaki Fukuda, recounted, "We were made to work on the construction of roads and airfield. We were also made to clean army stables, mess halls, and dancehalls. We were even made to transport ammunition.... Furthermore, when our spokesman requested that we be allowed to rest during the extreme heat of the afternoon, the officer in charge threatened us by firing his pistol. The watchtower guards often threatened us by shouting, 'Japs, we'll kill you.'"[34] Such threats did come to fruition. Nine days after Umakichi entered Lordsburg, two ill internees, unable to walk the distance from the train station to the camp, were killed by a watchtower guard. The deaths became known to the internees when some were forced to dig the graves. According to rumors in the camp, the responsible guard was praised for his "gallant action" and awarded four hundred dollars in donations at a local cafe.[35] The two slain Japanese men were fifty-eight years old: Toshiro Kobata, a tubercular farmer from Brawley; and Hirota Isomura, a fisherman with a bad back from San Pedro. For Umakichi and others, the resemblance to their own humble profiles must have been chilling.[36] While it seems evident that Umakichi's personal loyalties remained with Japan, there is no evidence that he acted in any way to undermine the security of his adoptive home.

Santa Anita existed in a parallel world. While her father was subjected to future uncertainty and the real possibility of death, Asawa was provided access to a dynamic community of artists, all of whom were Japanese American, an experience that would not have occurred without the incarceration. Thus, in a pattern

Ruth Asawa (standing right) and friends
at Rohwer War Relocation Center,
Arkansas, 1943

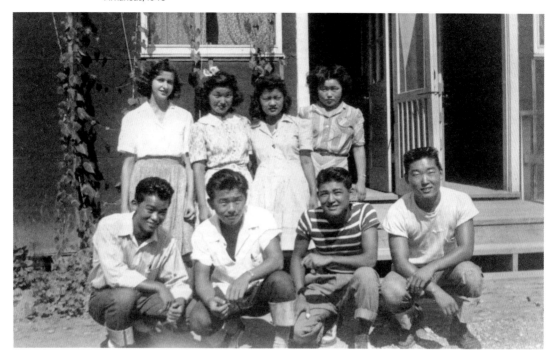

that would repeat in other instances during World War II, the negative consequences of her Japanese ancestry turned into an unprecedented opportunity. A section at the racetrack grandstand, adjacent to a section where internees were used to weave camouflage nets for the war effort, became a de facto arts studio. Painter Benji Okubo had been the director of the Art Students League of Los Angeles, a position once occupied by his teacher Stanton Macdonald-Wright. In Santa Anita, he and painter Hideo Date, a league associate he had first met at Otis Art Institute, carried on the activities of the Art Students League in the grandstands. They were joined by Tom Okamoto and Chris Ishii, who had attended Chouinard Art Institute. It was an informal arrangement born of a confluence of boredom and optimism, yet it provided young aspiring artists like Asawa with a chance to interact with artists whom they would have never met if the incarceration had not forced them together.

28 Peter Weverka and Addie Lanier, "Ruth Asawa: American Sculptor and Woman Activist," unpublished manuscript, 2.
29 Gunji's hearing resulted in a parole, and he was allowed to join his family in late May at the Santa Anita Assembly Center.
30 Ruth Asawa, interview on Japanese American internment camps during World War II, by ninth-grade world-history students at Granby High School, Norfolk, Virginia, sound recording, March 16, 1998, Asawa papers.
31 The family was able to sell their cars at Santa Anita. Asawa Oral History, 25.
32 Asawa, unpublished and undated draft of speech.
33 Asawa Oral History, 26.
34 Reverend Yoshiaki Fukuda, *My Six Years of Internment: An Issei's Struggle for Justice* (San Francisco: Konko Church of San Francisco, 1990), 40–41. Originally published in Japanese as *Yokuryu Seikatsu Rokunen* in 1957.
35 Ibid., 42.
36 The guard who was responsible for the killings was placed under arrest, but subsequent court-martial proceedings found him not guilty.

Ruth Asawa with trellised beans at the Rohwer War Relocation Center, Arkansas, 1943

Painted rocks and hammered metal created by students of Mabel Rose Jamison at the Rohwer War Relocation Center, Arkansas, ca. 1943

The varying experiences of these men provided models of an artist's life. Date and Okubo were self-described bohemians who bucked conventions of the Japanese American community to live and work among artists who were primarily not of Japanese ancestry.[37] Before incarceration, Date had been employed by the Federal Arts Project, a precursor of the Works Project Administration, and, with Okubo, had exhibited extensively throughout California. Okamoto, Ishii, and Ben Tanaka were among the nisei generation of Japanese American artists who found employment with Disney Studios. A principal expression of Asawa's artistry as a young girl was to copy cartoons. Now she studied painting and drawing with Okamoto, one of the animators associated with the most influential force in this popular form. "How lucky could a sixteen-year-old be," Asawa recollected.[38] The generative effect of this training had impact beyond Asawa. One of her "classmates," Shinkichi George Tajiri, became an influential artist and teacher in Berlin and Amsterdam.[39]

When Santa Anita closed and the Asawa family was sent to Rohwer War Relocation Camp, located in the wooded swamplands of southeastern Arkansas, it took only months before the camp was transformed by the ingenuity and labor of the inmates. As in life on the farm in Norwalk, every tangible material had to be utilized. Scrap wood became furniture, butsudans (Buddhist altars), or partitions for the undivided barracks. The seeds Asawa's mother had brought from Norwalk were turned into a kitchen garden with elaborate trellises made of found wood and used string. Swamp trees cleared for roads and barracks were refashioned into children's toys, such as a hobbyhorse, or hollowed out to form vases for ikebana, with foliage and flowers fashioned from newspaper, crepe paper, cloth, and any scrap material or plant material that could be adapted for that purpose. Hunting for *kobu*, the unusual growths found in hardwoods and especially prevalent in the cypress trees of the Rohwer swamps, became a popular pastime. The natural forms of the wood, sanded and hand polished to a glorious sheen, were transformed into objects of utility, such as doorstops, or simply used to adorn the forlorn barracks. The *kobu*'s metamorphosis from excrescence to beauty is perhaps the most powerful symbol of the daily transformations in the camps.

Unlike Santa Anita, Rohwer had officially organized schools for the children. Once again, Asawa had access to committed teachers who saw education as a means of democratization and considered art practice a central aspect of education. The high-school English instructor Louise Beasley and art teacher Mabel Rose Jamison were two influential figures for Asawa.[40] As wartime labor needs diminished the supply of teachers, the War Relocation Authority was faced with difficulties in recruitment, exacerbated further by the stigma of teaching "Japs." Perhaps such reactions emboldened the young teachers, who approached their positions with commitment and ingenuity. A description of Jamison's search for art material could easily be that of Asawa's forays with the Alvarado School some twenty-five years later. In a letter to Asawa, Jamison recalls, "The first year we HAD NO art paper of any kind except a few tablets and the notebooks some of you

37 See Karin Higa, "Living in Color: The Art of Hideo Date," in this book, 208–27.
38 Asawa, unpublished and undated draft of speech.
39 Asawa does not recall Okubo or Date, nor does it appear that she studied with them. However, her classmate Shinkichi Tajiri studied with Date during the same six-month period, so it could be surmised that they were part of the same loose group of artists working in the grandstands.
40 The Japanese American painter Henry Sugimoto was also on the faculty of Rohwer High School. An accomplished artist from Hanford, California, Sugimoto had attended the California College of Arts and Crafts, traveled extensively in France, and had a one-person exhibition at the California Palace of the Legion of Honor in 1933. However, his tenure at the high school began after Asawa had left Arkansas for Milwaukee. See Kristine M. Kim, *Henry Sugimoto: Painting an American Experience* (Berkeley, CA: Heyday Books, 2000).

had brought with you. So—from the warehouse at Rohwer I begged some bolts of cloth—army uniform twill, and dark blue denim which we painted on, using Crayolas for the first two sketches."[41] The class projects were likewise born of ingenuity. Jamison writes, "Do you remember all of our 'hammered metal' on tin cans from the mess hall with a few old nails? And our paintings on little rocks—the ONLY thing we had PLENTY of!"[42] The gift of a barrel of buttons prompted a project of jewelry making, poster paint on fabric became mural-size paintings, and paper was bound to make small journals and notebooks.[43]

Little remains of Asawa's artwork from this period. A watercolor of sumo wrestling conveys the frenetic activity of the sport and a crowd of kids and adults who seem to be enjoying the afternoon event. In the prewar period, sumo was especially popular in rural communities. Group entertainment like this occurred daily somewhere in the camp, whether it be a baseball game, talent show, or dance. While the watercolor is a lively depiction, nothing in it suggests the innovation and insight of Asawa's artwork to come. Yet her identity as an artist was firmly formed. She was the art editor of the 1943 *Delta Round-Up*, a mimeographed annual produced by the high school. Asawa and a boy named Sam Ichiba were chosen by their peers as the "most artistic." Jamison must have recognized Asawa's early talent, as she followed her former student's subsequent success with great interest.[44] The only two surviving watercolors by Asawa from the period were saved by Jamison, who returned them to Asawa decades later.

Asawa's oldest sister, Lois, was the first to leave Rohwer, in June 1943, to attend William Penn College in Oskaloosa, Iowa. In August 1943, Asawa and her next oldest sister, Chiyo, departed: Chiyo to join Lois in Iowa and Ruth to attend Milwaukee State Teachers College, chosen by Ruth because it was the cheapest school in the catalogue to which she had access.[45] All three left under the sponsorship of the National Japanese American Student Relocation Council (NJASRC), an initiative of the American Friends Service Committee that by the war's end helped more than 3,500 Japanese Americans attend college from the confines of the camps. The NJASRC worked closely with the camp authorities to secure leave clearances, recruit students from the camps, and identify colleges and communities that would accept Japanese Americans. More significantly for Asawa, once she was accepted, NJASRC raised funds to pay for tuition.[46] It is highly unlikely that Asawa, or many of the other nisei, would have had the opportunity to attend college were it not for the financial and logistical support of the NJASRC. This was not the first time the Asawas interfaced with the Quakers, nor would it be the last. As children, the Asawas attended—even though the family was nominally Buddhist[47]—a Quaker meeting, where a Japanese pastor had been installed: "That was the only Christian church that accepted Japanese in [Norwalk], in our community. We could not enter a Presbyterian or a Catholic or a Methodist church at that time."[48] The Quakers once provided a haven for Japanese Americans to worship. Now they enabled Asawa to leave. She was seventeen and had been incarcerated for nearly sixteen months.

41 Mabel Rose Jamison Vogel, letter to Ruth Asawa, May 30, 1978.
42 Ibid.
43 Jamison saved a substantial amount of her students' work, which she donated to the Japanese American National Museum, Los Angeles, in 1988.
44 Among Jamison's papers archived at the Japanese American National Museum are clippings about Asawa gathered from the postwar press.
45 Asawa Oral History, 28.
46 For a detailed history of the NJASRC, see Gary Y. Okihiro, *Storied Lives: Japanese American Students and World War II* (Seattle: University of Washington Press, 1999).
47 Like many Japanese Americans of the period, for the Asawa family the practice of Buddhism was more a cultural expression of being Japanese than a set of religious practices. The most visible expressions of Buddhist practice were the family butsudan, maintained by Ruth's mother, Haru, and the occasional visits to the Japanese American enclave of Little Tokyo to attend funerals at the Nishi Hongwanji Buddhist Temple.
48 Asawa Oral History, 6.

Ruth Asawa, *Sumo Wrestlers*, 1943.
Watercolor on paper, 10¼ × 14½ inches

Ruth Asawa's WRA identification
card, 1943

Ruth Asawa and Ora Williams at Black
Mountain College, North Carolina, 1946

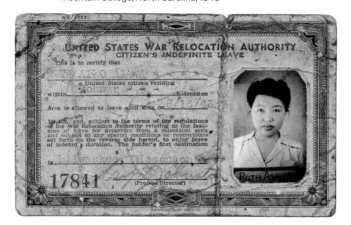

Elizabeth Jennerjahn, *Ruth Asawa Dancing*, 1948–49. Collage, 9¼ × 7¼ inches

Imogen Cunningham, Ruth Asawa, 1957

Away from Home

Milwaukee proved to be a hospitable environment for Asawa as she prepared for her vocation as a teacher. While she managed to find sympathetic homes, where she worked in exchange for room and board, and formed friendships with a dynamic group of artists, Asawa was told that no school in Wisconsin would hire someone Japanese. Since her fourth year of college would consist of practice teaching, she was forced to leave the college without graduating. Once again, her ethnicity dictated the course of her future. As Asawa put it, "Had Milwaukee State Teachers College not rejected me and forced me to the alternative of Black Mountain College, I would've quietly retired as an art teacher with retirement benefits."[49]

Asawa first learned of Black Mountain College before her prospects for teaching were dashed. For a couple of years, classmates from Milwaukee had spent the summers there. In 1945, her close friends Elaine Schmitt and Ray Johnson tried to convince her to join them, but Asawa chose to accompany her sister Lois to Mexico instead. Embodying a keen sense of adventure, Lois and Ruth traveled south to Mexico City by bus. The United States was still at war with Japan and her family was still in Rohwer.[50] At a bus stop in Missouri, they "didn't know whether to use the white or colored bathroom,"[51] but Lois decided they were colored, solving, for the moment, the question of Japanese Americans within American racial politics. In Mexico City, Asawa enrolled at La Escuela Nacional de Pintura y Escultura La Esmeralda, a newly formed art school, and the University of Mexico, where she studied with the innovative furniture designer Clara Porset. A Cuban immigrant who had trained in New York and Europe, Porset is considered a pioneer of Mexican industrial design. She had also spent time at Black Mountain College with Albers.[52] From another teacher, Asawa learned how to prepare a wall for fresco, assisting on a George Biddle mural.[53]

Black Mountain College

When Asawa arrived at Black Mountain College in the summer of 1946, she was only twenty. Yet despite her modest circumstances and young age, she had already traversed the United States—from Southern California to Arkansas to Wisconsin to Mexico and back again. She had studied and interacted with many significant artists and had lived on her own for nearly three years. The fact that no degrees were awarded at Black Mountain attracted students who were interested in an alternative educational experience. For Asawa, the spirit of Black Mountain, the aging physical plant, and the school's work requirements mirrored those of incarceration and her childhood farm. Thrift was required, collaboration was a necessity, and innovation that derived from modest transformations was valued over grand pronouncements. Student Albert Lanier, who would become Asawa's husband, recalled, "It was such a poor school economically, but we had this gorgeous 640 acres. We had a farm. There were cows that gave milk. We had a cook. We ate our three meals together."[54]

49 Ruth Asawa, handwritten notes for acceptance speech at San Francisco State University, May 30, 1998, Asawa papers. Asawa was conferred with an honorary doctorate.

50 Umakichi was released from the Justice Department camps to Rohwer in 1943. Ruth's brothers, George and Bill, left Rohwer for college in 1944, leaving Janet the only sibling left in Rohwer.

51 Ruth Asawa, letter to Sidney Shishido, December 17, 1999, Asawa papers.

52 Clara Porset Dumas was the subject of a retrospective exhibition at the Museo Franz Meyer in Mexico City (February–May 2006).

53 An American Social Realist, Biddle was invited by the Mexican government to create murals for the Supreme Court Building. He was instrumental in the development of the federal arts programs, due in part to his close relationship with Franklin D. Roosevelt, a prep-school classmate.

54 Albert Lanier, interview with Ruth Asawa and Albert Lanier by Paul Karlstrom, June 21–July 5, 2002, Archives of American Art, Smithsonian Institution, https://www.aaa.si.edu /collections/interviews/oral-history -interview-ruth-asawa-and-albert -lanier-12222.

The formalized Community Work Program required that students spend ten to twelve hours per week "on the farm, on the grounds, carpentry, electrical wiring, painting, etc.," and the official transcripts reflected compliance.[55] Among Asawa's contributions were churning the butter and cutting people's hair.

In Albers's teaching, Asawa not only found a validation of her cultural heritage but also gained a language to describe the intrinsic philosophies embedded in her experience in Japanese school and kendo. Albers gave the name Buddhism to the concepts that underlay the cultural practices of the Japanese American community. While some students could find Albers's teaching methods difficult, with his emphasis on stripping down the artistic process to primary observation and the systematic exploration of basic concepts, such as figure-background studies, he also prioritized repetitive action, a method that Asawa knew well from her years of Japanese school training.[56]

But it is Albers's concept of *matière* that returns us to Asawa's looped-wire sculpture. From Albers, Asawa believed that each material had its own inherent nature, which could be drawn out through combination, juxtaposition, or manipulation. "Each material has a nature of its own, and by combining it and by putting it next to another material, you change or give another personality to it without destroying either one. So that when you separate them again, they return back…to [their] familiar qualities."[57] Her wire sculptures maintain this equilibrium. While they are essentially a line, through manipulation they become volumetric, yet they retain their essential "line-ness": they could easily be unwound and returned to their initial state. Asawa goes further: "It's the same thing that you don't change a person's personality, but when you combine them with other people, other personalities, they take on another quality. But the intent is not to change them, but to bring out another part of them."[58] Inherent in an Asawa wire sculpture, then, are its various states. Not only does the exterior become the interior and back again, but the material contains simultaneously its past and future states.

This becomes the ultimate metaphor for understanding Asawa's Japanese American heritage. It is embedded in all her work and at the same time also always fluid, moving from one state to another while remaining essentially itself.

55 Ruth Asawa, Black Mountain College transcript, summer 1948, Asawa papers.
56 Asawa notes that Albers brought "an awareness of how stupid we are really, of how little we observe, how unconscious we really are about ourselves…. And for some people, it's insulting, but I don't think it is." Asawa, interview by Harris, 5. Albert Lanier noted, "Some regarded [Josef] Albers as a fascist, a dictator, because he didn't react to or condone your feelings." Lanier, interview by Karlstrom.
57 Asawa, interview by Harris, 6.
58 Ibid., 6–7.

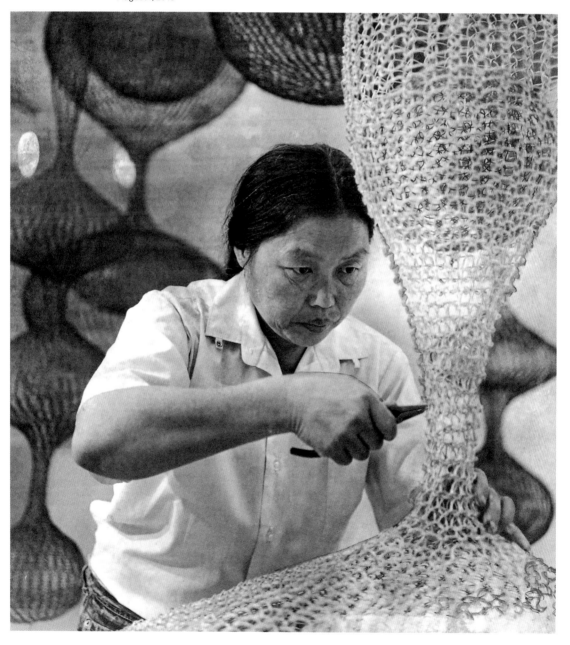

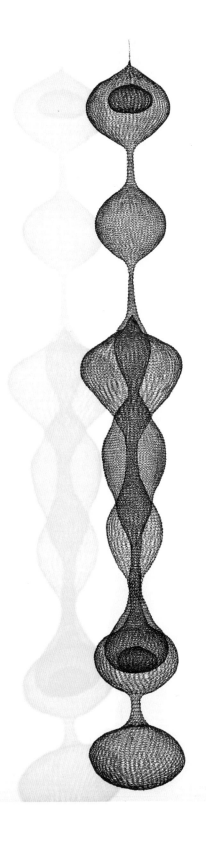

opposite: Ruth Asawa, *Untitled*, ca. 1954. Copper and iron wire, 105 × 15 × 15 inches

Ruth Asawa stamps issued by the U.S. Postal Service in 2020

Ruth Asawa in her studio in San Francisco, 1969

Installation view, *Ruth Asawa*,
David Zwirner, New York, 2017

Hidden in Plain Sight: Little Tokyo Between the Wars

The story begins and ends in Little Tokyo, Los Angeles, among the streets and alleys in the literal shadow of city hall and its majestic, pyramidal tower. The time is the decades before World War II, when Los Angeles was not considered a major metropolis. In this way, our story may seem a provincial one. After all, in the city yet to make its mark, Little Tokyo was an ethnic ghetto described by a special commission of the State of California as containing "all the evils of a foreign quarter" with no discernible "American influence...bad housing, frightful overcrowding, congestion of people."[1] Yet the artistic activity centered in Little Tokyo presents tantalizing evidence of a dynamic nexus of artists, art, audiences, and intellectual exchange. This essay explores this terrain by delving into the world of Little Tokyo and the work of some artists who inhabited it in the period between the two world wars. Their lives, their art, and their web of associations led away from the ethnic ghetto and into both crosstown and global contexts, at the same time remaining firmly rooted in the Japanese American community. Little Tokyo, therefore, and the stories of its artist-inhabitants, requires a shift in the operative frameworks of analysis from those that focus on local and ethnic history to others that consider national and transnational contexts, as well as the fluidity of cultural influences in early twentieth-century America.

Ethnic Ghetto/Global City

Perhaps because transportation and communication networks in the early decades of the twentieth century seem so antiquated by today's standards, it is easy to think of communities as being physically and intellectually isolated and operating outside of national and international forces, especially in the realm of art and culture. With the period's limited technical means of movement and communication— transpacific crossings of more than a fortnight; no mass penetration of telephone technology, even[2]—and a still-nascent mass media, many scholars have underestimated the tremendous fluidity of ideas, bodies, and capital in the early twentieth century and its import for assessing cultural production, especially emergent modernisms. In her recent study of global cities, sociologist Janet Abu-Lughod suggests that the common assumption that characteristics associated with globalism are a new phenomenon, generated by the development of an all-encompassing world system (variously termed as late capitalism, postindustrialism, or the Information Age), is misguided. Rather, she argues that all the characteristics of global cities were present, albeit in embryonic form, in earlier periods; in the case of Los Angeles, she locates this early stage in the beginning of the twentieth century, precisely that period under assessment here.[3]

Further still, in the case of Japanese American cultural production, one must read against the history and politics of exclusion as manifested by the formation of ethnic ghettos. Scholars of the Asian American experience have rightly assessed and analyzed the discourses of the anti-Asian movement or, alternately, the agency and success of Japanese Americans in the face of such discrimination. In the first case, the proliferation of overt anti-Japanese

1 California Commission of Immigration and Housing, Community Survey of Los Angeles (Sacramento, 1918), cited in John Modell, *The Economics and Politics of Racial Accommodation: The Japanese of Los Angeles, 1900–1942* (Urbana: University of Illinois Press, 1977), 69.
2 In 1920, there were approximately twelve phones for every hundred people. Transcontinental service was initiated in 1917; transatlantic service began in 1927.
3 Janet L. Abu-Lughod, *New York, Chicago, Los Angeles: America's Global Cities* (Minneapolis: University of Minnesota Press, 1999), 3–4, 133–63.

sentiment—whether it be hostile legislation on the state and federal levels or garden-variety expressions of racism, such as reduced job possibilities and restrictive housing covenants—demonstrates institutionalized marginalization and limited access to dominant power structures. In the second, the ability to collectively and efficiently organize vertically integrated networks of commerce, such as with the produce, floriculture, and nursery industries, as well as in the formation of diverse organizations such as *kenjinkai* (associations based on common districts of origin in Japan), business networks, sporting associations, and churches and temples, gave the impression that the Japanese American community was not only forced to be but actually flourished as a discrete, separate, and parallel community, prompting figures such as the normally astute Carey McWilliams to erroneously conclude that Little Tokyo was "more or less a self-contained community, an island within an island."[4]

Yet for Japanese American artists, Little Tokyo's borders were porous. Their art found a receptive audience in such far-flung places as New York, London, and Mexico City, just as it did closer to home, whether it was in an exhibition at the Los Angeles Museum of History, Science and Art; a nightclub in Chinatown; or the home of a Hollywood star. What's more, within the "island" of Little Tokyo, one could regularly see art by its inhabitants and others in exhibitions, in the *Rafu Shimpo* (the Japanese American daily newspaper), and through the regular reviews featured in the *Los Angeles Times*. The effects of the anti-Asian movement touched upon every aspect of Japanese American life, yet it did not fully circumscribe it. The dense, global urbanism of Little Tokyo provided fertile ground; its web of art and ideas was complex and dynamic.

East First Street

Sometime in the late 1910s, about the time of the state's withering report on the Japanese enclave, Toyo Miyatake was walking down East First Street, the main artery and heart of Little Tokyo, when he was seized with the idea

to become a photographer. Perhaps this youthful declaration, uttered to himself, would have meant little if within a few minutes Miyatake had not run into a close friend to whom he confided his revelation. The friend quickly pointed toward the Tomoe Hotel on the corner of Second and San Pedro Streets and said, "Harry Shigeta has a room on the second floor over there and he gives classes in photography," whereupon Toyo crossed the street and commenced his life as a photographer.[5]

At age twenty, Miyatake had been living in the United States since 1909. He had migrated at the behest of his father, who had earlier left the family in Kagawa to establish a base in America before calling them over. Seattle was chosen as the port of entry because immigration officials were rumored to be more lenient than in San Francisco. Toyo, his mother, and two brothers then traveled down the West Coast to Los Angeles and settled in the back of his father's confectionery, Shofudo. Over the next ten years, Miyatake attended Amelia Street Grammar School, helped with the family business, and tried his hand picking grapes in central California. Miyatake was to become the most prominent Japanese American photographer of the twentieth century, who made work without interruption for sixty years. But in 1920s Little Tokyo, he was one among many young Japanese Americans interested in the pursuit of art.

Miyatake's meeting of Shigeta was fortuitous. The older man had opened a photography studio on San Pedro Street, just south of

4 Carey McWilliams, *Southern California: An Island on the Land* (Santa Barbara, CA: Peregrine Smith, 1973), 321. Originally published as *Southern California County: An Island on the Land*, 1946.
5 This story originally comes from Shigemori Tamashiro, "Toyo Miyatake," *Ayumi no Ato*, vol. 4 (Los Angeles: Southern California Pioneer Center, 1980). Cited in *Toyo Miyatake: Behind the Camera 1923–1979*, ed. Atsufumi Miyatake, Taisuke Fujishima, and Eikoh Hosoe, trans. Paul Petite (Tokyo: Bungeishunju, 1984), 2.

Toyo Miyatake, *Early Morning, Jackson Street*, 1925. Bromide print, approx. 13½ × 10½ inches

Harry K. Shigeta, *Curves,
A Photographer's Nightmare*, 1937.
Gelatin silver print, 14 × 11 inches

First Street, in 1918. But that in and of itself was not particularly significant. Photographers and photography studios were ubiquitous in Little Tokyo. Panoramic photographs commemorated almost any formal gathering, from banquets to funerals. They were printed in multiples and sold to those depicted, so that even today, one frequently finds several prints of the same event despite the passage of more than ninety years and the upheaval caused by mass incarceration. Moreover, many immigrants were separated from their families (as Miyatake's father had been initially). Photographs were means of making a tangible connection and were exchanged from both sides of the Pacific. If families could not be together "in the flesh," they could be united in pictures. Using "double printing," separated families could be combined into one family portrait.[6] The immigrants' desire to have visual proof, or visual fabrication in some cases, of their success in America kept photography studios and their retouching departments busy in Little Tokyo. In the 1910s, most marriages in the Japanese American community were made by intermediaries in Japan with the exchange of photographs a significant part of the "courtship" process. Men often forwarded photographs taken in their youth or retouched to conceal age, blemishes, or baldness so that many picture brides were genuinely shocked to see their husbands: "Suave, handsome-looking gentlemen proved to be pockmarked country bumpkins."[7]

Shigeta provided an especially expansive model for Miyatake. By the time Shigeta opened his studio in Little Tokyo, he was already an established photographer with deep connections inside and outside of Little Tokyo. Born in 1887, the Nagano native migrated to the United States at age fifteen.[8] Within a year, he left the West Coast to enroll at the Saint Paul School of Fine Arts in Minnesota, where he took an integrated course of fine and applied arts, studying everything from drawing, illustration, and sculpture to ceramics, leatherworking and metalworking, and bookbinding. Accounts of Shigeta suggest a man of many talents and an entrepreneurial spirit whose manual dexterity and training as an artist served

him well. He initially turned to photography as an aid to draw life models but quickly parlayed this knowledge to secure employment at a St. Paul portrait studio. By the early 1910s, Shigeta moved to Los Angeles, where he found work as a portrait photographer, appeared on stage as a professional magician for the Orpheum Theatre chain, and became an expert retoucher at Edwards Histead Studio, among other places, applying his acumen to make his portrait subjects, like Cecil B. DeMille and Wallace Beery, more attractive in print.

That Shigeta was both a practicing magician and a photographer mirrors the diversity of his approach to the latter medium. His extant photographs of the period represent a heterogeneous range of styles and techniques, from conventionally staged portraits, often of people in their homes artfully surrounded by choice objects, to a stunning study of a nude and sand dune and a simple, stark depiction of trees, which has an effect quite modern in sensibility. What is remarkable about the extant

<hr>

6 Combination printing in photography emerged at photography's origins, though initially it was utilized to create "art" rather than as a method of manipulating the facts. Its first apologist, Oscar G. Rejlander, wrote, "To me double printing seems most natural.... The manual part of photographic composition is but wholesale vignetting." He argued further that photography was "excellent for details. You may take twenty good figures separately, they cannot be taken at once. You cannot even take four good ones at once; but then you cannot draw or paint a picture at once." See "An Apology for Art-Photography" (1863), in *Photography in Print*, ed. Vicki Goldberg (New York: Simon and Schuster, 1981), 141–47.

7 Yuji Ichioka, *The Issei: The World of the First Generation Japanese Immigrants, 1885–1924* (New York: Free Press, 1988), 164–68.

8 All biographical information comes from Christian A. Peterson, "Harry K. Shigeta of Chicago," *History of Photography* 22, no. 2 (Summer 1998): 183–98; and the exhibition catalogue *Harry K. Shigeta: Life and Photographs* (Ueda City, Japan: Ueda City Museum of History, 2003).

work is how little there is—in both style and subject matter—that is a cultural expression of his ethnicity. One exception is *Fantasy* (1923), a combination print that utilizes the pictorial conventions of ukiyo-e woodblock prints. Willow branches hang asymmetrically to the right of a distant crescent moon, which on closer viewing consists of the arched body of a nude woman. Yet even though the compositional reference for the photograph is clearly Japanese, the nude bears none of the hallmark signs of "Orientalness," and her body reads as European American. Given the societal and legal restrictions based on Japanese Americans, the fact that Shigeta's portraits and his models were European American suggests the ability of Japanese Americans to function, and even flourish, outside of a strictly Japanese American context. It also underscores how integrated early Japanese American experiences could be.

It is unclear what specifically Shigeta's curriculum was, how many students he had, or for how long he taught photography, but his studio in Little Tokyo was short-lived. In 1920, Shigeta closed it to work as a staff photographer for *Filmland* magazine, a new vehicle for the promotion of Hollywood stars. But ultimately feeling limited in Hollywood, Shigeta left in 1924 for more extended job possibilities in Chicago. Within fifteen years, he became a financially successful advertising photographer and one of the most prominent photographers working in a pictorialist vein; his essays and lectures on the relationship of pictorialism to commercial photography became influential texts. During this period, he continued to explore combination printing, producing Surrealist-inspired compositions akin to *Fantasy* but with no visual signifiers of the "Orient." Instead, his published work in this period is filled with dreamlike juxtapositions suggestive of his earlier forays into magic. "The experience of being a magician was good training for me.... I also learned that human eyes can be deceived by tricks and illusions," Shigeta wrote before concluding, "These findings were very useful to me as a photographer."[9]

Shaku-do-sha

As Shigeta was preparing to leave Los Angeles, Kaoru Akashi of Paris Photo Studio at 233½ East First Street decided to sell his business.[10] In November 1923, Toyo Miyatake marshaled his resources and found himself the proud owner of an established studio in the heart of Little Tokyo, which he renamed Toyo Studio.[11] But in addition to establishing a foothold in the commercial photography-studio market, Miyatake found himself the proprietor of a de facto salon, where a regular cadre of people would stop by and hang around. The actor and director Sessue Hayakawa, opera singer Yoshie Fujiwara, cinematographer James Wong Howe, and Tokyo-based artist Takehisa Yumeji were among those who regularly stopped by the studio, as did the Japanese American painters, poets, and photographers associated with Shaku-do-sha.[12]

9 Harry K. Shigeta, in *Harry K. Shigeta: Life and Photographs*, 31.
10 Why Akashi sold the studio is unclear. In 1922, he published a photographic directory of Japanese in Southern California. With a foreword by Ujirō Ōyama, consul of Japan—who wrote that Akashi was "one of the successes" of the Japanese community and "as a photographer has taken pictures of many of our compatriots"—the ambitious volume includes photographs of businesses, farmers, fishing concerns, educators, doctors, and other professionals. Although the directory remains one of the most important resources of 1920s Japanese America, perhaps the cost of its publication outweighed the profits realized, forcing Akashi to sell his studio. Strangely, the only photography-related business represented is Korin Kodak at 408 West Sixth Street, an art-supply-*cum*-photography shop co-owned by pictorialist photographer Taizo Kato. The author thanks Emily Anderson for her translation of the Akashi book.
11 When purchasing the studio, Miyatake dropped the long "o" of his first name and simply transliterated it as "Toyo." He was thereafter known as Toyo, rather than Toyoo or Toyo-o.
12 Archie Miyatake, conversation with the author, October 3, 2005.

Cover of the *Shaku-do-sha Art Exhibition* catalogue, 1923, with a woodcut by Tokio Ueyama

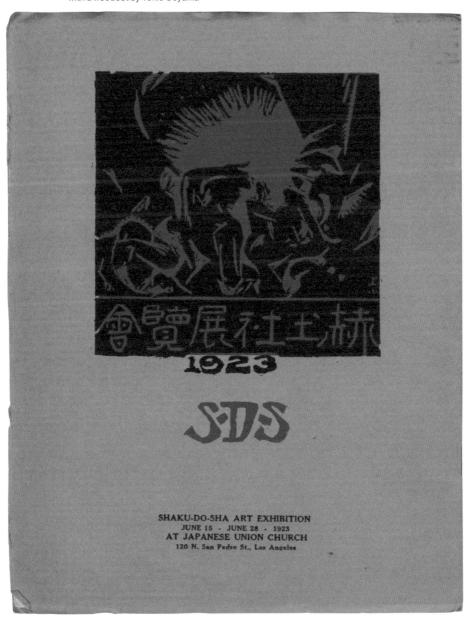

SHAKU-DO-SHA ART EXHIBITION
JUNE 15 · JUNE 28 · 1923
AT JAPANESE UNION CHURCH
120 N. San Pedro St., Los Angeles

Toyo Miyatake, advertisement for
the *Shaku-do-sha Art Exhibition*
catalogue, 1923

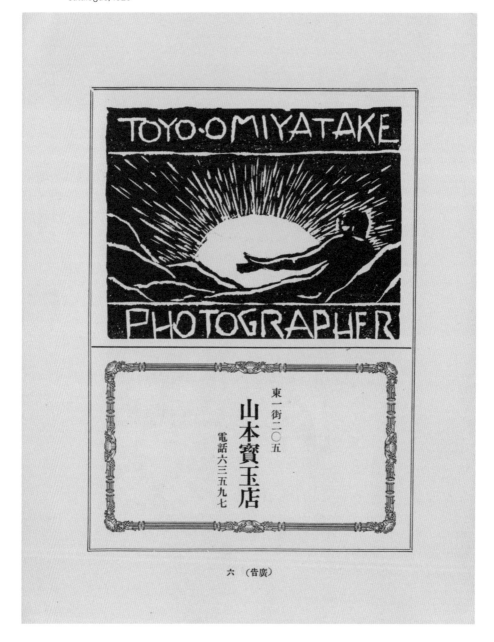

The Shaku-do-sha[13] was a newly formed association "dedicated to the study and furtherance of all forms of modern art."[14] Founded by the Japanese American painters Tokio Ueyama, Hojin Miyoshi, and Sekishun Masuzo Uyeno and the poet T. B. Okamura, the group was intellectually and organizationally ambitious. In June 1923, a major exhibition organized under its auspices was held in the newly constructed Union Church and featured twenty-four paintings by seven artists.[15] An eighteen-page catalogue, replete with reproductions of five of the paintings and accompanied by five original woodcuts (including a cover image by Ueyama), opened with an extended quote by Jean-François Millet (in Japanese rather than the original French) that ruminates on the struggles inherent in making art—that from pain and suffering, the expression of art derives its power. But the Millet quote also explicitly links these Japanese American artists to European traditions, signaling their connections to an artistic heritage beyond Japan.

The publication's nine pages of advertising at the back paint a broad portrait of the Little Tokyo community. The ads, mostly in Japanese with some English—for Diamond Brand shoes, "Selected Gifts that Last for June Brides and Graduates," violin lessons by a maestro Uesugi who appears dressed in tails, and the Shofudo confectionery[16]—all represent concerns located on First Street. Since Miyatake had yet to purchase his studio at the time of this catalogue, his ad simply states, "Toyo-o Miyatake, Photographer," and is represented by a strikingly graphic woodcut of a man, arm outstretched in front of a luminous sun. In its juxtaposition of Japanese-language text and American brands and holidays, high-cultural offerings of art and street-level commerce, the advertising provides a glimpse of the depth and texture of Japanese American community life in Little Tokyo. It also provides evidence that the Shaku-do-sha enjoyed widespread community support and was not an isolated or aberrant group. Not only were artists a part of the Little Tokyo life, they were a significant component of the cultural landscape.

Community support notwithstanding, a review of the exhibition took pains to critically assess each of seven artists. Written by Taizo Kato, himself a pictorialist photographer, and the proprietor of the Korin art and photography supply store (and likely the Kato named as a member of the Shaku-do-sha in the exhibition's catalogue), the review noted with frankness which works were masterful and which needed something more.[17] Even Ueyama joined the critical fray.[18] His review focused on three of his coexhibitors, Hojin Miyoshi, Shiyei Kotoku, and Sekishun Uyeno, and he is far from fawning.

13 The Japanese characters of *Shaku-do-sha* literally translate as "Glowing Earth Society," though the character for *shaku* is usually pronounced "kaku." A homonym, *shakudo*, is an alloy of bronze, which has symbolic meaning as long-lasting and durable. Artists in this period commonly selected names that had multiple resonances, and the founders of Shaku-do-sha likely intended such confusion.
14 From a July 7, 1927, article in artist Tokio Ueyama's scrapbook.
15 The seven artists were Shiyei Kotoku, Hojin Miyoshi, Sojiro Masuda, Kainan Shimada, Terasu Tanaka, Sekishun Uyeno, and Tokio Ueyama. The members of the Shaku-do-sha at the time were listed in alphabetical order on page six: Hiroshi Abe, [first name] Hayashi, [first name] Inouye, Kiyoko Iwa [?], [first name] Kato, Shiyei Kotoku, Hojin Miyoshi, Toyoo Miyatake, Kotori Okamura, Shizuko Otera, Kamejiro [last name], [first name] Sasaki, Terasu Tanaka, [unknown], Tokio Ueyama, [first name] Uesugi, Ryuji Komeda [?], [first name; a woman] Yamaguchi. (This list reflects the most current translation available.)
16 This same Uesugi was a member of Shaku-do-sha. Shofudo was owned by Toyo Miyatake's father. The catalogue also contains an ad for the Korin Bijutsuten (formerly Korin Kodak; see n10), now located at 522 South Hill Street.
17 Taizo Kato, review of Shaku-do-sha exhibition, *Rafu Shimpo*, June 20, 1923, Shiyei Kotoku biographical file, Asian American Art Project, Stanford University, Stanford, California.
18 Tokio Ueyama, review of Shaku-do-sha exhibition, *Rafu Nichi Bei*, June 20, 1923, Shiyei Kotoku biographical file, Asian American Art Project, Stanford University.

Like Kato, he made careful observations about the relative merits of the paintings and did not shy from making specific assessments, some positive but others quite critical.[19] That the Shaku-do-sha continued in earnest throughout the decade with the core of artists intact suggests that an engaged, critical dialogue was part of the group's appeal. They needed the support of one another, yes. But they also thrived on intellectually and formally challenging each painting. Direct criticism strengthened their resolve to make art. Pain and suffering fueled their expression.

In 1922, Ueyama was invited to participate in the second exhibition of the East West Art Society at the San Francisco Museum of Art.[20] Throughout the 1920s and 1930s, many of the Japanese American artists in Little Tokyo participated in exhibitions in other parts of Los Angeles, in San Francisco, and elsewhere in the United States, especially the annual exhibitions of the San Francisco Art Association. Whether they traveled to see the exhibitions in person is unclear,[21] but they were fully aware of the currents in contemporary art of the period—Japanese American or otherwise—and exchanged information about their activities.[22] Moreover, the diverse paintings by Japanese American artists demonstrated that no single formal or stylistic expression existed. Within the Shaku-do-sha, artists favored styles ranging from American realism and American Impressionism to the influence of Cézanne, but there was no prevailing or limiting aesthetic framework. Citing one of the many exhibitions of Japanese American art in Little Tokyo, the *Los Angeles Times* noted that among the exhibiting artists several different schools are in evidence, but few carried on in the "oriental manner."[23]

The seeming incongruity of Japanese ethnicity, Western-style painting, and slang-spouting Japanese Americans provided humorous fodder for a review by *Los Angeles Times* art critic Arthur Millier. Recounting an exchange between a "young college sheik" and "newspaper men" overheard at an exhibition in Little Tokyo, Millier noted with wry amusement that there was nothing strange about it "until one suddenly realizes that both the speakers were Japanese. Then the words became almost a key to the exhibition."[24] Of the twenty-four artists included, he commented that very little could be specifically linked to Japanese traditions. Instead, "they had completely embraced the modern occidental attitude toward life and art, dropped their old painting tradition founded on rhythmic line, yet were presenting us with works of real vitality, entirely lacking the hybrid feeling we might expect from such a revolutionary change."[25] Among the artists Millier singled out are Ueyama and Kazuo Matsubara, a painter principally based in San Francisco. He went on to write that "not the least significant sign of the interest Los Angeles Japanese take in the work

19 About Hojin, Ueyama wrote that "people wouldn't be surprised if the painting sells," suggesting that even in the early 1920s, a market existed for these paintings. Regarding Kotoku, Ueyama remarked that his painting "looks much tighter than last year."
20 See Mark Dean Johnson, "Uncovering Asian American Art in San Francisco, 1850–1940," in *Asian American Art: A History, 1850–1970*, ed. Gordon H. Chang, Mark Dean Johnson, and Paul Karlstrom (Stanford, CA: Stanford University Press, 2008), 1–30, for a discussion of Northern California Asian American artists.
21 For example, a box of Ueyama's art, valued at five hundred dollars, appears on the list of shipments made by the American Railway Express Company for the San Francisco Art Association, covering items taken from the California Palace of the Legion of Honor on June 24, 1930.
22 A copy of the 1923 Shaku-do-sha catalogue in the permanent collection of the Japanese American National Museum comes from the personal papers of Berkeley-based Chiura Obata.
23 "Art Talent among the Local Japanese," *Los Angeles Times*, December 21, 1930, part 3, 15.
24 Arthur Millier, "City's Japanese Show Art," *Los Angeles Times*, December 29, 1929, part 3, 9. This same anecdote and a summary of Millier's review appeared in "Japanese Artists Show Occidental Works," *Art Digest*, January 1, 1930, 19.
25 Ibid.

Tokio Ueyama, *Mt. Bandai in Fukushima*,
n.d. Oil on canvas, 15 × 18 inches

Exhibition guest book, ca. 1929

opposite: Tokio Ueyama's scrapbook, ca. 1920s

D E la tierra de las manzanas célebres (inclusive las de las Hespérides), vino hace pocos días un japonés mexicanófilo que se llama Tokio Ueyama. Lo presentó sin preámbulos el maestro de "ju-jitzu", señor Naboutaka Satake. Charlamos.

El señor Ueyama reside en Los Angeles. Es pintor y viajero. Algo más: es un buen muchacho, un estudiante que no vino a los Cursos de Verano. Entró, saludó, puso su cabellera frente a algunos de nuestras panorámicas, hizo dos o tres preguntas, y hace cinco días se volvió a la tierra de las manzanas.

Ueyama dijo en inglés a Grosmán Rivas:

—Hará un año que en la biblioteca pública de Los Angeles leí un libro de cuyo nombre no me acuerdo. Traía unas figuras aztecas muy curiosas, y desde ese momento comencé á planear mi viaje a México. Me dijeron que los bandidos ya se habían ido y que podía viajar del Norte al Sur y del Este al Oeste, sin más equipo que mi buena voluntad. Supe también, por el Cónsul General de México allá, que no había ya el riesgo de que la langosta fuera á detener la marcha del tren.... Vine y ya me voy. Volveré; por supuesto que volveré el año que viene. ¡Viva México!

El señor Ueyama se hospedó en el Salón Tokio de esta capital, y aunque el se llama Tokio no nació en la ciudad japonesa de ese nombre. Una de sus preocupaciones es la de conocer a Diego Rivera, pintor extraordinario, pésele a quien le pese.

—Rivera me es muy conocido desde hace algún tiempo. En los Estados Unidos lo conocen. ¿Y aquí cómo le va?

El compañero Rivas lo llevó una noche a oir la plática de Rivera en la Asociación Cristiana Femenina, y aunque no la entendió porque ignora el español, saltó muy complacido de conocer los esquemas de Rivera, los formidables dibujos que allí expuso.

—Lo de Chapingo es lo que más me gusta. Este pintor vale aquí y dondequiera. No se parece a ninguno de los que yo he visto. Sobre todo es muy mexicano, sin dejar de ser universal. Una noche estuve con él en un estudio de Mixcoac y hablamos largamente por medio de un intérprete. Nada especial me dijo, pero yo sí entiendo lo que Rivera dice en las paredes.

—Claro, claro.... Algunos tipos mexicanos parecen japoneses y he encontrado rastros en algunas piedras. No le quepa duda, por aquí anduvimos hace algún tiempo. ¿En dónde está don José Juan Tablada?

—¿Ha leído usted —preguntó Rivas— el folleto "La Futura Guerra Japonesa-Americana" del ingeniero naval inglés Mr. Bywater?

En seguida el señor Ueyama mostró sus apuntes tomados en el pueblo de Taxco. Hizo gratos recuerdos de don Juan Ruiz de Alarcón y de las minas. Aprendió una leyenda sobre éstas. La iglesia de Taxco le seduce tanto, que preguntó inquieto si algún turista yanqui había hecho proposición de compra ó de traslado.

—No la vendemos —le contestó el compañero Rivas.

Y Ueyama le enseña algunas cosas que se lleva de México, unas telas, un muñeco a caballo de esos que los indios tejen con tule, algunas figuras preciosas. A su regreso a Los Angeles quiere estudiar algo más sobre la arqueología mexicana. Estuvo diariamente a visitar el Museo Nacional; se lleva muchas fotografías y algunos apuntes de bandidos que le inquietaron. Rivas le dió una lista de obras en inglés que pueden serle muy útiles: Joyce, Saville, Maxley, Maudslay, etc.

18.—6 DE SEPTIEMBRE DE 1925.

Revista de Revistas

Tokio Ueyama: Un Pintor Japonés en México

En la parte superior: auto-retrato del pintor japonés Tokio Ueyama. Abajo: el notable artista nipón pintando dos de sus cuadros.

(Pasa a la Pág. 42)

Tokio Ueyama, *Morning View of Encampment by the Coast*, 1936.
Oil on canvas, 15 × 18 inches

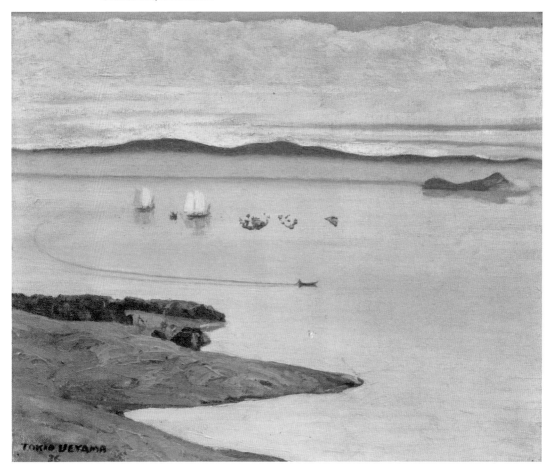

of the artists of their race was the liberal sprinkling of sold tags placed on the works."[26] Not only were Japanese Americans viewing art in Little Tokyo, they were buying it.

Photography

The Shaku-do-sha was not the only group of artists in Little Tokyo. In the early 1920s, the Japanese Camera Pictorialists of California was organized under the strident leadership of Kaye Shimojima. As Dennis Reed has explored in exhibitions and books, these Japanese American photographers created the most dynamic photographic work in Los Angeles of the period and were likewise recognized by inclusion in major national and international publications and exhibitions.[27] The first of many exhibitions organized by the Japanese Camera Pictorialists was sponsored by the *Rafu Shimpo* in 1924 with Margrethe Mather, N. P. Moerdyke, and Arthur F. Kales as judges; in 1926, Will Connell was enlisted. The involvement of these prominent European American photographers suggests a depth of interaction between Japanese American artists and their fellow photographers that unfolded and continued over time.

But the Shaku-do-sha is credited with the most-cited exhibition of photography in Little Tokyo. First in 1925, and then again in 1927 and 1931, in the Sumida Music Store on East First Street, the Shaku-do-sha sponsored exhibitions of Edward Weston's photographs. The late 1910s to the mid-1920s were tumultuous years for Weston. By the mid-1910s, his work was gaining critical acclaim, including a favorable notice by the critic Sadakichi Hartmann writing under the pseudonym Sidney Allan.[28] Amid this growing prominence, however, upheaval in Weston's romantic life and a tenuous financial situation produced what one scholar termed "melancholia."[29] Money was especially tight after Weston's return from Mexico, where he traveled with photographer Tina Modotti, his lover. Weston's entry in his daybooks underscores with enthusiasm the Japanese American support—intellectual and financial.

August 1925. The exhibit is over. Though weary, I am happy. In the three days I sold prints to the amount of $140.—American Club Women bought in two weeks $00.00—Japanese men in three days bought $140.00! One laundry worker purchased prints amounting to $52.00—and he borrowed the money to buy with! It has been outside of Mexico my most interesting exhibition. I was continually reminded of Mexico, for it was a man's show. What a relief to show before a group of intelligent men! If Los Angeles society wishes to see my work after this, they must come to the Japanese quarter and rub elbows with their peers—or no— I should say their superiors! I owe the idea for this show to Ramiel—and his help made it a success.[30]

26 Ibid.
27 See Dennis Reed, "The Wind Came from the East: Asian American Photography, 1850–1965," in *Asian American Art*, 141–68. See also Dennis Reed, *Japanese Photography in America*, 1920–1940 (Los Angeles: George J. Doizake Gallery, Japanese American Cultural and Community Center, 1985); and Michael G. Wilson and Dennis Reed, *Pictorialism in California: Photographs 1900–1940* (Malibu, CA: J. Paul Getty Museum; San Marino, CA: Henry E. Huntington Library and Art Gallery, 1994).
28 Sidney Allan, "Looking for the Good Points," *Bulletin of Photography*, November 1916; reprinted in *Edward Weston Omnibus: A Critical Anthology*, ed. Beaumont Newhall and Amy Conger (Salt Lake City: Peregrine Smith, 1983), 9–10.
29 Weston J. Naef, "Edward Weston: The Home Spirit and Beyond," in Susan Danly and Weston J. Naef, *Edward Weston in Los Angeles* (New York: Oxford University Press, 1986), 33.
30 Edward Weston, in *The Daybooks of Edward Weston* vol. 1, *Mexico*, ed. Nancy Newhall (New York: Aperture, 1990), 121–22.

Though short, the entry provides an interesting sketch of Little Tokyo from the perspective of a European American artist. It presents the opinion that within Los Angeles, Little Tokyo was a prime place for stimulating intellectual exchange and indicates that there was an active market consisting of Japanese Americans, who purchased art even when cash was not available. Notwithstanding his barely concealed contempt of the "American Club Women" versus the "man's show" in Little Tokyo, Weston's invocation of Mexico is an interesting one. Ueyama had traveled to and exhibited in Mexico City the previous year. And up until World War II, several Japanese American artists, including central California–based Henry Sugimoto, made the trek south of the border, where they met Mexican artists such as Diego Rivera and José Clemente Orozco, as well as connected with Japanese who had settled there. The appreciation that Weston expressed for his Japanese supporters in 1925 continued throughout his *Daybooks* to the point where a lack of sales in any particular instance was accompanied by the refrain "not like the Japanese" or some such variation.[31]

Michio Ito and Toyo Miyatake

Because Edward Weston is universally recognized as among the most significant photographers of twentieth-century America, it is easy to forget that at the time of his experiences in Little Tokyo, he was one among many of promise in the field. When choreographer Michio Ito arrived in Los Angeles in 1929, however, he had already achieved international status as a pioneering choreographer of modern dance in both Europe and United States. Born in 1892 in Tokyo, Ito was the son of a prominent architect. Around 1910, he left Tokyo to study voice and music in Paris. He became disenchanted with opera and spent his time traveling throughout Europe and actively engaging in the provocative offerings of new art. He became acquainted with figures such as Auguste Rodin and Claude Debussy and formed lifelong friendships with painters Tsuguharu Foujita and Jules Pascin. After reportedly witnessing

Vaslav Nijinsky and his company at Théâtre du Châtelet in June 1911 and possibly meeting Isadora Duncan in Berlin shortly thereafter, Ito turned to dance. He identified Hellerau as a place to study and began formal training in Émile Jaques-Dalcroze's Institute of Eurhythmics, an integrated approach to dance, music, and drama.[32]

With the outbreak of World War I, Ito moved to London, apparently with little financial resources. A strikingly handsome figure with long, straight, black hair, Ito soon frequented the Thursday evening salons of Lady Ottoline Morrell, where his solo performances to music performed by Lady Ottoline's husband, Philip, launched a "career." At Lady Ottoline's, Ito met Ezra Pound and W. B. Yeats. Pound had come across the manuscripts of Ernest Fenollosa, the American Orientalist, who had been translating Noh plays into English, which Pound then transformed into verse. Yeats saw Noh as a viable way of reinterpreting theater and likened its "otherness" to the alternative traditions of Irish theater. The appearance of Ito in London was perceived as fortuitous for the Western writers who sought his assistance. But Ito was initially

31 In his daybooks, Weston repeatedly invoked "the Japanese" as a paragon of an intellectual and responsive audience of collectors. "How rarely I sell to Americans! How appreciative, understanding and courteous the Japanese!" (April 6, 1927). In response to a nonsale of a shell print, Weston wrote, "The Japanese would have bought,—I never waste time with them!" (June 8, 1927). For Weston's show with his son Brett at the Los Angeles Museum of History, Science and Art in October 1927, he wrote, "Nothing has been sold as yet. Not much like the Japanese exhibit!" (October 20, 1927), and later, "That exhibit brought me no results,—financial I mean. Not one print sold: Quite different from the Japanese" (December 7, 1927). Weston, *Daybooks*, vol. 2, *California*, 14, 26, 39, 41.
32 All biographical information comes from Helen Caldwell, *Michio Ito: The Dancer and His Dances* (Berkeley: University of California Press, 1977); and Jan Breslauer, "New Legs for a Legend," *Los Angeles Times*, March 15, 1998, Calendar, 7, 84.

Toyo Miyatake, *Michio Ito*, 1929. Gelatin
silver print, approx. 14 × 10⅞ inches

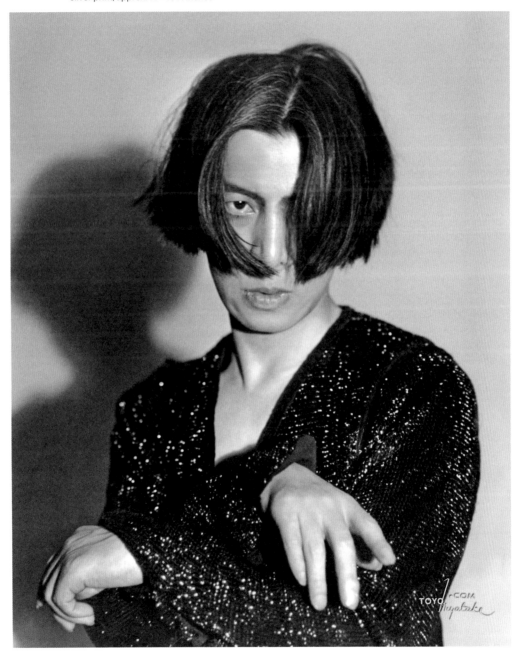

Isamu Noguchi, *Michio Ito*, 1926.
Bronze, 18¼ × 7⅛ × 4¾ inches

hostile to Pound's request. "Noh," in Ito's estimation, "is the damnedest thing in this world": an arcane, old tradition.[33]

This anecdote suggests one critical conundrum for Japanese artists of the late nineteenth and early twentieth centuries: namely, as European modernists looked to the simplicity and exotic otherness of Asia as a source to reinvigorate Western art forms, Japanese artists were automatically assumed to have some special relationship to their ancestral heritage. Yet this idea of a native informant presented complex opportunities, and in 1916, Ito and Yeats collaborated on *At the Hawk's Well*, or *The Waters of Immortality*, which had several performances in London. This liberal reinterpretation of the Noh style met with an immediate and positive critical response. T. S. Eliot remarked that upon seeing *At the Hawk's Well*, "Thereafter one saw Yeats rather as a more eminent contemporary than as an elder from whom one could learn."[34]

Dance, of course, is an ephemeral art. One of the few documents of Ito during this period are the photographs by Alvin Langdon Coburn, an expatriate American photographer, whose European circle included writers H. G. Wells, George Bernard Shaw, and John Galsworthy; and artists Auguste Rodin and Henri Matisse; in the United States, Alfred Stieglitz and Gertrude Stein were two of his cohorts. Coburn was among those who were associated with Stieglitz's *Camera Work*. A Japanese aesthetic was valorized in *Camera Work* in both direct and indirect ways. In the second issue, for instance, Sadakichi Hartmann (again writing as Sidney Allan) authored "The Influence of Artistic Photography on Interior Decoration," which discussed the Japanese interest in harmonious interior design as a model for the display of "artistic" photography. In the following issue, one of Mary Cassatt's ukiyo-e–inspired paintings appeared, and two years later a woodblock print by Kitigawa Utamaro was published in issue ten.[35] The modernist interest in Japanese culture provided a means by which a marginalized ethnic group in a Western context had access to high-cultural associations.

Ito left London for New York shortly after his collaboration with Yeats. Between 1916 and 1929, Ito performed extensively in New York, where Martha Graham was among his dancers and Hungarian American Nickolas Muray and Japanese American Soichi Sunami, both photographers, documented him on film. During this period, the young Isamu Noguchi sought out Ito, who had known his father, the poet Yone Noguchi, in London. Isamu Noguchi offered to design masks for Ito's New York 1925 performance of *At the Hawks Well*.[36] Noguchi's bronze head of Ito based on the original papier-mâché designs riffs on the characteristically smooth features of traditional Noh masks while clearly capturing Ito's likeness and the slight angle of his head. The elongated strand of hair reproduces another characteristic of Ito—his quite dramatic use of hair—but inventively employs it as a handhold for the mask. In almost all estimations of Noguchi's work, the Ito portrait appears as one of the earliest examples of the artist's engagement with modernist sculpture, one that registers the shift from his earlier studies with Gutzon Borglum, the stone carver of Mount Rushmore.[37]

In 1929, Ito moved to Los Angeles, where he dropped by Miyatake's studio with a

33 Caldwell, *Michio Ito*, 44.

34 Ibid., 50.

35 Alfred Stieglitz, *Camera Work: The Complete Illustrations* (Cologne, Germany: Taschen, 1997), 119–21, 129, 218.

36 These masks were the first of Noguchi's designs for dance and are no longer extant. Noguchi continued to work with choreographers, creating more than thirty-five collaborations, most significantly with Martha Graham. Most likely, Noguchi was introduced to Graham through Ito; Graham had been one of Ito's dancers in his Greenwich Village Follies performances of 1923. For a discussion of Noguchi's designs for performance, see Robert Tracy, *Spaces of the Mind: Isamu Noguchi's Dance Designs* (New York: Proscenium, 2001).

37 Bonnie Rychlak, *Noguchi and the Figure* (Monterrey, Mexico: Museo de Arte Contemporáneo de Monterrey, 1999), 38–39.

mutual friend.[38] For the next decade, Miyatake took on the task of fixing permanence to the fleeting forms of Ito's movements. In Ito's dance poems, as he called them, music regulates and controls the movement. The foundation of Ito's choreographic practice was an intricate system of gestures: ten basic arm movements in two forms—masculine and feminine—that could be combined into an infinite number of sequences. Miyatake's photographs of Ito capture this process of gesture. Ito's contorted hands appear as if bound, while the intensity of his facial expressions remains concealed by his trademark long hair. In most of Miyatake's interpretations of Ito, the shadow enters into play as if another body is participating in the action. It becomes a menacing witness to the articulation of the gesture. The stark depictions reverberate: "Ito's gesture is never final; it merely enters the spectator's mind, where it beckons the imagination into the future."[39] Miyatake appears to have engaged in an active collaboration with Ito and his dancers: "he and his almost anthropomorphic camera were always in evidence. Looking out from a prompter box, on top of a ladder or behind an arc-light, sometimes on his knees, his side and once in a while on his feet."[40] But Miyatake's friend James Wong Howe also gave him insight into the role of light and shadow, which he utilized in other photographs besides his Ito works.[41]

Throughout the early 1930s, Miyatake was the primary interpreter of Ito performances, as Coburn had been in the 1910s and Muray and Sunami in the 1920s. For Miyatake, the work with Ito presented new opportunities, pushing his photographic experimentation and providing a connection, through Ito's past experiences, to a dynamic international arena of arts and ideas. One photograph of *At the Hawk's Well* from 1929 found its way to the London Salon of Photography in 1930. Dance was not an uncommon subject for photographers of this period, especially staged tableaux that suggested antiquity or reenactments of mythological tales. However, Miyatake's interpretations of Ito and his students are concerned both with formal compositional issues and with the difficulties of capturing movement in a static form. Miyatake's experimentation with light and movement culminated in some of his most provocative works of the decade. The body of the dancer is reduced to a flicker of light in motion, cutting a wide sweep across the space of the photograph.

The Next Generation

Education in early twentieth-century America was a democratizing force, and this held true for Japanese Americans as well. As the generation of Japanese Americans born in the twentieth century reached college age, they found access to post-secondary education remarkably open, though prospects upon graduation were still quite limited. In art, more possibilities existed. As Bumpei Usui commented, "The least prejudice against our race is still in the art world."[42] Los Angeles's first formal art school, the Otis Art Institute, was founded in 1918 as an adjunct to the Los Angeles Museum of History, Science and Art, followed by the establishment of Chouinard Art Institute and Art Center, in 1921 and 1930, respectively. Young Japanese and Americans enrolled at all three institutions in the pre–World War II period. Otis, in particular, attracted a diverse student body, which in turn nurtured relationships among students of different backgrounds. For three years, beginning in 1929, Otis's highest honor, the Huntington Assistance Prize, went to Japanese Americans: Charles Isamu Morimoto, Benji Okubo, and Kiyoshi Ito, and Hideo Date received a Day School scholarship and selection

38 Toyo Miyatake, *A Life in Photography: The Recollections of Toyo Miyatake*, with Enid H. Douglas (Claremont, CA: Oral History Program, Claremont Graduate School, 1978), 19.
39 Caldwell, *Michio Ito*, 5.
40 Barbara Perry, cited in *Toyo Miyatake: Behind the Camera*, 10.
41 Archie Miyatake recounted how his father discussed the impact of James Wong Howe's cinematography on his photography; interview with the author, July 5, 2005.
42 Bumpei Usui, cited in Bunji Omura, "Japanese Artists Born in America Excel Many in Nippon, Experts Say," *Japanese American Review* (New York), August 9, 1941, 8.

Toyo Miyatake, *Evergreen Cemetery Tombstone*, 1925. Gelatin silver print, 11 × 14 inches

above: Benji Okubo, *The Kiss*,
ca. 1920–39. Oil on canvas,
10 × 11 inches

Hideo Date, *Bather*, ca. 1930s.
Watercolor and gouache on
paper, 28 × 20½ inches

by the College Art Association for the *Young Painters* exhibition at the Ferargil Galleries in New York. The Otis publication *El Dorado, Land of Gold*, "a series of pictorial interpretations of the history of California with accompanying rhythmic story by students of Otis Art Institute," featured woodcuts by twenty-nine students, of which five were Japanese American: Date, Ryuichi Dohi, Ito, Morimoto, and its editor, Okubo. Without a hint of irony, the students' work accompanied poetic verse that mused on the mythic founding of California by Spanish settlers with titles such as "Juniper and His Indian," "Conquest of the Gringos," and "Bartering Their Goods for Candles." Between 1930 and 1941, George Chann, Henry K. Fukuhara, Hideo Kobashigawa, Sueo Serisawa, and Tyrus Wong were among the other Asian American artists who attended Otis. In roughly the same period, Gyo Fujikawa, Chris Ishii, Ken Nishi, Keye Luke, Gilbert Leong, Milton Quon, and Gene I. Sogioka studied at Chouinard.

The Art Students League of Los Angeles and its charismatic leader, Stanton Macdonald-Wright, formed another nexus where Asian American artists were active players. The league was founded in 1906 and provided a setting for the study of art outside a traditional art school. In 1910s Paris, Macdonald-Wright and Morgan Russell, who later taught at the league as well, developed a theory of abstraction in painting based on complex color theory linked to music. Synchromism, as they termed it, placed Macdonald-Wright and Russell at the vanguard of modernist painting, but upon returning to Los Angeles in 1919, Macdonald-Wright abandoned pure abstraction in favor of figurative work inspired by Asian art. Under his leadership, the Art Students League became a bohemian outpost that attracted a wide range of creative innovators, such as director John Huston and architect Harwell Hamilton Harris, in addition to artists Lorser Feitelson, Herman Cherry, and Albert King. That Macdonald-Wright was so enamored of Asian art provided a milieu where Japanese and Chinese ancestral heritage was valued and valuable. Date and Okubo were key participants in the league.

Date intermittently lived at the league studios, and Okubo was director in the period before World War II.

In 1939, Macdonald-Wright was invited to guest edit an issue of *California Arts and Architecture* that aimed to "give the reader an impression of Chinese influence in California."[43] Tyrus Wong and Milton Quon created the cover. Macdonald-Wright wrote about Chinese artists in California, Chingwah Lee covered Chinese art, and articles on James Wong Howe, Chinatowns in America, and Chinese plants, drama, music, architecture, and garden design rounded out the issue.

The relationship between Asian American communities and Asia in the pre–World War II years was far more complex than can be efficiently summarized. It was not unusual for Japanese Americans to make trans-Pacific crossings: as individuals, with family, or as part of formal groups.[44] In 1929, Date interrupted his studies at Otis to spend a year in Tokyo studying at the Kawabata Gakkō, a private studio established by Kawabata Gyokushō, a well-regarded painter in the *nihonga* style. Date travel to Tokyo again in 1936 as a translator for a European American acquaintance interested in ikebana.[45] *Nihonga* emerged in the late nineteenth century as a painting style that self-consciously adapted traditions of Japanese painting—from material to method—and was conceived as a direct response to the promulgation of Western-style oil painting in the decades after the Meiji restoration. Date returned to Japan with the explicit intent to study Japanese-style painting, but his choice of the Kawabata School was by chance; a Japanese American artist gave him a letter of introduction to an artist in Japan who eventually introduced him to the school, further evidence of artistic connections formed across the Pacific.

43 Editorial, *California Arts and Architecture* 56, no. 4 (October 1939): 3.
44 For instance, Miyatake was in Japan from 1932 to 1933. Gyo Fujikawa traveled there from 1929 to 1930.
45 For information on Date, see "Living in Color: The Art of Hideo Date," in this book, 208–27.

Date's paintings and works on paper from this period combine an exquisitely rendered line with atmospheric renderings, which have a controlled but dreamlike effect. In *Bather*, circa 1930s, green and yellow lines form a mane of hair. The precise lines contrast with the sensitive modeling of the face and background, which Date created through painstaking successive washes of watercolor. But it is the contrasting pictorial strategies that produce a dynamic tension. The work is flat and graphic at the same time that it is delicately modeled. In many of Date's works, graphic patterns of gouache anchor the lower part of the sheet: a stylized textual design, adornment, or floral pattern, despite its recession into space, meets with a graphic sensibility akin to that of Japanese prints.

An odd and unnatural quality is further created by his juxtaposition of contrasting colors—a chartreuse face with orange hair, for instance—something Date attributed to Macdonald-Wright's color theories. Macdonald-Wright's influence can also be seen in the large-scale muscular bodies and faces of Date's women, which derive from Macdonald-Wright's interest in Michelangelo. Date's women contain a charged sexuality that mirrors what we know of Date and his sitters. Some of the women were his sexual partners, and accounts suggest that within their small circle of friends, various couplings occurred over time. In a period when antimiscegenation laws were in effect, such liaisons were far from unusual, but making them public and official was taboo and illegal.

Although Benji Okubo was a nisei, having been born and raised in Riverside, California, and Hideo Date was an immigrant from Japan, they were good friends and artistic compatriots. Okubo's paintings relate to an interest in the arts of Asia, but the mysterious figures, strange compositions, and psychological introspection of his work also align with aspects of California Surrealism, most notably with Lorser Feitelson and Helen Lundeberg.[46] In *The Kiss*, circa 1930s, the face of the artist is partially obscured by a small, floating, upside-down figure, which holds onto the left side of his face. The intensity of the man's eyes recalls Persian miniatures, a subject upon which Macdonald-Wright often lectured. This painting, like others of the period, makes no attempt at an easy narrative, though by the World War II incarceration, the haunting commentary in Okubo's work becomes more explicit and radically critical of the political situation.

In 1933, Date and Okubo exhibited together in a two-person show sponsored by the *Rafu Shimpo* and *Kashū Mainichi*, another vernacular newspaper, held on East First Street. In 1934, Date and Okubo, along with Tyrus Wong and Gilbert Leong, exhibited as the Los Angeles Oriental Artists' Group, under the auspices of the Foundation of Western Art, an association of artists that supported the art of the West Coast. The exhibition featured twenty-two works, including one by Date that had already entered the collection of the Los Angeles Museum and was accompanied with a foreword and biographical notes by Macdonald-Wright, who aptly commented that "today, and especially here on the West coast, the flow from the East is again evident." Both the sensitive artist and the sensitive layman "will find in the work of these young Asiatics much to inspire and instruct."[47] That same year, Date, Wong, and Leong participated in the *Contemporary Oriental Artists Exhibition*, also sponsored by the Foundation of Western Art, which included ten painters each from San Francisco and Los Angeles. Henry Sugimoto, Miki Hayakawa, and Tokio Ueyama were among them. Until the outbreak of World War II, Date, Okubo, and Wong continued to exhibit in such contexts and were joined by Sueo Serisawa, Miné Okubo, Jade Fon Woo, and Keye Luke. "I met Henry Sugimoto through his paintings before I met him in person," Date recounted. Thus, the exhibitions provided a means to "meet" artists who lived up the California coast.

Hollywood

Perhaps the most visible project by Okubo was a mural he designed and executed with Tyrus Wong and Hideo Date for the Dragon's Den, a restaurant and club in Chinatown that was owned and run by Eddy and Stella See. On the whitewashed brick walls, they painted the Chinese immortals watching

over the steady stream of Hollywood stars, such as Anna May Wong, Sydney Greenstreet, Peter Lorre, and Walt Disney, as well as friends and artists from the Art Students League, Chinatown, and nearby Little Tokyo.[48] Date was responsible for another mural, this one for a room at Pickfair, the infamous house owned by Mary Pickford and Douglas Fairbanks. Described as "Oriental-inspired," the room's blue carpets, golden curtains, red chairs, silver-leafed walls, and Date mural provided the backdrop for kimono-clad servants serving cocktails.[49]

The growing industry of Hollywood provided employment to many Japanese American artists—behind the camera or at the animation table. Photographer and painter Kango Takamura worked as a cameraman at RKO Studios. Chris Ishii, Tom Okomoto, Tyrus Wong, Milton Quon, Wah Ming Chang, James Tanaka, Robert Kuwahara, and Gyo Fujikawa all worked for Disney at some point in the pre–World War II period. Fujikawa was unique in being a young nisei woman and a published children's book illustrator, who moved to New York before the mass incarceration.[50] When faced with suspicion there during the war, she would often tell people she was Anna May Wong. Recounting the story to Disney, he chastised her and exhorted her to proclaim her status as an American citizen, which she henceforth did.[51]

Little Tokyo

Harry Shigeta "learned that human eyes can be deceived by tricks and allusions." After a brief explanation of Little Tokyo and the artists who lived and passed through it in the 1920s and 1930s, one wonders: Is it tricks and illusions that prompts one to see a self-contained community, an "island within an island," rather than a place of dynamic and diverse artistic activity? Perhaps the fact that Little Tokyo was an ethnic ghetto in a global city is a partial explanation. Its intensive urbanism, it's "congestion of people," its density, and its manifestation of racial segregation made it difficult to see it as an international arena of art and ideas, where ripples of association radiated out and back in again. That there were so

many artists, of different generations and artistic interests and with numerous associations within and beyond Little Tokyo, confuses the search for a single group or emblematic individual who can represent what it meant to be an artist of Japanese descent.

East First Street was the hub of Little Tokyo. There, Miyatake had his studio-*cum*-salon, Weston exhibited his photographs, Michio Ito presented modern dance,[52] and Date and Okubo showed new work. There, paintings and photography by Japanese American artists were on view in storefronts and restaurants.[53] But just as First Street extended beyond Little Tokyo in two directions, the art and ideas of the enclave moved and mattered in multiple directions.

46 For a discussion of Surrealism in Los Angeles, see Susan Ehrlich, ed., *Pacific Dreams: Currents of Surrealism and Fantasy in Early California Art, 1934–1957* (Los Angeles: UCLA at the Armand Hammer Museum of Art and Cultural Center, 1995).

47 Stanton Macdonald-Wright, exhibition catalogue of Los Angeles Oriental Artists' Group, Collection of the Japanese American National Museum.

48 Lisa See, *On Gold Mountain: The One-Hundred Year Odyssey of a Chinese-American Family* (New York: St. Martin's Press, 1995), 193–98.

49 David Wallace, *Lost Hollywood* (Los Angeles: LA Weekly Books, 2001), 68.

50 Upon the release of Dorothy Walter Baruch's *I Like Automobiles* (New York: John Day, 1931), with illustrations by Fujikawa, reviewers commented that "her drawings are a unique revelation of the adaptability of Japanese art made of Western subjects." Cited in "News of Day in Brief," *Rafu Shimpo*, November 20, 1931.

51 Elaine Woo, "Children's Author Dared to Depict Multicultural World," obituary, *Los Angeles Times*, December 13, 1998.

52 Ito and his company performed at Koyasan Temple, located on the south side of First Street, between San Pedro and Central Avenues.

53 For instance, a painting of a desert landscape by Sueo Serisawa, circa 1927, hung on the wall of Mansei-An restaurant until January 1942, when Japanese Americans were incarcerated. The work is now in the collection of the Japanese American National Museum, a gift of Yoshiko Hosoi Sakurai.

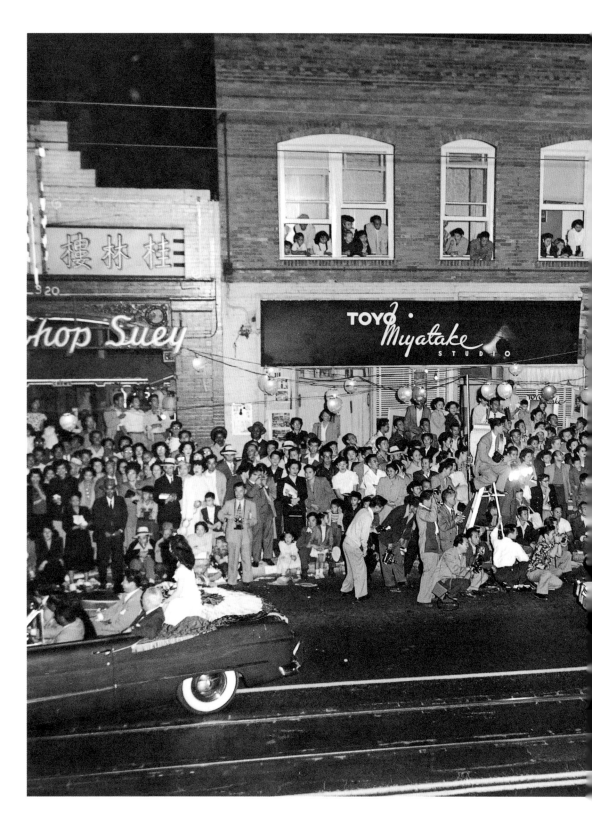

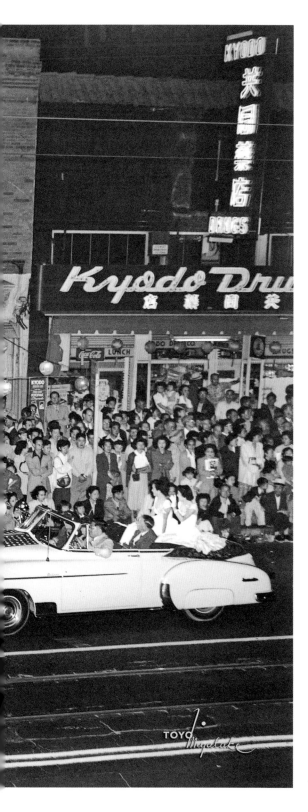

Toyo Miyatake, Nisei Week parade, 1950

The Search for Roots, or Finding a Precursor

As the first comprehensive exhibition that examines the historical presence of artists of Asian descent in American art, *Asian/American/ Modern Art: Shifting Currents, 1900–1970* (2008) bears a particularly heavy burden. The multiple concepts in its title—Asian, American, and modern—form a collective juggernaut that encapsulates the predominating discourses of recent art history. Considered in another light, the terms *Asian, American,* and *modern* function as stand-ins for *race, national identity,* and *modernism,* and the canny use of the slashes is a way to both bracket and elide the components of the exhibition's tripartite structure. *Shifting Currents* ambitiously, or audaciously (depending upon one's perspective), presents a view of art in the United States from 1900 to 1970, where the compilation and display of ninety-five diverse works are explicitly filtered through questions of race, identity, and notions of modernism.

"Race" is a slippery and contested rubric that raises as many questions as it answers. While scholars have thoroughly discounted a biological or scientific basis for race, it still has a pervasive hold on the American imagination. It is used to describe behaviors, explain intent, and suggest allegiances and alliances. Since race cannot be explained in scientific or anthropological terms, what remains, as Michael Omi and Howard Winant propose, is a theory of racial formation that foregrounds the social nature of race and its expressions in a dynamic matrix of personal and collective identity.[1] Omi, Winant, and others have demonstrated that racial categories, having no essential or biological characteristics, are historically flexible, changing meaning depending on the contingent circumstance or context of articulation. Racial dynamics, therefore, are inherently unstable, potentially contradictory, and ever changing.

To build an exhibition from the shaky foundations of race would seem to spell trouble, its very premise predicated on a category of changing dimensions. The outcomes necessarily will be in flux too, as the second part of the exhibition title suggests. For the organizers of *Shifting Currents,* the specter of race raises a critical question: What are the politics of organizing an exhibition based on race at this historical juncture? I would like to propose that the basic framework of *Shifting Currents*—its assumptions about race, identity, and modernism—is as much a revelation of the present moment of art and culture as an unencumbered recovery of the past. What follows, therefore, are some thoughts on the critical need for an exhibition such as *Shifting Currents,* the exciting possibilities afforded by the art contained within it, and some problems raised by its framework of analysis.

Exhibitions are far from being neutral expressions of historical knowledge or disinterested containers of art. The art of selecting artists and objects for an exhibition is an argument, one that takes place in the space of a gallery and the pages of a catalogue, each with their attendant conventions and modalities. Exhibitions have become, as some have argued, the primary medium through which most art becomes known; they are "part spectacle, part socio-historical event, part structuring device."[2] Exhibitions not only provide opportunities for the firsthand viewing of art, they also propose narratives of art history, whether implicit or explicit, in which specific works are placed in conversation with one another, the past, and a projected future. Cumulatively, exhibitions play a critical role in establishing and administering the cultural meanings of art by creating lineages of art and history.

In writing about representations of and by African Americans, photography historian Karen C. C. Dalton acknowledges the importance

1 Michael Omi and Howard Winant, *Racial Formation in the United States from the 1960s to the 1990s* (New York: Routledge, 1994).
2 Reesa Greenberg, Bruce W. Ferguson, and Sandy Nairne, eds., *Thinking about Exhibitions* (London: Routledge, 1992), 2.

of "ancestor" exhibitions, pathbreaking antecedents that can be built upon, destroyed, or reassembled.[3] Such forerunners play a particularly significant role when the terrain is limited due to historical exclusions or omissions. The logistical impediments to information cannot be underestimated, making the simple act of presenting art in public settings and reproducing images and catalogues a means for the work to enter public discourse. In the absence of monographs or summary histories, these exhibitions form the building blocks of knowledge, with any subsequent endeavor entering into a dialogue with what has come before.

Dalton's use of the term *ancestor* is especially evocative. Not only does the word mean "prototype" or "forerunner," it also suggests an embodied predecessor, a *someone*, not just a *something*. This inflects the search for historical examples of art, whether by African Americans, Asian Americans, or others outside mainstream discourses, with a personal, subjective quality. This search for roots seems a particularly strong urge, if the massive popularity of genealogy is any indication, and the impulse to do so in the realm of art is no less powerful. On one level, the sheer breadth of work in *Shifting Currents* answers that need for lineage. The exhibition contains a dizzying array of styles, forms, and content, with each work opening up exciting new lines of historical inquiry and serving as an implicit precursor to the art that follows. Much of the art in the exhibition has been known, cherished, and collected by a small coterie of individuals and institutions who have recognized its aesthetic and historical richness, yet many works have not been exhibited publicly for decades—if ever. Even the works from museum collections are shown here anew, either because conservation needs kept them out of view or simply because opportunities for display did not occur to their caretakers.

While the list of antecedents for *Shifting Currents* remains relatively short, the exhibition fits within the broader discourse of Asian American studies and the drive to find historical evidence of Asian American creative production.[4] Two earlier exhibitions predicated on a pan–Asian American identification closely resemble the current exhibition's framework.[5] *They Painted from Their Hearts: Pioneer Asian American Artists*, organized by the Wing Luke Asian Museum in Seattle in 1994, focused on early Asian American artists in Washington State with the explicit aim of "re-illuminating the Asian Pacific American story and the overall heritage of the Pacific Northwest."[6] In 1995, *With New Eyes: Toward an Asian American Art History in the West*, organized by the San Francisco State University Art Gallery, had the ambitious goal of critiquing the art historical canon by proposing an alternative art history of the West in which Asian American artists were central.[7]

3 Karen C. C. Dalton, "Introduction: Exhibitions and their Ancestors," in Gwendolyn DuBois Shaw, *Portraits of a People: Picturing African Americans in the Nineteenth Century* (Seattle: University of Washington Press, 2006), 10.

4 Although the term *Asian American* is not explicit in the title, the two factors that link the artists in *Shifting Currents* is that they can be identified as Asian or of Asian ancestry and that their art was made in the United States.

5 Here I am limiting my discussion to those exhibitions where the primary organizing principle is race. There are other exhibitions of Asian American artists that have taken national origin, thematic connections, or a particular historical experience, such as the World War II internment of Japanese Americans, as the curatorial focus. See, for example, Anne L. Jenks and Thomas M. Messer, *Contemporary Painters of Japanese Origin in America* (Boston: Institute of Contemporary Art, 1958); Jeffrey Wechsler, *Asian Traditions/Modern Expressions: Asian American Artists and Abstraction, 1945–1970* (New York: Abrams, 1997), and *The View from Within: Japanese American Art from the Internment Camps, 1942–1945*, ed. Karin Higa (Los Angeles: Japanese American National Museum, UCLA Wight Art Gallery, and UCLA Asian American Studies Center, 1992).

6 Ron Chew, foreword to *They Painted from Their Hearts: Pioneer Asian American Artists* (Seattle: Wing Luke Asian Museum, 1994), 4.

7 Irene Poon Anderson, Mark Johnson, and Dawn Nakanishi, et al., *With New Eyes: Toward an Asian American Art History in the West* (San Francisco: San Francisco State University Art Gallery, 1995).

Toshio Aoki, *Woman with Birds*, ca. 1890s.
Watercolor on paper, 40½ × 34¾ inches

The Search for Roots, or Finding a Precursor

Despite their modest scales, both exhibitions brought to light remarkable works of art that hinted at a richness and density that *Shifting Currents* aims to mine. More significantly, both proposed a category of Asian American art history in which the historical presence of artists could be seen as a precursor to a contemporary Asian American identification.

It would be easy to confine the search for art historical roots to marginalized communities in the United States, but even a cursory view of the exhibition history of modern art in twentieth-century United States demonstrates how the search for precursors was essential to the development of a certain strain of American modernism. When New York's Museum of Modern Art (MoMA) was founded in 1929, its aim was to collect and exhibit art from the previous fifty years. Yet the following year, its director, Alfred H. Barr Jr., presented an exhibition of Jean-Baptiste-Camille Corot and Honoré Daumier, notable because both artists died in the decade before 1880, the starting date for MoMA's programs.[8] Corot was characterized as a precursor of 1920s classicism, Daumier of expressionist draftsmanship. In subsequent decades, MoMA organized a significant number of important exhibitions devoted to "precursors," ranging from those focused on non-Western art, such as pre-Colombian (1933) and "African Negro" art (1935), to those on British painting from 1800 to 1950 (1956), Claude Monet (1960), and J.M.W. Turner (1966).[9] These exhibitions ultimately formed the critical terrain of modern art in America. Precursors, John Elderfield argues, serve "two interrelated functions: first, to contemporize the historical and, second, to historicize the contemporary."[10] The past was marshaled to create a specific view of art of the various presents. If Monet and Turner could be seen as anticipating the light, color, and allover compositions of Abstract Expressionism, as precursors they could validate the present, make it more understandable, and link American art of the mid-twentieth century to a longer-standing, European tradition. MoMA's program of precursors can be seen, by supporters and detractors alike, as positing a specific lineage of modernist

art history. Whether such a lineage can be legitimately sustained, the drive to create such a history reveals the interests, prejudices, anxieties, and infatuations of the period.

Shifting Currents can be seen to enact a similar logic. It contemporizes the historical existence of artists of Asian descent by an ecumenical approach. But its commitment to surveying a broad range of artistic practice from a seventy-year period creates an exhibition of such diversity that its organizing framework of Asian/American/modern can hardly contain it. This presents a fissure in *Shifting Currents*. The links between Toshio Aoki's depiction of a thunder god from the turn of the twentieth century and a 1953 painting by Alfonso Ossorio are tenuous at best, and one wonders how a 1933 painting by Chee Chin S. Cheung Lee can accrue meaning by its exhibition with Nam Jun Paik's 1963 installation of twenty-four television sets. While to see these works in person or published on the page is itself a virtue, how can such juxtapositions in the exhibition be generative of meaning? Race, national identity, and the modern may be the encompassing framework, but the most captivating works in the exhibition resist attempts to fix their meanings. One of the great contributions of *Shifting Currents* is that it recovers much significant art that has been lost from sight. But the disjunctions produced by seeing this work anew are as important as the clear-cut connections, for they point to both the possibilities and insufficiencies of an "Asian American" framework.

The term *Asian American* did not exist when most of the art in *Shifting Currents* was made. Rather it came into being in the late 1960s and became the preferred replacement for *Oriental* in the 1970s, the period that coincides with the end date of *Shifting Currents*. One risk of utilizing the determinate categories of an Asian American racial identity in the present is that they can undo the complexity of the past, obscuring how the earlier work functioned and created meaning for its makers and viewers. A startling fact that emerges from *Shifting Currents* is that the artists included were not, in fact, wholly dismissed or overlooked by their

contemporaries. Instead, their work resonated in many ways that might be difficult to decipher simply by using the framework of "Asian" or "Asian American," echoing what scholar Susan Koshy has argued about Asian American literary criticism. She laments the inadequacy of the term *Asian American*, which can collapse the contradictions and heterogeneities within the field of art, while cautioning against the type of archival recovery that takes the object of inquiry out of its complex theoretical and historical contexts.[11] On the other hand, the great opportunity of *Shifting Currents* is that it allows us to consider the reception and contextualization of the work after its moment of execution. Tracing the history of the object through time and place is a means to understand not only the past and present but also various intermediate stops. In so doing, the exhibition encourages us to think about how works of art take on different inflections through time and to assess contemporary critical opinion against that of various pasts.

While I have attempted to scrutinize the "Asian" part of the exhibition title, there remain two other parts: "American" and "modern." The exhibition participates in the larger project of simultaneously critiquing and rebuilding the corpus of American art at the same time as it questions the very categories of modernism and modern art. In this way, *Shifting Currents* is the heir to the pioneering work of feminist and African American art historians, among others, who have highlighted the structural limits of the discipline and brought to light the legacy of artists who were previously excluded or simply unknown.

It has been argued that the threat or experience of racism has served to unify an Asian American identity while allowing Asian Americans to become a cultural and political entity. Yet, as Viet Nguyen has argued, Asian American identity "has now also become a thing, a commodity, to be marketed and consumed."[12] As such, an Asian American identity runs the risk of being fixed as something to be bought or a group to be sold to instead of remaining open as a relational alliance born from a set of shared experiences. The potential for an emancipatory

cultural and political identity can get lost in the marketplace of consumption. *Shifting Currents* also challenges the conventional categories of "American" and "modern" art. Such an assessment presents a cautionary tale for *Shifting Currents*. One possible by-product of the search for the roots of an Asian American art production is the creation of both a new market for and a new commodity of "Asian American art," one that elides the complex and specific differences that exist among artworks in favor of an easily identifiable and consumable entity.

Works of art can be expansive and open-ended, asking more questions of the viewer than can be answered. Yasuo Kuniyoshi's 1924 *Self-Portrait as a Photographer* is one such quizzical painting. A large and mysterious burnt-red curtain drapes across the right side of the picture. The artist's face appears out from under a velvety black cloth, his left hand grasping the shutter release of the camera as if interrupted midshoot. His right arm is raised above his head in the way that a photographer might signal to his sitter. However, here the object of Kuniyoshi's camera is not a person but a landscape characteristic of his work of the period, executed in a grisaille that anticipates its final form as the photograph that the artist is taking. Kuniyoshi the artist plays multiple roles here. He is the maker of the total painting, the painter of the painting in the painting, and the photographer who will capture the painting's representation. Kuniyoshi plays all these various roles simultaneously, unwilling to submit to one position.

8 Alfred H. Barr Jr., *Corot, Daumier: Eighth Loan Exhibition* (New York: Plandome Press for the Trustees of the Museum of Modern Art, 1930).

9 John Elderfield, "The Precursor," in *Studies in Modern Art I: American Art of the 1960s*, ed. John Elderfield (New York: Museum of Modern Art, 1991), 88n5.

10 Ibid., 65.

11 Susan Koshy, "The Fiction of Asian American Literature," *Yale Journal of Criticism* 9, no. 2 (1996): 315–16.

12 Viet Thanh Nguyen, *Race and Resistance: Literature and Politics in Asian America* (New York: Oxford University Press, 2002), 9.

At the time he made this work, he was a thirty-five-year-old immigrant from Japan who supplemented his income taking photographs, even though his paintings were garnering increasing critical interest and modest sales. Six years earlier, he had married Katherine Schmidt, a European American woman, an event that not only elicited controversy among their shared group of European American friends[13] but also caused Schmidt to immediately lose her American citizenship.[14] Several decades later, in 1948, Kuniyoshi was hailed as a master of American painting when he became the first living artist to have a solo exhibition at the Whitney Museum of American art,[15] yet at the time Japanese immigrants were forbidden by law to become naturalized citizens.[16] After falling from critical favor in the intervening decades, Kuniyoshi has now been cited as an early Japanese American progenitor. When he painted his self-portrait, Kuniyoshi could not have anticipated the history that followed. Yet the painting itself foregrounds the act of representation with its multiple plays on the artist as a producer. I'd like to think that Kuniyoshi can occupy all these various representations simultaneously, as he did in his 1924 self-portrait. This is the promise of *Shifting Currents*. It presents the opportunity to see works by Asian American artists, so that we can consider how their work both illuminates and exceeds the designation *Asian/American/Modern*.

Yasuo Kuniyoshi, *Self-Portrait as a Photographer*, 1924. Oil on canvas, 20⅜ × 30¼ inches

13 Kuniyoshi's Art Students League friend Arnold Blanch recalled, "Some of his friends didn't think it was the right thing for a Japanese to marry an American girl....It got to be a great controversy among the students." Arnold Blanch, cited in Tom Wolf, "Kuniyoshi in the Early 1920s," in Jane Myers, Yasuo Kuniyoshi, and Tom Wolf, *The Shores of a Dream: Kuniyoshi's Early Work in America* (Fort Worth, TX: Amon Carter Museum, 1996), 25–26.

14 At the time, U.S. law stipulated that an American woman lost her citizenship if she married a noncitizen. In 1922, the Cable Act reversed this law except for women who married "aliens ineligible for naturalization." Asian immigrants were such "aliens."

15 Lloyd Goodrich, *Yasuo Kuniyoshi: Retrospective Exhibition* (New York: Macmillan for the Whitney Museum of American Art, 1948).

16 The McCarran-Walter Act of 1952 removed the restrictions to citizenship, and shortly thereafter, before his death in 1953, Kuniyoshi became a naturalized citizen.

Living Flowers: Ikebana and Contemporary Art

Living Flowers (2008) began with a simple premise: what could be learned by exhibiting ikebana and contemporary art in the same gallery? The exhibition proposes that the practice of ikebana, the centuries-old Japanese art of flower arrangement, provides a way to consider a range of formal, conceptual, compositional, and pictorial strategies in contemporary art, and that, conversely, contemporary art can illuminate the principles and practices of ikebana. The Japanese characters that form the word *ikebana* literally translate as "arranging flowers," but the term *living flowers* is part of its etymology. The title *Living Flowers* also refers to the unique presence of living flowers in the galleries, created by masters of the Ikenobō, Ohara, and Sōgetsu schools of ikebana. The earliest artwork in the exhibition is from 1952, and there is work from the succeeding decades to the present.

The exhibition considers ikebana and contemporary art as two vital, parallel practices of making art today. It uses juxtaposition to tease out distinctions, to challenge ideas about art and tradition in contemporary life, and to ponder art that inhabits the same time and place yet seems to operate in parallel spheres. The works of art in *Living Flowers* were selected because they have affinities with ikebana and share mutual influences. Some of the art directly references ikebana, such as Manfred Pernice's incorporation of an ikebana photograph in *exscape 1* (2006) or Judy Fiskin's photographs from the mid-1980s of ikebana-inspired arrangements at the Los Angeles County Fair. Other works explore ephemerality, shadow, and depth, the symbolism of flowers, and the quotation of broader Japanese aesthetics—all elements at play in ikebana. In Bas Jan Ader's video *Primary Time* (1974), the artist's insertion and removal of red, yellow, and blue carnations is a meditation on the paintings of Mondrian. Although the form of the arrangement is dissimilar to ikebana, the act of arrangement finds a parallel: that meaning derives from both the action and the object of flowers.

Living Flowers aims to generate a visual and conceptual argument that expands understanding of the aesthetic objects of contemporary art and ikebana. It is not simply an exhibition of flowers in art or flower arrangements as art, though Sherrie Levine's readymade *Flower Papers 1–12: Scarlet Roses* (2005) and Monique van Genderen's untitled painting of 2008 are representative of the former, while Jeroen de Rijke/Willem de Rooij's *Bouquet III* (2004) is of the latter. In all three works, the symbolic power of flower imagery has a resonance that belies its simple representation, whether it is a commentary on the nature of the art object, a means to explore issues of abstraction, or a political critique of war and international politics. Nor is *Living Flowers* an exhibition of flower arrangements in response to works of art. Instead, it considers ikebana as a significant art practice with its own codes and conventions. The exhibition aims to explore how the conceptual underpinnings of traditional ikebana inform and provide a counterpoint to tendencies within contemporary art practice.

Most significantly, the exhibition is intended to foster careful and deep looking. It values the possibilities that derive from seeing and experiencing objects through the deliberate act of installing them in space, rather than in communicating ideas about them through language and text. Art historian Svetlana Alpers has argued that the act of looking constitutes a social fact and that visual distinction and experience are the intelligences that can come out of it. For her, ideal museums are places "where our eyes are exercised and where we are invited to find unexpected as well as expected crafted objects to be of visual interest."[1] Such is the aim of *Living Flowers*:

1 Svetlana Alpers, "The Museum as a Way of Seeing," in *Exhibiting Cultures: The Poetics and Politics of Museum Display*, ed. Ivan Karp and Steven D. Lavine (Washington, DC: Smithsonian Institution Press, 1991), 30.

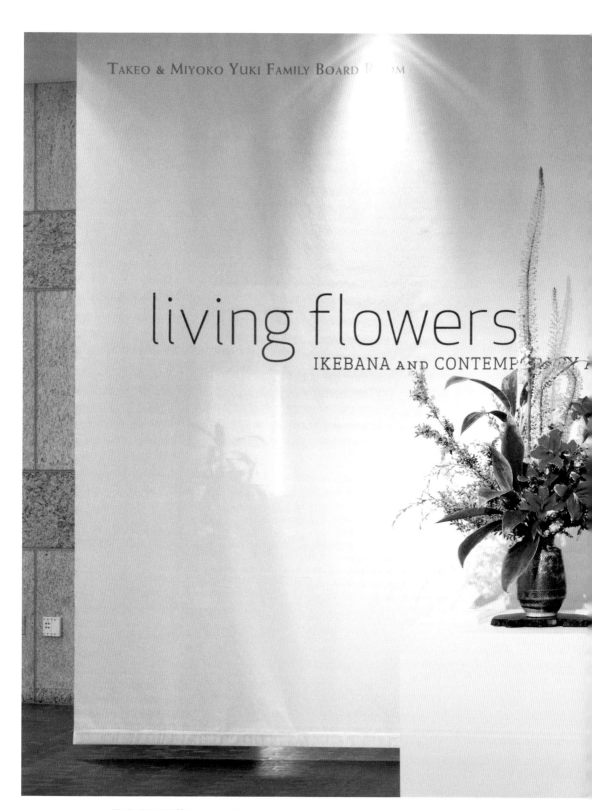

TAKEO & MIYOKO YUKI FAMILY BOARD ROOM

living flowers

IKEBANA AND CONTEMPORARY A

Noriko Naruishi (Ohara school). Installation view,
Living Flowers: Ikebana and Contemporary Art,
Japanese American National Museum, Los Angeles, 2008

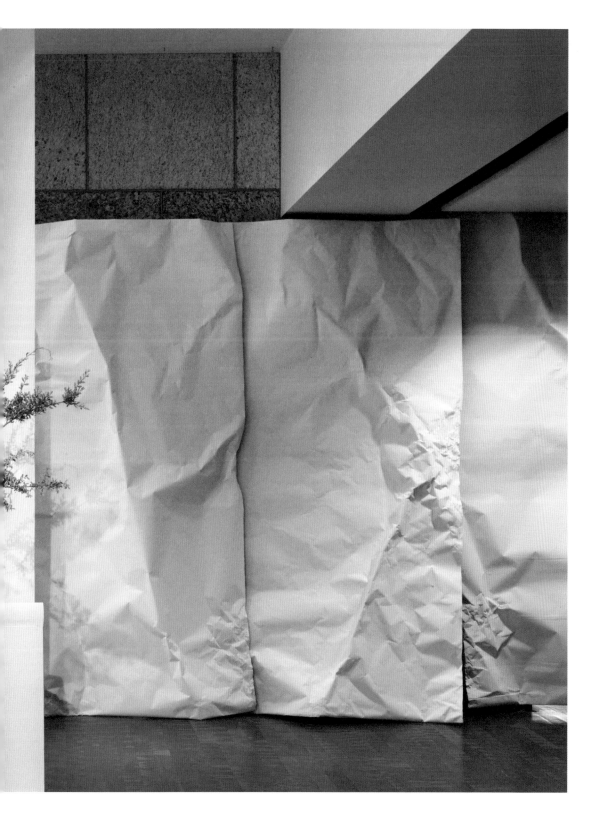

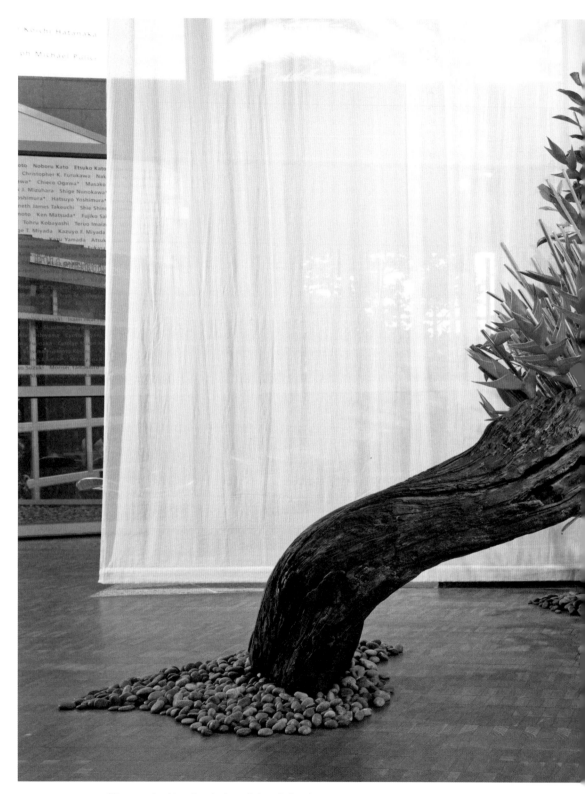

Sōgetsu school, Los Angeles branch. Installation view,
Living Flowers: Ikebana and Contemporary Art,
Japanese American National Museum, Los Angeles, 2008

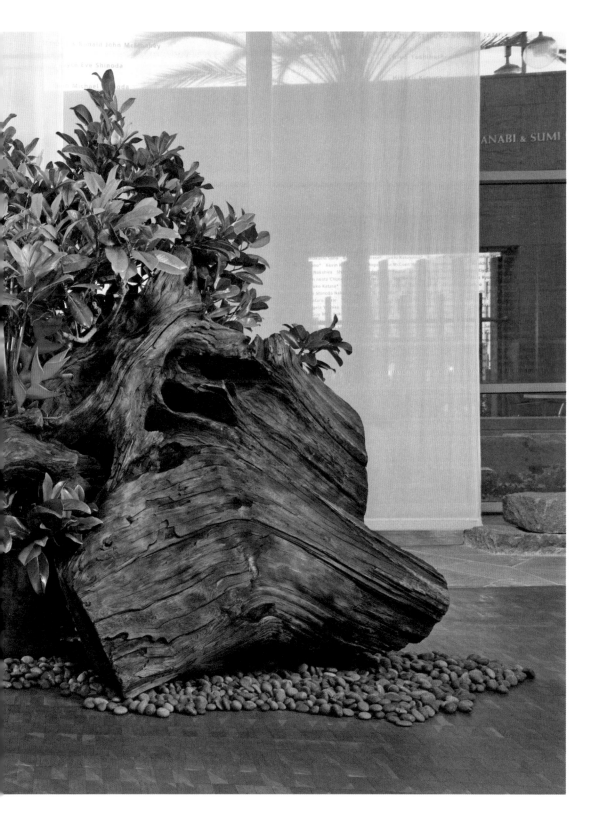

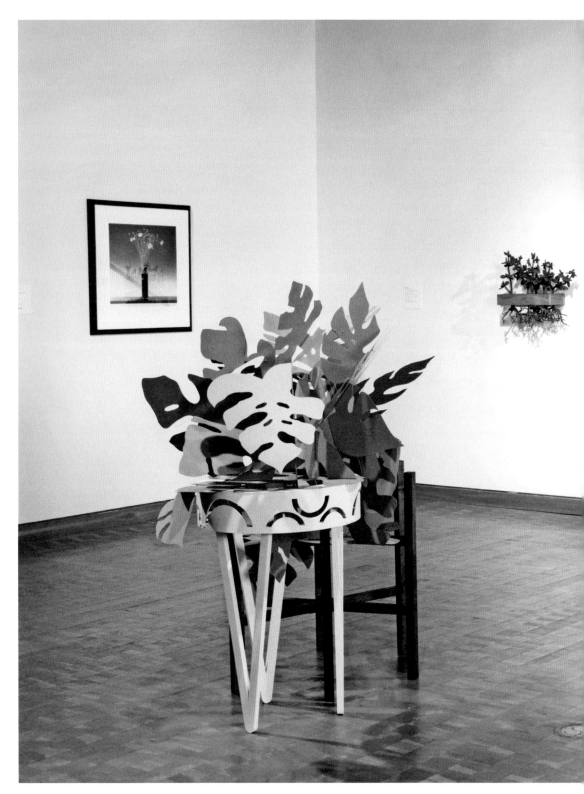

Installation view, *Living Flowers: Ikebana and Contemporary Art*,
Japanese American National Museum, Los Angeles, 2008, with works by
Robert Mapplethorpe, Andy Ouchi, and Gyokufu Laudermilk (Sōgetsu school)

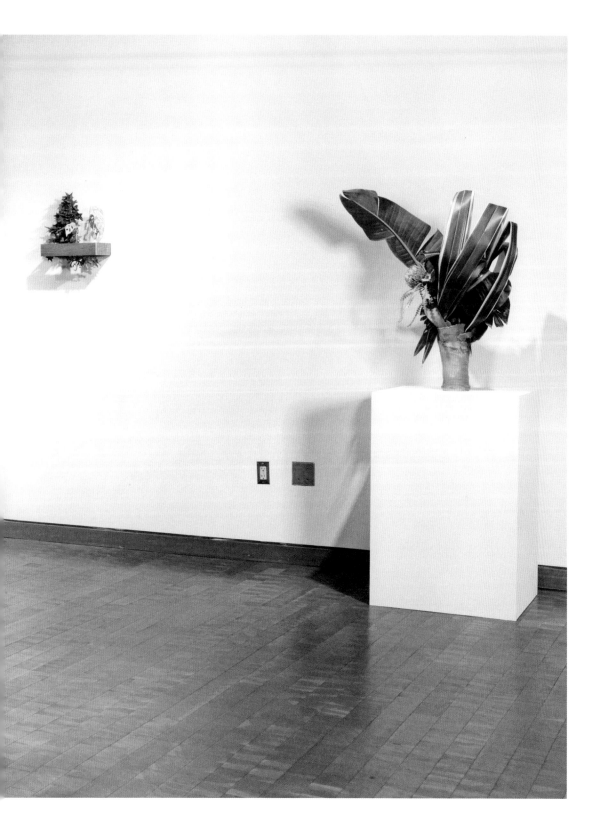

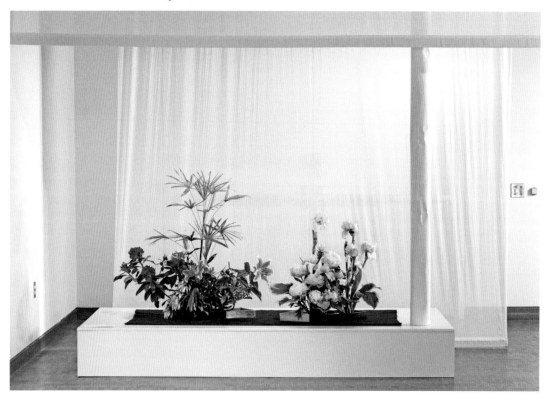

Shofu Shohara (Ohara school).
Installation view, *Living Flowers:
Ikebana and Contemporary Art*,
Japanese American National
Museum, Los Angeles, 2008

to show the unexpected and expected (what is unexpected or expected depends, of course, on one's own experiences), so that one may see the unfamiliar and the familiar as reflected through two cultural traditions that intersect and diverge.

History and Practice of Ikebana

The art of flower arrangement as a secular and artistic pursuit originates in the reign of shogun Ashikaga Yoshimasa (1443–1473). Although remembered as a feeble military and state ruler, Yoshimasa's retreat into aesthetic practices formed, as historian Donald Keene has argued, "the soul of Japan."[2] It was during the construction of Yoshimasa's mountain retreat in Kyoto—now known as the Silver Pavilion—

that poetry, Noh theater, tea ceremony, garden design, architecture, and flower arrangement became codified as art forms, with their own aesthetic formal sensibilities or "ways" of being. As such, flower arrangement emerged in direct relationship to a range of aesthetic manifestations that are now seen as hallmarks of traditional Japanese culture.

Two related phenomena are key to ikebana's origins: the display of kakemono (hanging scroll paintings) and the development of *shoin*-style architecture, or study architecture.[3] When the importation of Chinese hanging scroll paintings commenced in the twelfth century, no suitable places to display them existed in Japanese architecture. Initially a small oblong

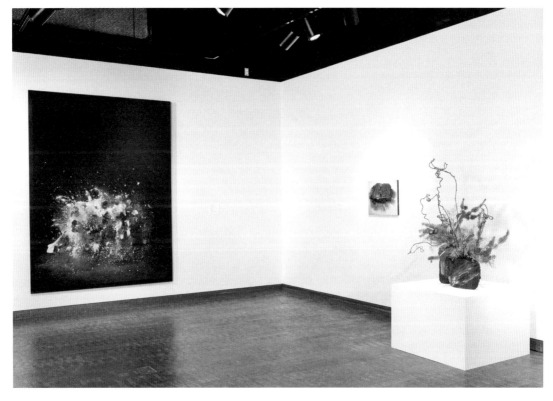

table with a vase and incense burner was placed under the hanging scroll to establish a defined space, or "frame," for the paintings. This later developed into a fixed part of the architectural structure known as a tokonoma, a deep alcove with vertical supports often made of slender tree trunks that is a prominent feature of Japanese reception rooms and tea ceremony rooms even today. The tokonoma serves as the frame for three elements: a hanging scroll, a vessel or basket, and an arrangement of flowers in the vessel, each selected in dynamic interplay with one another. Accounts of flower arrangement in the fifteenth century reveal that debates about the relative merits and hierarchy of the painting, vessel, and flowers were central to its genesis. In other words, flower arrangement, as an art, was not necessarily subsidiary to the art of painting or ceramics but rather was formed in direct relationship to them. The fact that flowers were manifestations of the subtle yet distinct changes in the seasons heightened their allure.

2 Donald Keene, *Yoshimasa and the Silver Pavilion: The Creation of the Soul of Japan* (New York: Columbia University Press, 2003), especially chapter 8.
3 For a history of ikebana as well as essays by Sen'ei Ikenobō, Houn Ohara, and Sōfū Teshigahara, see Donald Richie and Meredith Weatherby, *The Masters' Book of Ikebana* (Tokyo: Bijutsu Shuppan-Sha, 1966).

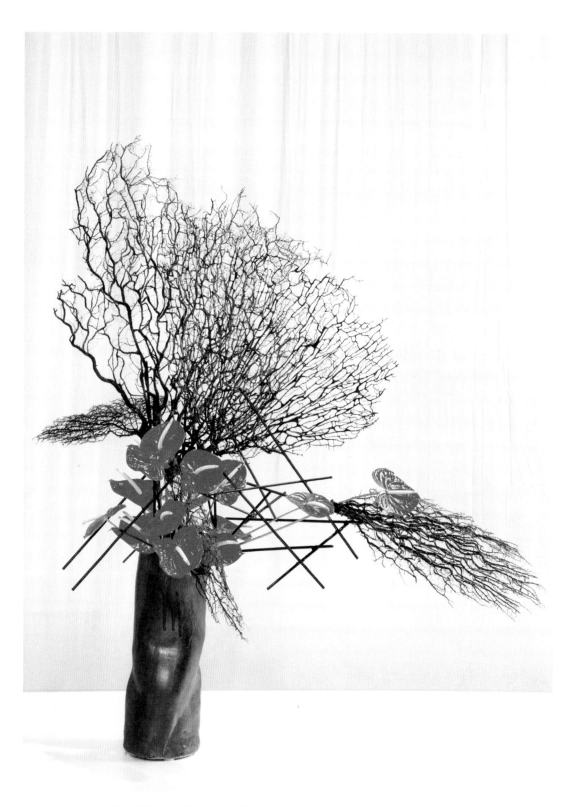

Yoshu Miyahara (Sōgetsu school). Installation view,
Living Flowers: Ikebana and Contemporary Art,
Japanese American National Museum, Los Angeles, 2008

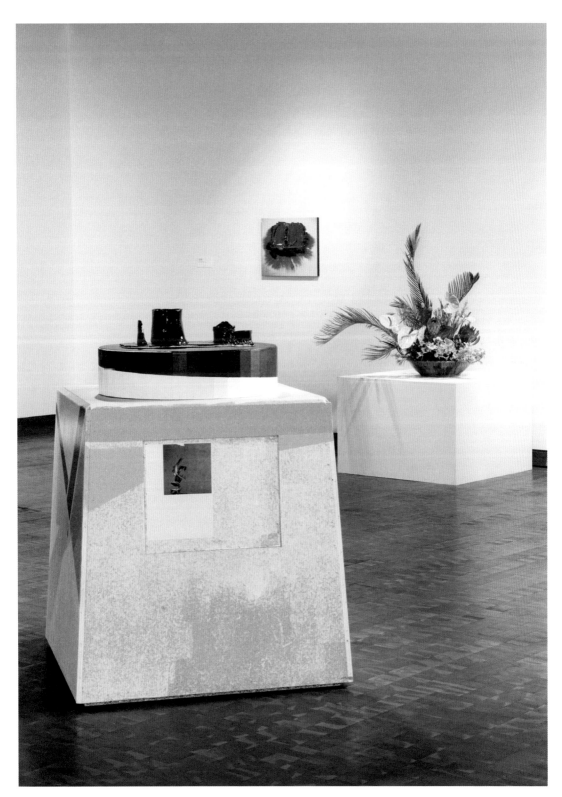

Installation view, *Living Flowers: Ikebana and Contemporary Art*,
Japanese American National Museum, Los Angeles, 2008, with works by
Manfred Pernice, Yukio Nakagawa, and Noriko Naruishi (Ohara school)

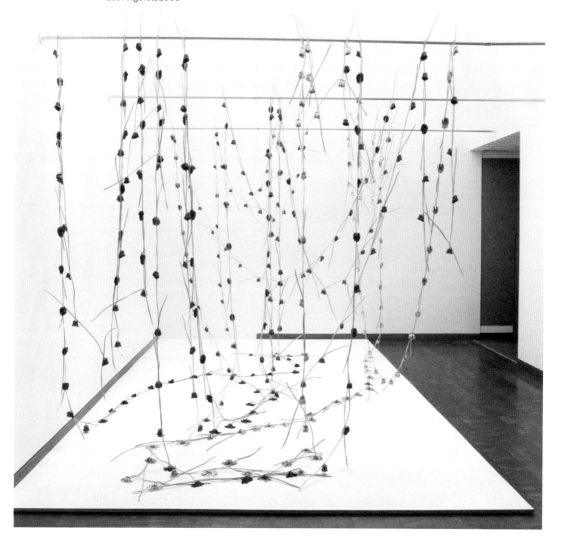

Anya Gallacio, *in a moment*, 1997.
Installation view, *Living Flowers:
Ikebana and Contemporary Art*,
Japanese American National Museum,
Los Angeles, 2008

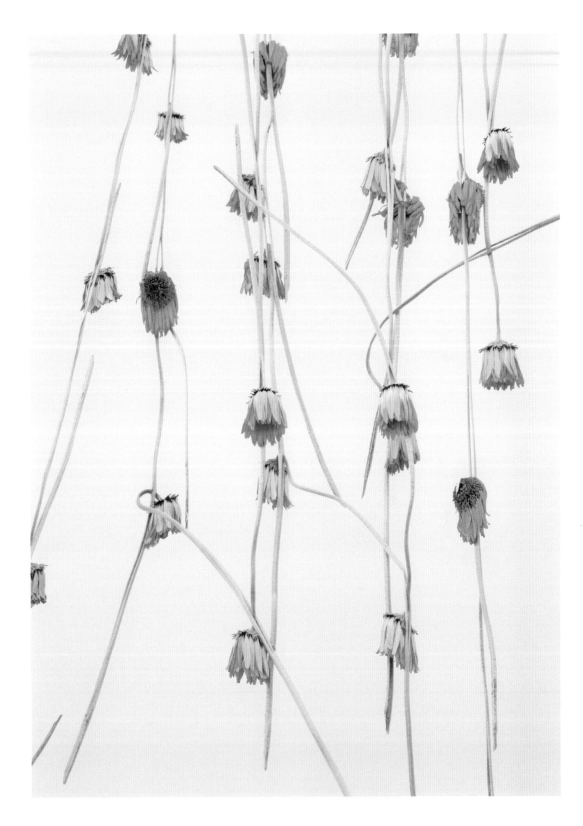

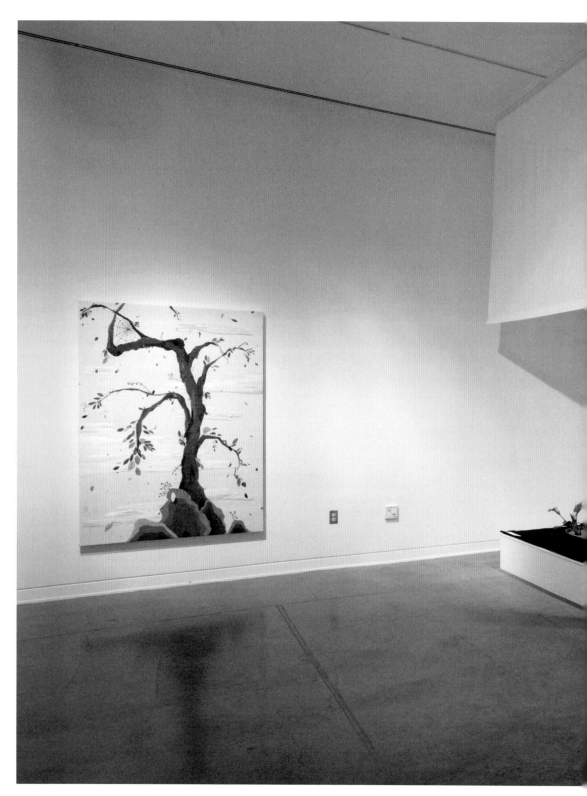

Installation view, *Living Flowers: Ikebana and Contemporary Art*, Japanese American
National Museum, Los Angeles, 2008, with works by Laura Owens, Satsuki Palter and
Minako Hayashida (Ohara school), Jeroen de Rijke and Willem de Rooij, and Isamu Noguchi

346

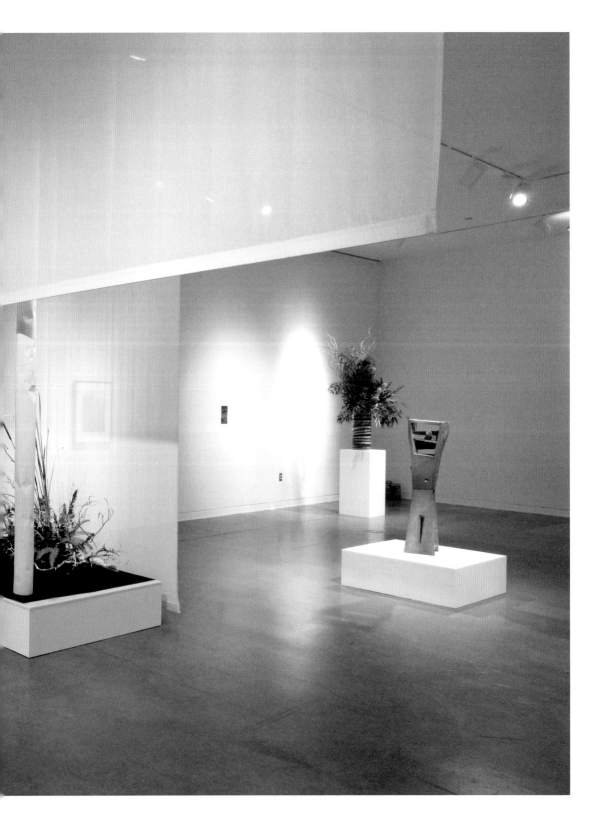

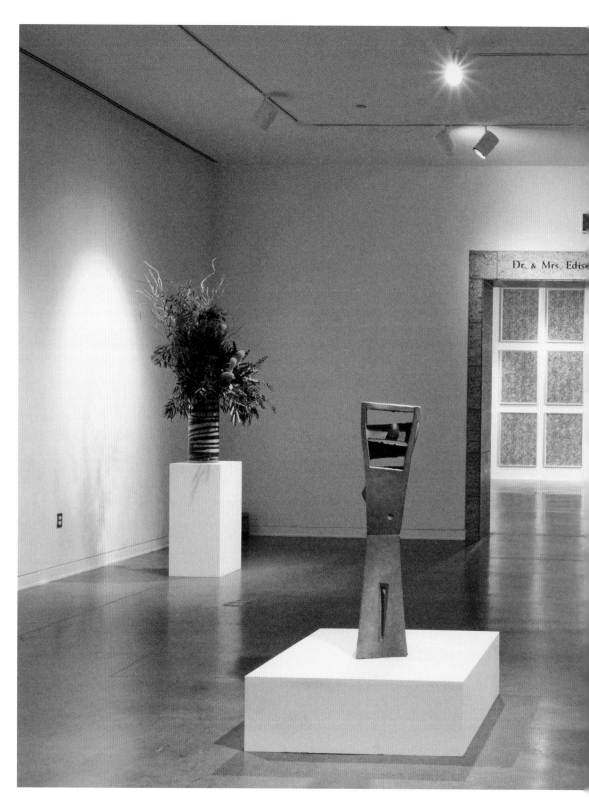

Installation view, *Living Flowers: Ikebana and Contemporary Art*, Japanese American National Museum, Los Angeles, 2008, with works by Jeroen de Rijke and Willem de Rooij, Isamu Noguchi, Sherrie Levine, B. Wurtz, and Anna Sew Hoy

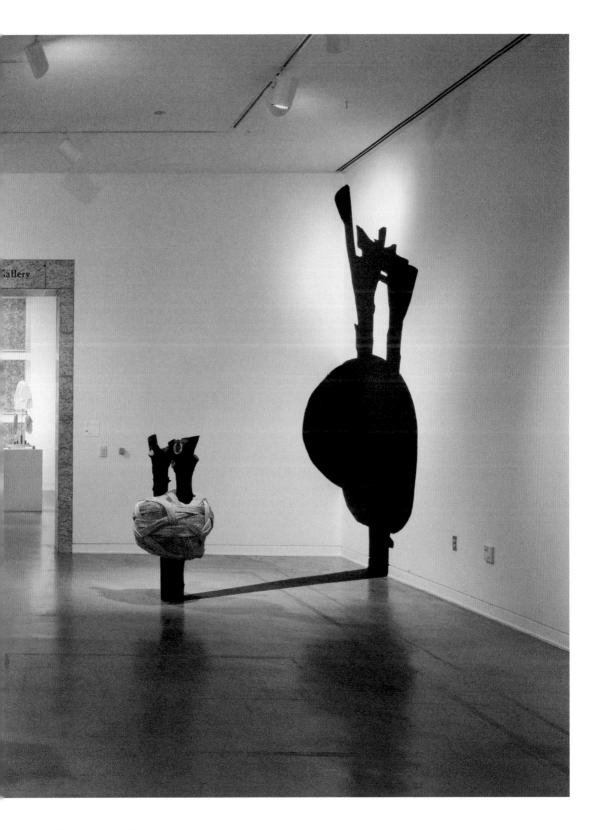

Shigee Homma in front of a display in
the Homma Floral Designing School
exhibition at Heart Mountain High
School, Heart Mountain War Relocation
Center, July 15–16, 1944

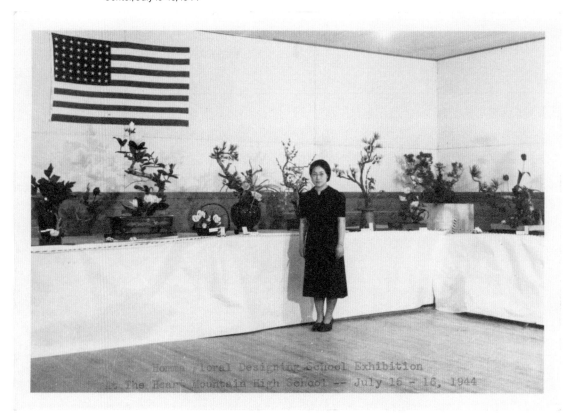

That they began to decay as soon as they were chosen served as a metaphor for the ephemerality of human existence. This also meant that flowers played a significant role in the triad of painting, vessel, and arrangement.

Jun'ichirō Tanizaki goes even further in his 1933 essay *In Praise of Shadows*. He argues that the paintings and ikebana displayed in a tokonoma exist not for their own ornamental sake but "rather to give depth to the shadows." He ultimately posits that the fundamental basis of Japanese aesthetics derives from the variation of shadows produced by qualities of light.[4] In this vein, both painting and flower arrangement are relative to the three-dimensional space of architecture, providing a counterpoint to the plastic space of installation. In Robert Mapplethorpe's *Poppies* (1988) and many of his other photographs of flowers, the blossoms occupy a frame akin to a photographic tokonoma, where the play of light and shadow activate the space. For Joe Scanlan, the shadow is what makes the work visible. The yellow paper blossoms of *Untitled* (2008) appear prosaic as they lean against the wall. The shadow brings them to life.

The flower arrangements in *Living Flowers* were created by master sensei and their advanced students from three different schools of ikebana practice: Ikenobō Ikebana Society of Los Angeles, Ohara School of Ikebana Los Angeles Chapter, and Sōgetsu Los Angeles Branch. These were selected because of their long-standing traditions, the range of their aesthetic principles, and the fact that they are excellent and recognized sensei in the Los Angeles area. The three schools are currently the largest in Japan, and each has chapters throughout the world. "Schools" of ikebana are not brick-and-mortar entities, although many have headquarters. (Ikenobō's is at the Rokkakudō Temple in Kyoto; Ohara has two main centers in Kobe and Tokyo; and Sōgetsu's is in a Kenzō Tange–designed building in Tokyo.)[5] Rather, a "school" of ikebana translates into a specific theoretical approach to the arrangement of flowers. It is expressed as kadō—the "way" or "path." The philosophical and spiritual means of arrangement,

as opposed to the mere acquisition of skills, are paramount in ikebana. As sixteenth-century tea master Sen no Rikyū noted about flowers, "We don't give them life with our hands, but with our minds."[6] Hence, one never graduates from these "schools"; the practice of ikebana requires a lifetime of study. Even the most advanced sensei are mere students in the presence of their teachers.

Schools of ikebana are controlled by an *iemoto* (headmaster) who articulates the *kadō* of a particular school. Traditionally, the role of *iemoto* is passed down from father to son and, beginning in the last century, to daughter. The *iemoto* controls curriculum, instruction, the granting of rank, the establishment of regional branches, and the approval of teachers. Chapters may operate worldwide, but they operate as subsidiaries that pay dues and fees. They must follow curricula established by headquarters in Japan. The bestowal of rank and the certification of accomplishments are likewise overseen by the central operation. Ikebana, therefore, is more than just an aesthetic preoccupation. It can be a big business of powerful figures and institutional structures, not unlike the complex world of contemporary art. There are hundreds, if not thousands, of schools of ikebana, some with as few as one follower, making it difficult to determine a precise number of schools in existence.

The central compositional form of ikebana is made up of three components, *shin soe tai*, signifying heaven, earth, and man. The longest branch in an arrangement represents heaven. The shortest represents the earth, with man occupying a mediating position between the two. Unlike the massings of Western floral

4 Jun'ichirō Tanizaki, *In Praise of Shadows*, trans. Thomas J. Harper and Edward G. Seidensticker (New Haven, CT: Leete's Island Books, 1977), 19–22.
5 Kenzō Tange designed two structures for Sōgetsu. The first was completed in 1958. It was replaced with a new headquarters by Tange on the same site in 1977.
6 Sen no Rikyū, cited in *Ikebana* (1956), a documentary film by Hiroshi Teshigahara about his father, Sōfū Teshigahara.

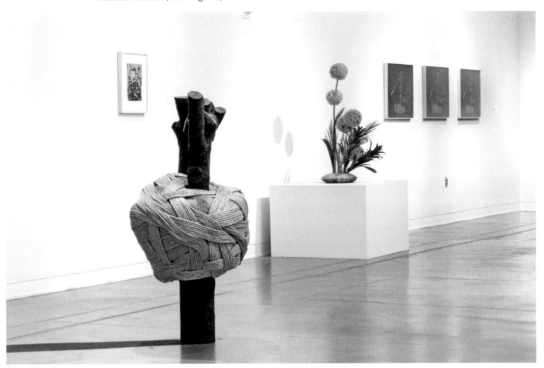

arrangements, an essential part of ikebana is the beauty of the space between things, the negative space. Ikenobō is the oldest school of ikebana, and to some degree all ikebana traces its origins to the first recognized master, Ikenobō Senkei, who was active in the fifteenth century. In the classical styles of Ikenobō, flowers emerge from a single point and produce an asymmetrical, triangular composition of startling simplicity and formal complexity. These arrangements are designed specifically for the tokonoma, where the optimal frontal viewing position is controlled by the architecture. If seen from the side, the tightly composed arrangements can collapse visually into incoherent lines and shapes.

Ikebana in tokonoma are three-dimensional, yet they function essentially like pictures rather than sculptures. The vacillation between pictorial depth and flatness has a visual analogue in the photographs of James Welling and the sculpture of Anna Sew Hoy. Welling's work begins as a photogram where the image is created by plant material placed directly on photosensitive paper. While the density of the image relates to its proximity to the paper's surface, the space within the ultimate photograph pulls the eye between various states of flatness and spatial depth. In Anna Sew Hoy's sculpture *Why* (2006), what appears to be a shadow of the central object is actually a surface painted to trick the eye.

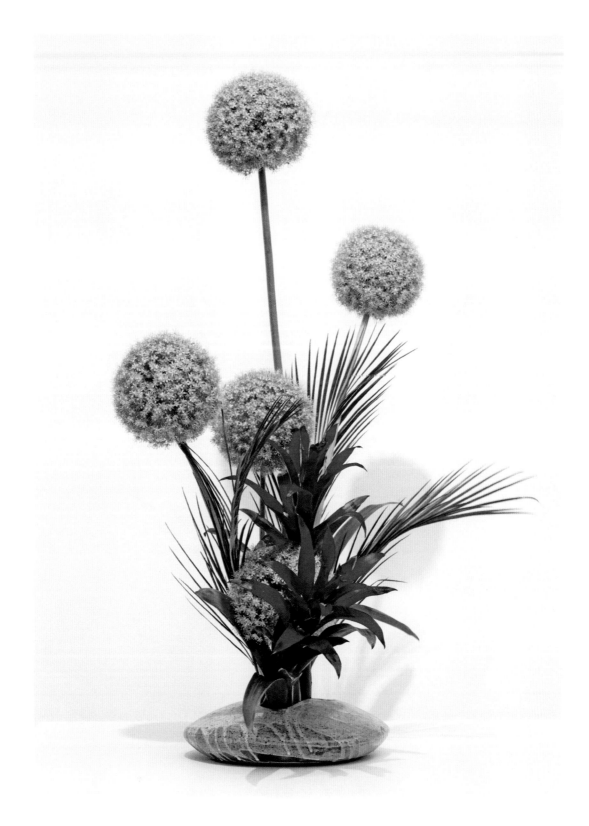

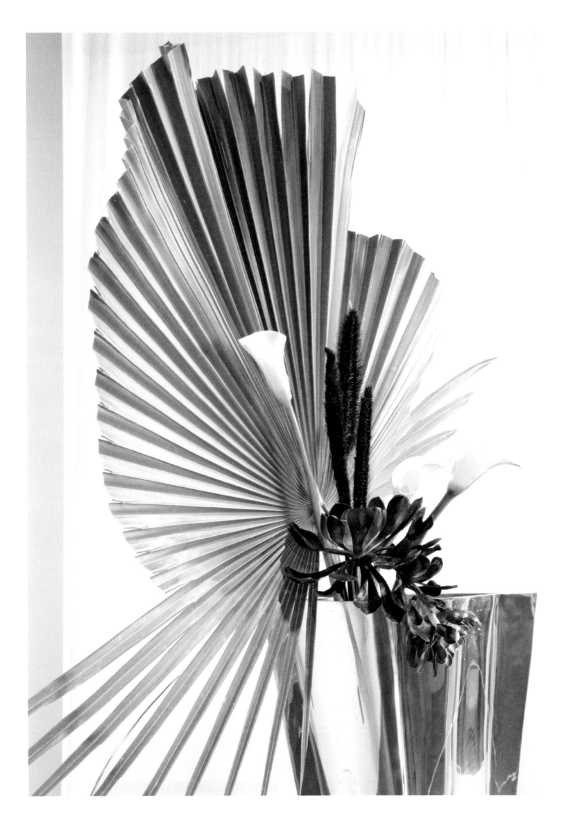

Unshin Ohara, the founder of the Ohara school, represents a late nineteenth-century development in ikebana. An apprentice to a ceramicist while studying Ikenobō, Ohara is credited with two major innovations: the introduction of Western flowers into traditional ikebana and the development of the *moribana* style. In a *moribana* arrangement (the term literally means "piled-up flowers"), plant material is arranged in low containers to form naturalistic landscapes. As the arrangement exists on a plane rather than deriving from a single point, it allows for greater exploration of surface depth and planar compositions. In some styles of the Ohara school, the flat, wide vessels facilitate the use of water as a compositional element, rather than simply as a source of sustenance for the flowers. The formal shifts in ikebana initiated by Ohara mirrored other changes in Japanese architecture. As domestic and official spaces became more Westernized, the tokonoma lost its ubiquity. New forms of ikebana were needed for modern Japan, which had new kinds of private and public spaces.

The changes in modern ikebana practice are best exemplified in the work of Sōfū Teshigahara, who established the Sōgetsu school in 1927. Teshigahara was a polymath of the Japanese avant-garde, who strove to push the boundaries of ikebana as a means of contemporary expression. For Teshigahara, arranging flowers was a form of sculptural art, and he

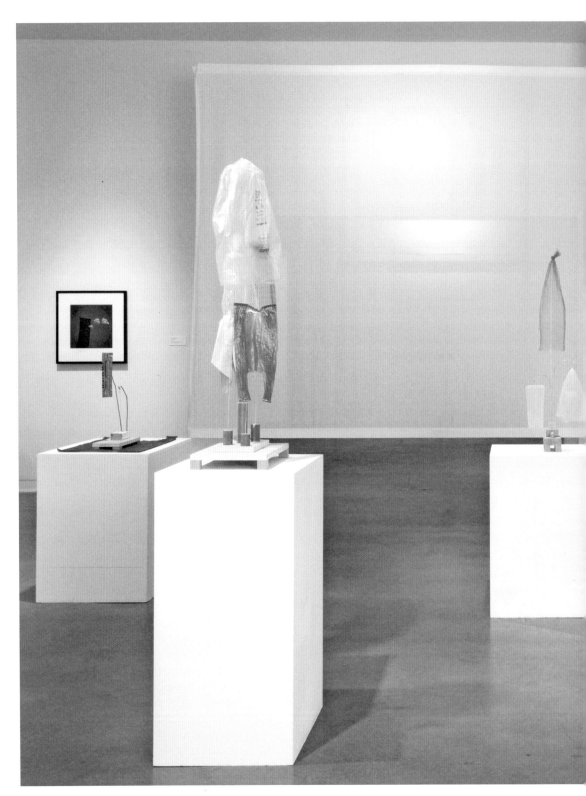

Installation view, *Living Flowers: Ikebana and Contemporary Art*, Japanese American National Museum, Los Angeles, 2008, with works by Robert Mapplethorpe, B. Wurtz, Eika Fukui (Sōgetsu school), and Monique van Genderen

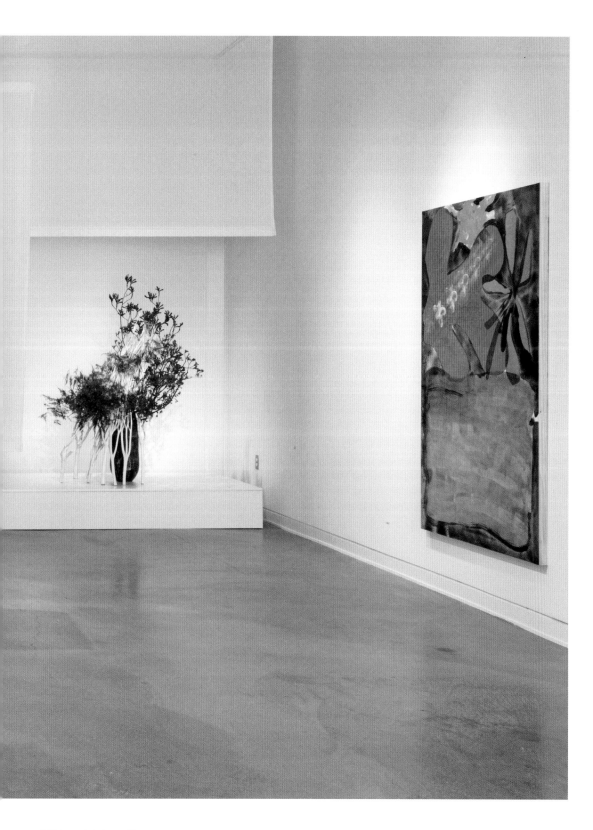

consequently played with dramatic scale and unconventional material. His ikebana demonstrations were akin to performance art and his collaborations with the vanguard of European, American, and Japanese artists were instrumental in introducing and supporting radical art practices in Japan. The Sōgetsu Art Center in Tokyo was the preeminent venue for contemporary art, performance, and music in the 1950s and 1960s, where Teshigahara hosted or collaborated with figures from Art Informel and Gutai, and individual artists Toru Takemitsu, John Cage, Robert Rauschenberg, and Isamu Noguchi, among others.[7] Noguchi's *Large Square Vase* (1952) sought to blur the boundaries between ikebana and sculpture. Noguchi challenged the hierarchy between functional objects and sculpture by declaring, "Some of my sculptures take the form of vases—sculptures with flowers."[8] The connection of Sōgetsu to other artistic media was extended in 1980 when Sōfū's son Hiroshi, the noted filmmaker of *Woman in the Dunes* (1964) and *The Face of Another* (1966), essentially retired from his life as a filmmaker to take the position of Sōgetsu *iemoto*.[9]

It can be difficult for those oriented in Western ideas of artistic autonomy to understand that ikebana artists are able to work in a particular tradition while simultaneously expressing their own sensibilities and individual voices. Their individuality becomes apparent through expression and interpretation in an arrangement, even if that arrangement conforms to the existing forms and standards. The overall ethos of the ikebana arrangers in *Living Flowers* is to subsume individual recognition in favor of group affiliation. Moreover, most schools see no contradiction in maintaining older styles while adding new approaches. Ohara may have developed *moribana*, but nearly all schools incorporate *moribana* styles, just as avant-garde or freestyle arrangements have entered general usage.

For some ikebana artists, this is not enough. Although trained in Ikenobō, in 1951 Yuko Nakagawa found the organizational structure and formal strictures of ikebana too rigid and in essence became an ikebana school

of one. He rejected affiliation with established schools to work as an independent artist. Nakagawa's arrangements transform plant material into visceral, bodily entities. *Discovery* (1976) resembles a hunk of bloody raw meat, but it is made up of flower petals. To extend the life of his arrangements, he began photographing them so that they exist in two forms: as the original arrangement and as a photograph.

The ability to showcase ikebana as a form of art in *Living Flowers* was made possible by the fact that Los Angeles is a city rich in ikebana resources. As a consequence, the exhibition also touches on the role of Japanese Americans in promulgating ikebana in the United States. Japanese immigrants settled on the West Coast in the early twentieth century and developed vital communities at the same time as the "taste" for Japanese art and aesthetics was heightened in architecture and landscape design. The architecture of Greene and Greene, Frank Lloyd Wright, and Rudolph Schindler utilized a vocabulary influenced by Japanese design, while the Japanese-style pleasure gardens, curio shops, and art galleries provided access to Japanese-inspired spaces and objects. For the cultural elite, the collection of Japanese art was a sure sign of sophistication. For Japanese immigrants, traditional Japanese culture became a critical means of maintaining ties to their ancestral homeland. It also provided a vehicle for cultural expression in their new country, one that was often hostile to racial and ethnic differences. Ikebana displays were

7 Dore Ashton, *The Delicate Thread: Teshigahara's Life in Art* (Tokyo: Kodansha, 1997), 33–66.

8 Isamu Noguchi, cited in Bert Winther-Tamaki, "The Ceramic Art of Isamu Noguchi: A Close Embrace of the Earth," in *Isamu Noguchi and Modern Japanese Ceramics*, ed. Louise Cort and Bert Winther-Tamaki (Berkeley: University of California Press, 2003), 78.

9 Hiroshi's younger sister Kasumi Teshigahara became the second Sōgetsu *iemoto* after the death of her father, Sōfū, in 1979. When Kasumi died less than a year later, Hiroshi became the third *iemoto*. Today, Hiroshi's daughter, Akane Teshigahara, is the fourth *iemoto*.

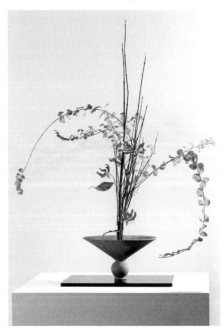

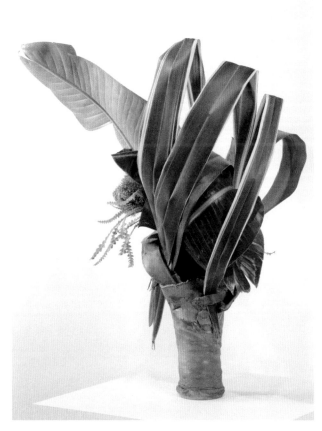

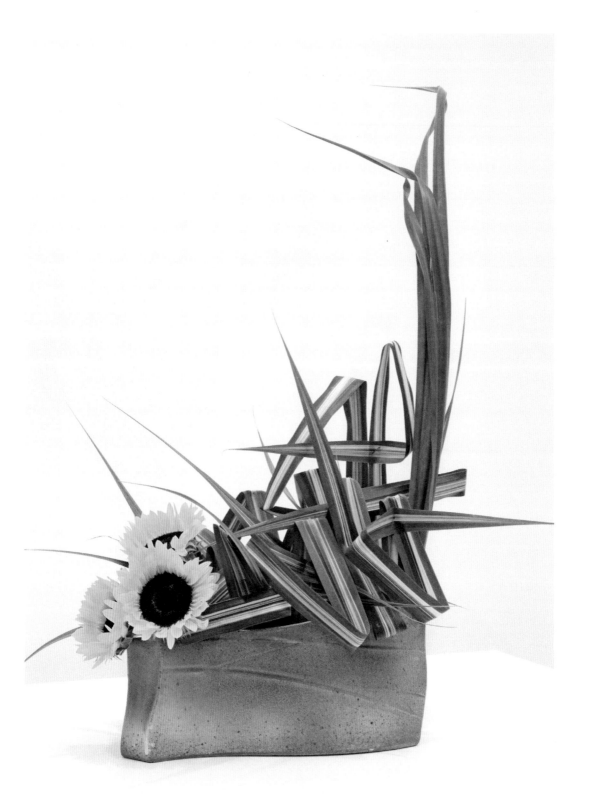

Sandra Kitayama (Sōgetsu school). Installation view,
Living Flowers: Ikebana and Contemporary Art,
Japanese American National Museum, Los Angeles, 2008

a draw to European American audiences at the Japanese American–owned Southern California Flower Market's flower festivals in the 1930s and at Nisei Week, the Japanese American festival in Los Angeles's Little Tokyo that began in 1934 and continues today.

The Ikenobō Ikebana Society of Los Angeles was established more than seventy years ago as the first chapter outside Japan. In 1938, ikebana teachers from several schools in Los Angeles formed the Hokubei Kadō Kyōkai as a support network for ikebana practitioners. During World War II, the practice of ikebana continued even during the incarceration of Japanese Americans. As Japanese American communities sought to rebuild after the war, six ikebana sensei of the Ikenobō, Ohara, Shōfu, and En-Shōfu schools established the Kadō Kyōju Kai, or Ikebana Teacher's Guild, in 1952. Still active, the Kadō Kyōju Kai and the more recently formed Nanka Ikebana Kyōju Kai organize demonstrations and exhibitions, as well as provide support for ikebana teachers. Today, the Los Angeles area boasts one of the largest contingents of high-ranking ikebana sensei outside Japan, no doubt because of the extensive and deep networks of the Japanese American community. The hospitable climate and extensive network of Japanese American nurseries, flower growers, and home gardens translate into an abundant source of specialized plant material. Nearly all the ikebana masters grow their own material to supplement what is commercially available, making the arrangements in *Living Flowers* unique and specific to the season and Los Angeles.

The Exhibition

Ikebana is an ephemeral art form that challenges the conventions of museum exhibitions, where works of art may be on display for months a time. Ikebana lasts for two or three days at most. For every week of *Living Flowers*, there were between eleven and twelve new ikebana arrangements created by sensei of the Ikenobō, Ohara, and Sōgetsu schools and their senior students. On Friday mornings, the ikebana masters created their arrangements at the museum. Tuesdays were the "refresh" days, when wilted

plant material or open blooms were replaced. Then on the following Friday, entirely new arrangements were installed and the cycle continued. Over the course of the exhibition, there were 135 discrete and distinct arrangements.

The impact of the ikebana in the galleries was startling. The introduction of living material into the gallery palpably changed the dynamic of the space, prompting one to consider how the experience of museums is so conventionalized that one is scarcely aware of it until faced with something different. The color, textures, and relative weight (or weightlessness) of the blossoms and branches created a mood contrary to expectations. The plant material refracted the gallery lights differently than the artwork. Aromas wafted through the air, testing the nose, which tried to discern their origins. The exhibition design by Frank Escher, Ravi GuneWardena, and Chau Truong of Esche GuneWardena Architecture contributed to the otherworldly effect of the exhibition. They utilized sculpted paper and translucent fabric scrims to define spaces throughout the museum and created abstracted versions of the traditional tokonoma out of the same material.

Anya Gallaccio's installation *in a moment* (1997) provided a dramatic counterpoint to the ikebana arrangements in the exhibition. It consisted of 365 gerbera daisies strung in a literal daisy chain. When the piece is first installed, it is a profusion of fresh flowers. As time goes by, the flowers wither, registering the passage of time and the natural processes of organic material, elements that ikebana arrangements deny with their constant freshness. *NŌ-no ikebana, arranged by Haruko Takeichi, December 1, 2002 (December 2–3)* (2003) by Sharon Lockhart functions in a similar manner. Lockhart commissioned an arrangement of Noh-no ikebana, an ikebana of agriculture, where inspiration is drawn from farming. Lockhart then photographed the arrangement (whose main element is a stock of brussels sprouts) multiple times a day for a month, charting its withering and demise.

It is a basic assumption in theories of reception that context informs how one receives

or interprets a work of art. In *Living Flowers*, the artwork and locations for ikebana remained in a fixed place for the duration of the exhibition, but every week the three schools of ikebana were placed in rotation, so that arrangements by the three schools were displayed on a specific pedestal or tokonoma-like space over three successive weeks before the rotation began again. The schools were given no proscriptions regarding their creations and were free to structure their participation as they wished.[10] The Ikenobō Ikebana Society of Los Angeles assigned two master sensei to create all the arrangements in a single week. The result was that each week represented the specific artistic sensibility of those two sensei. For Ohara and Sōgetsu, there were examples of up to four different arrangers during any given week. For those who viewed *Living Flowers* on multiple occasions, the opportunity to see so many arrangements in regular succession enabled the development of connoisseurship; through looking, one could learn to identify the different formal approaches of the schools, as well as the sensibilities of the individual arrangers.

The impact of the changing ikebana arrangements on the works of art was remarkable. In some instances, an arranger chose to refer to the artwork surrounding it. Andy Ouchi's sculpture *Monstera* (2007), where abstracted monstera leaves overwhelm a small table, took on a different inflection when Ohara sensei Jose Salcedo created a nearby arrangement that meditated on the color green. The arrangement contained five different green elements, including waxy monstera leaves. The juxtaposition highlighted the divide between the artificial and the real at the same time it called attention to the meticulous fabrication of both expressions. Sōgetsu sensei Yoshu Miyahara mused on the exploding floral arrangement in Ori Gersht's nearby work. Gersht plays with the paradox of beauty and violence in his photographs. Miyahara's incorporation of a jagged armature introduced parallel action to the arrangement.

It is a misconception that ikebana is somehow more natural than Western floral arrangements. As Sōfū Teshigahara said about

flowers, "There are more defects than beauty about them."[11] It is only through manipulation by the arranger that the plant material gains its beauty. The material in ikebana always undergoes a degree of stylization, even when it appears simple and offhanded. B. Wurtz enacts a corresponding process in his sculptures, where prosaic material such as plastic and mesh bags, metal wire, fabric remnants, and blocks of wood are transformed into tableaux of striking beauty and sensitivity.

Wurtz recounted that ikebana was a tangential reference for him, a fleeting thought about something he knows little of despite a sincere and respectful admiration. This is a critical aspect of *Living Flowers*: that there can be productive affinities and borrowings of Japanese aesthetics. The perspectival space of Laura Owens's untitled tapestry of 2003 is reminiscent of the pictorial conventions of Japanese woodblock prints, and Gabriel Orozco's collage references the Japanese practice of *suiseki* (finding stones in nature and through recontextualizing them to create tableaux for contemplation and aesthetic appreciation).

Living Flowers began by asking what could be learned by showing ikebana and contemporary art in the same space. Rather than producing specific answers, it generates a dialogue on ideals central to ikebana and the specific works of art on display. The permanent/ephemeral, frontal/three-dimensional, composed/natural, and "East"/"West" are all dyads that suffuse the exhibition, but neither ikebana nor the art is defined by them. Rather, by exhibiting ikebana and art together, *Living Flowers* argues for a deep and careful looking, one that is attentive to cultural traditions and simultaneously seeks to look beyond them.

10 Due to pest-management concerns, homegrown plant materials were restricted in one of the galleries. This proved to be a challenge for the sensei, who utilize material not readily available in commercial markets.
11 Sōfū Teshigahara, cited in Richie and Weatherby, *The Masters' Book of Ikebana*, 236.

Kiyoko Arimura and Kayoko Hamada
(Ikenobō school). Installation view, *Living
Flowers: Ikebana and Contemporary Art*,
Japanese American National Museum,
Los Angeles, 2008

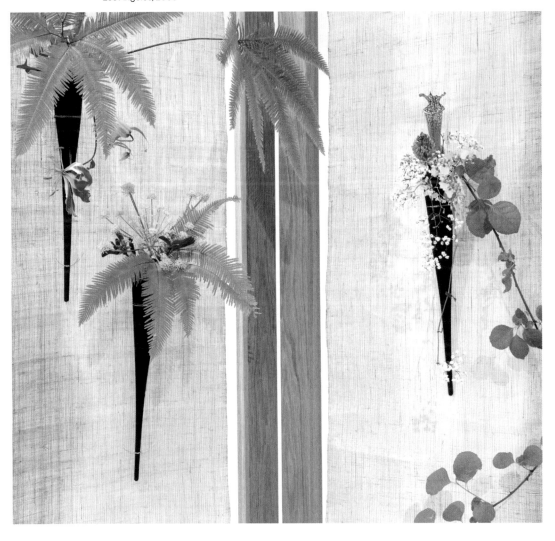

Toshun Yasuda (Sōgetsu school).
Installation view, *Living Flowers:
Ikebana and Contemporary Art*,
Japanese American National Museum,
Los Angeles, 2008

opposite: Kyoko Oshiro (Ohara school).
Installation view, *Living Flowers:
Ikebana and Contemporary Art*,
Japanese American National Museum,
Los Angeles, 2008

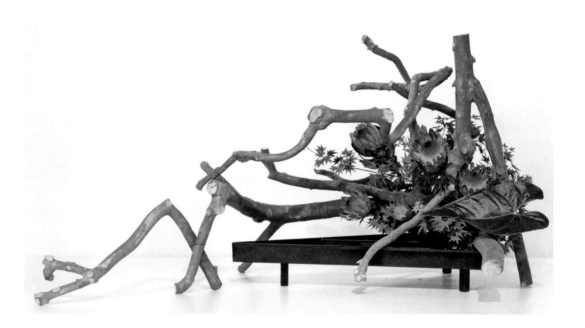

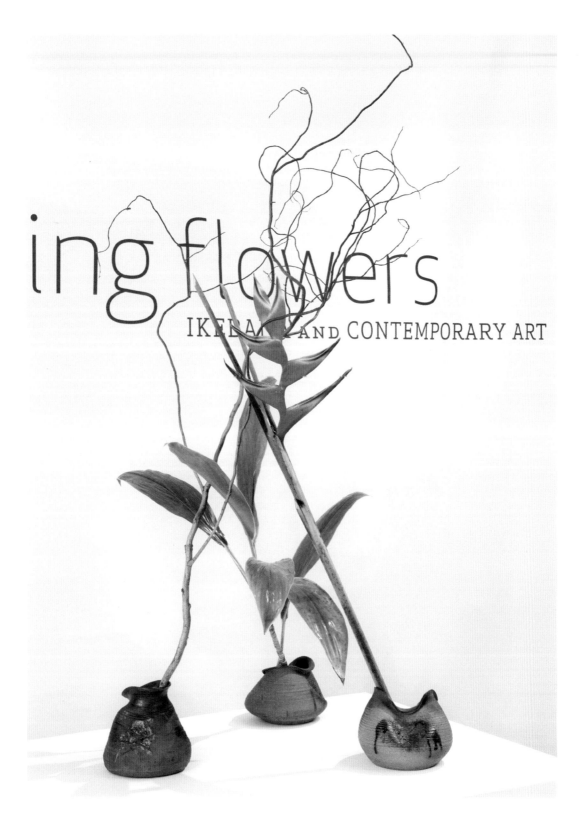

Ikebana workshops for *Living Flowers:*
Ikebana and Contemporary Art,
Japanese American National Museum,
Los Angeles, 2008

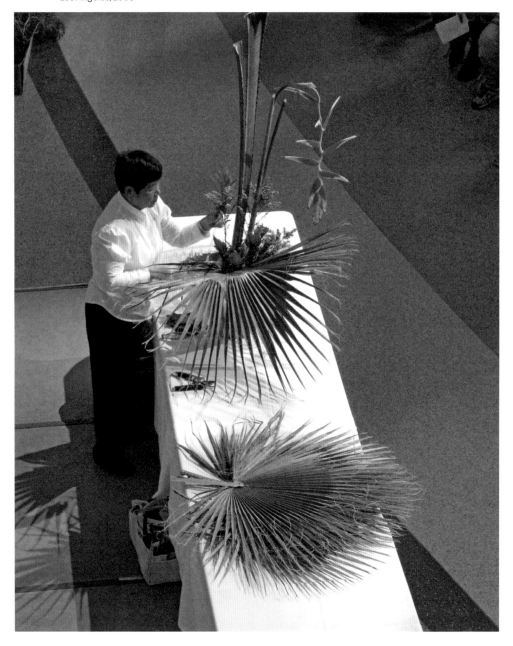

Beyond
East
and
West:
Isamu
Noguchi

I find myself a wanderer in a world
rapidly growing smaller. Artist,
American citizen, world citizen,
belonging anywhere but nowhere.
—Isamu Noguchi[1]

The binary of East and West is a central aspect of Isamu Noguchi's life and work. From his birth in Los Angeles in 1904 to his childhood in Japan, education in the American heartland, and travels as an artist, Noguchi moved between Japan and the United States and the two spheres of artistic traditions they represented. When he died in 1988, the studios he left behind in Queens, New York, and Mure, a small village on the island of Shikoku in Japan, literalized this divide. Art historian Dore Ashton succinctly summarized it in the title of her 1992 biography of the artist, *Noguchi: East and West*.[2] But just as this paradigm illuminates many aspects of Noguchi's artistic practice, it can obscure others. For "East" and "West" are far from stable entities. Over the course of Noguchi's long life, they meant different things to the artist and to the world, coloring interpretations of his work and subtly shaping how the artist perceived himself.

Notions of "East" and "West" are further complicated by two ways of considering Noguchi. There is the artwork and the man. The two spheres do not necessarily cohere into a unified, easily integrated whole. Instead, the creation of art and the identity of the man bump into each other in ways that can be difficult to parse. In this essay, I explore episodes in which Noguchi's artwork and his Japanese American identity exist in uneasy tension, in particular by focusing on some of his environmental designs. In the pre–World War II period, an association with Japan and its rich artistic legacy enabled the young artist to forge a place for himself as he became enveloped in the language of modernism. At midcentury, with Japan and the West engaged in war, the crisis of Japanese Americans in the United States momentarily provided Noguchi with a place to merge his political ideals with utopian visions of sculptural practice. In the post–World War II period, when a Western fascination with Zen and Eastern cultures brought a new awareness to Japanese art, he constructed a version of Japan that was at once authentic and fantastic. In each instance, Noguchi simultaneously conformed to and challenged the prevailing assumptions of East and West to create, rather than simply reflect, new ideas about sculpture, landscape, and art.

What Is in a Name?

One wonders if Noguchi understood the pervasive hold Japan would have on his art and life when he adopted the name Isamu Noguchi in 1923. This action represents the birth of the artist and forever links him to Asia and all that the word conveys. Prior to that, Noguchi had many different monikers. As a baby in Los Angeles, he was called "Yo," short for "Yosemite," bestowed by his European American mother Léonie Gilmour.[3] Upon his arrival in Japan in 1907, he became Isamu, which his father, Yone Noguchi, spelled with the Japanese characters meaning "courageous." For the next two decades, he was variously known as Noguchi Isamu (in the Japanese fashion of family name first), Isamu Gilmour, and Sam Gilmour, before he decisively became Isamu Noguchi about the same time as he established his own studio in New York and began to identify as a sculptor. By his own admission, there was "no hint of

1 Isamu Noguchi, *A Sculptor's World* (New York: Harper & Row, 1968), 39.
2 Dore Ashton, *Noguchi East and West* (Berkeley: University of California Press, 1992).
3 Biographical information regarding Noguchi's early life comes from Masayo Duus, *The Life of Isamu Noguchi: Journey without Borders*, trans. Peter Duus (Princeton, NJ: Princeton University Press, 2004), especially chapters 1 and 2.

Japan about me." But the association with Japan was an alluring one. "When I finally became conscious that I was to be a sculptor, I decided almost involuntarily to change my name, adopting one that perhaps I had no right to."[4]

Noguchi's choice of name can be understood as fashioning a direct link to the artistic legacy of his father, Yone, despite the elder Noguchi's virtual abandonment. Although Isamu lived in Japan from 1907 to 1918, his relationship to his father was nearly nonexistent. Léonie traveled to Japan with Isamu at the express invitation of Yone, but Yone concealed that he had established another family with a Japanese woman. The revelation left Léonie and Isamu essentially on their own; Léonie and Yone had not been legally married in either the United States or Japan, nor did Yone officially acknowledge Isamu as his son. It is a testament to Léonie's skill and determination that she could live as an American woman in Japan in a period when foreigners were rare, let alone live as a single mother raising a biracial child. During his boyhood, Isamu recalls only occasional visits by his father, including the day when Isamu boarded the ship that returned him to the United States, where he briefly attended a progressive high school in northern Indiana and was mentored by its equally progressive founder, Dr. Edward Rumely. The strained relationship with Yone continued into adulthood. When Noguchi traveled to Asia in 1931, Yone asked him not to come to Japan. Noguchi ignored his request. In Tokyo, there was "a trying meeting" with his father followed by "long silent conversations."[5]

As a poet who wrote in English, Yone had established a reputation in the United States and Europe as a bohemian interpreter of Japan to the West. With the editorial assistance of Léonie, Yone had published more than a half-dozen tomes before his son's birth, including two novels in the voice of Miss Morning Glory, a young Japanese girl whose satirical observations of the mores of the United States also provided opportunities to reveal picaresque aspects of Japanese culture. Yone appears to have a played a similar, real-life role as the fictional Miss Morning Glory. He was a lively, exotic presence whose success hinged on his persona as an authentic Japanese artist who could reveal insight into that foreign land.

Perhaps more significantly than the connection to his Japanese father, Noguchi's Japanese name opened up a dynamic world of art and access to it. There was direct access to friends of his father in the United States and Europe, but even more potent was the idea of Japan as a transformative source of artistic inspiration for the West. When Japanese art first reached Europe in the mid-nineteenth century, its impact was nothing short of "revolutionary."[6] Described under the broad rubric of Japonisme, European artists from Édouard Manet to Henri Matisse mined Japanese art and aesthetics for its bold use of color, graphic patterning, asymmetrical compositions, and collapsed pictorial space. In early twentieth-century America, the association of Japan with vanguard artistic practice continued in art, architecture, and design. Alfred Stieglitz and his circle valorized Japanese aesthetics, as evidenced in the writings of Sadakichi Hartmann (published under the pseudonym Sidney Allan)[7] and the reproduction of ukiyo-e prints in Camera Work.[8]

The arts of Japan were considered both venerably ancient and protomodernist, connections that gave Noguchi added allure. It also helped that some of Yone's friends were significant Japanese figures in New York. Japanese choreographer Michio Ito, whose collaboration with W. B. Yeats and Ezra Pound in London placed him at the cutting edge of performance, had been immortalized in photographs by Alvin Langdon Coburn, a key member of Stieglitz's circle and a photographer heavily influenced by Japanese aesthetic traditions. In fact, Noguchi's first designs for theater were for Ito's New York production of Yeats's At the Hawk's Well. It was Stieglitz who served as a recommender for Noguchi's 1926 Guggenheim application, where Noguchi proposed first to spend a year in Paris to gain "a certain cultural background from residence in this European metropolis," before traveling to India, China, and Japan. Noguchi made explicit his desire to travel to

Asia. "My father, Yone Noguchi, is Japanese and has long been known as an interpreter of the East to the West, through poetry. I wish to fulfill my heritage."[9]

"Semi-Oriental Sculptor"

Noguchi's physical appearance may not have automatically pegged him as Japanese. His name, however, did. From the outset, Noguchi's ancestral heritage occasioned comment in the critical press, with his ethnicity generating both positive and negative associations. In the first published monographic essay on Noguchi, pioneering dealer Julien Levy described the sculptor's approach of alternately exploring abstraction and more concrete forms of representation as a "bi-polarity," to which he added that the sculptor "exercises a vigorous interpretation of oriental and western aims."[10] Levy locates the bipolarity in an analysis of the art, but in a pattern that was repeated until Noguchi's death the reference to his dual heritage was evoked even when it appeared to have little to do with the form or content of the work in question. Instead, his biracial ancestry was offered as an explanation or, in some instances, to condemn him. In a 1930 Vogue magazine review of his portrait busts, "the fact that he is the son of a Japanese poet-father and a Scotch author-mother" was seen by the writer as an asset that provided an explanation for Noguchi's "curious combination of an exotic imagination and precise grasp of essential qualities."[11]

The most notorious instance of using racial terms to characterize Noguchi belongs to the critic Henry McBride. His status as a perceptive interpreter of early American modernism did not exempt McBride from resorting to language that played upon fears of the foreign, sneaky Japanese. "You cannot deny that Isamu Noguchi, the Japanese-American sculptor, now exhibiting in the Marie Harriman Galleries has grand ideas," he concedes in a 1935 review. "I hate to apply the word 'wily' to anyone I so thoroughly like and respect as I do Mr. Noguchi, yet what other word can you apply to a semi-oriental sculptor who proposes to build in the United States the following gigantic monuments."[12]

4 Noguchi, A Sculptor's World, 15.
5 Ibid., 20.
6 "When I said that Japonisme was in the process of revolutionizing the vision of the European peoples, I meant that Japonisme brought to Europe a new sense of color, a new decorative system, and, if you like, a poetic imagination in the invention of the objet d'art." Edmond de Goncourt, cited in Klaus Berger, Japonisme in Western Painting from Whistler to Matisse (Cambridge, MA: Cambridge University Press, 1992), 1.
7 Art critic Sadakichi Hartmann was the biracial son of a Japanese mother and German father, who was raised in Hamburg. He migrated to the United States at the age of fourteen and became a perceptive critic of emergent American modernism from the late 1880s to the 1920s. Since Hartmann left New York in 1921, it is unlikely that he and Noguchi met, though Noguchi may have been aware of the older man's criticism and his book Japanese Art (1903). See Jane Calhoun Weaver, ed., Sadakichi Hartmann: Critical Modernist (Berkeley: University of California Press, 1991).
8 Alfred Stieglitz, Camera Work: The Complete Illustrations (Cologne: Taschen, 1997), 119–21, 120, 218.
9 Isamu Noguchi, "Guggenheim Proposal," in Isamu Noguchi: Essays and Conversations, ed. Diane Apostolos-Cappadona and Bruce Altschuler (New York: Abrams, 1994), 17.
10 Julien Levy, cited in Ingrid Schaffner and Donna Ghelerter, "Mr. Expanding Universe: Isamu Noguchi's Affiliations across the New York Art World(s) of the 1930s," in Isamu Noguchi: Sculpture Design, ed. Jochen Eisenbrand, Katarina V. Posch, and Alexander von Vegesack (Weil am Rhein, Germany: Vitra Design Museum, 2002), 75.
11 Helen Appleton Read, "Portraits in Sculpture," Vogue, February 1, 1931. Cited in Sam Hunter, Isamu Noguchi (New York: Abbeville Press, 1978), 40. The exhibition took place at the Marie Sterner Gallery in New York and included fifteen portrait heads: Berenice Abbott, Charles Allen (Alan), Anna Bodi, Harvey Wiley Corbett, John Erskine, Edla Frankau, Buckminster Fuller, George Gershwin, Martha Graham, Marion Greenwood, Beatrice Looker, Marion Morehouse, Ruth Parks, Thérèse Thorne, Ladjos Tihanyi, Head of a Boy (Scott Rumely), and Colonna-Walewski. A version of the exhibition subsequently traveled to the Harvard Society for Contemporary Art in Cambridge, Massachusetts, and the Arts Club of Chicago. See Nancy Grove, Isamu Noguchi: Portrait Sculpture (Washington, DC: National Portrait Gallery, 1989).
12 Henry McBride, "Attractions in the Galleries," New York Sun, February 2, 1935. Cited in Noguchi, A Sculptor's World, 22.

Isamu Noguchi, *Play Mountain*, 1933.
Bronze, 3⅜ × 25¼ × 28¾ inches

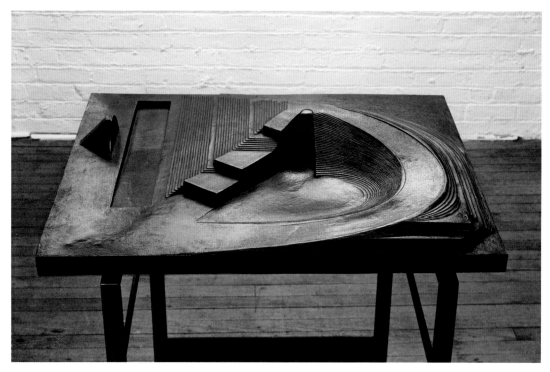

Among the works to which McBride objected were *Monument to the Plow* (1933) and *Play Mountain* (1933), now considered among Noguchi's most significant early achievements. Both represent a radical rethinking of sculptural practice, one that moves beyond the creation of discrete objects to fashion environments that reframe the relationship of viewers to art and blur the boundaries of sculpture and landscape. *Monument to the Plow* was a proposal to create a massive pyramid of earth, sited in the American heartlands at the geographic center of the country. The ambitious proposal was intended as an homage to the steel plow, which Noguchi understood as making possible the cultivation of the western plains. In *Play Mountain*, Noguchi proposed to shape the earth on a smaller scale to create a "playground as sculptural landscape."[13] With its terraced mound, slopes, ramps, and amphitheater, the design creates a setting for human interaction and engagement, essentially a

city block "in the form of a room where you could go both inside and outside—a big play object."[14]

Monument to Benjamin Franklin (1933)[15] and the *Carl Mackley Memorial* (1933) (which was dedicated to a garment workers union) were also included in the show. For Noguchi, these proposals respectively celebrated the distinctly American ingenuity and experimentation of Franklin and the underacknowledged contributions of labor to American prosperity. In sum, they represented his "wish to belong to America."[16] For McBride, the interest in American ideals was a sinister, alluring plot—to what end he did not specify. He scoffed at the audacity of the "semi-Oriental sculptor" to initiate proposals for American monuments, maintaining that "all the time he has been over here, [Noguchi] has been studying our weakness with a view of becoming irresistible to us."[17] The convoluted logic of McBride's language echoed the rhetoric used by the anti-Japanese movement, which considered

Japanese immigrants a "yellow peril" set on infiltrating and insidiously taking over American life. By the time of the review, the anti-Japanese movement had succeeded in halting emigration from Asia, restricting property rights of those who were already in the United States, and forbidding naturalization—all based on race. Indeed, it was early episodes of anti-Japanese fervor in California that pushed Léonie to take her young son to Japan.[18] Furthermore, antimiscegenation laws were enacted in many states.[19] Where marriages were allowed, an American woman lost her rights of citizenship if her husband was an "alien ineligible for citizenship"—a confusing term that applied only to Asian immigrants. Had Léonie and Yone been legally married, she would have been a woman stripped of her birthright.[20] As their offspring, Noguchi could be seen as the proof of their transgression.

McBride reserved his most dismissive criticism for Noguchi's sculpture *Death (Lynched Figure)* (1934), a nearly life-size metal form that was based on a photograph of a lynched and burned African American man. The contorted limbs and shiny, reflective surface abstract the body of the man, but the dangling rope and metal gallows give it an unambiguous and startling edge. Sadly, lynching was not uncommon in many parts of the United States, where vigilante justice was disproportionately meted out to young African American, Latino, and Native American men.[21] Noguchi's explicitly political statement places it within a strain of leftist politics practiced by many of his artistic colleagues, but its narrative approach is anomalous in Noguchi's work. McBride did not critique the work on artistic grounds, as some other contemporaneous critics did. Rather, he simply called it "just a little Japanese mistake."[22] The venom of McBride's comments stung, as Noguchi recounted in his autobiography more than thirty years later. While acknowledgment of Noguchi's heritage was commonplace, the seething racism was hard to ignore, especially when it was directed at works Noguchi conceived as quintessentially American. Japanese art may have been a bounty of influence to modernist practice, but being of Japanese ancestry was not.

Monument to the Plow and *Play Mountain* were created after Noguchi's first return visit to Japan. Consequently, scholars have considered Noguchi's environmental approach in these works as an outgrowth of his Japanese experience, during which visits to gardens offered a model where "sculpture" is inscribed into the landscape and where the viewers are active participants, experiencing spatial and temporal changes as they traverse the terrain.[23] Such an interpretation is entirely reasonable and one later promulgated by Noguchi himself, but on the level of form, there are other important associations. The elegiac, monumental quality of the proposals closely hews to the platform mounds constructed by ancient Indigenous Native Americans that dot the Great Lakes and Ohio Valley regions, within close range to northern Indiana, where Noguchi spent his teenage years. The pyramidal massing of both projects

13 Noguchi, *A Sculptor's World*, 22.
14 Isamu Noguchi, interview by Paul Cummings, November 7, 1973. Archives of American Art, Smithsonian Institution, Washington, DC, https://www.aaa.si .edu/collections/interviews/oral-history -interview-isamu-noguchi-11906.
15 An alternate version, *Bolt of Lightning…Memorial to Ben Franklin*, was erected in Philadelphia in 1984.
16 Noguchi, *A Sculptor's World*, 22.
17 Henry McBride, cited in Noguchi, *A Sculptor's World*, 22.
18 Duus, *The Life of Isamu Noguchi*, 46.
19 In California, antimiscegenation laws affecting Japanese and European marriages were in place from 1905 to 1948.
20 The Cable Act (1922) was biased in terms of gender. It applied only to women and not men, who could marry "aliens ineligible for citizenship" without losing their citizenship. It was repealed in 1931.
21 See James Allen, ed., *Without Sanctuary: Lynching Photography in America* (Santa Fe, NM: Twin Palms, 2000); and Ken Gonzales-Day, *Lynching in the West, 1850–1935* (Durham, NC: Duke University Press, 2006).
22 McBride, cited in Noguchi, *A Sculptor's World*, 23.
23 Dana Miller, "Breaking Ground: The Environmental Works of Isamu Noguchi," in *Isamu Noguchi: Master Sculptor*, ed. Valerie J. Fletcher (London: Scalo Publishers, 2004), 162–85.

furthermore creates a monumental effect that differs from the meandering, constructed views one experiences in prototypical Japanese gardens. This is not to say that the Japanese association is a false one but rather to stress that recourse to Japanese influences as an explanation for Noguchi's work at times has the effect of discounting other readings. It also diminishes the true radicality and innovations of Noguchi's work in the 1930s. In these unrealized projects, Noguchi introduces a unique approach to the landscape and the definition of sculptural practice that has no parallel. He revisited and expanded upon these ideas throughout his career. *Contoured Playground Model* (1941), *Model for the United Nations Playground* (1952), and *Model for Riverside Playground* (1965) represent Noguchi's continued engagement with molding the topography to create tableaux for play.

"Not Just American, but Nisei"

Many immigrant artists—including fellow sculptors Elie Nadelman and Alexander Archipenko, and other artists such as Joseph Stella, Marcel Duchamp, and Noguchi's good friend Arshile Gorky—populated the world of American art in the pre–World War II period, but while their ethnicity may have been seen as an element of their practice, it in no way defined it as it did for Noguchi. The U.S. entry into World War II pushed Noguchi further into being identified as a hybrid American of Japanese ancestry. In the early months of 1942, all Japanese Americans (citizens and noncitizens) living on the West Coast were rounded up and subjected to incarceration in camps located in the interior of the country. The mass imprisonment of Japanese Americans precipitated a major awakening in Noguchi. His commitment to leftist politics and experiences of racism sensitized him to the plight of fellow Japanese Americans who were caught between warring nations. "With a flash I realized I was no longer the sculptor alone. I was not just American but Nisei. [As a] Japanese American…I felt I must do something."[24]

He joined the Japanese immigrant painter Yasuo Kuniyoshi in organizing the Nisei Writers and Artists for Democracy to identify tangible means of assistance and to counteract the anti-Asian sentiment that proliferated in the American press. Because Noguchi lived on the East Coast and therefore outside the boundaries of forced removal, he was not subject to incarceration but spurred by a sincere desire to help, he volunteered to enter Poston, the camp established at the Colorado River Indian Reservation and one of the largest of the ten War Relocation Authority facilities. His explicit goal was to design an "ideal cooperative community" that "might contribute toward a rebirth of handcraft and the arts which the Nisei have so largely lost in the process of Americanization."[25] Less than three months after his arrival, Noguchi sought permission to leave. His idealistic desire to "fight for freedom" through creative endeavors was frustrated by the camp administration and his incompatibility with the interned nisei.[26] Although his autobiography circumspectly recounts the experience, his letters of the period suggest that the desert heat, difficult living conditions, and restrictions on his freedom left Noguchi embittered. "I resolved henceforth to be an artist only," he concluded after his release.[27]

Nevertheless, Noguchi's designs for Poston represent his first attempt to extend creative control to a large-scale environment, albeit within the parameters of an internment camp. Noguchi hoped to facilitate the rebirth of Japanese arts and craft traditions, but his design for Poston betrays no sense of "Asia." (One fellow internee recalls Noguchi clad in a pith helmet and dusty denims, tramping through the desert to collect ironwood, a lusciously colored hardwood. Apparently the front of his barrack

24 Noguchi, *A Sculptor's World*, 25. *Nisei* is a Japanese term that literally means "second generation" and refers to the American-born children of Japanese immigrants, who are referred to as *issei*, or first generation.
25 Isamu Noguchi, letter to Mr. Fryer, July 28, 1942, from the War Relocation Authority case file of Isamu Noguchi.
26 Isamu Noguchi, letter to John Collier, July 27, 1942, from the War Relocation Authority case file of Isamu Noguchi.
27 Noguchi, *A Sculptor's World*, 26.

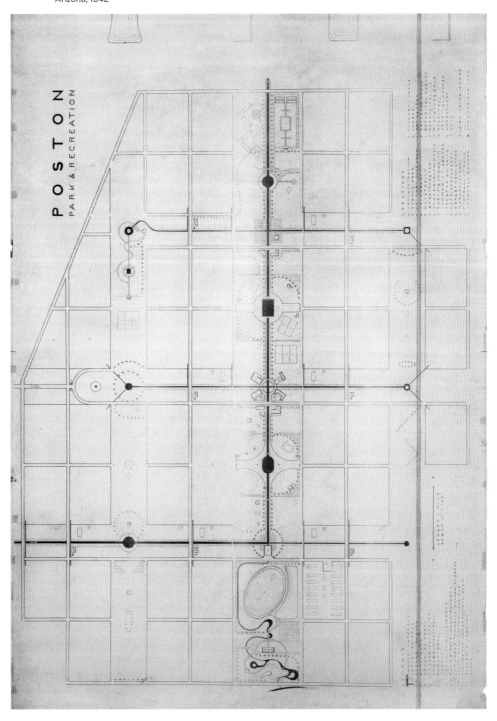

Isamu Noguchi, blueprint for
Poston park and recreation areas
at Poston War Relocation Center,
Arizona, 1942

was covered with masks he made, described as "fearsome African," rather than anything resembling Japan.)[28] The grid of the camp—populated with rows of undifferentiated barracks to house the nearly eighteen thousand people who were sent there—is broken by a large central swath of "public" space, punctuated by service buildings, areas for recreation, and structures to house creative activities. Three perpendicular axes intersect to create promenades leading to other ends of the camp, giving a semblance of expansiveness in what was essentially a civilian prison. Noguchi even designed a cemetery. Little of his proposal remains and nothing was executed, but in plan the swimming area at one end of the design closely resembles other playscapes, especially his *Contoured Playground*. In later years, Noguchi realized large-scale environments including the Billy Rose Sculpture Garden in Jerusalem (1960–65), the Philip A. Hart Plaza in Detroit (1972–79), and the Lillie and Hugh Roy Cullen Sculpture Garden in Houston (1978–86). His most ambitious environment is the posthumously constructed four-hundred-acre Moerenuma Park in Sapporo, Japan. The rolling topography and specific setting differs, but it bears the utopian idealism and coherent plan first seen in his Poston designs.

Japanese Earth

In 1950, after an absence of nearly two decades, Noguchi returned to a radically changed Japan and found himself amid the country's artistic vanguard. Out of the ashes of world war, Japanese artists now "had the liberty of imagining a new, ideal and at times utopian society" that was fueled by the development of new institutional infrastructures for contemporary art.[29] Museums, cultural centers, annual exhibitions, publications programs, and international exchange flourished, supported in part by the resources of the American occupation, which also pumped resources into rebuilding war-ravaged cities.

Keiō University in Tokyo, the academic home of Yone Noguchi, had been badly damaged during the war and architect Yoshiro Taniguchi was charged with reconstructing the campus. Noguchi was commissioned to design a faculty room and garden in honor of his father, who had died in 1947. The Shin Banraisha (1950–51) and the garden that surrounds it represent Noguchi's first foray into the creation of a unified building and landscape design. A Japanese sensibility suffuses the structure with its horizontally oriented volumes, Bizen tiles, ancient bronze bell, and haniwa figurine, a ceramic funerary sculpture from the third century AD. Noguchi and Taniguchi invited the prominent painter Genichiro Inokuma and designer Isamu Kenmochi to the collaboration and thus the design could be said to embody the major issues facing Japanese postwar artists: how to fuse the quest for modernity with the Japanese past. In fact, the designers of pre–World War II Japan had already begun to tackle this question in dialogue with European modernists, who, in turn, had earlier looked to Asia for inspiration. The Czech American architect Antonin Raymond, who invited Noguchi to design the garden at the new Reader's Digest Building in Tokyo in 1951, was one such figure.

From an American perspective, the image of postwar Japan was transformed from the home of an enemy aggressor to the serene repository of ancient traditional arts.[30] The popularity of Zen and Japanese cultural practices exploded. D. T. Suzuki and Alan W. Watts became the most prominent interpreters of Zen to the West, with Watts acknowledging that the interest was "one of the constructive results of the late war."[31] Abstract Expressionism and European Art Informel and Tachisme found a morphological and philosophical analogue in Asian traditions. Such interest was not limited to the world of arts and letters. As a consequence of the occupation, average Americans had greater access to the arts of Japan. Servicemen returned home with Japanese curios and art objects, while women who joined their husbands overseas practiced tea ceremony, took ikebana classes, and learned about Zen. To help their young women readers master the philosophy that had entered "cocktail party conversation," *Mademoiselle* magazine published "What Is Zen?"[32] *Time* magazine later proclaimed that

Zen "is growing more chic by the minute."[33] This context is critical to understanding Noguchi's headlong embrace of his father's country. His previous experience in Japan had not been a particularly welcoming one. Now Noguchi's biracial heritage was embraced as a symbol of a new world without borders. In the United States, Noguchi was perceived to have special access to the culture of Japan because of his heritage, a far cry from his prewar and wartime experiences.

In 1952, Noguchi married the glamorous Japanese movie star Yoshiko Yamaguchi and adopted an extreme interest in Japanese traditions. The influential potter Kitaōji Rosanjin invited Noguchi and Yamaguchi to live in a thatched-roof cottage at his hillside property near the village of Kita-Kamakura, a few miles from the famed Daibutsu at Kōtoku-in Temple. Noguchi carved into the adjacent upslope to create a studio where the back wall consisted entirely of the bare surface of the earth. To comply with the atmosphere of the rustic setting, Noguchi wore the clothes of a Japanese peasant and forced his wife to wear scratchy sandals made of straw to go with her Japanese dress.[34] Noguchi recalls that from his engagement with the Japanese earth, "I was with joy and energy," but his marriage with Yamaguchi was short-lived.[35] The recourse to a folkloric version Japan represented a romantic ideal that proved difficult to sustain for a cosmopolitan movie star.

The search for an old Japan culminated in Noguchi's studio complex in Mure. The breathtakingly beautiful landscape features a two-hundred-year-old traditional home, an old storage house used as a studio, numerous pathways, crafted gardens, and carefully placed sculpture. It was an environment where "he would be simultaneously actor, director, and spectator," Noguchi's biographer Dore Ashton has written.[36] Every detail of the sprawling, hillside landscape was created by Noguchi as an imaginary Japan, one that never really existed. Yet the atmosphere he cultivated, down to the shafts of light that stream into the interior of the old house, are permeated with a sense of authentic Japan. "He well knew it was a dramatic artifice: a work."[37] Like Noguchi's earlier landscape designs, Mure is a work of art created by Noguchi, but because it represents the "East," it is difficult for Western viewers to decipher the artistic codes he enacted.

Noguchi's work embodies the East and the West, but to truly understand the innovation and complexity of his sculptural designs and landscapes, one must move beyond the paradigm of East and West. The true radicality of Noguchi, and his significance as an artist of major import, lies in his movement between cultures, modes of working, and identities. At different points in his life, he both defied and met expectations, but in ways that challenged assumptions about art, its parameters, and its cultures.

28 Wakako Yamauchi, "Poston, Arizona: A Personal Memory," in The View from Within: Japanese American Art from the Internment Camps, 1942–1945, ed. Karin Higa (Los Angeles: Japanese American National Museum, UCLA Wight Art Gallery, and UCLA Asian American Studies Center, 1992), 69.

29 Nishikawa Nagao, cited in Charles Merewether, "Disjunctive Modernity: The Practice of Artistic Experimentation in Postwar Japan," in Art Anti-Art Non-Art: Experimentations in the Public Sphere in Postwar Japan, 1950–1970, ed. Charles Merewether and Rika Iezumi Hiro (Los Angeles: Getty Research Institute, 2007), 1–2.

30 For a discussion of postwar Japan and the role of the culture during the occupation, see John W. Dower, Embracing Defeat: Japan in the Wake of World War II (New York: New Press, 1999).

31 Alan W. Watts, The Way of Zen (New York: Pantheon, 1957), ix.

32 Nancy Wilson Ross, "What Is Zen," Mademoiselle, January 1958, 64.

33 "Zen: Beat and Square," Time, July 21, 1958, 49.

34 Bert Winther-Tamaki, "The Ceramic Art of Isamu Noguchi: A Close Embrace of the Earth," in Louise Allison Cort and Bert Winther-Tamaki, Isamu Noguchi and Modern Japanese Ceramics: A Close Embrace of the Earth (Washington, DC: Arthur M. Sackler Gallery, Smithsonian Institution, 2003), 38.

35 Noguchi, A Sculptor's World, 33.

36 Dore Ashton, Noguchi East and West, 242.

37 Ibid., 242.

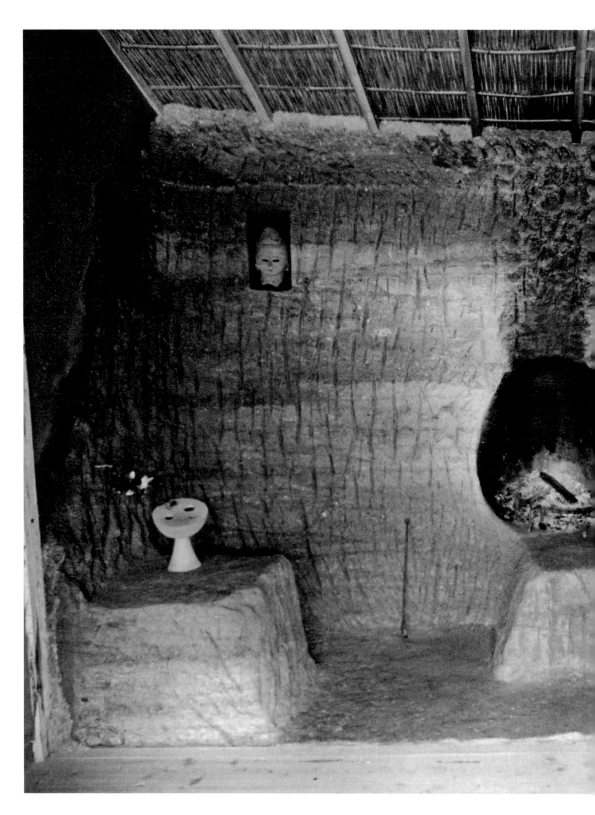

Interior of Isamu Noguchi's studio, Kita-Kamakura,
Kanagawa, Japan, ca. 1951–52

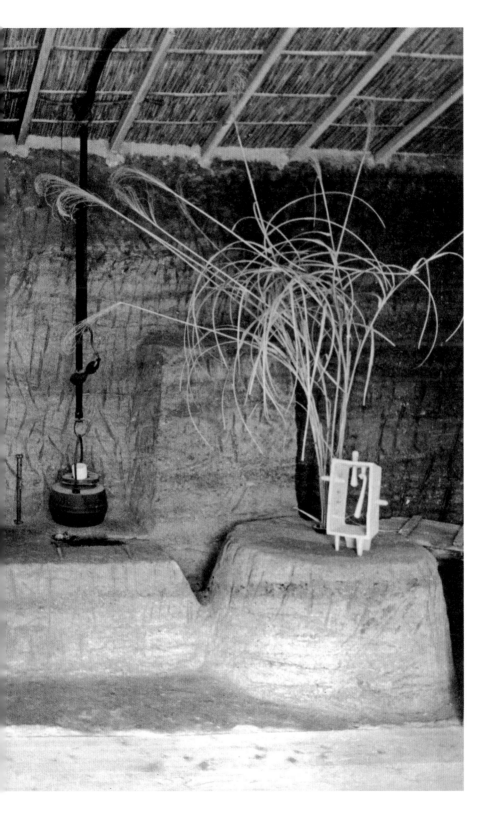

Barbed Wire and Barracks: Roger Shimomura's Paintings and Collections

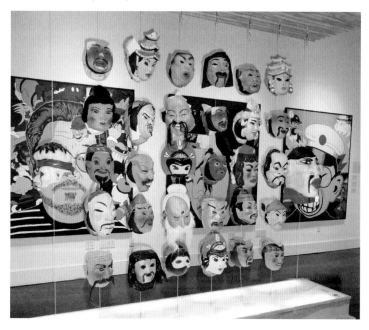

In *Yellow Terror: The Collections and Paintings of Roger Shimomura*, organized in 2009 by Seattle's Wing Luke Museum, the artist and educator Roger Shimomura's vast collection of memorabilia catalogued the long history and pervasive hold of anti-Asian stereotypes in American visual culture. Shown alongside his paintings, the collection gave insight into Shimomura's deep understanding of visual and cultural references.

The exhibition *Shadows of Minidoka: Roger Shimomura's Paintings and Collections* (2011, Lawrence Art Center, Lawrence, Kansas) shares the approach of juxtaposing Shimomura's collection with his paintings. But the collection in *Shadows of Minidoka* is distinct. It encompasses objects and ephemera about and by Japanese Americans, thereby restoring a featured place to those who were literally silenced by World War II. The paintings likewise have a markedly different tone from Shimomura's acerbic critiques of American popular culture and their dense, allover configurations, layered references, and cacophonous energy.

By contrast, the *Minidoka* paintings are infused with a quiet intensity, like images refracted through a child's hazy memory, where biting wit and comic juxtapositions give way to simple, graphic depictions. A combination of anger and resignation seethes just under the surface, simultaneously repressed and acquiesced. The work is not without Shimomura's trademark sense of humor, but the irony stings even more because it feels closer to home, as indeed Minidoka was Shimomura's home.

The unsteady toddler in *American Alien #2* (2006), who grows older and reads a Batman comic book in *The Lesson* (2007), is undoubtedly the artist himself. Within these autobiographic elements, however, it is necessary to see Shimomura's artistic intervention. The project is more than mere documentary reminiscences of a childhood behind barbed wire. The paintings don't simply depict events or explain why the incarceration of Japanese Americans was wrong. Instead, by collapsing the past and the present within the pictorial frame,

Roger Shimomura, *Classmates #3*, 2008.
Acrylic on canvas, 24 × 36 inches

Roger Shimomura, *American Alien #4*,
2008. Acrylic on canvas, 36 × 24 inches

Roger Shimomura, *Desert Garden*, 2007.
Acrylic on canvas, 60 × 24 inches

Shimomura's work underscores the process of reflection and, by extension, argues that this period in American history remains relevant today. In *Enemy Alien #2* (2006), both the young and old Shimomura exist within the same canvas. The bespectacled, gray-haired artist peers out of a barrack's window, while the image of his younger self leaning on a baseball bat hovers as a dark shadow on the exterior wall. (We have seen this shadow before in *American Alien #3* [2006], where the boy remains in darkness while his mother is in clear light behind him.) Despite the passage of time, the artist literally remains enclosed within the barracks walls, suggesting a critical aspect of this traumatic event: one cannot truly escape it.

Shimomura strategically employs several formal devices to accentuate the feelings of confinement and everyday oppression. Horizontal lines of barbed wire appear on most of the canvases in the series *Minidoka on My Mind*. At times they are innocuously placed, as in *Enemy Alien* (2006), where a line of twisted barbs hovers at the top of the image, inexplicable except for its symbolic reference. In other instances, they appear as prisonlike bars in windows, counteracting the light- and air-emitting function of these openings to the outside world. In *Classmates* and *Classmates #2* (both 2008), the barbed wire becomes a third character in the paintings' implied narrative. Two classmates—one Japanese American, one not—are separated by a lattice of wire. Because Shimomura's painting style emphasizes broad expanses of color and strong, graphic lines, pictorial depth is here conveyed by the overlay of barbed wire. The fashionable young Asian woman in *Classmates* may appear acculturated as an all-American girl with her flouncy dress, hair accessories, bold lipstick, and red apple, but she is literally marked by the barbed wires that lie across her face and body. Clearly, she is on the wrong side of the fence.

Classmates #2 poses child star Shirley Temple with a young Japanese American boy, a tag with his family number hanging from his lapel. Ironically, both the movie star and the boy were victims of the same venomous rage of Texas congressman Martin Dies Jr., who in 1938 as chairman of the House Un-American Activities Committee (HUAC) branded ten-year-old Temple a Communist sympathizer for sending greetings to a French Communist newspaper.

The American public and the political establishment—including the administration of President Franklin D. Roosevelt—responded with incredulity and protest. Yet a mere four years later, the Dies Committee issued its notorious *Report on Japanese Activities*, claiming that Japanese American veterans' organizations, Buddhist and Shinto religious groups, the Japanese American Citizens League, farmers, and Japanese-language-school educators were "fifth-column instruments for the forthcoming attack on the United States." Dies's warmongering hysteria of massive espionage and sabotage was accepted both as truth and as further justification for incarcerations.

Shimomura uses other narrative and formal devices to underscore the way Japanese American lives were circumscribed by incarceration. All the paintings in *Minidoka on My Mind* feature the ubiquitous army-issued barracks. The barracks' tarpaper-and-batten exteriors create a vertical grid that, combined with the horizontality of barbed wire and the frequent depiction of floorboards, suggests spatial enclosure. When depicting interior spaces, the frame construction of the barracks has a similarly confining effect, situating the presumably joyful movement depicted in *Block Dance* (2000), for example, as regulated by the fact of incarceration.

In this way, Shimomura answers one refrain used to justify imprisonment ("if Japanese American internees maintained some semblance of normal life in the camps, then it couldn't have been so bad after all"). In Shimomura's paintings, however, the relentless control of daily life as emphasized by the repetition of barbed wire and barracks builds quietly and cumulatively, leaving the viewer with a sense of silent oppression.

Objects and ephemera from the past are literally silent, too. Yet the items related to the World War II incarceration gathered by Shimomura speak volumes about both the artist

Roger Shimomura, *Enemy Alien #2*, 2006.
Acrylic on canvas, 30 × 24 inches

Map of Minidoka War Relocation Center,
Idaho, 1940s, formerly belonging to
Roger Shimomura

English-Japanese dictionary, formerly
belonging to Roger Shimomura

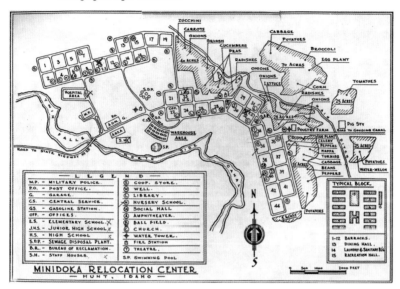

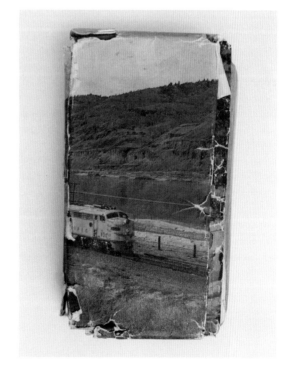

and the experience. One may not be able to tell that the humble ikebana vase had its origins in a hollow branch from the camp at Tule Lake, but its very existence suggests other narratives and stories, such as the cultivation of flowers or the practice of Japanese traditional arts in an American concentration camp. That ikebana is ephemeral underscores the fleeting nature of life. Shimomura also depicts the drive to conjure aesthetic beauty from nothing in *Desert Garden #3* (2007), where a pond, a Japanese stone lantern, and vibrant flowers miraculously bloom from the desert floor.

A quilt made by internees for Miss Thompson's sewing class in Poston is simultaneously an exercise in domestic arts, an autographed book of the girls who were incarcerated, and a practical item for use. The squares that bear names emphasize the girls' individuality. Some simply embroidered their signatures, while others created elaborate scenes of cacti, the barracks, dolls, animals, and, in one instance, a tropical idyll. This and the other objects made in the camps remind us that although the imprisonment was a mass one, there were individual and varied lives that were impacted by the experience.

Two items from Shimomura's collection directly relate the artist to his creative forebears. Henry Sugimoto was an ambitious and talented painter who trained at the California College of Arts and Crafts in the 1920s, studied and exhibited in France in the early 1930s, and in 1932 returned to the United States and a solo exhibition at the California Palace of the Legion of Honor in San Francisco. In the Fresno Assembly Center and the War Relocation Authority camps Jerome and Rohwer in Arkansas, Sugimoto continued to paint while using his skills to teach in the camp's high school and contribute to the camp's official publications. The woodcut used as a cover for the Rohwer Red Cross Unit of 1945 was from a series he made when interpreting his environment and experiences.

When war broke out, Miné Okubo was a recent graduate of the University of California, Berkeley, and an up-and-coming artist. At the Tanforan and Topaz camps, she was part of a dynamic community of artists from the San Francisco Bay Area that organized an art school (led by Chiura Obata and later George Matsusaburo Hibi), held exhibitions, and created the literary publication *Trek*. Her cover art for the magazine found its way to the New York–based editors of *Fortune* magazine, which led to a job creating illustrations for the magazine's special April 1944 issue on Japan. Two years later, *Citizen 13660*, her visual and textual account of the war years, was published by Columbia University Press. Sugimoto and Okubo are but two artists who interpreted their experiences in the camps as they unfolded and maintained their respective practices as artists by contributing to the broader visual culture of the war years. In Shimomura's collection, there are additional aesthetic and practical objects made by Japanese Americans, attesting to the range and prevalence of art making despite confinement.

Custom Homes (2007), Shimomura's five-part painting, provides an analogue to the varied artistic responses and experiences in camp evidenced in his collection. Each canvas depicts the end of a barrack. At a glance, the barracks all look identical, anchored on the same yellow sand and subjected to the same horizontal lines of barbed wire that stretch across the width of the painting. But upon closer examination, each is slightly different: the door to one has a peaked pediment, while another appears to have a screen. Each window shows a different treatment.

Similarly, artists Henry Sugimoto and Miné Okubo, the ikebana vase maker, the girls of Miss Thompson's class, and the countless others who interpreted the wartime experience demonstrate specific and distinct perspectives and sets of experiences. With *Shadows of Minidoka*, Shimomura joins them, extending their legacy with his own incisive critique and persistent vision.

Miné Okubo, *Trek* 1, no. 2 (February 1943),
Topaz War Relocation Center, Utah

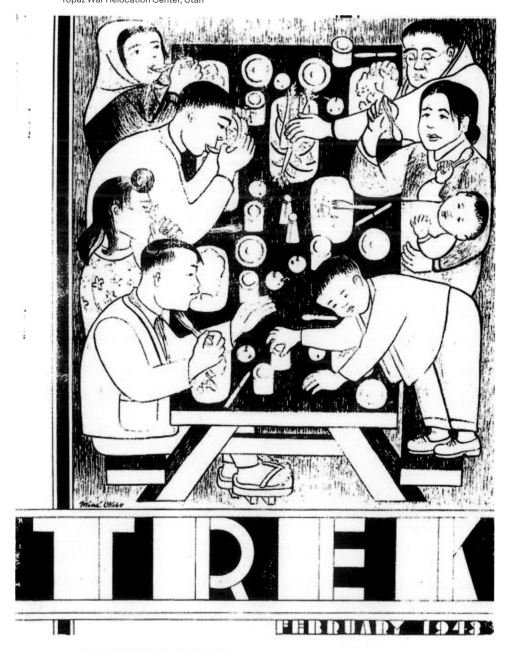

Black Art in L.A.: Photographs by Robert A. Nakamura

In 1970, my father, Kazuo Higa, was the director of the Da Vinci Art Gallery at Los Angeles City College (LACC). He had started teaching art and art history at LACC in 1968 and recognized the important connection for aspiring artists of color between making and seeing art. At that time, Black art became a key source of identification not just for African Americans but in the broader Third World sense of people-of-color coalitions. My father invited Alonzo Davis, of the Brockman Gallery, to gather artists who represented the "new Black renaissance in art" for the exhibition *Black Art in L.A.* There were thirteen artists total, of several generations, and all men save for Betye Saar.[1]

Davis emphasized in his introduction that the artists in the exhibition showed unmediated reactions to life: "be it militant, black, love, mother-Africa, dance, sex, humanitarianism, abstract or non-objective." The heterogeneity of this list suggests a freewheeling range of work. Although no checklist survives to specify the ways in which these issues were explored, the exhibition panels created by my father hint at the project's richness. He enlisted his good friend and former Marshall High School classmate photographer and filmmaker Robert A. Nakamura to make portraits of the artists in their studios, which, along with the biographical list of their accomplishments, formed the exhibition's interpretive frame.

Over a two-day period, my father and Nakamura drove across Los Angeles to meet and photograph the artists. These photographs were taken in the early part of Nakamura's career, before he made his mark as a filmmaker. Nakamura's photographs attest to both the provocative presence of the artists in the exhibition and his skill at art directing his subjects

to emphasize aspects of their personality and art. The simple act of photographing Black artists cannot be underestimated in a period when representations in the mainstream media were nearly nonexistent. Nakamura exquisitely crafted the mise-en-scène to interpret the art. His photographs also reveal something significant about the conception of the artist as a role model. All the photographs depict the artist working–not as an isolated, lofty practitioner but as someone with whom people can identify. The images show creativity happening in the studio, articulating an identity outside cultural institutions. It is noteworthy that many of these artists went to LACC, which, alongside other community colleges in the city, was important as an educational institution and as a place for activism.

In Nakamura's portrait of John Outterbridge, the artist wears a paint-covered smock in his messy garage studio, surrounded by art, tools, and *stuff*. Noah Purifoy gazes off camera with a dreamy look. Charles White sits at his drafting table, cigarette in hand, amid posters of his past shows and various diplomas, certificates, and proclamations that attest to his stature in the world of art. The photograph of Betye Saar shows her in her first studio: the sun porch of her home. Her kitchen table and refrigerator are visible in the foreground, while her kids' drawings appear on the back wall–perhaps one of the first public displays of daughters Alison and Lezley Saar's art. Most significant, Nakamura's photograph shows two of Saar's key early works: *View from the Palmist Window* (1966) and *Black Girl's Window* (1969), which mark her transition from a primarily printmaking practice to one of collage and assemblage.

In the portrait of David Hammons, the artist is seen in profile, donning a cap and sunglasses with an American flag draped over his shoulder. He faces *Pray for America*, his 1969 body print that shows him with his hands

raised in prayer, his head and body covered by the graphic Stars and Stripes of the American flag. The sight of a Black man wrapped in an American flag may appear innocuous by today's standards, but it was considered controversial and irreverent. Indeed, Cecil Fergerson recounts the piece nearly cost the Los Angeles County Museum of Art (LACMA) the sponsorship of Bank of America and that when deciding on an acquisition of a Hammons work for its collection, the museum opted for *Injustice Case* (1970). Its representation of a Black man bound, gagged, and tied to a chair was a more palatable option, despite its explicit critique.[2] Nakamura deftly and simply encapsulates this controversy in his portrait, underscoring awareness of the ensuing conflicts in the realm of representation.

Collectively, Nakamura's photographs present a rich and nuanced portrait of Black artists in L.A., simultaneously demystifying the artistic process and conveying seriousness, dignity, and perseverance, in contrast to the often negative media depictions of Blacks. This was, after all, only five years after the Watts uprising. The studio visit has long been seen as a key to unlocking an artist's ideas and intentions. These photographs reproduce that process and, more important, visualize Black art making in its full range and diversity. Creativity was not the sole domain of white artists exhibiting in La Cienega galleries or at the newly created LACMA in Hancock Park, a refrain I heard repeatedly as a child from my father as we traversed the city in the family's VW bus.[3] To underscore this point, on the exhibition panels, a list of the artist's accomplishments accompanied each portrait: his or her education, exhibitions, awards, and employment. What is surprising is how long these lists are. Brockman Gallery and Ankrum Gallery, two L.A. venues known for showing Black artists, appear frequently, but the range of other places demonstrates the degree to which these artists were part of multiple cultural and community networks. In the period before Proposition 13, the state initiative that changed tax codes and had the effect of decimating public education, it is interesting to note how many artists in the exhibition taught art at secondary

and college levels. The panels doubly normalized the artists, demonstrating their ties to the community and emphasizing their standing in the world of art.

This collaboration between Davis, Higa, and Nakamura provides a brief view into the relatedness of Asian American and African American communities in the activism of the 1960s and 1970s. The connection between Black Power and the emergence of the Yellow Power movement is inextricable. The San Francisco Chinatown Red Guards, for instance, employed the same types of titles as those used by the Black Panthers. One of the most penetrating and lucid figures of the Red Guard was Alex Hing, their minister of education. We can also situate these relationships within the broader context of global Third World struggles. The U.S. wars with Korea and Vietnam, in which many African Americans fought, formed a backdrop for a wide range of activism in the United States. It was not lost on Asian Americans that the country had been (or was at that very time, in the case of Vietnam) at war with people who looked like them. The relative silence that had accompanied the World War II incarceration

2 Cecil Fergerson, interviewed by Karen Anne Mason, August 12, 1994, African American Artists of Los Angeles, Oral History Program, University of California, Los Angeles, transcript, 467–68, Charles E. Young Research Library, Department of Special Collections, UCLA. The man in *Injustice Case* was meant to represent Black Panther Bobby Seale, who was bound and gagged during his 1968 trial.
3 For activists like my father, the establishment of LACMA as a separate institution from the Los Angeles Museum of History, Science and Art and its move from Exposition Park in Central L.A. to its new location in Hancock Park, which was then considered to be on the west side of the city, was a sad example of cultural resources being taken from communities of color and transferred to elite, primarily European American, neighborhoods. Additionally, at the time of the split, the art of non-Western cultures was still considered within the realm of "natural history" rather than art, further evidence of cultural myopia and implicit racism.

Alonzo Davis in his Los Angeles studio,
1970. Photo: Robert A. Nakamura

John Outterbridge in his Los Angeles
studio, 1970. Photo: Robert A. Nakamura

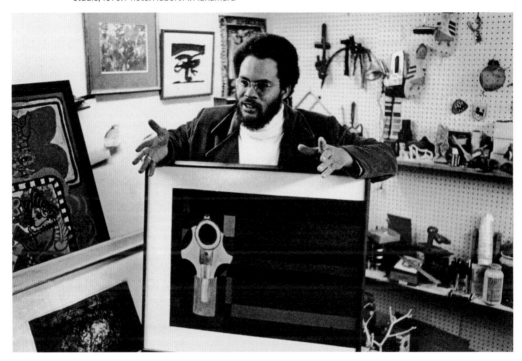

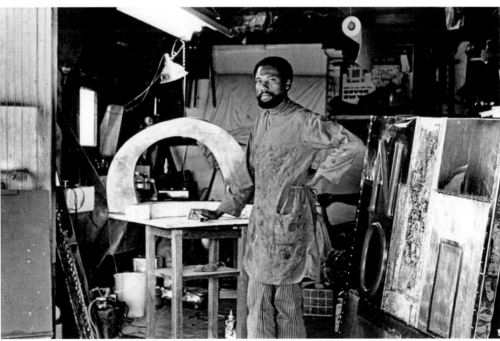

Noah Purifoy in his Los Angeles studio,
1970. Photo: Robert A. Nakamura

Charles White in his Los Angeles studio,
1970. Photo: Robert A. Nakamura

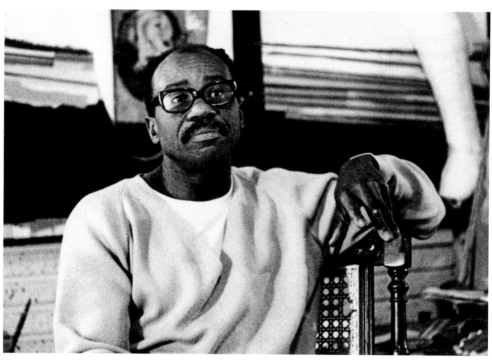

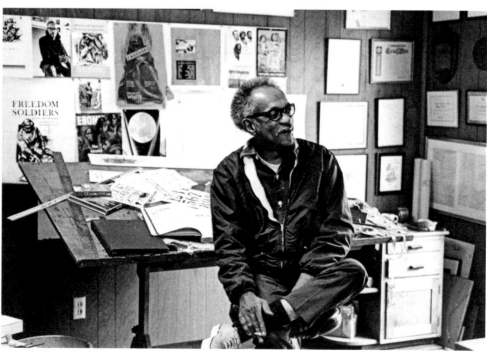

of Japanese Americans was slowly eroding as young activists sought greater knowledge of and government accountability for the mass imprisonment of civilians, one based solely on race. When the nightly news broadcast the Vietnam War into U.S. homes, it also brought racist cries of "gook" and "chink" to the forefront, reminding Americans of Asian ancestry that—in the eyes of many and in the social sphere—they remained forever foreign. Nakamura and my father were in the camps as children, respectively at Manzanar in eastern California and Heart Mountain in Wyoming. They knew all too well the consequences of looking like the enemy.

The year in which these photographs were made, 1970, was a pivotal one for Nakamura. It was the year he sidelined a career in commercial photography and photojournalism to cofound the Asian American media artist collective Visual Communications (VC) with Duane Kubo, Alan Ohashi, and Eddie Wong, and with my father as board chairman. Nakamura had graduated from Art Center (now the Art Center College of Design in Pasadena) with a specialization in photography and in a short amount of time found incredible success. He, along with my father, worked in the studio of Charles and Ray Eames in the late 1960s. Nakamura photographed many influential people and things—some of it idiosyncratic, such as the folk-art collection of Alexander Girard—for magazines such as *Life*, *Collier's*, and *McCall's*. It is critical to recognize that although committed to a form of oppositional cultural politics, Nakamura and my father were also educated in and aware of vanguard artistic practice. (My father had attended Art Center, Chouinard Art Institute, and the University of California, Los Angeles.) But increasingly Nakamura recognized that the battleground of representation was central to achieving an equitable society.

In the early 1970s, Nakamura enrolled at UCLA film school and became associated with the Ethno-Communications program, with which African American filmmaker Charles Burnett and Chicano filmmaker David Garcia, among other artists of color, were also affiliated. Nakamura, individually and with his

collaborators at VC, created landmark films exploring the Asian American experience. The morass of Vietnam and the legacy of the World War II incarceration were the crucial backdrop. It is no coincidence that VC's initials also held significance in contemporary parlance for the Viet Cong. *Manzanar* (1972), which Nakamura produced as part of his MFA thesis, meditatively explores the physical terrain of the former concentration camp site to mine the psychic, political, and emotional toll of the incarceration and its aftermath. The introspective tone, combined with its searing political indictment, has been an influential model of filmic exposition.[4] *Wataridori: Birds of Passage* (1974), a documentary produced under the auspices of VC, represents a hallmark of Nakamura's and the VC's practice. It focuses on the first-person perspectives and lives of Japanese immigrants and tacitly argues that a fuller picture of the collective American experience can emerge from individual stories of ordinary people.

As a community-focused educational organization, VC envisioned media as a key vehicle for community empowerment and the development of grassroots critique in photography, audio, film, and video. With the VC's founding, Nakamura and his cohorts collected old family photographs to establish a photo archive and organized an influential exhibition about the World War II experience, innovatively designed using cubes for easy transport to and installation at community centers, libraries, and colleges. In 1980, VC produced its first feature-length film, *Hito Hata: Raise the Banner*, which charts the life of a Japanese immigrant bachelor against the sweep of the twentieth century. (I had the job of making origami paper cranes for a climactic scene and appeared as an extra. My role: Japanese American Girl.)

4 In 1969, Nakamura and my father joined a group of former inmates and activists for the first official pilgrimage to Manzanar. For more on this event and its significance, see *Pilgrimage* (2007), directed by Robert Nakamura's son, Tadashi Nakamura.

David Hammons in his Los Angeles studio, 1970, with *Pray for America* (1969) visible at left and a portion of *The Wine Leading the Wine* (ca. 1969) at right. Photo: Robert A. Nakamura

Betye Saar in her Los Angeles studio, 1970, holding *Black Girl's Window* (1969) and with *View from the Palmist Window* (1966) visible behind her at left. Photo: Robert A. Nakamura

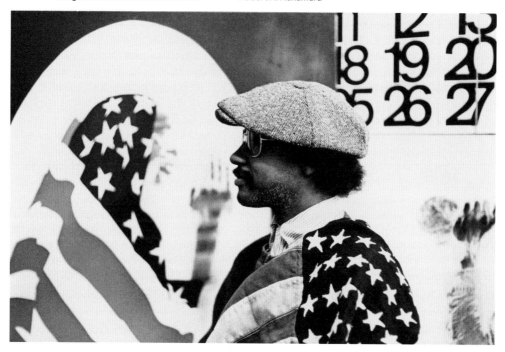

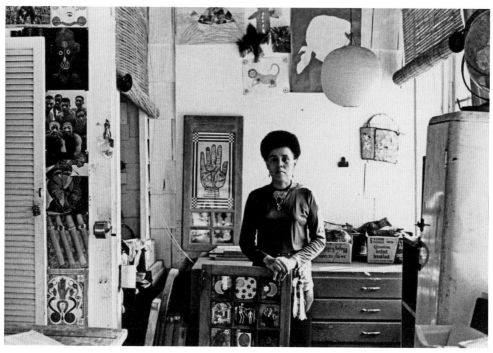

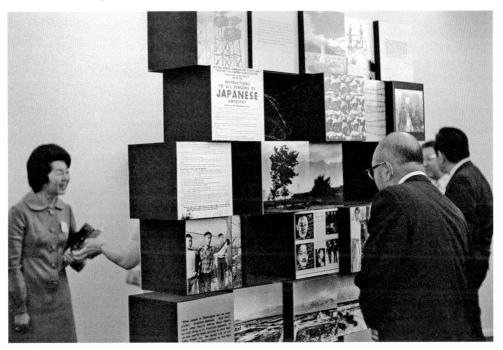

Visual Communications, *America's Concentration Camps*, 1970. Modular exhibit by Robert A. Nakamura and Alan Ohashi, dimensions variable

Kazuo Higa (left) with artist Oliver Nowlin, ca. 1970s

While Nakamura's stature as a pioneering Asian American filmmaker and community activist is without question, the portraits he made for *Black Art in L.A.* demonstrates a crucial, if little understood, aspect of the city's cultural terrain. Theorists of Los Angeles have characterized it as a dispersed, disintegrated, and fragmented metropolis, deeply divided socially and too disjointed to generate a vital public life.[5] Even if one accepts this dystopic vision of the city, there are moments of cross-cultural flowering, often in modest places such as the Da Vinci Gallery at LACC. My father understood this and so did Nakamura. In his photographs of Saar, Outterbridge, and others, the artists are portrayed as commanding their creative space and image, claiming a place for themselves and their art.

5 Robert M. Fogelson, *The Fragmented Metropolis: Los Angeles, 1850–1930* (Berkeley: University of California Press, 1983).

Use-Value:
Value:
Art
Museums
and
Humanistic
Study
in the
University

Do the humanities have to be useful? In considering this question, I wonder if the work of museums, broadly defined to encompass institutions that collect and interpret art and where the rigors of the humanities find an applied outcome, might provide an answer. My opinions are decidedly partisan. I have worked in museums for half my life. Even more prosaically, I find the direct encounter with art to be immensely satisfying. Museums are fundamentally engaged with humanistic pursuits. They probe the meaning of art and objects, suggest comparison through physical juxtaposition, and situate objects within different historical and cultural frameworks. Museums participate in judgments of value that derive from particular points of view. Scholarship engaged with interrogating the cultural assumptions of museums, their participation in advancing colonial and nationalistic agendas, and involvement in illicit trade, cultural patrimony, and war booty, for example, have invigorated the field of art history since the mid-1980s.[1]

At their ideal, exhibitions—from permanent collection installations to temporary displays—are arguments that unfold through the space of galleries with objects and exhibitionary frameworks serving as nodes in the debate. Even if viewers gloss over the finer points of an exhibition or miss its intentions entirely, engagement can occur in minute interactions. "Why is *that* work here?" "This one is beautiful," and "I don't get it" are responses that begin to question or agree with curatorial premises. If the creation of a work of art is a practice, the practice of making arguments through exhibitions (curating) is the *interrogation* of a practice, in this case that of making art. This interrogation is the primary work of the humanistic

critic, Michael Wood suggests.[2] As largely public and accessible spaces, museums are places where (ideally speaking, that is) visitors enact that very same process of questioning, becoming the critic of the critic.

Visits to museums are voluntary (one can think of school tours as an exception). Indeed, the discourse around adult museum visitorship often suggests that other forms of leisure, such as attending a sporting event or taking in a movie, are directly competing with seeing an exhibition. There is no question that overall attendance at museums has declined after decades of incremental increases. The National Endowment for the Arts (NEA) 2009 quinquennial report on arts participation lamented this fact. The study found that the rate of attendance for art museums in the United States fell from a high of 26 percent of American adults in the period between 1992 and 2002 to 23 percent in 2008, a drop to 1982 levels.[3] In raw

1 The following anthologies provide a snapshot of key debates: *Exhibiting Cultures: The Poetics and Politics of Museum Display*, ed. Ivan Karp and Steven D. Lavine (Washington, DC: Smithsonian Institution Press, 1991); Bruce W. Ferguson, Reesa Greenberg, and Sandy Nairne, *Thinking about Exhibitions* (London: Routledge, 1996); and Kate Fitz Gibbon and American Council for Cultural Policy, *Who Owns the Past?: Cultural Policy, Cultural Property, and the Law* (New Brunswick, NJ: Rutgers University Press, 2005).
2 Michael Wood, "A World without Literature?," *Daedalus* 138, no. 1 (Winter 2009): 58.
3 National Endowment for the Arts, *Arts Participation 2008: Highlights from a National Survey*, June 15, 2009. The effect of declining attendance on specific institutions is more difficult to parse. At the end of 2009, the *Art Newspaper* surveyed twenty American museums and found that the largest and most notable among them actually experienced a rise in attendance from the previous year, with museums that exhibited contemporary art demonstrating the most significant increases. *Art Newspaper*, no. 208 (December 2009). The popularity of contemporary art within the academy can be seen as a related effect. If sessions at the

numbers, this translates into nearly 6.75 million fewer American adults visiting a museum. But considered from another angle, what is astounding in the NEA study is that nearly fifty-eight million people *chose* to attend a museum. Given the commonplace rumblings about the decline of the humanities in American life, the fact that so many Americans opted to participate in what is an essentially humanistic practice should be cause for serious recognition if not celebration. (Factoring in student attendance and repeat visits, the American Association of Museums suggests that the number of visits is 850 million—more than all major league sporting events and amusement park visits combined.) Of course, quantitative metrics provide only one measurement. These numbers do not tell us about the quality of individual experience or whether more time was spent partaking in those increasingly prevalent ancillary aspects of the museum: shopping and dining.

The raw number does provide numerical evidence of the museum's baseline utility. It is a place where millions of people go. It is an economic engine. In 2008, American museums made a direct contribution to the U.S. economy in the amount of $20 billion (counting direct expenses such as salaries and purchases; the addition of indirect expenses would increase that amount by billions). Museums employ four hundred thousand people. They generate tax revenues and serve as tourist destinations. On the qualitative side, even without data as proof, one can assume that these millions of people go to museums because they enjoy it, because they find in it something of value, whether a source of personal enlightenment or some form of cultural capital.

University art-history departments would do well to recognize that engagement with and research in the humanities happen in many places outside their walls and to identify ways to link their seemingly unapplied study in the classroom to application in the world beyond. The argument that humanities study has direct usefulness can be appealing to parents who pay for their child's expensive education and for the student who is concerned about

paying off debts or simply preoccupied with getting a job. Of course, this already happens in various forms, more often through informal initiative rather than institutional or disciplinary practice. To take just one example of lacunae within the university: in an evaluation of an art-history department's success in job placement of its graduate students, only teaching positions within academia are counted, suggesting that the myriad range of other jobs in the broad field of art criticism and art history are not of consequence. Of course, if one presumes that the goal of graduate training is to create university educators, it is an appropriate measurement of success. So the question needs to be reframed: Is the reproduction of university teachers the sole goal of the humanistic study of art and if so how might it affect undergraduate education? Dominic Boyer argues that it is essential for humanities scholars to become better translators and public intellectuals in the many worlds outside university culture.[4] Recognizing that the work of humanities practitioners occurs in the museum is surely one way to heed his call.

Humanistic Study in the University and in the Museum

In the drive to answer the question of whether the humanities must be useful, I am forced to consider my own trajectory. After working as a museum curator and administrator at the Japanese American National Museum for more than fifteen years, I returned to the university for graduate training in art history. If art historical research, interpretation, and the transmission of knowledge can occur outside the university, then why did I return to it? It might seem to be for the utilitarian reason of credentials or a career change from museums to the academy. While certainly a PhD is required for permanent teaching positions, the longer one has worked in museums, the less impact a graduate degree will make on professional opportunities in the field. The lack of a PhD has not radically affected my ability to publish, secure employment or external grants, or serve on review committees and editorial

boards. Arguably, by taking myself out of curatorial work for the six years it takes to complete a PhD, I have done a disservice to my "career" as a curator. But if one sees humanistic study beyond its immediate instrumental value, the university affords opportunities largely unavailable elsewhere. I found the university context to be the only viable place where I could create rigorous, challenging, and cross-disciplinary work that has no *immediate* application.

What humanistic study in the university uniquely fosters is the opportunity to engage in unapplied research, which is not to say that it will not be useful at some future date. The humanities may engage in the transmission of knowledge, but their central reason for being is the act of analysis, a mode of criticism that "rearranges understanding rather than increases it."[5] Furthermore, this action is capable of informing and being applied to *unanticipated* conditions. Here Dominick LaCapra's distinction between what he calls problems and puzzles can help illuminate the differences.[6] Puzzles are questions that can be answered, with a solution that often has an immediate use. His examples include the dating of a document, the attribution of a text, and the identification of a reference or allusion. On the other hand, there are "problems or processes" that cannot be answered by a definitive solution. They may be elucidated but not necessarily solved. Those he identifies in this category are various and somewhat incommensurate: trauma, gift giving, and works of art, to name just a few. Analyzing these "problems" are an essential aspect of humanistic studies, LaCapra argues, because the university affords opportunities for cross-disciplinary assessment that is not narrowly utilitarian but instead allows "one to intervene in, or contribute to, an open, questioning, and self-questioning process of inquiry as well as implicate the self in relation to those processes."[7] LaCapra goes further to suggest that cross-disciplinarity does not simply mean combining existing disciplines (interdisciplinarity) to provide better answers to existing questions. Rather, he argues that a cross-disciplinary approach explores problems that span multiple

disciplines and hence require refraction through different frames of analysis. Humanistic texts—in my case, works of art—are significant in ways that exceed any particular discipline. Another way to consider the humanities in the university centers on what Jeffrey Nealon calls research as innovation. Innovation doesn't mean just identifying new things in a lab; it also entails rearranging existing ideas and objects to create new, previously unforeseeable understandings.

By way of contrast, it may be helpful to return to the workaday function of museums. It is virtually impossible in twenty-first-century museums to conduct research that does not have a stated application, even if such a use-value is scheduled for an unknown future date.[8] One conducts humanistic study in museums with an eye toward two primary applications: an acquisition for the collection and necessary research for exhibitions. Both the acquisition of objects for the collections and the production of exhibitions provide the building blocks for knowledge creation. They hinge on specific, tangible actions and require fundamental conditions: there must be items to acquire or objects

(cont.) College Art Association annual conference are any indication, the number of graduate students interested in contemporary art has induced anxiety among more "traditional" fields of art historical study.

4 Dominic Boyer, "Do the Humanities Have to Be Useful?," in *Do the Humanities Have to Be Useful?*, ed. G. Peter Lepage, Carolyn (Biddy) Martin, and Mohsen Mostafavi (Ithaca, NY: Cornell University, 2006), 3.

5 Wood, "A World without Literature," 59.

6 Dominick LaCapra, "What Is Essential to the Humanities?," in Lepage, Martin, and Mostafavi, *Do the Humanities Have to Be Useful?*, 76–77.

7 Ibid., 77.

8 Although beyond the scope of this paper, the surging commercialism in and business approach taken by universities, which Christopher Newfield has studied, find parallels in museums. See Christopher Newfield, *Unmaking the Public University: The Forty-Year Assault on the Middle Class* (Cambridge, MA: Harvard University Press, 2008).

to exhibit. This is perhaps an obvious statement but one that is often overlooked. What if works of art are absent, either because they no longer exist or because they have yet to be found? What if one is concerned with questions of a primarily discursive nature that span multiple disciplines and subjects? The exhibition format may not be the best way to tackle these questions— at least not at the outset. In the university, these conditions are not obstacles.

My Dissertation Research

In 1992, I organized an exhibition of paintings, drawings, prints, and sculpture from the World War II incarceration of Japanese Americans. The standard assumption within the field of ethnic studies was that incarcerated Japanese Americans took up arts activity as a means to interpret their experiences, pass the time, and create objects of utility and beauty. This theory bears out in my research. However, a question arose that centered not on *what* was created but rather *who* did the making. It turned out these people were artists, who were self-identified, trained, and circulated in the world as artists. They exhibited in the major cultural institutions of the period, were friends and associates with non-Asian artists, and were recognized in the popular press and arts journals. They inhabited this identity and practiced as artists before World War II, an era characterized by rampant institutionalized racism. After the war, their work essentially dropped out of circulation and their legacies were largely overlooked. Their very existence challenged the knowledge base of the two disciplines in which my curatorial work was framed since the discourse of art history and the burgeoning field of ethnic studies both presumed that there were no Asian American artists of consequence in the pre–World War II period. When their artwork was acknowledged, it was most often lumped under the rubric of "arts and crafts," a phrase commonly used to suggest either handicrafts and the decorative arts or the work of naïve, untrained makers rather than professional artists working in the high-art traditions of painting and sculpture.

In the intervening years since that first exhibition of art from the incarceration, I explored aspects of the prewar legacy of Japanese American art in exhibitions, collections acquisitions, and essays. This led me to a focused study on the artistic activity between the two world wars in Little Tokyo, a dynamic nexus of artists, art, audiences, and intellectual exchange that has import beyond a discussion of a particular ethnic group, because it shapes an understanding of American art and the place of Los Angeles in the early twentieth century. The artists in Little Tokyo grappled with what it meant to be "modern." They explored the contours of modernist form in their art and thereby narrated a different, messier version of early twentieth-century American art, in particular of what we call "modernism." An analysis of pre–World War II Los Angeles enables a consideration of cosmopolitan culture, decentralized urbanism, and nascent transnational contexts as defining elements of American modernity. It is precisely because Los Angeles sits at the periphery of conventional discourses of American art and because Japanese American artists are peripheral to the conventional narratives of Los Angeles that their art, interactions, and milieu shed light on the pressures, fissures, and issues surrounding American art and cultural production in the interwar period.

My study sits at the intersection of several strands of scholarship. Art history and Asian American studies are the two obvious ones, but studies of Los Angeles and histories of the American West are others. The artists of Little Tokyo do not easily fit into the standard trajectories of these disciplines, especially American art history, but they also do not conform to assumptions about the early Asian American immigrant as laborer or member of an oppressed minority group. Japanese American artists may have been restricted in the social and political sphere, but their art found a receptive audience in such far-flung places as New York, London, Mexico City, Budapest, and Tokyo just as it did closer to home, whether through an exhibition at the Los Angeles Museum of Science, History and Art; at a night club in Chinatown; or in the

home of a Hollywood star. The nation of Japan and its growing presence on the international political stage presented a challenge to Western dominance, but "Japan" also existed as an idea—an Oriental fantasyland—that could be found both across the ocean and around the corner in the form of Little Tokyo. Scholars have explored the constitutive role that Japanese art and aesthetics played in the formation of European and American modernism from the mid-nineteenth century onward. By virtue of ancestry, Japanese American artists had a special relationship—whether perceived or real—to "things Japanese" that situated their work in this broader intellectual and aesthetic context. Hence, my dissertation engages in a complex exploration of the role that Asian Americans played in the development of American Orientalism. At the same time, it counters a tendency in Asian American studies to focus on the effects of exclusion.

On the face of it, these research interests seem tailor-made for the mission of the Japanese American National Museum, yet I realized that it would not be possible to execute this study in the context of the museum for three simple reasons. First, I became interested in art that often did not exist as tangible object. Instead, it appeared as a picture in a period publication, as a listing in a catalogue, or as a description in a newspaper. Second, since the questions I asked moved me through different fields of thought, I was unwilling to remain in one area of study. This cross-disciplinary approach took on an increasingly discursive cast. Finally, I struggled to find an *immediate* application to the primary tasks in the museum: collecting and exhibiting.

Gardener by Day, Artist by Night

The story of Harry Hayashida, one artist in my study of artistic activity in interwar Los Angeles, demonstrates the necessity of examining a life from a cross-disciplinary perspective. Through the framework of ethnic studies, his life exposes the struggles of Japanese immigrant life. From another, it illuminates aspects of American modernism. Taken together, these two frames allow us to consider broader questions (or "problems," to use LaCapra's language) of cultural production, globalism, and art making in early twentieth-century America.

One Narrative: Hayashida was born in Utah in 1905, the child of Japanese migrants who intended to return to their country after making their fortune in America. As was common in the period, when Hayashida reached school age he was sent to Japan to be educated and cared for by grandparents. After finishing secondary school, when it became clear that his parents were staying in the United States, he returned and settled in Los Angeles. He joined a cohort of Japanese Americans known as kibei, American-born, but educated in Japan, a group which garnered the attention of anthropologists who were working within the context of ethnic studies beginning in the 1980s.[9] By law, the kibei were American citizens, but their acculturation in Japan and their limited English-language skills created a hybrid identification. Job prospects for university-educated Japanese American men were extremely limited; occupational opportunities for someone without American educational credentials or English fluency, like Hayashida, were even more restricted. Hayashida hung out in Little Tokyo and eventually landed a job as a groundskeeper for the Chapman Park Hotel complex, which consisted of an upmarket, multistory masonry structure, Spanish "pueblo-type" bungalows, and a "Mexican rural" church set in the five acres of gardens on Wilshire Boulevard a few blocks from the Ambassador Hotel.[10]

9 See Jere Takahashi, *Nisei/Sansei: Shifting Japanese American Identities and Politics* (Philadelphia: Temple University Press, 1997).
10 These descriptions come from "How Extensive Pueblo Project on Wilshire Boulevard Will Appear When Completed," *Los Angeles Times*, May 24, 1936, E1. The array of architectural styles highlights the degree to which the vernacular architecture of Los Angeles trafficked in romantic notions of its Spanish and Mexican colonial past. In 1969, the hotel was replaced by the Equitable Plaza, a modernist high-rise office complex.

Harry Hayashida, *Untitled*, ca. 1938.
Toned bromide print, 20 × 16 inches

The stereotype—and later cachet—of the aesthetically endowed, reliably humble Japanese gardener was already circulating in prewar California. Indeed, a leaflet from the anti-Japanese "Swat the Jap" campaign highlights the gardener in defining the limits of acceptance of Japanese immigrants in 1920s Los Angeles:

> JAPS
> You came to care for lawns,
> we stood for it
> You came to work in truck gardens,
> we stood for it
> You sent your children to our
> public schools,
> we stood for it
> You moved a few families in our midst,
> we stood for it
> You proposed to build a church in
> our neighborhood
> BUT
> We DIDN'T and WE WON'T STAND
> FOR IT…SO GET BUSY, JAPS, AND
> GET OUT OF HOLLYWOOD[11]

Hayashida's work in the ethnically defined, occupational niche of gardening provided a stable foothold. His wages as a gardener gave him the resources, and his citizenship enabled him to purchase a home in south Los Angeles, but on the face of it Hayashida lived a circumscribed and seemingly unremarkable life. Other than when incarcerated during the war, he tended the grounds of the Chapman Park Hotel (until it was razed in 1969) and resided in the same house (until his death in 2005).

Hayashida's experiences can be easily marshaled to narrate the history of an immigrant community in Los Angeles, the institutional and social discrimination they faced, the complexity of their acculturation and identification in an American context hostile to their presence, and the push-pull of cultural stereotypes—themes in fact that early Japanese American studies explored. The restrictions faced by Hayashida and Japanese Americans like him served as the proof of anti-Asian bias.

Another Narrative: In a photograph simultaneously pastoral and industrial, water trickles from a pipe into a shallow pond, generating concentric circles that radiate outward before fading into the distance. Elongated bulrush anchors an upper corner; a few of its strands reflect a source of light, giving depth to the shadowy mass. A bent reed punctuates the lower register of the photograph and functions as a counterbalancing line to the pipe, adding dynamic tension to the serene subject. Along the water's surface, an amorphous shape of white air bubbles breaks the geometry and echoes a whitish area above—perhaps the reflection of clouds. With its tranquil repose and subtle geometric patterning, this untitled photograph by Harry Hayashida evokes both a Japanese garden and the graphic, flattened pictorial space of Japanese woodblock prints. The spout in a Japanese garden would be bamboo; here, the corroded surface of the metal pipe adds a jarring industrial edge.

By exploring subject matter and formal approaches influenced by Japanese art, Japanese American photographers became influential in American photographic circles of the interwar period. The editors of the American Annual of Photography wrote in 1928, "The influence of this group on our Pacific coast has put a lasting mark on photography in this country, the repercussions of which are echoing through the world."[12] Most of these photographs by Japanese American artists that reverberated through the interwar period are now lost.

11 "Swat the Jap" leaflet, quoted in Roger Daniels, *The Politics of Prejudice: The Anti-Japanese Movement in California and the Struggle for Japanese Exclusion* (Gloucester, MA: Peter Smith, 1996), 97. Daniels indicates that a copy of the flyer is in the files of the California Joint Immigration Committee, Documents Division, University of California Library, Berkeley.

12 *The American Annual of Photography* (Boston: American Photographic Publishing, 1928), quoted in Michael G. Wilson and Dennis Reed, *Pictorialism in California: Photographs, 1900–1940* (Malibu, CA: J. Paul Getty Museum, 1994), 84.

A few remain. Harry Hayashida and his fellow Japanese American photographers in Los Angeles's Little Tokyo were among those who exhibited their work in national and international contexts, demonstrating how the works of art circulated in ways that the artist could not. The verso of this photograph shows a startling international trajectory: exhibition labels from shows in San Francisco, Tokyo, Budapest, and Buffalo. The rich tonalities of the bromide photographic print shares a mood recognizably linked to pictorialist photography. Its technical acumen underscores Hayashida's interest in the craft of photography where the success of the ultimate artwork hinged on both image (the content) and object (the form that the content takes).

Not only were Hayashida and his circle of Japanese American photographers making work, they were engaged in the broader milieu of art in Los Angeles. In 1925, an exhibition of Edward Weston's photographs opened in Los Angeles's Little Tokyo. In his daybooks, Weston enthusiastically recounted the positive reception he received from his Japanese American audience:

> The exhibit is over. Though weary, I am happy. In the three days I sold prints to the amount of $140.— American Club Women bought in two weeks $00.00—Japanese men in three days bought $140.00! One laundry worker purchased prints amounting to $52.00—and he borrowed the money to buy with! It has been outside of Mexico my most interesting exhibition. I was continually reminded of Mexico, for it was a man's show. What a relief to show before a group of intelligent men! If Los Angeles society wishes to see my work after this, they must come to the Japanese quarter and rub elbows with their peers— or no—I should say their superiors![13]

The painters, poets, musicians, and photographers of Little Tokyo met to discuss and debate art and theory, and occasionally held exhibitions of their own work and that of others, like Weston. They were far from an obscure or marginal group. Their activities received notices in both Japanese-language newspapers and the mainstream press with the *Los Angeles Times* art critic Arthur Millier a frequent commentator on the group's projects. With their discerning eye and willingness to buy art despite limited financial resources, the Japanese men of Little Tokyo were intellectually superior to the Los Angeles elite in Weston's estimation.

How can one reconcile these seemingly disparate narratives of a single person's life? Through one narrative, Hayashida's life was circumscribed by racial exclusion and limited opportunities. But an examination of his art and his connection with other artists suggests an entirely different story. The relationship between the material and political conditions of Hayashida's life—his Japanese ancestry, which limited job prospects and his ability to travel across social and national borders and, during World War II, subjected him to incarceration—and that of his artwork are asymmetrically linked. On the most fundamental level, *the very same person* is the subject of discussion. But the life of the man and the artwork exist in different registers, registers that ask different sets of questions and, necessarily, provide different answers. No single aspect represents the correct "explanation" of his life. This is what LaCapra means when he writes of "problems." There is no one answer. Rather the very incommensurability of the two registers underscores the complexity of what humanistic study aims to enact: to interpret contingent data, to cross boundaries of disciplinary frameworks, and to question the past in ways that enable other possible futures.

The idea of possible futures raises the key question of time. I began this text by posing the question, Do the humanities have to be useful? By considering museums as places where humanistic inquiry happens both for the people who produce the work of museums and the millions who engage with it as audience, I demonstrated one instance where the humanities

have an applied and tangible outcome. But in recounting my own return to the university, I aimed to show the limits of emphasizing immediate use. Humanistic study in the university affords the latitude of intellectual inquiry where complex problems can benefit from cross-disciplinary questioning free from the strictures of direct application. This is a promise of humanistic studies in the university. It can be useful, but in ways that are unpredictable and that unfold over time.

13 Edward Weston, *The Daybooks of Edward Weston*, vol. 1, *Mexico*, ed. Nancy Newhall (New York: Aperture, 1990), 121–22.

Bibliography

"The Artist as Traveler." In *SITEseeing: Travel and Tourism in Contemporary Art*, 2–7. Exhibition brochure. New York: Whitney Museum of American Art, 1991.

"The View from Within." In *The View from Within: Japanese American Art from the Internment Camps, 1942–1945*, edited by Karin Higa, 21–44. Los Angeles: Japanese American National Museum, UCLA Wight Art Gallery, and UCLA Asian American Studies Center, 1992. ★

"Mapping from the Cultural Cringe: A Roundtable Discussion with Michael Dear, Ann Goldstein, Karin Higa, and Stephen Prina." In *LAX/94: The Los Angeles Exhibition*, edited by Catherine Gudis and Sherri Schottlander, 9–23. Los Angeles: LAX Los Angeles Exhibition, 1994.

"Some Notes on an Asian American Art History." In *With New Eyes: Toward an Asian American Art History in the West*, edited by Irene Poon Anderson, Mark Johnson, Dawn Nakanishi, and Diane Tani, 11–14. San Francisco: San Francisco State University, 1995. ★

"Relics from Camp." In *Relics from Camp: An Artist's Installation by Kristine Yuki Aono and Members of the Japanese American Community*, 2–4. Exhibition brochure. Los Angeles: Japanese American National Museum, 1996.

"Some Thoughts on National and Cultural Identity: Art by Contemporary Japanese and Japanese American Artists." *Art Journal* 55, no. 3 (Autumn 1996): 6–13. ★

Karin Higa and Claudia Sobral. "Finding Family Stories." *Japanese American National Museum Quarterly* (Winter 1996): 3–8.

"*Flower Drum Song* Revisited." master's thesis, University of California, Los Angeles, 1997.

"From Enemy Alien to Zen Master: Japanese American Identity in California during the Postwar Period." In *Asian Traditions/Modern Expression: Asian American Artists and Abstraction, 1945–1970*, edited by Jeffrey Wechsler, 190–93. New York: Abrams, 1997. ★

"Finding Family Stories." In *Finding Family Stories: An Arts Partnership Project 1995–1998*, edited by Charlotte Hildebrand, 81–87. Los Angeles: Japanese American National Museum, 1998.

"Bruce and Norman Yonemoto: A Survey." In *Bruce and Norman Yonemoto: Memory, Matter and Modern Romance*, edited by Karin Higa, 8–37. Los Angeles: Japanese American National Museum, 1999. ★

"'Out of the Headlines': *Little Tokyo, U.S.A.* and Representations of the Japanese American Internment." Unpublished manuscript, 1999.

"The Permanent Collection and Re-Visioning Mazanar." *Japanese American National Museum Quarterly*, special opening-year issue (1999): 21–22. ★

Karin Higa and Tim B. Wride. "Manzanar Inside and Out: Photo Documentation of the Japanese Wartime Incarceration." In *Reading California: Art, Image, and Identity, 1900–2000*, edited by Stephanie Barron, Sheri Bernstein, and Ilene Susan Fort, 315–37. Los Angeles: Los Angeles County Museum of Art; Berkeley: University of California Press, 2000. ★

Introduction. In *Henry Sugimoto: Painting an American Experience*, edited by Kristine Kim, ix–xiv. Los Angeles: Japanese American National Museum; Berkeley, CA: Heyday Books, 2001. ★

Introduction. In *Living in Color: The Art of Hideo Date*, edited by Karin Higa, 7–24. Los Angeles: Japanese American National Museum; Berkeley, CA: Heyday Books, 2001. ★

Karin Higa and Sally Stein. Interview with Ruth Asawa. Unpublished manuscript, September 7, 2001.

"What Is an Asian American Woman Artist?" In *Art/Women/California, 1950–2000: Parallels and Intersections*, edited by Diana Burgess Fuller and Daniela Salvioni, 81–94. Berkeley: University of California Press, 2002. ★

Karin Higa and Noel Korten. Introduction. In *C.O.L.A 2002 Individual Artist Fellowships*, 5–7. Los Angeles: City of Los Angeles Cultural Affairs Department, 2002.

"The Right to Make Waves: Lincoln Tobier's Radio Projects." In *Radio L'dA*, edited by Yvane Chapuis, 35–39. Paris: Les Laboratoires d'Aubervilliers, 2003.

Sights Unseen: The Photographic Constructions of Masumi Hayashi, n.p. Exhibition brochure. Los Angeles: Japanese American National Museum, 2003. ★

"Toyo Miyatake and 'Our World'" [abbreviated version of "Manzanar Inside and Out"]. In *Only Skin Deep: Changing Visions of the American Self*, edited by Coco Fusco and Brian Wallis, 335–43. New York: Abrams; New York: International Center for Photography, 2003.

"Interested in Signs: Sam Durant in Conversation with Karin Higa." In *The Wrong Gallery*, edited by Maurizio Cattelan, Massimiliano Gioni, and Ali Subotnick, n.p. New York: Wrong Gallery, 2004.

"History Detective: Solving the Mystery Behind the Painting." *Japanese American National Museum Member Magazine* (Winter 2005): 8–9.

"California Registered Historical Landmark no. 850." In *Andrew Freeman (Manzanar) Architectural Double*, 13–15. Los Angeles: Center for Land Use Interpretation/ RAM Publications, 2006. ★

"Inside and Outside at the Same Time." In *The Sculpture of Ruth Asawa: Contours in the Air*, edited by Daniell Cornell, 30–41. Berkeley: University of California Press, 2006. ★

"Origin Myths: A Short and Incomplete History of Godzilla." In *One Way or Another: Asian American Art Now*, edited by Melissa Chiu, Karin M. Higa, and Susette S. Min, 21–25. New York: Asia Society; New Haven, CT: Yale University Press, 2006. ★

"François-Thomas Germain's *Machine d'Argent* in the J. Paul Getty Museum." Unpublished manuscript, December 4, 2006.

"In, around, and from the City: Araki Nobuyoshi's Satchin and Mabo and Yōko." Unpublished manuscript, May 4, 2007.

"Untitled" [Michio Ito]. Unpublished manuscript, December 11, 2007.

"Hidden in Plain Sight: Little Tokyo Between the Wars." In *Asian American Art: A History, 1850–1970*, edited by Gordon H. Chang, Mark Dean Johnson, and Paul Karlstrom, 31–53. Palo Alto, CA: Stanford University Press, 2008. ★

"Kevin J. Miyazaki, Home: Known and Unknown." In *Fellowships for Individual Artists 2007*, n.p. Milwaukee: Greater Milwaukee Foundation, University of Wisconsin, Milwaukee, 2008.

"Michael Arcega in Conversation with Karin Higa." In *California Biennial*, edited by Lauri Firstenberg, 38. Newport Beach, CA: Orange County Museum of Art, 2008.

"The Search for Roots, or Finding a Precursor." In *Asian/American/ Modern Art: Shifting Currents, 1900–1970*, edited by Daniell Cornell and Mark Dean Johnson, 15–20. Berkeley: University of California Press, 2008. ★

"Paintings from the Margin: Diego Rivera's Cubism." Unpublished manuscript, March 31, 2008.

"Japonisme: The Impact of Japanese Aesthetics in Europe and the United States." Unpublished manuscript, May 2, 2008.

"Enemy Alien/Cultural Interpreter: Race and Visual Culture in Little Tokyo, Los Angeles, in the Interwar Period." Unpublished manuscript, December 15, 2008.

"Living Flowers." In *Living Flowers: Ikebana and Contemporary Art*, edited by Karin Higa, 4–13. Los Angeles: Japanese American National Museum, 2009. ★

"Beyond East and West." In *Isamu Noguchi: Between East and West*, edited by Kyriakos Koutsomallis, 61–68. Turin, Italy: Umberto Alemandi; Andros, Greece: C. and Basil & Elise Goulandris Foundation, 2010. ★

"Chapter Six: Creativity." In *Los Angeles's Little Tokyo*, edited by Little Tokyo Historical Society, 105–27. Charleston, SC: Arcadia Publishing, 2010.

"Barbed Wire and Barracks: Roger Shimomura's Paintings and Collections." In *Shadows of Minidoka: Paintings and Collections of Roger Shimomura*, 13–19. Lawrence, KS: Lawrence Arts Center, 2011. ★

"Black Art in L.A.: Photographs by Robert A. Nakamura." In *Now Dig This! Art and Black Los Angeles, 1960–1980*, edited by Kellie Jones, 51–55. Los Angeles: Hammer Museum; New York: DelMonico Books · Prestel, 2011. ★

"Use-Value: Art Museums and Humanistic Study in the University." Unpublished manuscript, June 24, 2011. ★

"Conversation 2: Asian American Community. Kyung Sun Cho, Karin Higa, Candace Lee, Ann Page, Kim Yasuda and Notes from May Sun." In *Personal Voices/ Cultural Visions: Conversations in the Visual Arts Community, Los Angeles 1994–1996*, edited by Ann Isolde, 44–83. Los Angeles: Southern California Women's Caucus for Art, 2018.

"Little Tokyo, Los Angeles: Japanese American Art and Visual Culture, 1919–1945." PhD diss. [unfinished], University of Southern California, typescript.

★ Reprinted in this book

Photo Credits

Introduction:
The Making of Karin Higa
p. 15
top: Japanese American
National Museum (Gift of Jack
and Peggy Iwata, 93.102.102)
bottom: Farm Security
Administration and Office of
War Information Collection
(Library of Congress).
Lee Russell, photographer
[LC-DIG-ppmsca-38735]

p. 17 (top and bottom)
Courtesy Karen Ishizuka

p. 18
UCLA Asian American Studies
Center, Gidra Photo Collection

pp. 20, 23
Courtesy Laura Kina

p. 26
Photo: Joshua White/JWPictures

The View from Within:
Japanese American Art
from the Internment Camps,
1942–1945
p. 36
Chiura Obata papers, 1891–
2000, Archives of American Art,
Smithsonian Institution

p. 37
Courtesy Estate of Chiura Obata

p. 39
top: Smithsonian Institution
Archives, Image #2020.72.2,
gift of Estate of Chiura Obata
bottom: Courtesy Estate of
Chiura Obata

p. 40
Japanese American Research
Project (Yuji Ichioka) collection
of material about Japanese in the
United States, 1893–1977, UCLA
Library Special Collections

p. 41
Japanese American National
Museum (Gift of Ibuki Hibi Lee,
99.63.17), image courtesy Fine
Arts Museums of San Francisco

p. 42
Japanese American National
Museum (2015.100.44)

p. 43
Japanese American Research
Project (Yuji Ichioka) collection
of material about Japanese in the
United States, 1893-1977, UCLA
Library Special Collections

p. 44
Fine Arts Museums of San
Francisco, Achenbach Foundation
for Graphic Arts, 1963.30.3126.23;
image courtesy the Fine Arts
Museums of San Francisco

p. 45
Japanese American National
Museum (Gift of Ibuki Hibi Lee,
96.601.43)

p. 46
Japanese American National
Museum (Gift of Ibuki Hibi Lee,
96.601.1)

p. 47
Japanese American National
Museum (Gift of Ibuki Hibi Lee,
99.63.1)

p. 48
Japanese American National
Museum (2015.100.45)

pp. 49, 74
U.S. National Archives and
Records Administration

p. 50
Japanese American National
Museum (Gift of Miné Okubo
Estate, 2007.62.14)

p. 51
top: Japanese American National
Museum (Gift of Miné Okubo
Estate, 2007.62.36)
bottom: Japanese American
National Museum (Gift of Miné
Okubo Estate, 2007.62.82)

pp. 52–53
Courtesy Irene Tsukada Simonian,
Bunkado, Inc., Los Angeles,
photo: Joshua White/JWPictures

p. 54
Courtesy Irene Tsukada Simonian,
Bunkado, Inc., Los Angeles,
photo: Joshua White/JWPictures

p. 56
Japanese American National
Museum (Gift of Kayoko Tsukada,
92.20.3)

p. 57
Courtesy Irene Tsukada Simonian,
Bunkado, Inc., Los Angeles, photo:
Joshua White/JWPictures

p. 59
George Biddle papers, Box 14,
the Library of Congress
Manuscript Division,
Washington, DC

p. 60
TOMO Foundation Collection,
courtesy California State
University, Fresno, photo:
Tom Parker

p. 61
Japanese American National
Museum (Gift of Madeleine
Sugimoto and Naomi Tagawa,
92.97.5)

p. 63
top: Gift of Kamekichi Tokita,
Seattle Art Museum
bottom: Eugene Fuller Memorial
Collection, Seattle Art Museum

p. 64
Tacoma Art Museum, The George
and Betty Nomura Collection,
2013.7.2

p. 65
Courtesy Manzanar National
Historic Site and the Kango
Takamura Collection, Denshō:
The Japanese American
Legacy Project

p. 66
Courtesy Manzanar National
Historic Site and the Kango
Takamura Collection, Denshō:
The Japanese American
Legacy Project

p. 68
Japanese American National
Museum (Gift of June Hoshida
Honma, Sandra Hoshida,
and Carole Hoshida Kanada,
97.106.1EN)

p. 69
Japanese American National
Museum (Gift of June Hoshida
Honma, Sandra Hoshida,
and Carole Hoshida Kanada,
97.106.2CA)

p. 70
Purchased with funds provided
by Mr. and Mrs. Thomas H.
Crawford Jr, (M.2005.115.3).
Los Angeles County Museum
of Art, Los Angeles, photo:
digital image © 2021 Museum
Associates/LACMA. Licensed
by Art Resource, NY

p. 72
Japanese American National
Museum (94.195.24I)

p. 73
Courtesy Manzanar National
Historic Site

p. 75
Tokio Ueyama papers, courtesy
Irene Tsukada Simonian,
Bunkado, Inc., Los Angeles, photo:
Joshua White/JWPictures

pp. 76–77
© Toyo Miyatake

Some Notes on an Asian American Art History
p. 81
Courtesy Astilli Fine Art Services,
Santa Fe

p. 82
Purchased with funds provided
by Mrs. James D. Macneil
(M.2004.27.2), Los Angeles

County Museum of Art,
Los Angeles, photo: digital
image © 2021 Museum
Associates/LACMA. Licensed
by Art Resource, NY

p. 83
Courtesy Estate of Yun Gee

p. 84
Purchased with funds provided
by Mr. and Mrs. Robert B.
Honeyman Jr. and Mrs. James
D. Macneil (M.2004.27.1),
Los Angeles County Museum
of Art, Los Angeles, photo:
digital image © 2021 Museum
Associates/LACMA. Licensed
by Art Resource, NY, courtesy
Estate of Yun Gee

p. 85
Fine Arts Museums of San
Francisco, museum purchase,
Achenbach Foundation for
Graphic Arts Endowment Fund,
2001.93.4, image courtesy
the Fine Arts Museums of
San Francisco

p. 86
Collection of Aaron Shurin,
San Francisco

p. 88
top: Courtesy Astilli Fine Art
Services, Santa Fe
bottom: San Francisco Museum
of Modern Art, Lent by
Michael Chepourkoff
© George Matsusaburo Hibi,
photo: Don Ross

p. 89
Courtesy Irene Tsukada Simonian,
Bunkado, Inc., Los Angeles,
photo: Joshua White/JWPictures

p. 90
Tokio Ueyama archive, courtesy
Irene Tsukada Simonian,
Bunkado, Inc., Los Angeles, photo:
Joshua White/JWPictures

p. 91 (top and bottom)
Courtesy SFSU Fine Arts Gallery,
San Francisco

Some Thoughts on National and Cultural Identity: Art by Contemporary Japanese and Japanese American Artists
pp. 94–95
Collection National Gallery of
Australia © Yanagi Studio

p. 96
Courtesy Lynne Yamamoto

p. 97
Courtesy Lynne Yamamoto,
photo: Daniel Mirer

p. 99
top: Hammer Contemporary
Collection, Hammer Museum,
Los Angeles, purchase
through the Karin Higa Memorial
Acquisitions Fund, photo:
Brian Forrest
bottom: Courtesy Bruce
Yonemoto, photo: Oggy Borisov

p. 100
© 1997 Takashi Murakami/Kaikai
Kiki Co., Ltd. All Rights Reserved

p. 101
Courtesy Deitch Projects, NY
© Mariko Mori 2009. All Rights
Reserved. Photo courtesy
Mariko Mori/Art Resource, NY

From Enemy Alien to Zen Master: Japanese American Identity in California during the Postwar Period
p. 104
left: Courtesy the San Francisco
Chronicle Collection, Denshō:
The Japanese American
Legacy Project
right: Courtesy the Shosuke
Sasaki Collection, Denshō:
The Japanese American
Legacy Project

p. 107
top: Library of Congress,
Prints & Photographs Division,
Ansel Adams, photographer
[LC-DIG-ppprs-00386]
bottom: Courtesy Estate of
Chiura Obata, photographer
unknown

p. 108
Courtesy Louis Stern Fine Arts

p. 110
Courtesy The Noguchi Museum Archives (09153.3), photo: Michio Noguchi © The Isamu Noguchi Foundation and Garden Museum, New York/ARS

p. 111
Collection of The National Museum of Modern Art, Kyoto

Bruce and Norman Yonemoto: A Survey
pp. 114, 115 (top and bottom), 116 (top and bottom), 121 (top and bottom), 123 (top and bottom), 124, 126, 130 (bottom), 136 (bottom), 139 (all), 140, 143, 145 (top and bottom), 146 (top and bottom), 147 (top and bottom)
Courtesy Bruce Yonemoto

p. 118
Courtesy Bruce Yonemoto, photo: Fredrik Nilsen

pp. 127 (all), 129 (top and bottom), 130 (top left and right), 135, 136 (top), 141 (all)
Courtesy Bruce Yonemoto and Electronic Arts Intermix (EAI), New York

p. 132 (top)
Courtesy Bruce Yonemoto, photo: Rue Mathiessen

p. 132 (center and bottom)
Courtesy Bruce Yonemoto, photo: Laura London

p. 144
Courtesy Bruce Yonemoto, photo: Norman Sugimoto

The Permanent Collection and Re-Visioning Manzanar
pp. 150–51
Japanese American National Museum (Gift of John Korty and Visual Communications, 93.84.1), photo: John Tonai

p. 153
Library of Congress, Prints & Photographs Division, Ansel Adams, photographer [LC-DIG-ppprs-00249]

p. 154
Courtesy Yale University Library

p. 155
Courtesy Manzanar National Historic Site and the Kango Takamura Collection, Denshō: The Japanese American Legacy Project

Manzanar Inside and Out: Photo Documentation of the Japanese Wartime Incarceration
pp. 164, 178, 180–81, 182, 183, 184–85, 193, 195
© Toyo Miyatake

p. 166 (top)
Library of Congress, Prints & Photographs Division, Ansel Adams, photographer [LC-DIG-ppprs-00243]

p. 168
Library of Congress, Prints & Photographs Division, Ansel Adams, photographer [LC-DIG-ppprs-00279]

p. 169:
Library of Congress, Prints & Photographs Division, Ansel Adams, photographer [LC-DIG-ppprs-00314]

pp. 170–71
Library of Congress, Prints & Photographs Division, Ansel Adams, photographer [LC-DIG-ppprs-00285]

p. 173
Library of Congress, Prints & Photographs Division, Ansel Adams, photographer [LC-DIG-ppprs-00354]

p. 174
Library of Congress, Prints & Photographs Division, Ansel Adams, photographer [LC-DIG-ppprs-00247]

p. 175
Library of Congress, Prints & Photographs Division, Ansel Adams, photographer [LC-DIG-ppprs-00363]

p. 176
Library of Congress, Prints & Photographs Division, Ansel Adams, photographer [LC-DIG-ppprs-00442]

p. 177
Library of Congress, Prints & Photographs Division, Ansel Adams, photographer [LC-DIG-ppprs-00448]

pp. 187, 188, 190, 191
Courtesy Yale University Library

Introduction: Henry Sugimoto
p. 197
Japanese American National Museum (Gift of Madeleine Sugimoto, 2015.2.54)

pp. 198–99
Japanese American National Museum (Gift of Madeleine Sugimoto and Naomi Tagawa, 92.97.92)

p. 200
Japanese American National Museum (Gift of Madeleine Sugimoto and Naomi Tagawa, 92.97.82)

p. 202
Japanese American National Museum (Gift of Madeleine Sugimoto, 2015.2.75)

p. 204
Japanese American National Museum (Gift of Madeleine Sugimoto and Naomi Tagawa, 92.97.7)

p. 205
Japanese American National Museum (Gift of Madeleine Sugimoto and Naomi Tagawa, 92.97.132)

p. 206
Japanese American National Museum (Gift of Madeleine Sugimoto and Naomi Tagawa, 92.97.106)

p. 207
Japanese American National Museum (Gift of Madeleine Sugimoto and Naomi Tagawa, 92.97.105)

Living in Color: The Art of Hideo Date
p. 209
Japanese American National Museum (Gift of Hideo Date, 2001.77.19A)

p. 211
Japanese American National Museum (Gift of Chisato Okubo, 2003.159.19)

p. 212
Japanese American National Museum (Gift of Hideo Date, 99.111.150)

p. 215
Japanese American National Museum (Gift of Hideo Date, 99.111.52)

p. 218
Japanese American National Museum (Gift of Hideo Date, 2001.77.19C)

p. 221
U.S. National Archives and Records, photo: Tom Parker

p. 222
Japanese American National Museum (Gift of Hideo Date, 99.111.93)

p. 224
Courtesy Japanese American National Museum

p. 226
Japanese American National Museum (Gift of Hideo Date, 99.111.104)

p. 227
Japanese American National Museum (Gift of Hideo Date, 99.111.74)

What Is an Asian American Woman Artist?
p. 232
Courtesy Estate of Ruth Asawa, photo: Greta Mitchell

pp. 234–35
© Laurence Cuneo, Artwork © 2021 Estate of Ruth Asawa/Artists Rights Society (ARS), NY, courtesy Estate of Ruth Asawa and David Zwirner

p. 237
Japanese American National Museum (Gift of Ibuki Hibi Lee, in honor of Karin Higa and Kristine Kim 2000.401.2)

p. 238
Courtesy the University of California, Berkeley Art Museum and Pacific Film Archive, photo: Trip Callaghan

p. 241
Courtesy Hung Liu

pp. 242–43
Courtesy Rea Tajiri, photo: Rea Tajiri

Sights Unseen: The Photographic Constructions of Masumi Hayashi
pp. 246–47, 248 (top), 250–51, 252–53
Courtesy Estate of Masumi Hayashi (Dean Keesey)

p. 248 (bottom)
Courtesy MOHAI, Seattle Post-Intelligencer Collection, PI28050

California Registered Historical Landmark no. 850
p. 255
Courtesy Kevin Higa

pp. 256, 258 (top and bottom), 259 (top and bottom), 261
Courtesy Andrew Freeman © 2007

Origin Myths: A Short and Incomplete History of Godzilla
p. 264
Courtesy Tomie Arai, photo: Tom Finkelpearl

pp. 266, 267
Courtesy Godzilla: Asian American Arts Network and Fales Library and Special Collections, NYU

pp. 269, 270
Courtesy Godzilla: Asian American Arts Network and Artists Space

p. 271
Courtesy Carol Sun

p. 272 (all)
Courtesy Helen Oji, photos: Helen Oji

p. 273 (top and bottom)
Courtesy Arlan Huang, photos: Arlan Huang

Inside and Outside at the Same Time: Ruth Asawa
pp. 276, 285
Artwork © 2021 Estate of Ruth Asawa/Artists Rights Society (ARS), NY, courtesy Estate of Ruth Asawa and David Zwirner

pp. 278, 281, 282 (top)
Courtesy Estate of Ruth Asawa

p. 282 (bottom)
Gift of Mabel Rose Jamison (Jamie) Vogel, Japanese American National Museum, Los Angeles, image courtesy Fine Arts Museums of San Francisco

p. 286
top: Courtesy National Portrait Gallery, Smithsonian Institution, Gift of the children of Ruth Asawa
bottom: Courtesy Estate of Ruth Asawa, photo: © Mary Parks Washington

p. 287
© Elizabeth Jennerjahn

Acknowledgments

I am grateful to Mark Johnson, Pamela Lee, Nicolas Linnert, Betty Marín, Richard Meyer, and Mika Yoshitake for valuable input early in developing this project. David Joselit and Miwon Kwon have provided precious support. Marina Chao contributed crucial help in gathering images. Gratitude is due to all those who generously mined archives, furnished information, and facilitated reproductions elsewhere named in this book. Special thanks to Alejandro Cesarco, Howie Chen, Aiko Cuneo, Susan Grinols, Clement Hanami, Dakin Hart, Kristen Hayashi, Kimi Hill, Dane Ishibashi, Karen Ishizuka, Dean Keesey, Addie Lanier, Ibuki Hibi Lee, Karl McCool, Alan Miyatake, Larry Rinder, Roger Shimomura, Irene Tsukada Simonian, Dan Trujillo, and Joshua White. I thank Martin Beck, Susan Cahan, Gary Garrels, Byron Kim, Susan Morgan, and Bruce Yonemoto for various suggestions, input, and feedback.

For critical financial support, we are indebted to the Graham Foundation, the Magnum Foundation, the Andy Warhol Foundation for the Visual Arts, Furthermore: A program of the J. M. Kaplan Fund, the Terra Foundation for American Art, and the College Art Association, as well as to Yukiko Yamagata for her fortifying generosity. I am personally grateful to the MacArthur Foundation.

Denshō has been a consistent source for information and historical material, as has Mark Johnson. I am indebted to Jamie Henricks of the Japanese American National Museum for her persistent commitment to effectively scouring the museum's archives and collections. Gratitude goes to Marci Kwon of Asian American Art Initiative at Stanford University, Patty Chang and Kris Kuramitsu of LA AAPI Arts Network, and Jo-ey Tang at Kadist Foundation for their eagerness to honor Karin Higa's lifework and present this volume.

Karen Kelly and Barbara Schroeder of Dancing Foxes Press have seen the book to fruition with characteristic expertise, care, and passion. Kristen Lubben of Magnum Foundation embraced the undertaking with enthusiastic resourcefulness. Alice Chung, Karen Hsu, and Julie Cho of Omnivore have beautifully shaped the book's visual, graphic, and material presence with tireless and artful attention. Sincere thanks are due Pamela Lee for her profound and intimate essay.

I deeply appreciate the support of Kevin Higa and the Higa family and am grateful for correspondence with Kevin while making this book. Russell Ferguson provided vital insight, advice, and reinforcement throughout the process.

–J. A.

Published in 2022 by Dancing Foxes Press, Brooklyn,
in association with the Magnum Foundation
Counter Histories initiative

Edited by Julie Ault
Managing editors: Karen Kelly and Barbara Schroeder
Proofreading: Karen Kelly and Polly Watson
Design by Omnivore, Inc.

Texts and images by Karin Higa © Estate of Karin Higa
Texts by Pamela M. Lee and Julie Ault © the authors

In addition to the correction of typographical errors and
inadvertent grammatical slips, the reprinted texts in this
book have been minimally edited for consistency.

Cover: Sōgetsu ikebana by Gyokushu Kurahashi.
Photo by Joshua White / JWPictures

This book is typeset in Minister and Brut Grotesque
and printed on Munken Polar 120 gr.
Printed and bound by Brizzolis, arte en gráficas, Madrid

ISBN: 978-1-954947-02-3

Dancing Foxes Press
16 Lefferts Place
Brooklyn, NY 11238
dfpress.org

Distributed by
ARTBOOK | D.A.P.
75 Broad Street, Suite 630
New York, NY 10004
artbook.com

Printed in Spain

This publication has been made possible through
support from the Terra Foundation for American Art
International Publication Program of CAA, the
Graham Foundation for Advanced Studies in the Arts,
the Andy Warhol Foundation for the Visual Arts,
and Furthermore: a program of the J. M. Kaplan Fund.